Adobe® Photoshop® LIGHTROOM® 2

Nathaniel Coalson

Streamlining Your Digital Photography Process

Published by

Wiley Publishing, Inc. 10475 Crosspoint Boulevard Indianapolis, IN 46256

www.wiley.com

Copyright © 2009 by Wiley Publishing, Inc., Indianapolis, Indiana

Published simultaneously in Canada

ISBN: 978-0-470-40076-0

Manufactured in the United States of America

10987654321

No part of this publication may be reproduced, stored in a retrieval system or transmitted in any form or by any means, electronic, mechanical, photocopying, recording, scanning or otherwise, except as permitted under Sections 107 or 108 of the 1976 United States Copyright Act, without either the prior written permission of the Publisher, or authorization through payment of the appropriate per-copy fee to the Copyright Clearance Center, 222 Rosewood Drive, Danvers, MA 01923, (978) 750-8400, fax (978) 750-4744. Requests to the Publisher for permission should be addressed to the Legal Department, Wiley Publishing, Inc., 10475 Crosspoint Blvd., Indianapolis, IN 46256, (317) 572-3447, fax (317) 572-4355, or online at http://www.wiley.com/go/permissions.

Limit of Liability/Disclaimer of Warranty: The publisher and the author make no representations or warranties with respect to the accuracy or completeness of the contents of this work and specifically disclaim all warranties, including without limitation warranties of fitness for a particular purpose. No warranty may be created or extended by sales or promotional materials. The advice and strategies contained herein may not be suitable for every situation. This work is sold with the understanding that the publisher is not engaged in rendering legal, accounting, or other professional services. If professional assistance is required, the services of a competent professional person should be sought. Neither the publisher nor the author shall be liable for damages arising herefrom. The fact that an organization or Web site is referred to in this work as a citation and/or a potential source of further information does not mean that the author or the publisher endorses the information the organization or Web site may provide or recommendations it may make. Further, readers should be aware that Internet Web sites listed in this work may have changed or disappeared between when this work was written and when it is read.

For general information on our other products and services or to obtain technical support, please contact our Customer Care Department within the U.S. at (800) 762-2974, outside the U.S. at (317) 572-3993 or fax (317) 572-4002.

Wiley also publishes its books in a variety of electronic formats. Some content that appears in print may not be available in electronic books.

Library of Congress Control Number: 2008938486

Trademarks: Wiley and the Wiley Publishing logo are trademarks or registered trademarks of John Wiley and Sons, Inc. and/or its affiliates. All other trademarks are the property of their respective owners. Wiley Publishing, Inc. is not associated with any product or vendor mentioned in this book.

Credits

Acquisitions Editor Courtney Allen

Project Editor Mimi Brodt

Technical Editor Monte Trumbull

Copy Editor Mimi Brodt

Editorial Manager Robyn Siesky

Business Manager Amy Knies

Senior Marketing Manager Sandy Smith

Vice President and Executive Group Publisher Richard Swadley

Vice President and Publisher Barry Pruett

Book Designer Nathaniel Coalson

Media Development Project Manager Laura Moss

Media Development Assistant Project Manager Jenny Swisher

For Mom and Dad, with much love and gratitude

INTRODUCTION

Foreword	
Preface	ii
Acknowledgements	v
How to use this book	
Conventions	
Icons	
CHAPTER 1. DIGITAL IMAGING FOUNDATIONS	
The State of the Art	
Anatomy of a Digital Image	
Pixels and resolution	2
Digital color	4
Color Management Essentials	7
Color spaces	7
ICC profiles	8
Calibrating and profiling your display	9
File Formats	
CHAPTER 2. DIGITAL PHOTOGRAPHY WORKFLOW	.13
Criteria for an Efficient Workflow	. 14
The Digital Photography Workflow	. 14
Non-destructive image processing	
Enter Lightroom	
Introduction to Develop presets	
Saving your work	
DNG	. 18
Original, master and derivative files	
Bringing it All Together	
3 3	
CHAPTER 3. THE LIGHTROOM WORKSPACE	.21
Modules	. 22
Library	. 22
Develop	. 23
Slideshow	. 24
Print	. 24
Web	. 25
Toolbars	. 26
Panels	. 27
Image display area	. 27
Top panel (Module Picker)	
Bottom panel (Filmstrip)	
Left module panels	

	Right module panels	31
	Hiding and showing panel groups	
	Change panel size	34
	Expand and collapse individual panels	
	Add and remove individual panels	35
	Solo Mode	
	Panel end marks	
	Scrolling panel tracks	
Pan	el Input Controls	
	Triangle buttons	
	Arrow buttons	
	Sliders	
	Panel switches	
	Tooltips	
Ligl	htroom Menus and Commands	
	Contextual menus	
	Commands and shortcuts	
The	Lightroom Application Window	
	Screen Modes	
	Lights Out	
	The Secondary Window	47
C 11	ADTED A DICITAL IMACE CADTURE	40
	APTER 4. DIGITAL IMAGE CAPTURE	
	oturing High Quality Image Data	50
	oturing High Quality Image Data How a digital camera captures an image	50 50
	oturing High Quality Image Data	50 50 51
Cap	oturing High Quality Image Data	50 50 51 53
Cap	oturing High Quality Image Data	50 50 51 53 55
Cap	oturing High Quality Image Data	50 50 51 53 55 55
Cap	How a digital camera captures an image Raw image capture. Why not JPG? gital Exposure Expose carefully. Maximizing dynamic range.	50 50 51 53 55 55 56
Cap	turing High Quality Image Data How a digital camera captures an image Raw image capture Why not JPG? gital Exposure Expose carefully Maximizing dynamic range Camera histograms	50 50 51 53 55 55 56 57
Cap	How a digital camera captures an image Raw image capture. Why not JPG? gital Exposure Expose carefully. Maximizing dynamic range. Camera histograms Clipping	50 51 53 55 55 56 57
Cap	How a digital camera captures an image Raw image capture Why not JPG? gital Exposure Expose carefully Maximizing dynamic range Camera histograms Clipping mera Settings	50 50 51 53 55 56 57 57 58
Cap	How a digital camera captures an image Raw image capture. Why not JPG? gital Exposure Expose carefully. Maximizing dynamic range. Camera histograms Clipping mera Settings Color space	50 50 51 53 55 56 57 57 58 58
Cap	How a digital camera captures an image Raw image capture Why not JPG? gital Exposure Expose carefully Maximizing dynamic range Camera histograms Clipping mera Settings Color space White balance	50 50 51 53 55 56 57 57 58 58 59
Car Dig Car	How a digital camera captures an image Raw image capture Why not JPG? gital Exposure Expose carefully Maximizing dynamic range Camera histograms Clipping mera Settings Color space White balance ISO setting	50 50 51 53 55 56 57 57 58 58 59 62
Car Dig Car	How a digital camera captures an image Raw image capture. Why not JPG? gital Exposure Expose carefully. Maximizing dynamic range. Camera histograms Clipping mera Settings Color space White balance ISO setting. tting Sharp Captures	50 50 51 53 55 56 57 57 58 58 59 62 62
Car Dig Car	How a digital camera captures an image Raw image capture. Why not JPG? gital Exposure Expose carefully. Maximizing dynamic range. Camera histograms Clipping mera Settings Color space White balance ISO setting. tting Sharp Captures Handheld shooting	50 50 51 53 55 56 57 58 58 59 62 62 62
Car Dig Car	How a digital camera captures an image Raw image capture. Why not JPG? gital Exposure Expose carefully. Maximizing dynamic range. Camera histograms Clipping mera Settings Color space White balance ISO setting. tting Sharp Captures Handheld shooting Using a tripod.	50 50 51 53 55 56 57 57 58 59 62 62 62 63
Car Dig Car	How a digital camera captures an image. Raw image capture. Why not JPG? gital Exposure Expose carefully. Maximizing dynamic range. Camera histograms Clipping. mera Settings Color space. White balance ISO setting. tting Sharp Captures Handheld shooting Using a tripod. ng Lens Filters in the Digital Workflow	50 51 53 55 56 57 57 58 58 59 62 62 62 63 63
Car Dig Car	How a digital camera captures an image Raw image capture. Why not JPG? gital Exposure Expose carefully. Maximizing dynamic range. Camera histograms Clipping mera Settings Color space White balance ISO setting. tting Sharp Captures Handheld shooting Using a tripod.	50 51 53 55 56 57 58 58 59 62 62 63 63 63

Workflow: Digital Capture Checklist6	5
CHAPTER 5. IMPORT PHOTOS INTO LIGHTROOM6	
Lightroom Data Architecture	0
Lightroom catalogs7	0
Image files	3
Lightroom previews7	4
Digital Photo Storage7	4
Folder structures7	
Guidelines for folder and file naming7	8
Renaming photo files7	9
Import Photos into Lightroom8	3
About batch processing	3
Setting up the import8	
File handling8	
Presets and templates8	5
Keywords8	8
Previews8	8
Workflow: Copy Files from Your Camera	
and Import them into Lightroom	8
What Happens During the Import9	15
Workflow: Import Existing Files from Your Hard Disk9	6
Workflow: Shooting Tethered with Auto Import	12
Alternative Import Workflows10)4
Catalog and Image File Backups10	8
Backing up Lightroom catalogs10	8
Backing up image files10	19
CHAPTER 6. ORGANIZE YOUR PHOTOS IN LIBRARY11	
Image Sources	
Catalog panel sources11	
Folder panel sources11	
Hard disk drives and volumes	
Folders and subfolders	
Managing folders and photos	
Dealing with missing folders and photos12	
Keywords as sources12	
Collection and filter sources	
Working with Thumbnails in Grid View12	7
Changing thumbnail size12	8.
Sort Order	
Thumbnail badges	
Grid view style	2

Grid view options	122
Selecting and Deselecting Images	
The active photo (most selected)	
Select None	
Select None	
Add, Subtract, Intersect	
Grouping Thumbnails into Stacks	
Rotating and Flipping Images	
Working with Large Previews in Loupe View	
Zooming in and out of images in Loupe view	143
Showing photo info in Loupe view	145
Comparing Two Images	145
Comparing More than Two Images	
The Secondary Display Window	
Metadata	152
The Metadata panel	152
Titles and captions	153
EXIF	
IPTC	
GPS and altitude	155
Audio files	
Metadata presets	
Metadata status	
Saving metadata to files	150
Reading metadata from files	162
Keywords	
Keywording strategies	
Keywording panel	
Keyword List panel	166
Rating Photos with Lightroom Attributes	
Star ratings	
Color labels	
Flags	
Marking rejected photos	
Using Filters to Create and Modify Image Sources	
Text	
Attributes	
Metadata	
None	
Filters controls on the Filmstrip	
Saving filter presets	
Photo Collections	177
Collections	177

Quick Collection	
Smart Collections	
Collection Sets	183
Processing Photos in Library	184
Histogram overview	184
Quick Develop	184
Sync Settings	185
Copy/Paste Settings	186
Reset Settings	186
Removing all Develop settings	187
Fast metadata changes with the Painter	187
Converting raw files to DNG	188
Workflow: Editing the Shoot	
3	
CHAPTER 7. PROCESS YOUR PHOTOS IN DEVELOP	195
Plan for Processing	
Evaluating the photo	196
Lightroom defaults	204
Maintaining maximum quality	205
About composite images	208
Developing Photos	209
Undo/Redo	209
Applying camera profiles	210
Cropping	212
Adjusting tone and contrast	216
Targeted adjustments	233
Adjusting color	234
Removing artifacts	244
Dodging and burning	248
Sharpening	259
Retouching	262
Special effects	265
Comparing before and after	269
Creating multiple versions of a photo	271
Resetting adjustments	272
Applying Settings to Multiple Photos	274
Copy/Paste	274
Sync Settings	275
Develop presets	275
Auto and Default Settings	280
Workflow: Develop a Photo	282
Workflow: Roundtrip Editing with Photoshop	283
Example Before/After Photos	286

CHAPTER 8. EXPORT IMAGES FROM LIGHTROOM	
You're Done in DevelopNow What?	292
Original and derivative files	293
Planning the export	294
The Export Dialog Box	
Export Location	296
File Naming	298
File Settings	
Image Sizing	
Output Sharpening	307
Metadata	308
Post-Processing	
Export Plug-Ins	
Export Presets	
Export Workflows	
Burning a DVD	315
Emailing photos	317
Watermarking images	
Exporting Catalogs	319
CHARTER & DRECENTING VOLUDINORY	
CHAPTER 9. PRESENTING YOUR WORK	
Making and Presenting Slideshows	322
Setting up the slideshow	
Previewing the slideshow	328
Presenting the slideshow	328
Printing photos from Lightroom	329
Setting up the print job	
Printing the job	
Workflow: print from Lightroom	357
Making Web Galleries	358
Selecting a template	358
Customizing the template	359
Deploying your Web gallery	366
Exporting Web galleries	369

APPENDICES

Most Useful Shortcuts Resources Optimizing Lightroom Performance

Foreword

Nat Coalson's new Lightroom 2 book provides a simple yet very thorough discussion of how to use this powerful and vital software tool for all photographers. His clear text guides you through the basic processes of digital imaging including capture, import and organization, optimizing, printing and sharing your images in Web portfolios. His in-depth writings are valuable to the experienced user as well as beginning Lightroom user.

Using Lightroom has greatly improved my ability to work with the large numbers of digital photographs I create. This applies to reviewing and comparing files, checking for sharpness, and quickly applying the necessary post-processing to maximize each image. Many functions, such as spotting, cropping, printing and Web sharing, can be applied to many frames at once. All this makes for a more efficient workflow for me.

This book will improve your workflow, and in general, improve your photography through Lightroom's methods of selecting, editing, processing and sharing your images. Coalson's text will give you what you need to streamline your workflow, save time and get more from your digital photography. Enjoy!

WILLIAM NEILL

Preface

I'll admit it: I'm obsessed with digital imaging. I have been since 1987, when I first used a Mac for desktop publishing. I was 17.

Professionally, I come from a design and production background. As a teenager I started in graphic design, ran printing presses and worked in the litho darkroom. In my 20s, I became enthralled with digital imaging technology and worked as a prepress technician. On the side, I produced digital video and computer animation. At 28, I founded a Web and multimedia design firm that served corporate clients worldwide.

Sure, I always took pictures, but back then it was just for fun. In my daily work, I most enjoyed being the person responsible for making *other* people's photographs look great in print and digital media.

For several years, during the early- to mid-1990s, I managed a Scitex prepress service bureau in the Los Angeles area. Producing high-end imagesetter film separations and contract proofs, my staff and I were routinely processing images and layout files made by people with varying skill and expertise. These early desktop publishers all had one thing in common: everyone wanted to know how to get the printed piece to look like what they saw on their computer monitors. Thus I was forced to confront color management, device gamuts and calibration profiles before there were any real industry standards, and we handled huge numbers of high-resolution files on systems barely capable of it. During this time, I was also becoming enchanted with photography.

Then in late 2000, after casually shooting color and black and white films for around a decade, my interest in photography was given a huge boost. My lifelong friend, Eric Arbach, had a Sony point-and-shoot digital camera; I recall it was around 4 megapixels. He showed me his macro images of flowers and other still-life subjects and the image quality immediately caught my attention. I recognized in that moment that digital image capture was on the verge of becoming truly viable for high quality photographic work, on a massive scale. I knew right away that I was seeing my future. Prior to that time—shooting film—I never could fully commit to photography as a profession. Having a lab process the film (and sometimes destroy it), scanning the film, etc.... all such a hassle. And I certainly had enough of darkroom work. Digital capture changed all that for me.

As an artist, I knew I could finally create beautiful digital pictures with complete control over the entire process. From the original capture through the final print and multimedia presentations, imaging took on a whole new meaning for me. Thus began my love of photography. Not just designing and producing other people's pictures, but making them myself.

Through the years, I've worked with virtually every mainstream software application for processing, printing, managing and distributing digital images. For a long time, that meant using several programs, each for a different part of the workflow. I had used Photoshop for the majority of my photo processing work, beginning in 1992, and used many different database applications to catalog image archives.

I didn't expect the tools or techniques to change so much in such a short period of time. But with the potentially huge numbers of images captured when shooting digital, new methods were clearly needed.

I teach photography and imaging classes and provide one-on-one training to photographers at all levels. A couple of years ago, I was faced with the important decision to choose a single software platform on which to base my teaching. I had continually researched, tested and processed my photos using the available solutions from Canon, Adobe, Apple, DxO, Phase One (Capture One) and many others. Then came Lightroom.

I started working with Lightroom beta 2 in 2006. By now, probably 90 percent of my imaging work is done in Lightroom, with the remaining ten percent in Photoshop. I use Lightroom daily to process and present my photographs, make prints for clients, and to catalog projects. Lightroom has changed my work for the better, and I enjoy photography more every day. I'm sure it will do the same for you.

Whether you're a working pro or an aspiring amateur, my goal for this book is to give you real-world, professional-level proficiency with Lightroom, in as short a time as possible, so you will continue to find ever more success and enjoyment from your photography.

Nathaniel Coalson Conifer, Colorado January 2009

Acknowledgements

Many people have contributed, both directly and indirectly, to my writing this book. In particular, my great buddy Charles (CAZ) Zimmerman provided invaluable personal advice and professional legal counsel on the project. Our discussions about all kinds of topics were a great help in working out my plans. Thanks a million, CAZ!

Monte Trumbull, also a close friend and fellow photographer, provided expert technical editing that helped guide the direction of the book in key areas and kept the content on track.

Thanks to the publishing group: Courtney Allen, Acquisitions Editor at Wiley, Project Editor Mimi Brodt; and content reviewers/testers Kurt Bowman, Jim Casteel, Gerry Goggins, Rand Herman and Kathy Pancoe, for a job well done.

My students have helped me immensely in their eagerness to learn Lightroom; much of the material in this book was refined through teaching it to them. Thanks especially to Ron Cooper, Tom Tenenbaum, Rik Williams, Jane Glenn and my good friend Jim Talaric.

Classes I've taught at Denver Darkroom and Illuminate Workshops in Denver have been a development ground for many of my Lightroom training materials. Efrain Cruz and his team have been a joy to work with, and I wish them all continued success. Thanks also to photograhers Grant Collier and Bret Edge for their collaboration in leading very successful workshops with me.

I owe a lot to Joe Bullard at Publication Design in Denver, Colorado and Larry Bird at Monterey Graphics in Torrance, California, for giving me opportunities to grow early in my career.

And to my dear friends Kelly and Mark Cates, Blair and Mark Ferguson, Robin and Oscar Irwin, Janna and Erik Oakes, and my wine-partner-in-crime, Richard Reel, who have provided boundless friendship and support over the years... To my best friend Charlie Amrich, a talented artist whom I've known since the early days and whose imaging career has often intersected mine... to Eric Arbach for that all-important spark of inspiration... and most of all, my dear family: thank you all very much.

How to use this book

This book was written for digital photographers capturing and processing lots of images. Lightroom represents a major change in how we work with our photographs. The main purpose of this book is to give you the Lightroom skills to process your images more quickly and with greater confidence while achieving the highest quality results possible. Your expertise will lead to expanded creative freedom and the joy of seeing your inner visions become real.

This book is not meant to be *read* as much as it is meant to be *used*. Though the workflow is presented in sequence, it's also helpful to jump from one topic to another as needs dictate. You can use the material to learn Lightroom from the ground up or to refer back to something later. If you're new to digital photography, or have never used Lightroom, you can benefit from working through this book in a linear fashion. When you have a basic familiarity with the software and workflow, you can refresh your knowledge by going straight to the section or page containing the shortcuts, tips and techniques appropriate for the task at hand. Before long, you'll know Lightroom inside and out—and that's when the real fun begins.

The content of this book assumes you have basic- to intermediate-level computer skills, are comfortable managing files on your hard disk drives and removable media and understand common computer operations such as copy/paste and manipulating dialog boxes. I also assume you have a fundamental working knowledge of your camera, especially using exposure compensation, and that you are capturing in raw format (or ready to start right away).

If you take away one thing from this book, I hope it's the full comprehension of what you are capable of doing in Lightroom. Understanding the depth of Lightroom's nuances takes time, but is well worth it. This software can truly change your photography for the better.

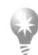

Get the book spiral bound

It would be nice if we were able to release this book in spiral-bound form, but it's just not logistically feasible with a publication like this. So I recommend that you take the book to your nearest office supply store or copy shop, have them chop the spine off, and put on a plastic coil binding. This will allow the book to lay flat when you're working through the material.

CONVENTIONS

The following terms are used interchangeably:

- Image, photo and file
- · Catalog and database

- Hard disk, hard drive, disk and drive
- Folder and directory

Also, though I use the term DSLR (digital single lens reflex) throughout the book, the principles and workflow also apply to other forms of digital capture such as mediumformat digital.

Keyboard variations

On Mac, the Apple key and \(\mathbb{H} \) Command (cmd) are the same.

On Windows, Control and Ctrl are the same. (In some places, Control is also used on Mac.)

Option on Mac is the same as Alt on Windows...

ICONS

I've included shortcuts, tips, tricks and professional-level techniques that you can use to empower your digital photography workflow—and make it more fun. These icons appear throughout the book.

Shortcut: Mac or Windows

A keyboard or menu command that eliminates steps and makes performing a task faster. The Mac shortcut is listed first, followed by the Windows shortcut.

The shortcuts in this book are based on Lightroom version 2, although most of them also work in version 1, and most will continue to work in future versions. Some of these shortcuts are not included in Lightroom Help or other documentation. This increases the possibility they may change from one version release to another. In a printed book, I can't guarantee that the accuracy of the shortcuts will last forever. Stay current with the latest revisions online.

Suggestions for speeding up the workflow, methods of processing or the best ways to approach a problem. Though some of the Tips are more important than others, they are all suggested reading.

! Warning

Strong cautions against doing something a certain way or explanations of tricky aspects of the workflow to watch out for.

Reminder

Could be repeats of any of the above and may refer to text elsewhere in the book. Reminders are placed at key points in the workflow between Shortcuts and Tips.

CHAPTER 1

DIGITAL IMAGING FOUNDATIONS

Photography is, and always has been, a blend of art and science. The technology has continually changed and evolved over the centuries but the goal of photographers everywhere remains the same: to make compelling images.

Mastering photography means mastering the art and the craft. Proficiency with current tools facilitates much greater creative potential.

This chapter provides the technical foundation to process your photographs for the highest quality.

1

The State of the Art

Until just a few years ago, professional photographers commonly would expose rolls or sheets of film, send them to a lab for processing and then review them on a light table. Though some photographers processed their own film and/or produced final prints, the amount of control offered in the analog process was inherently limited by the technology. As a result, not all photographers took a creative role in the final outcome of their photographs.

With the switch to digital imaging over the past decade or so, the technical demands on today's photographer are much greater than in the past, but the potential for individual creativity in photography is also greatly enhanced. With digital capture and processing, the photographer can remain in control all the way through the imaging process. The final manifestation of each image can be exactly what you want.

Making the most of this new technology requires learning new skills. Processing your digital photos requires strong computer abilities and the willingness to continually purchase and master new hardware and software. There's no getting around it: with the freedom of expression offered by modern photographic tools comes the responsibility to handle the process yourself. Take the time to improve your photography by continually learning to properly use the latest tools.

Before we get into the Lightroom workflow, let's be sure we're all on the same page with respect to a few key fundamentals of digital imaging.

Anatomy of a Digital Image

Understanding the characteristics common to every digital image will help you make better processing decisions. The primary attributes common to all digital images are *resolution*, *bit depth*, *color mode* and *file format*.

PIXELS AND RESOLUTION

By now most photographers understand that a digital image is made up of pixels. But what exactly is a pixel? It's simply a piece of binary information... a "picture element". A pixel is the building block of a *raster* or bitmap image. A pixel doesn't have an inherent size—is is just a piece of data in a fixed position on a grid. The pixel contains data for color and brightness, as well as alpha channel (transparency) information.

This is where resolution comes in, and many people get confused about it. Put most simply, resolution is the number of pixels in the image. Among other things, resolution determines the maximum size at which the file can be printed at

Figure 1–1: Close-ups of low and high resolution raster images

high quality. When printing, the image resolution can be specified as pixels-perinch (ppi) to determine the output size.

Resolution also describes the ability to *resolve* detail (see Figure 1–1). More pixels equal higher resolution. Fewer pixels equal lower resolution. A digital photograph with high resolution has the potential to show more detail and be printed at a larger size. For example, if you photograph a tree in low resolution, one leaf might equal one pixel—not a lot of detail. Photographed in high

resolution, one leaf could be made of dozens of pixels, showing stem, veins etc.—thus the power to resolve detail.

65,000 pixel limit

Lightroom can only import files up to 65,000 pixels on the longest side.

Native resolution and resampling

The original, unaltered resolution of a digital image file is its *native resolution*. Digital images can also be *resampled*, which either adds or discards pixels. *Upsampling* adds pixels and allows printing at larger sizes. *Downsampling* discards pixels and is usually used to reduce file sizes and to prepare files for viewing on screen, which requires less resolution than printing. Resampling requires the software to *interpolate* the existing image data in order to make new pixels. During interpolation, pixels are analyzed with their neighbors to generate new pixels. This results in a loss of data. For this reason, it is imperative that any resampling be done only when needed for a specific purpose. Resampling is discussed in more detail in Chapter 8.

When you work on photos in Lightroom, you're always working at the native resolution of the original file. You can't resize/resample images within Lightroom; you do this only when exporting derivative files from the originals or when printing. Resolution is discussed in more detail in Chapters 8 and 9.

Always process your master image files at native resolution

Keep your original masters in their native resolution. Later in the workflow you can resample as necessary and save derivative files for a particular purpose.

DIGITAL COLOR

After resolution, the second main characteristic of a digital image is color, or lack of it. In the computer, mathematical models numerically describe the way colors in the real world appear to the human eye. Image files can also be comprised of only black and white or grayscale values.

Bit depth and color values

The numeric values assigned to pixels in an image file are based on *bit depth*, which is the number of binary digits used to describe a color value (see Figure 1–2). All the pixels in a single image file have the same

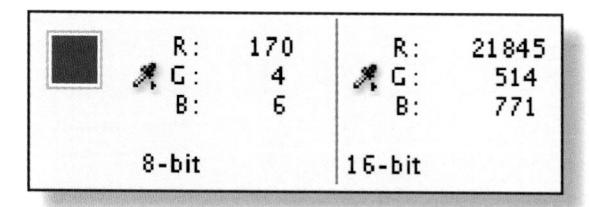

Figure 1–2: Bit depth and color values (from Photoshop)

bit depth; it's the variation of the numeric values assigned to each pixel that provide color information and give the appearance of continuous tone in an image.

Bit depths most often range from 1-bit (black or white) to 8-bit (grayscale or color) and 16-bit (grayscale or color). Though few applications and devices currently support it, 32-bit can be used as an intermediate working space when making HDR (High Dynamic Range) images.

More bits mean that more data is being used to describe the color values of the pixels. An image containing 16-bit data provides more "headroom" for processing than does an 8-bit image. This is because the additional data can be manipulated further before the appearance of the image starts to degrade. 16-bit allows smoother transitions between colors and reduces the appearance of *posterization* where areas of color become solid and transitions become hard-edged.

Based on bit depth, each pixel in an image is assigned a numeric color or grayscale value. In the RGB (red, green, blue) color model, each pixel has a color specified by a combination of three numeric values, ranging from 0-255 in 8-bit or 0-32768 in 16-bit. For example, in 8-bit RGB color, pure red is 255, 0, 0; pure green is 0, 255, 0 and pure blue is 0, 0, 255. (You will rarely, if ever, see these pure values in your images, though; colors captured from the real world will contain arbitrary levels in each channel.)

Monitor bit depth

Your display hardware is dependent on color depth, too. Make sure your monitor color settings are as high-bit as available; at minimum, Thousands of Colors, and ideally, Millions, for the most accuracy evaluating your photos on screen.

Color modes and channels

The industrial revolution brought with it major advances in measuring and reproducing color. Throughout the 20th century various color models were developed and refined to mathematically describe colors from the real world. Because they are based on math, these models translate well to computer processing.

There are a variety of digital color models (often called *modes* in computer imaging) in use today. The most common color mode for photographic imaging is RGB (red, green, blue). This model is based on the cones in our eyes,

which respond individually to red, green and blue wavelengths of light. In addition to RGB, common color modes you'll see are CMYK for printing (cyan, magenta, yellow, black (or *key*)) and Lab (Lightness plus a and b), which is most often used as an intermediate color mode during processing.

In a color image, each *color channel* is made up of grayscale values (*levels*) that indicate the density of that color for each pixel (see Figure 1–3). An RGB image file contains three color channels: one each for red, green and

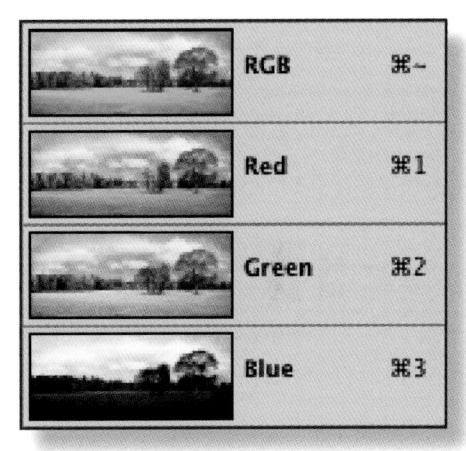

Figure 1-3: Color channels

blue. Lab also has three channels; CMYK has four channels and a grayscale image has only one channel.

It's useful to know the basis of the numeric color values. At times it's better to work with colors "by the numbers". Some images have compositions with color combinations that are deceiving to the eye, and knowing what the true color is, based on the numeric values, helps make accurate processing decisions.

Lightroom uses 16-bit color for internal processing and color measurements are displayed as percentages rather than actual numeric values (see Figure 1–4). For example, 0%, 0%, 0% is solid black and 100%, 100%, 100% is pure white.

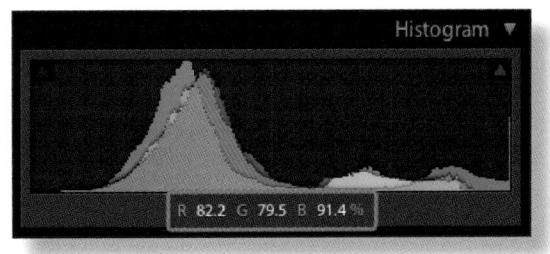

Figure 1-4: Lightroom color measurements

1

Components of digital color

Color in digital image files has three components (see Figure 1–5):

- Hue: the dominant wavelength and the named color, i.e. red, purple, orange are all hues.
- **Saturation:** purity of the hue; how far from neutral gray.
- Luminance: how light or dark the color is; how close to pure white or solid black. (In various software you may also see this referred to as Lightness, Brightness or Luminosity.)

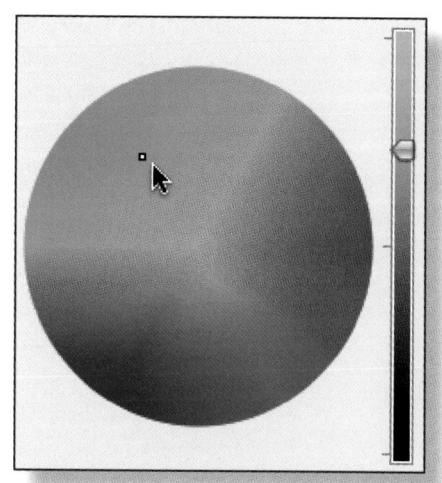

Figure 1–5: Hue and saturation are shown in the circle; luminance is on the slider. The center of the circle is neutral gray; moving outward increases saturation.

Color temperature

With digital capture, you can control how the color of light in the scene affects the colors captured. *Color temperature* is measured in degrees Kelvin and refers to the measured color of light sources (see Figure 1–6). For example:

- Bright sunlight at midday is approximately 5000k;
- Open shade is around 6500k; and
- Tungsten light bulbs are about 2800k.

Color temperature dramatically affects the overall colors in a digital photograph so understanding how the color temperature of light affects the digital capture

is essential. White Balance controls on your camera and in software let you manipulate the global rendition of colors in a photo based on color temperature. White Balance is covered in more detail in Chapters 4 and 7.

Figure 1-6: Color temperatures: tungsten, cloudy, daylight.

Challenges exist when translating colors from the real world into the digital realm. A given color, numerically described, will have different renditions on different devices. This is where *color management* comes in.

Color Management Essentials

Implementing color management is a critical aspect of getting your digital photos from capture through print; for your photos to look their best you should establish and follow a color-managed workflow. Color management refers to an integrated system of computer hardware and software working together to translate color from one device to another in a controlled way. The color management system (CMS) is built into your computer's operating system; on Mac it's ColorSync and on Windows it's ICM (WCS on Vista). The CMS handles color management at the system level. The CMS is responsible for translating digital color values to and from digital files and output devices. Software applications, such as Lightroom, Photoshop, etc., can be programmed to take advantage of the CMS (or not), and some programs, including most Web browsers, do not use color management at all. This is why a photo can look different depending on the application used to view it.

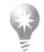

Lightroom Color Management

Lightroom is internally color-managed; there are no options to configure. If you're using a properly calibrated and profiled display, you can trust that the colors you see on-screen are very accurate. Lightroom will respect and preserve embedded profiles in image files, and uses a proprietary color space for internal processing.

COLOR SPACES

A color space is a 3-dimensional mathematical model describing the range of colors possible in an image file or on an imaging device, such as a monitor or printer (see Figure 1–7). Using the RGB color model, there are several color spaces in widespread use today. The most common RGB color spaces used in digital photography are:

- SRGB
- Adobe RGB (1998)
- ProPhoto

Figure 1–7: Three-dimensional plot of the Adobe RGB (1998) color space

1

Color spaces and their uses are discussed in more detail in Chapter 8.

ICC PROFILES

The color space of an image can be embedded as an ICC (International Color Consortium) profile. JPG files captured from your camera will contain the profile for the color space set on your camera (usually SRGB or Adobe RGB).

Camera raw and DNG files can not contain embedded ICC profiles, however, DNGs can contain a DNG profile. Previously processed image files on your hard drive, such as PSD and TIF, may or may not have embedded color profiles depending on processing previously done. For more information on file types and their uses see Chapter 8.

Source and Destination

An ICC profile describes the color space of an image file or imaging device. A color–managed workflow uses profiles for each file and device in the imaging pipeline.

Profiles are stored in specific places within your operating system so they are made available to any program using the CMS. The CMS uses the profile to handle the translation of numeric color values between devices. In a digital image file, an embedded ICC profile tells the color management system the rules for translating the colors in the image through the pipeline. For a device, the profile tells the CMS how to convert the color data in an image to the output device—a printer, monitor, etc.

The CMS processes the color values in the *source* profile to create the optimum values for the *destination*. For example, when printing, an image file in the Adobe RGB color space would be the source and an Epson printer profile would be the destination.

ICC profiles are also discussed in more detail in Chapter 8.

Gamut: The Range of Colors Available

Different devices (monitors, printers etc.) interpret color numbers in different ways, because of differences in the type of device and their primaries (their main colors: red/green/blue, or cyan/magenta/yellow/black, etc.) No device can reproduce all colors and all devices reproduce color differently. The range of colors that a device can reproduce (or that a digital file contains) is called the color *gamut* (see Figure 1–8). A large gamut contains many possible colors and a small gamut has relatively few colors available. The gamut is described within the ICC profile.

Of the three main color spaces, sRGB has a relatively small gamut, Adobe RGB is considered to have a relatively large gamut, and ProPhoto has the largest gamut and is capable of containing the most possible colors. (Note that there are a few lesser-used color spaces. Such as EktaSpace, that have even larger gamuts than ProPhoto.)

- Smaller color space=fewer colors
- Larger color space=more colors.

ta ta

Figure 1–8: These plots of Adobe RGB (1998) on the outside and SRGB on the inside clearly show the difference in the sizes of their gamuts.

Rendering Intents

Out-of-gamut colors are those present

in the source file but not in the destination profile. For example, the limited gamuts of many color printers pose difficulty reproducing bright shades of blue found in many RGB image files. When the source color can't be reproduced in the destination, the *Rendering Intent* determines how the color value(s) are translated to the destination space.

The two most common rendering intents are *Perceptual* and *Relative Colorimetric*. Perceptual compresses the gamut of the source to fit into the destination, remapping all the colors to preserve their visual appearance as perceived by the human eye. Relative Colorimetric keeps all the in-gamut colors unchanged and clips the out-of-gamut colors to the closest possible match within the destination gamut. Perceptual may provide for the most pleasing overall rendering for some images, but Relative Colorimetric is numerically more accurate and is most often ideal. Rendering Intents are discussed further in Chapter 9.

CALIBRATING AND PROFILING YOUR DISPLAY

The most important factor in achieving accurate color for your digital photographs is working on a calibrated and profiled display. Calibrating your display corrects its output settings, and profiling makes an ICC profile for use by the CMS.

Calibrating and profiling your display must be done with a combination of dedicated hardware and software. Software alone, such as Adobe Gamma, is not sufficient; you must use a measurement device to perform accurate calibration. I recommend the X-Rite i1 (Eye One) systems for this; see Resources in Appendix.

1

FILE FORMATS

There are many image file formats in use today, but most are highly specialized. In the digital photography workflow there are only a few kinds of files you need to deal with. Following are the file formats that Lightroom can read and, in most cases, write to:

- Camera raw: These files come directly from your camera with formats specified by the camera manufacturer and are encoded in a way that they cannot be directly modified. Common examples are Canon's .CR2 and Nikon's .NEF formats. Note that two raw files with the same file extension but from different cameras are likely to be programmatically different; your camera model's native format must be supported by Adobe for you to work with those files in Lightroom. Adobe imaging software supports nearly all digital cameras available on the market and support for new models is continually updated. However, when a new camera is released there may be a period of lag time during which your files cannot be read by Lightroom or Adobe Camera Raw. In our workflow, camera raw files serve as the original capture from the camera but are only used temporarily.
- DNG (Digital Negative): Adobe's open raw format. Camera raw files converted to DNG contain all the original raw data from a camera raw capture plus optional previews and metadata (embedded textual information about the file). DNG allows saving metadata inside the file and does not require sidecars (see below). dng is my recommended raw format.
- TIF or TIFF (Tagged Image File Format): Industry standard, open-source file format. May contain layers, vector objects and transparency. TIF files can be compressed using lossless algorithms.
- **PSD** (**Photoshop document**): Photoshop files must be saved with the Maximize Compatibility option enabled in order for Lightroom to read them.
- JPG or JPEG (Joint Photographic Experts Group): this is the standard format for presenting and exchanging continuous tone (photographic) images, especially on the Web. A JPG file is compressed using *lossy* algorithms, which means that data is discarded during saving (even at the highest quality level). In Lightroom, JPG files from your camera can be used as originals. However, for the best quality, always capture raw (see Chapter 4).

Lightroom doesn't support:

- Files in the CMYK color mode
- Adobe Illustrator® files
- Files larger than 65,000 pixels on any side
- Files larger than 512 megapixels
- · Video files

Camera raw files and sidecars

Because a raw file straight from the camera typically cannot be modified using software, any metadata applied to the file must be stored elsewhere. The most common method is the use of *sidecar* files in .xmp (Extensible Metadata Platform) format. A sidecar file is associated with a specific, individual file and contains metadata changes made to the raw file in software such as Lightroom and Adobe Camera Raw. The sidecar must always accompany the original file in order for the metadata changes to be available to the software. This is one reason I recommend using DNG originals instead of native camera raw files.

Chapter Summary

All digital image files share several common characteristics. How these affect the quality of the data in the image file should be considered when making processing decisions. Implementing color management policies and calibrating your display are essential for accurate color reproduction.

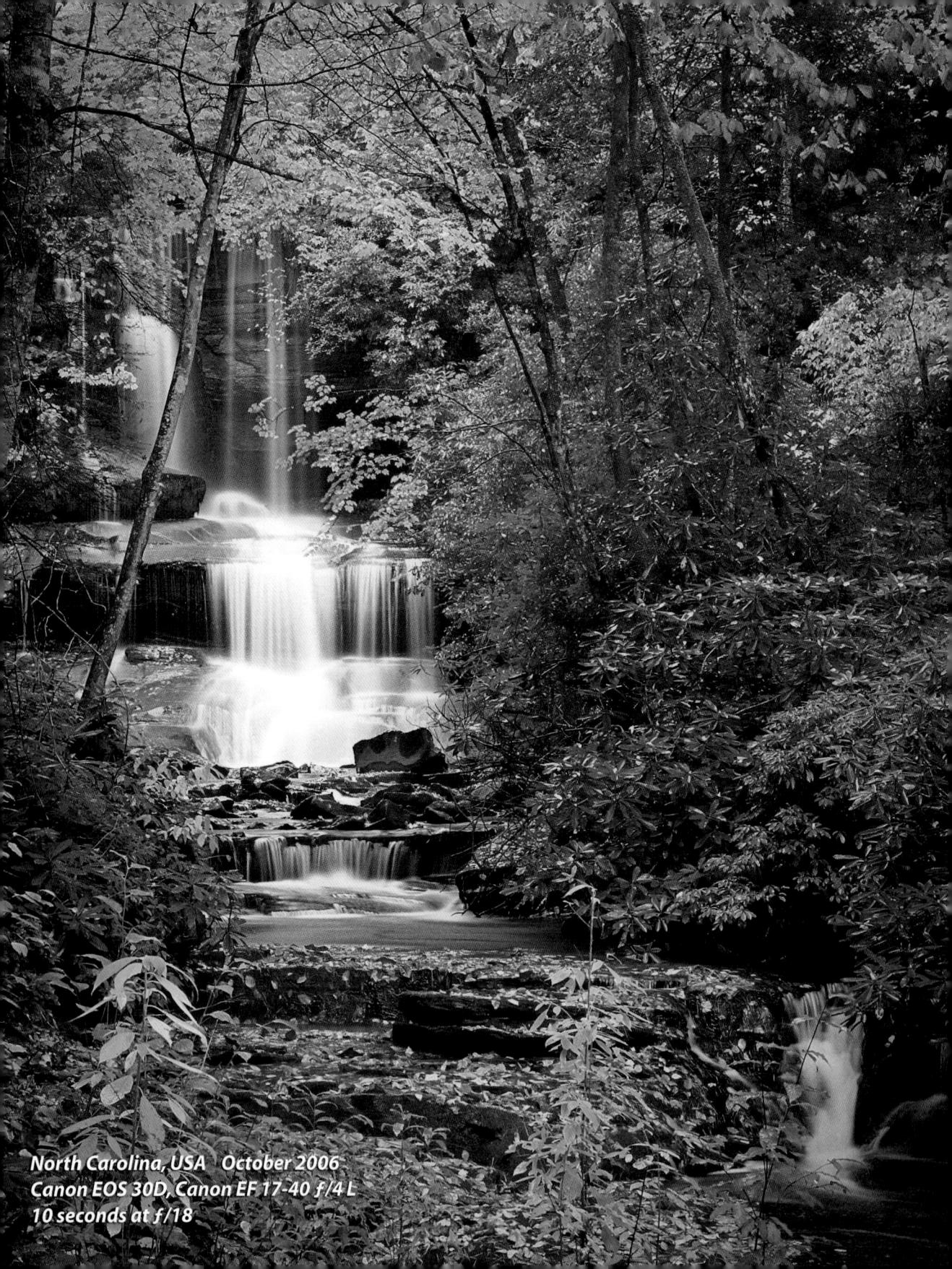

CHAPTER 2

DIGITAL PHOTOGRAPHY WORKFLOW

There's a lot of talk about workflow these days. Sometimes it seems that everybody's promoting a different one.

Though circumstances will vary, the basic steps in a truly efficient digital photography workflow always remain the same. Only the per-job variables change—usually accomplished by simply modifying a few software settings.

Developing a good workflow is important: it will enable you to process more images in less time, leaving more time for working on your favorites. A good workflow makes photography more fun.

This chapter outlines the essential workflow you will use to process your photos in and out of Lightroom.

Criteria for an Efficient Workflow

Making high quality images today is an entirely digital process, from capturing the photograph to making the final print. Your *workflow* is the sequence of steps you follow to capture, process and present your photographs.

Today there's an overwhelming variety of hardware and software available to process digital images. Not to mention myriad, specialized solutions for different kinds of photography. Everyone has different equipment and is comfortable with certain ways of working with their photographs. So it's inevitable that one person's workflow won't be exactly like another's. And even for a single photographer, no one workflow will be appropriate in every situation. The "best" workflow is determined by circumstances and personal preferences.

With all this in mind, you still can—and should—use a consistent sequence of steps to capture and process your digital photographs. An efficient workflow is flexible and adaptable, yet has specific characteristics:

- Does not include any unnecessary steps
- Is learnable and repeatable
- Provides for the fastest possible throughput and the highest quality
- Remains non-destructive to original image data
- Uses organizational systems that scale effectively with ongoing use
- Is flexible enough to accommodate unpredictable requirements
- Works with all required image file formats

The Digital Photography Workflow

Even with all the variables involved, it is possible to characterize a standard workflow for digital photography. This is the skeleton framework—you can customize this to the needs for your photography as you see fit. In any case, the basic steps of the workflow remain the same (see Figure 2–1):

- 1. Capture the raw digital photographs with your camera.
- 2. Import the images onto your computer disk drives and into Lightroom.
- 3. Organize your photos and isolate the best ones in Library.

- 4. Process (Develop) the selected images.
- 5. Export derivative image files from Lightroom as necessary for specific purposes.
- 6. Present your work as fine art prints, Web sites and slideshows.

Of course, each of these steps is actually comprised of multiple tasks that vary depending on circumstances. These tasks—and time saving shortcuts and techniques—are explained in detail in the following chapters.

If you perform each phase of the workflow similarly every time, you will soon be able to think several steps ahead. This facilitates better decision-making and dramatically speeds up your work.

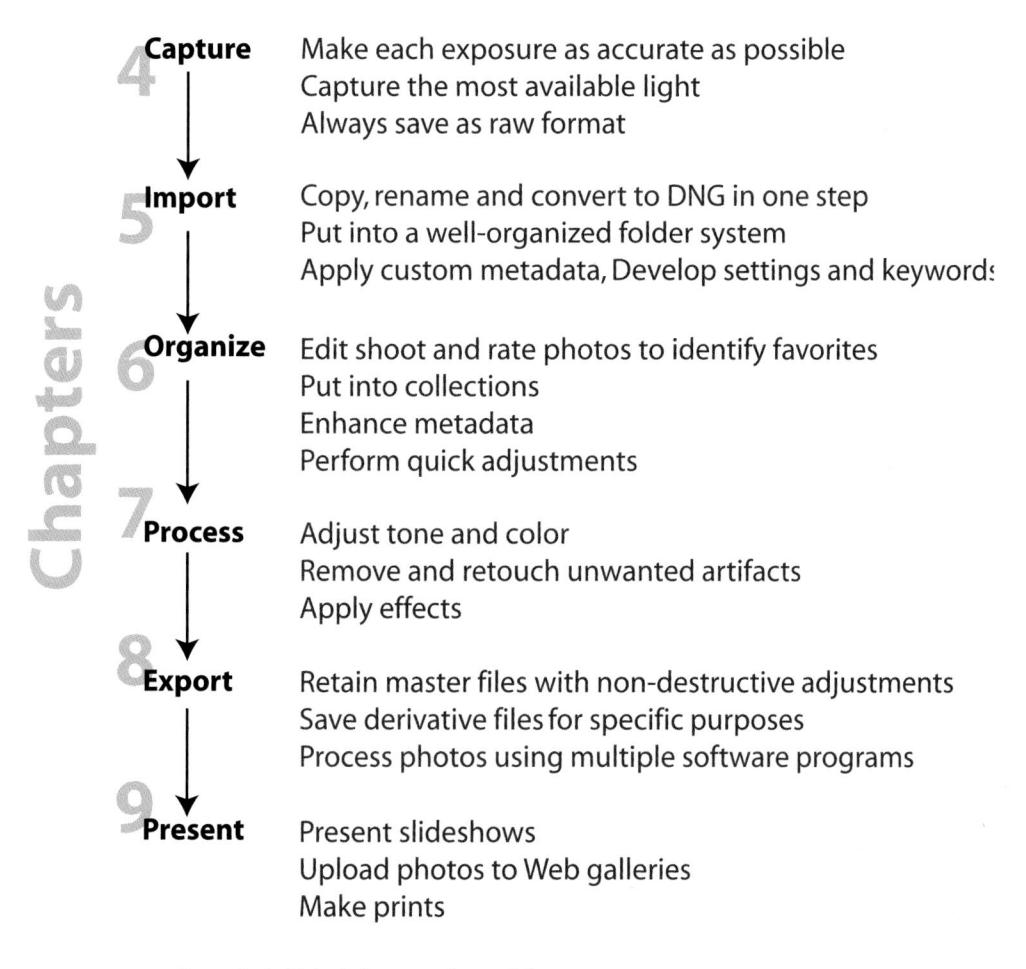

Figure 2–1: Digital photography workflow

Nothing lasts forever

Using a system is the key to efficiency, but systems also need to be designed to improve with use. Know when it's time to make a change to your workflow. Work with your system until you see an opportunity to improve it. Also, expect that new software, or changes to software you're using, may require refining your system.

NON-DESTRUCTIVE IMAGE PROCESSING

Capturing, processing and storing a digital image file require many steps. When you process a digital image, you manipulate the binary data in the file. In many cases, data is discarded during each step of processing. Non-destructive image processing refers to software methods that always preserve the original, unaltered data. Modifications to the appearance of an image are applied in ways that can be further adjusted or "undone" later. This allows you to go back to a previous work point, when necessary, without the risk of permanently altering or losing the original image data.

Using non-destructive processing does not mean that you can't visually destroy an image with the adjustments you apply in Lightroom. Even using non-destructive tools, it's all too easy to make an image look terrible by processing it in ways that render the final image with less than optimal quality. (Of course, some of these ugly processing artifacts can become creative devices!)

Regardless of the processing necessary, it's essential to retain as much data as possible as far through the processing pipeline as you can.

Loss of data equals loss of quality

Lightroom applies the adjustments you make in the order that preserves the highest possible quality. However, when editing an image using any software, it's important to use as few adjustments as are necessary to create the result you want. Most importantly, never apply one adjustment to correct another.

Metadata editing: the new frontier

Until recently, digital photo processing required direct alteration of pixel data. This often required very large, complex files to store adjustments as nondestructive data. While tools like Photoshop's layers and masks, smart objects, smart filters, etc. allow the reversal of adjustments at a later time—and therefore can be considered non-destructive—they also take large amounts of computer memory and storage space to process and save the adjusted files.
With the advent of metadata image editing, adjustments to photos are stored separately from the original pixel data and are applied when the software renders the image. Lightroom (and similar software products) uses metadata to read and write simple, textual instructions for processing the image without directly affecting the data of the underlying pixels (see Figure 2–2).

```
<crs:WhiteBalance>As Shot</crs:WhiteBalance>
<crs:Temperature>4900</crs:Temperature>
<crs:Tint>-3</crs:Tint>
<crs:Exposure>0.00</crs:Exposure>
<crs:Shadows>5</crs:Shadows>
<crs:Brightness>+50</crs:Brightness>
<crs:Contrast>+30</crs:Contrast>
<crs:Saturation>+15</crs:Saturation>
<crs:Sharpness>65</crs:Sharpness>
```

Figure 2-2: Example Lightroom metadata

Enter Lightroom

Lightroom excels at non-destructive, metadata image editing and processing. In fact, within Lightroom you will often be able to perform all but the capture step of the workflow. Lightroom can help you with importing, organizing, processing, exporting and presenting your images.

DEVELOP PRESETS

Another advantage to using simple metadata instructions for image adjustments is that they can easily be saved for later use. A Lightroom Develop preset is a very small, compact text file that can be easily moved to other computers or shared with other photographers. See Chapter 7 for more about Develop presets.

SAVING YOUR WORK

As you work on your photos, Lightroom automatically saves your adjustments in the database (mainly as text variables with numeric and Boolean values) and generates screen previews based on the adjustments that have been applied. In general, each software control is assigned an absolute value: Exposure=+.50, Saturation=-5, etc. Your original file (regardless of its format) remains unaltered, giving you unlimited flexibility for changing your mind later.

However, storing all your editing instructions *only* in the Lightroom database carries some risk. For example, if you do all your processing in Lightroom and the database becomes corrupt (and you haven't made backups) you could lose that editing data, requiring the work to be redone.

This is why you must get in the habit of saving your work frequently when working in Lightroom, just like working with any other software. When you save metadata to files, in addition to being stored in the Lightroom catalog, the metadata processing instructions for the adjustments you make should also be saved to files *outside* the database. This can be done using sidecar files (for camera raw formats; see below) or by saving metadata in the actual files themselves (for all other formats). Saving out the metadata helps ensure 1) your work won't be lost and 2) your edits travel with the original file wherever it goes.

Even when you save metadata adjustments into a file, the pixel data is not changed: the metadata is stored in a separate part of the file, and read back in when Lightroom or other software loads the image.

DNG

DNG stands for Digital NeGative, an open source raw format developed and standardized by Adobe. Whereas proprietary camera files require sidecar files to save metadata edits, DNG files can store metadata directly in the file.

Convert your raw files to DNG early in the workflow To save time and effort later.

ORIGINAL, MASTER AND DERIVATIVE FILES

For each digital photograph you make, you will likely produce several (if not many) image files on disk, each serving a different purpose. The number of versions you can produce from a single image is unlimited, but efficiency favors conservatism here.

- Original: In Lightroom, the Original is always a file on disk, for example, the raw
 capture in camera raw and/or DNG format. Originals can be in any file format
 Lightroom supports. Archive these files and protect them long-term; these are
 like original slides in boxes. If the worst should happen, and all else is lost, you
 need to be able to go back to these.
- *Master*: the file that contains all the final processing and from which all derivatives are made. In the end, the Master is even more important than the Original, because it contains all the painstaking work you did to finish the image. If you completed processing on your raw/DNG file it can also serve as the Master. Otherwise, the Master is usually a layered TIF or Photoshop file.
- Derivative: files saved from the Master and modified for specific purposes such as
 printing or Internet distribution. These are usually TIF or JPG files for printing and
 for the Web. Derivative files are often temporary and trashed when their task is done.

Know when to Export

Sometimes you may want to work on your images in other software after you've gone as far as you can processing them in Lightroom. Think carefully about your plans for the image, and the workflow steps required, and export new master files in order to use other, specialized software. See Chapter 8 for more about Exporting.

Use DNG as your raw format and TIF as your layered work format From these two master file formats you can produce derivatives of any kind, for any purpose.

Bringing it All Together

You may be thinking, "This all sounds too simplistic. Isn't there more to the workflow than that?" Well, no, and yes. Regardless of whether you're a professional wedding photographer, a nature photographer, a photojournalist or any other kind of photographer, you can use one master workflow for all your photographic processing.

There will, of course, be photographic situations in which the steps in the workflow are rearranged or different steps receive a higher priority and more attention. Depending on the work at hand, the necessary imaging tasks may vary.

For example, a wedding photographer's workflow will require less time editing to determine selects (because the client will largely determine that) and more time in the presentation stage, preparing many images for client review. Most processing will be automated, allowing for fast application of global adjustments to many files at once.

Conversely, a landscape photographer will spend more time in the organization and editing phases, narrowing down many shots to just a few and taking more time processing each individual image.

Furthermore, differences in workflow tasks may also arise from varying lighting conditions. For instance, balancing the color in images shot under studio lighting will require a different approach than images captured outdoors.

But the tools, techniques and conventions remain the same. Strive to follow one workflow for all your processing and you'll accomplish more in less time, allowing more time for the fun stuff.

Chapter Summary

Practice using a consistent workflow for your photo-imaging work. Think about the steps required and plan ahead. Don't over-process images. Carefully manage the files you use to produce your finished work.

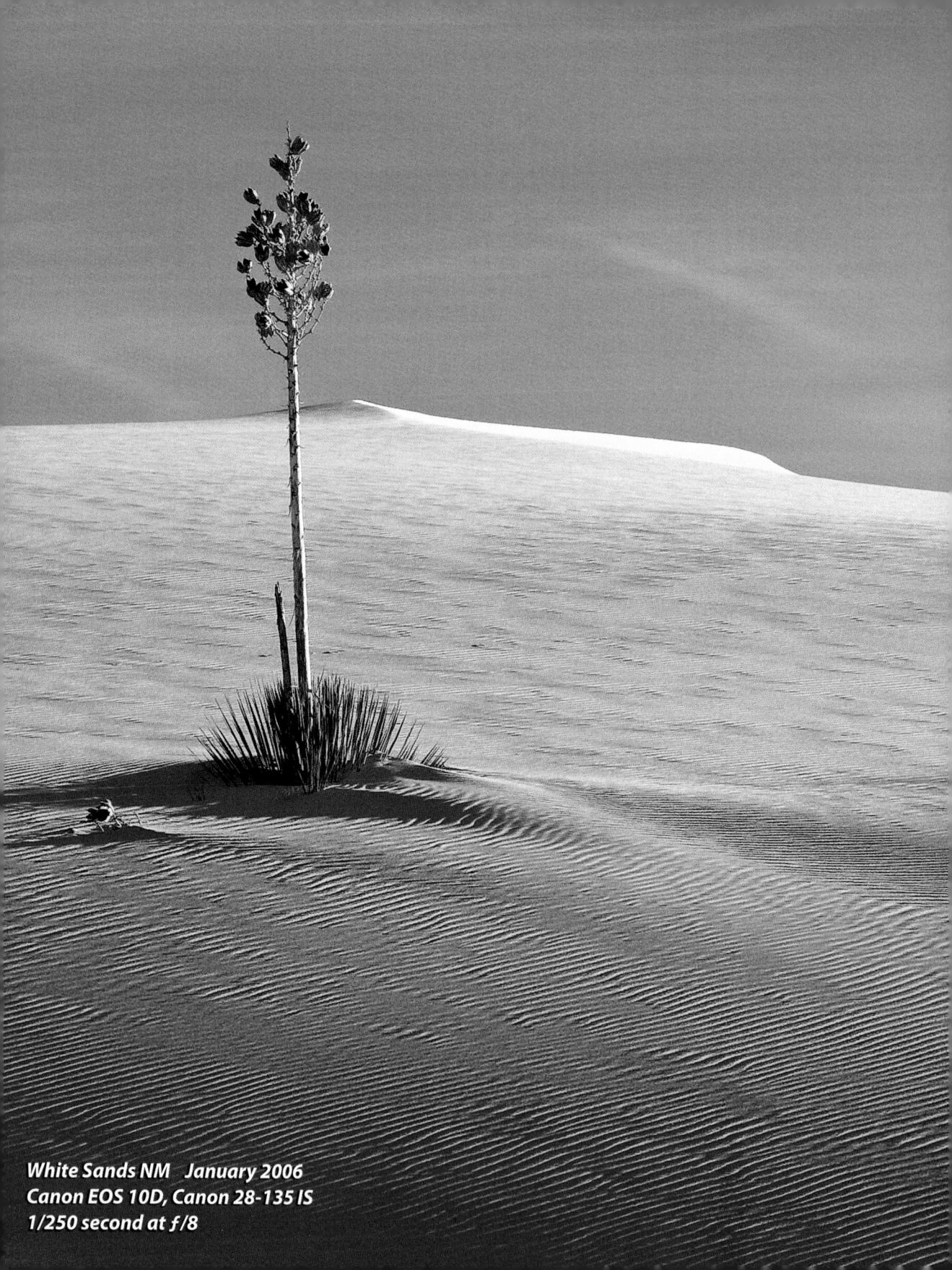

CHAPTER 3

THE LIGHTROOM WORKSPACE

As a new software application, Lightroom's user interface was designed to facilitate easier interaction with vast numbers of images.

Compared with programs like Photoshop, its unconventional tools and screen layout represent a different way of working with digital photos. In particular, using the keyboard to process images is a new approach for many photographers and thus carries a bit of a learning curve.

This chapter provides in-depth explanations of the Lightroom workspace and offers numerous shortcuts and tricks that will make your use of Lightroom fast, fluid and fun. 3

Modules

All work in Lightroom is done in one of five *modules*. The modules provide tools and commands specific to each phase of the workflow. The modules can be accessed using the *Module Picker* (to the right of the top panel; see Figure 3–1) or by using various keyboard shortcuts.

Figure 3-1: Module Picker

1. LIBRARY

This is where you organize, sort and manage your images (see Figure 3–2). A limited subset of processing controls is also included (Quick Develop). See Chapter 6 for more information about Library.

Figure 3–2: Library module in Grid view

G
To load the Library module in Grid view.

E E

To load the Library module in Loupe view.

2. DEVELOP

Here you can process your photos to perfection (see Figure 3–3). Cropping and straightening, tone and color adjustments, noise reduction, sharpening, creative effects... the list goes on and on. The Develop module is the core of Lightroom's image processing power. See Chapter 7.

Figure 3-3: Develop module

> [

To load the Develop module; or

₩+Option+2 or Ctrl+Alt+2
To load the Develop module.

3. SLIDESHOW

In the Slideshow module (see Figure 3–4) you can design presentations for playback within Lightroom or exporting as PDF or JPG files. See Chapter 9 for information about working in Slideshow.

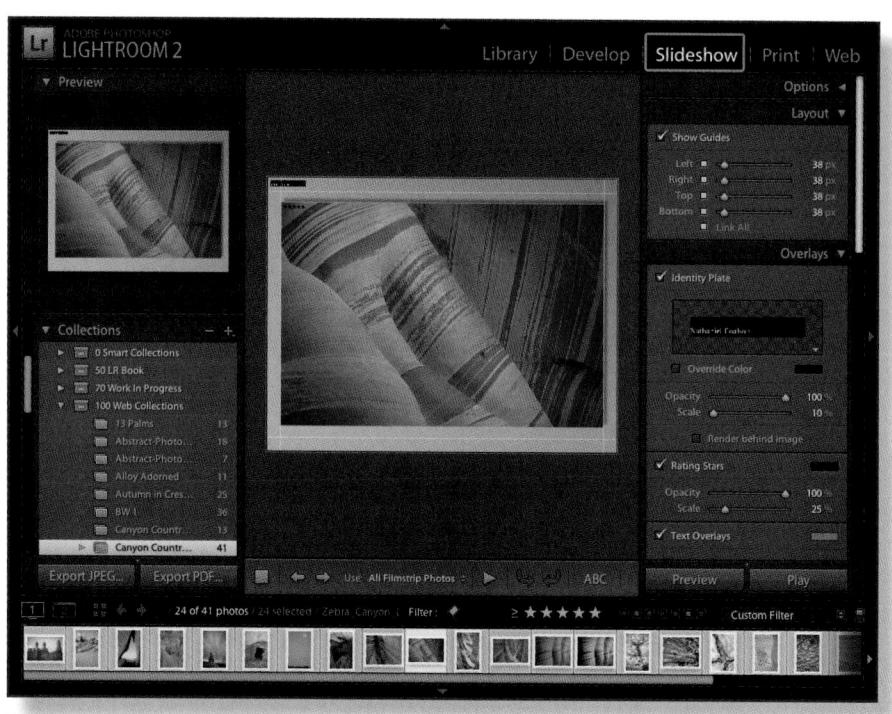

Figure 3-4: Slideshow module

%+Option+3 or Ctrl+Alt+3

To load the Slideshow module.

4. PRINT

A photograph isn't truly finished until it is printed. Lightroom's Print module (see Figure 3–5) gives you a variety of tools to create custom layouts and make prints. See Chapter 9.

∺+Option+4 or Ctrl+Alt+4

To load the Print module.

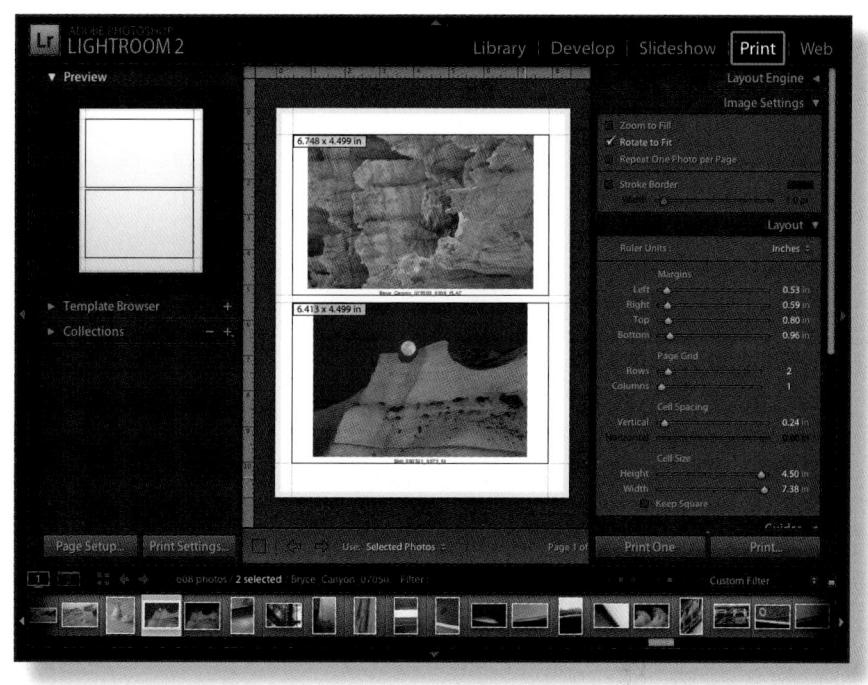

Figure 3-5: Print module

5. WEB

In Lightroom's Web module (see Figure 3–6) generating Web galleries in HTML or Flash format is quick and easy. See Chapter 9.

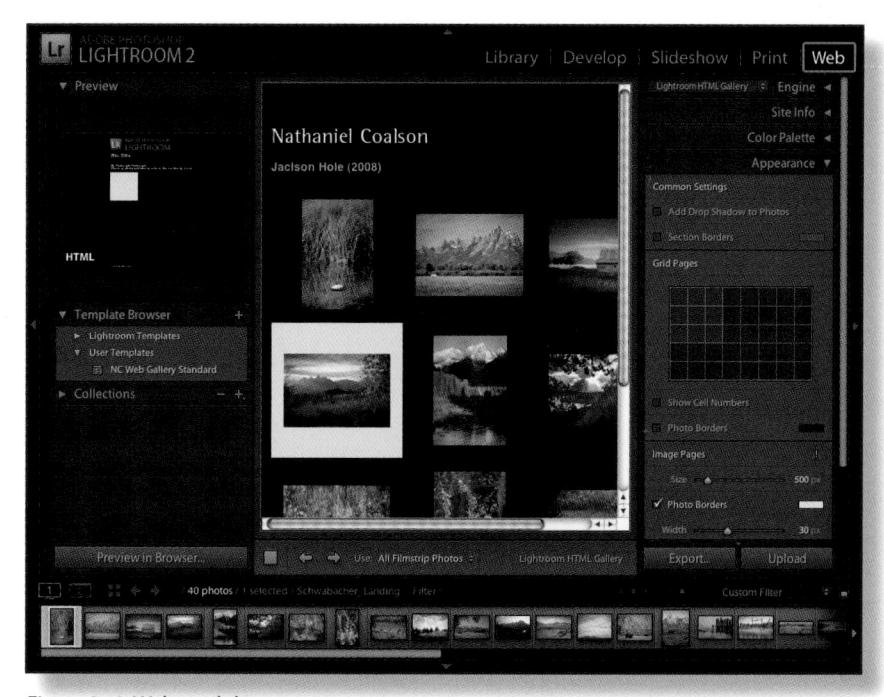

Figure 3-6: Web module

**HOption+Up Arrow or Ctrl+Alt+Up Arrow To return to the previous module.

Let Lightroom do its thing

There are times when Lightroom's performance slows or seems to stall. Often this happens when switching between modules or tools. In most cases, it's best to wait (stop clicking!!) and let Lightroom finish the current process. You will often find that, even when Lightroom appears to have crashed, if you give it a few moments, the program will recover, finish processing and resume normal operation.

TOOLBARS

Each module has its own toolbar containing various tools specific to that module (see Figure 3–7). Toolbars are shown at the bottom of the image preview area. Most of the tools and functions on the toolbars can be performed using shortcuts. Once these are committed to memory, it's possible to work most of the time with the toolbar not showing.

Figure 3–7: Toolbars: Library, Develop, Slideshow, Print, Web

To hide/show the toolbar.

Change what shows in the Toolbars

At the right side of the toolbar is a triangle button that, when clicked, activates a menu that you can use to customize the contents of the Toolbar.

Panels

Lightroom's *panels* contain the majority of controls you will use to process your photos. Note that panels can't be "undocked", moved or placed floating in the main window; they are always in the same position. However, they can be hidden and resized.

IMAGE DISPLAY AREA

Photos and layouts are shown in the center of the Lightroom window. In the presentation modules, this area is used to preview the current layout. The size of the image display area is variable, based on the visibility and sizes of the panels. (In Adobe* documentation, this area is also referred to as the "preview area" and the "central area" of the module.) See Figure 3–8.

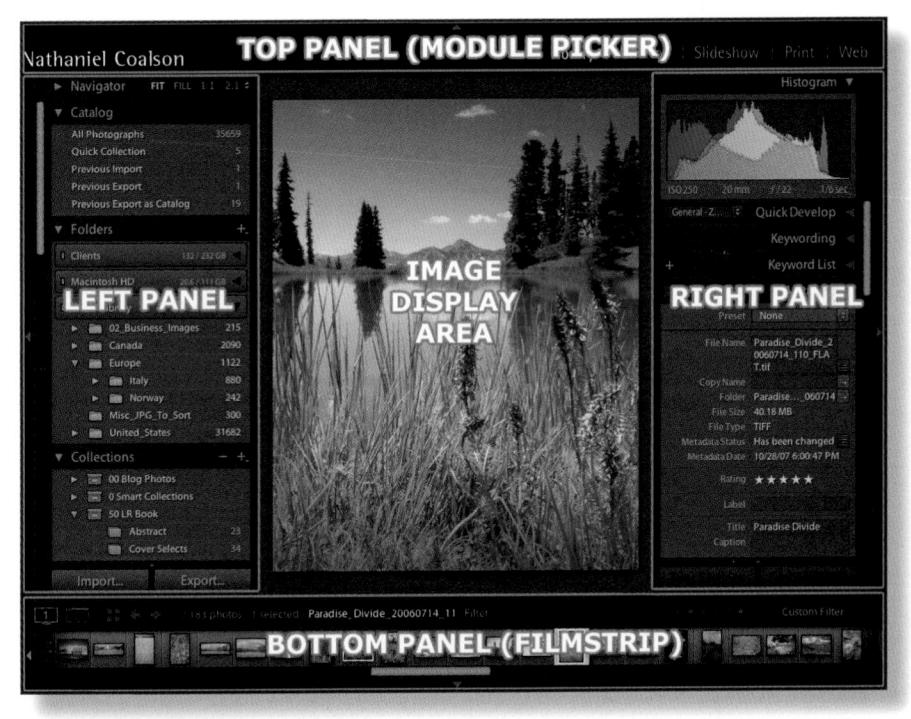

Figure 3-8: Image display area; panels

Around the image display area, the Lightroom application window is divided into four panels. The contents of the left and right panels change within each module. Generally, left module panels are used for organizing, batch processing and accessing presets and templates, while right panels contain tools used for applying specific settings to photos. The bottom panel (Filmstrip) and top panel (Module Picker) remain consistent throughout all the modules.

TOP PANEL (MODULE PICKER)

The top panel (see Figure 3–9) contains the Module Picker (right) and the Identity Plate (left). During processing, Lightroom's progress indicators are also displayed in the Identity Plate area.

Figure 3-9 Top panel, Module Picker and Identity Plate

F₅

To hide/show the top panel.

Identity Plates

At the far left of the top panel is the main Identity Plate (see Figure 3–9). You can customize it with your own text or graphic files. The main Identity Plate can be used in slideshows, Web galleries and print layouts, and in those modules you can also create additional Identity Plates. See Chapter 9 for more about using Identity Plates.

Lightroom menu→Identity Plate Setup or Edit...→Identity Plate Setup
To customize and save Identity Plate presets. See Figure 3–10.

Figure 3–10: Identity Plate Setup window

The Activity Viewer and Multithreading

When Lightroom is working on a process, the main Identity Plate is replaced with the Activity Viewer, which shows one or more progress bars (see Figure 3–11). Lightroom is *multithreaded*, which means it can multitask: several operations can be performed at the same time. If more than one process is going, multiple progress bars are shown.

Figure 3–11: Activity Viewer and progress bar

Stopping a process

To stop a process, click the small X at the right side of the progress bar.

Move on to other tasks

There is usually no need to wait for a process to complete before moving on to another task. For example, if you are in the middle of an import, you can still work on images already in the Library. If you're exporting a Web gallery, a batch of images, etc., the same applies. The only operation that you can't have more than one going at a time is Import (see Chapter 5).

BOTTOM PANEL (FILMSTRIP)

Also called the Filmstrip, the bottom panel shows thumbnails for the images in the current source (refer to Figure 3–8). The Filmstrip remains the same throughout all the modules.

F6

To hide/show the Filmstrip.

LEFT MODULE PANELS

The contents of the left panels change from module to module. Generally, the left panels provide access to files and templates within the selected module. Refer to Figure 3–8.

F7

To hide/show the left panel group.

#+Shift+a Number or Ctrl+Shift+a Number

To open/close the left panels.

The Navigator Panel

The Navigator (see Figure 3–12) is present in the first position of the left panel group in all the modules (though it's the Preview panel in the presentation modules, and functions a bit differently). The Navigator shows a preview of the selected photo or the active photo if multiple images are selected. The Navigator panel can be used to select zoom ratios, or levels of magnification. Selecting a zoom ratio in the Navigator enlarges the photo preview to that size.

But the Navigator offers more than just another preview. For instance, in Library, moving your mouse over folders or collections will show the first image in that source in the Navigator. And in Develop, Navigator shows previews of presets. Just roll your mouse cursor over the presets in the list, and Navigator will show you what that preset looks like applied to the selected image.

Figure 3–12: Navigator panel; popup menu with user selectable zoom ratio

Zoom Ratios

Unlike other programs that specify magnification level with a percentage, Lightroom's zoom levels are based on the ratios between image pixels and screen pixels. 1:2 is one screen pixel for two image pixels. 4:1 is four screen pixels for one image pixel, and so on.

The preset zoom ratios are:

- Fit: fits the entire photo into the image display area.
- Fill: fills the available view top-to-bottom with the image. The sides of
 images using landscape orientation may not remain visible.
- 1:1: one image pixel for one screen pixel. 1:1 has special importance in Lightroom: some settings in Develop, such as Sharpening and Noise Reduction, are not visible in the preview unless you're viewing the image at 1:1 or greater.
- **User selected setting:** the fourth zoom ratio shown uses the last custom zoom ratio you selected. Clicking this ratio will also display a popup menu for you to choose the custom zoom ratio.
- Move around an enlarged preview with the Navigator.

 When zoomed in to a photo, drag the white box in the Navigator preview to change the area shown in the main preview.
- Larger Navigator previews

Enlarge the left panel group to make the Navigator preview bigger. (Click and drag the inner panel edges to resize them.)

RIGHT MODULE PANELS

In Library and Develop, the right panels include tools for modifying the image(s) within the current module. In the presentation modules, the right panels contain controls for changing layout settings.

- F8
 To hide/show the right panels.

White Sands NM January 2009

Canon EOS 5D Mark II, Canon EF 100-400 f/4 L IS

1/25 second at f/25

HIDING AND SHOWING PANEL GROUPS

The combined assemblages of the left and right module panels are typically referred to as *panel groups*. To hide a panel group, click its outer edge. Click again to show it. Or, when a panel group is hidden, you can temporarily show it by hovering your mouse cursor over the collapsed panel at the outer edge of the window. This is called Auto Hide/Show, and can be enabled or disabled. Auto Hide/Show allows you to temporarily access the panel group to make whatever changes are necessary and when you move your mouse away the panel group is hidden again.

The state of hidden and visible panels persist for each module until you change them.

Hides/shows the side panels.

Shift Tab

Hides/shows all panels.

Right-Click or Ctrl+Click a panel edge

To set options for Auto Hide/Show and syncing between opposite panels.

Show the panels you use; hide the others

I usually work with different panel groups hidden in each module. For example, in Library, I prefer to keep the right panel hidden and the left panel showing. This is because the left panel provides access to files in Folders and Collections, which I use a lot. I less frequently use the Library right panel to make metadata edits to files (mostly keywords). Conversely, in the Develop module, I usually work with the left panel hidden and the right panel showing, because the tools I use most often are in the right panel. (I temporarily auto-show the left panel to apply Develop presets.)

CHANGE PANEL SIZE

Panels can be resized by dragging their edges. Wider panels shows longer file and template names and provides greater sensitivity for adjustment sliders. Narrower panels make more room for photos.

Resize panels by dragging their inner edges

Position your mouse cursor over the inside edge of any panel; the mouse cursor changes to a double arrow. Click and drag to resize the panel. Note that all panels have a minimum and maximum width. (These can be changed using third-party solutions such as Jeffrey Friedl's Configuration Manager; see Resources in the Appendix.)

Change the size of Filmstrip thumbnails

Drag the bottom panel edge to resize it; this changes the size of the thumbnails in the Filmstrip. See Figure 3-13.

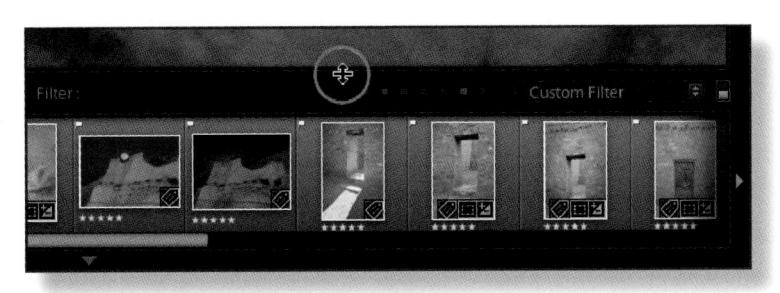

Figure 3-13: Chanaina the size of the Filmstrip and thumbnails

EXPAND AND COLLAPSE INDIVIDUAL PANELS

In addition to hiding and showing the entire left and right panel groups, individual panels can be expanded and contracted (see Figure 3-14). Click anywhere in the top bar of each panel to hide or show its contents (it's not necessary to click directly on the triangle).

▶ Navigator

#+Ctrl+0, 1, 2, 3 etc. or Ctrl+Shift+0, 1, 2, 3 etc.

To open and close panels in the left group.

1, 2, 3 etc.

> To open and close panels in the right group.

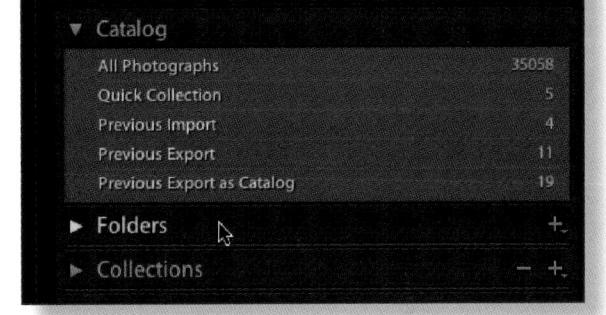

Figure 3-14: Panels expanded and collapsed

Expand all and collapse all Right-Click or Ctrl+Click on

the panel header and select Expand All or Collapse all to expand or collapse all the panels in the group.

Keep unused panels closed

Get in the habit of removing all unnecessary information from your working environment.

ADD AND REMOVE INDIVIDUAL PANELS

The individual panels in the left and right panel groups can be removed and restored from the main panel track as you see fit (see Figure 3–15).

Note: the Navigator/Preview and Histogram panels cannot be removed.

Right-Click or Ctrl+Click on a panel header

...then make selections from the contextual menu to show or hide individual panels or select Hide All/Show All.

SOLO MODE

When you enable Solo Mode, opening one panel closes all the others. This is my preferred way of working, except in the Library left panels, where it's often advantageous to have Folders and Collections open at the same time. See Figure 3–16.

Right-Click or Ctrl+Click

...on any of the panel headers; select the option from the popup menu to enable Solo Mode.

Option+Click or Alt+Click

On any panel header to open that panel and simultaneously toggle Solo Mode.

> Shift+Click

On a panel header to open it without closing the previous one.

PANEL END MARKS

The *panel end mark* ornaments at the bottoms of the left and right panel groups (see Figure 3–17) are designed to let you know there are no more panels below. You can change the graphic used for the panel end marks and you can add your own. Once you get used to the panels, though, these end marks become unnecessary. I prefer to leave them turned off to reduce screen clutter.

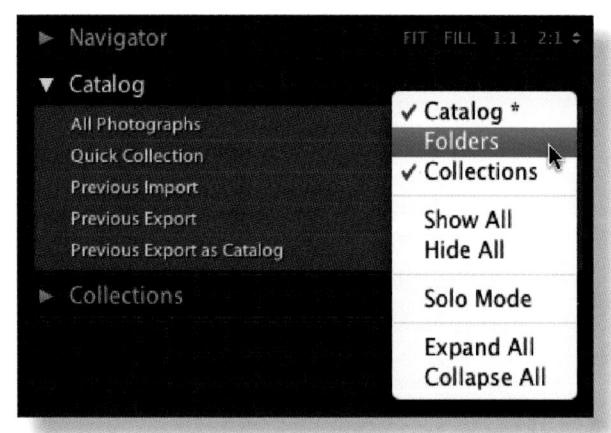

Figure 3–15: Adding and removing panels using the panel contextual menu

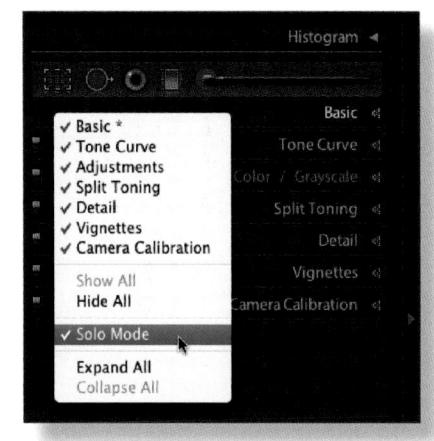

Figure 3–16: Enabling Solo Mode from the panel contextual menu

Figure 3-17: Panel end marks (Develop right panel group)

Right-Click or Ctrl+Click on or around the end mark ...and select a panel end mark from the list.

Add your own panel end marks

From the panel contextual menu, select Go to Panel End Marks Folder. Create custom graphics in Photoshop (using transparent layers works best) and save them as PNG format. Put your PNG files in the folder and restart Lightroom; your custom files will show in the list.

SCROLLING PANEL TRACKS

When multiple left and right panels are open, it's likely their contents will be too long for all the panels to show on the screen. In this event, scroll bars appear to allow you to move up and down within the panel track. Click and drag the bar to scroll. See Figure 3–18.

Click and drag to scroll panels (Mac only)

To quickly scroll panels, click and drag anywhere in a panel that's not an input control, such as the header; a hand icon will appear and you can drag the panel group up and down.

Panel Input Controls

Within the panels, Lightroom provides several types of software controls to edit and process your photos. Most can be manipulated using

either your mouse or the keyboard. Some require you to select from a menu; others let you type directly into text boxes.

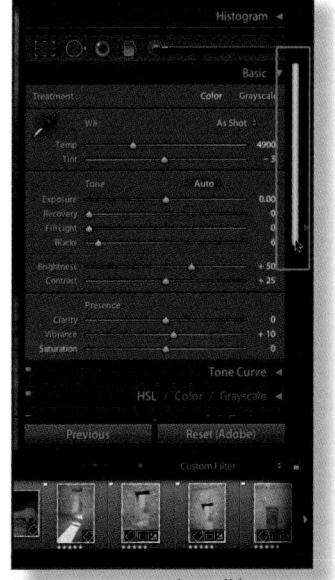

Figure 3-18: Panel scroll bar

Look closely

Many of Lightroom's interface widgets are very small and—using various shades of gray, black and white—can be easily missed. Get in the habit of looking very closely at the Lightroom interface to discover the full set of controls.

TRIANGLE BUTTONS

Throughout Lightroom's panels there are very small and easily overlooked black triangleshaped buttons (see Figure 3–19). These open and close a subsection of the panel, revealing or hiding more controls.

Figure 3-19: Triangle buttons

ARROW BUTTONS

These are found on the quick Develop panel and the local adjustment tools (see Figure 3–20). While most of Lightroom's settings are absolute (applying a specific value), the arrow button controls are relative—they are applied on top of whatever settings are already present. The single arrow buttons apply changes in smaller amounts than the double arrows.

Relative versus absolute

With most Develop controls in Lightroom, when you apply a settings change to an image, the value of that adjustment is absolute. For example, if you have Saturation set at +8 and change it to +12, the value becomes +12, not +20. The effects of the two sequential adjustments are not cumulative.

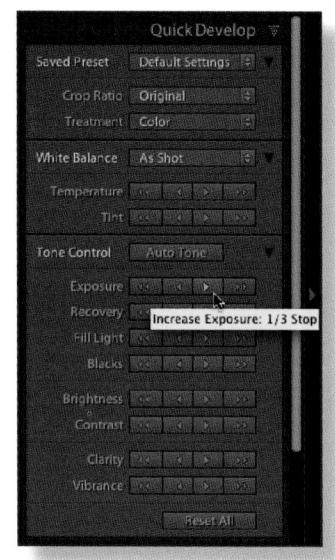

Figure 3-20: Arrow buttons

However, the arrow buttons are relative adjustments, meaning that when applied, their value will be added to the existing value. For example, if you start with a Saturation

setting of +6 and click an arrow button to apply a +5 Saturation increase, the resulting value will be +11.

SLIDERS

Particularly in Develop, the sliders (see Figure 3–21) are the most obvious method of making adjustments to photos. Lightroom's sliders can be adjusted in several ways:

- Drag the slider with your mouse cursor.
- "Scrub" the slider's numeric value left and right using the mouse.
- Position your cursor anywhere over the slider and then use the up and down arrow keys to increase or decrease the value.
- Double-Click the numeric field and type in a value.
- Double-Click a slider to Reset it to its default value.

Figure 3-21: Sliders five ways

Return or Enter

Always be sure to press Enter or Return when you're done typing text into a field anywhere in Lightroom. This reduces the chance of accidentally typing something into a text box when you're trying to use a shortcut.

If you change your mind typing into a text or dialog box, or to deactivate a tool, press Esc to cancel.

Option or Alt

In many areas of Lightroom's interface, holding the Option or Alt key reveals additional functions, such as hidden controls, buttons and options. For example, the Quick Develop panel in Library shows additional controls when Option or Alt is held down. The Sharpening panel in Develop has uses for Option/Alt. And, holding Option/Alt changes the Export button to Export Catalog. Memorize the most important places the Option/Alt key is useful, then as you're working, periodically press the key and watch how it changes the options on the screen. Many more functions become readily available.

PANEL SWITCHES

Most panels that provide controls for image adjustments (and Filmstrip filters) provide a small "switch" that allows you to disable/enable the adjustments for that panel. Like a light switch, up is "on" and down is "off". See Figure 3–22.

Look for these switches in numerous places throughout Lightroom's interface. In some cases, they may be oriented left/right. In all cases, they perform the same function: enabling and disabling the effects of that panel.

Tone Curve ◀

Figure 3-22: Panel switch

Hide/show adjustments

As you're working, use the switches to toggle an adjustment on and off. See Chapter 7 to learn how to use them in Develop.

TOOLTIPS

Place your cursor over part of the interface and let it remain for a few seconds without moving or clicking to see a popup tooltip telling you what that control does. If there is a keyboard shortcut for the tool or command, it will also be shown in the tooltip. See Figure 3–23.

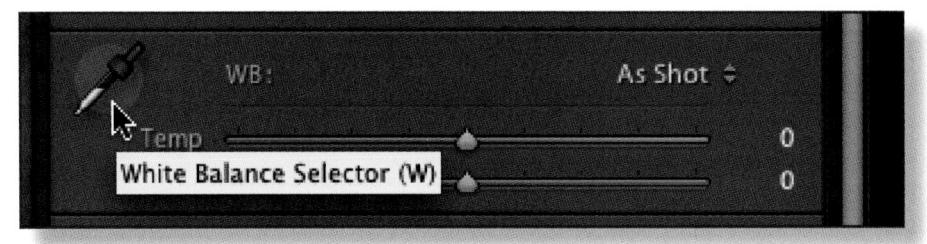

Figure 3-23: Tooltip

Lightroom Menus and Commands

Lightroom's main menu bar changes from one module to the next. In this way, Lightroom is like five programs in one. To memorize all the commands available in Lightroom requires using and remembering all the different menus in each module. However, the main menus and commands persist between modules.

Look at all the menus

As you're learning to master Lightroom, frequently look at the menus, commands and shortcuts available in each module. This will not only give you a better grasp of the full functionality available in Lightroom, it will speed your work as you memorize the locations and shortcuts for specific commands.

CONTEXTUAL MENUS

Lightroom is full of contextual menus (see Figure 3–24); using them is essential to speeding up your work. A contextual menu's contents are determined by the context in which you clicked. Depending on where you click, contextual menus appear showing the commands most useful and appropriate for the object clicked.

Though this book is loaded with keyboard-driven shortcuts, I use contextual menus as much or more than the keyboard. I always work with a Wacom tablet and stylus (never a mouse) when editing, and a Right-Click or

Figure 3-24: Contextual menus

Ctrl+Click is often faster than switching to the keyboard.

Right-Click or Ctrl+Click

To open contextual menus throughout Lightroom.

COMMANDS AND SHORTCUTS

All the commands available in Lightroom can be found on menus throughout the program interface. But often, using a menu is not the fastest method: Lightroom is replete with shortcuts; keyboard and otherwise. It's designed to let you work quickly and smoothly—kind of like "stream-of-consciousness" editing. Once

you get the hang of it, the software steps aside to allow your photographs and editing work to come to the forefront of the process.

As with Lightroom's menus, each module has its own shortcuts, and some shortcuts in different modules share the same key. For example, the N key in Library switches to Survey view; in Develop, N activates the Remove Spots tool (see Chapter 7).

Shortcuts are shown next to the corresponding commands in menus (see Figure 3–25).

Figure 3-25: Menus and shortcuts

Use the keyboard

You can manipulate most of the Lightroom photo editing and developing tools using the keyboard. Practice using the mouse as little as possible!

In Lightroom, many of the keyboard shortcuts turn tools on and off or make items active/inactive. This is a *toggle* control.

To see a list of shortcuts for the current module.

Use shortcuts in sequence

You can really fly through your work in Lightroom by stringing shortcuts together, one after another. Below is an example; try it!

G to enter Library Grid view
Arrow keys to select an image
E to see the selected image in Loupe view
L twice to enter Lights Out
R to enter Develop in crop mode
Optionally, drag corners to adjust crop
R again to turn off crop overlay

#+S or Ctrl+S to save
G to go back to Library Grid view
L to return to Lights On

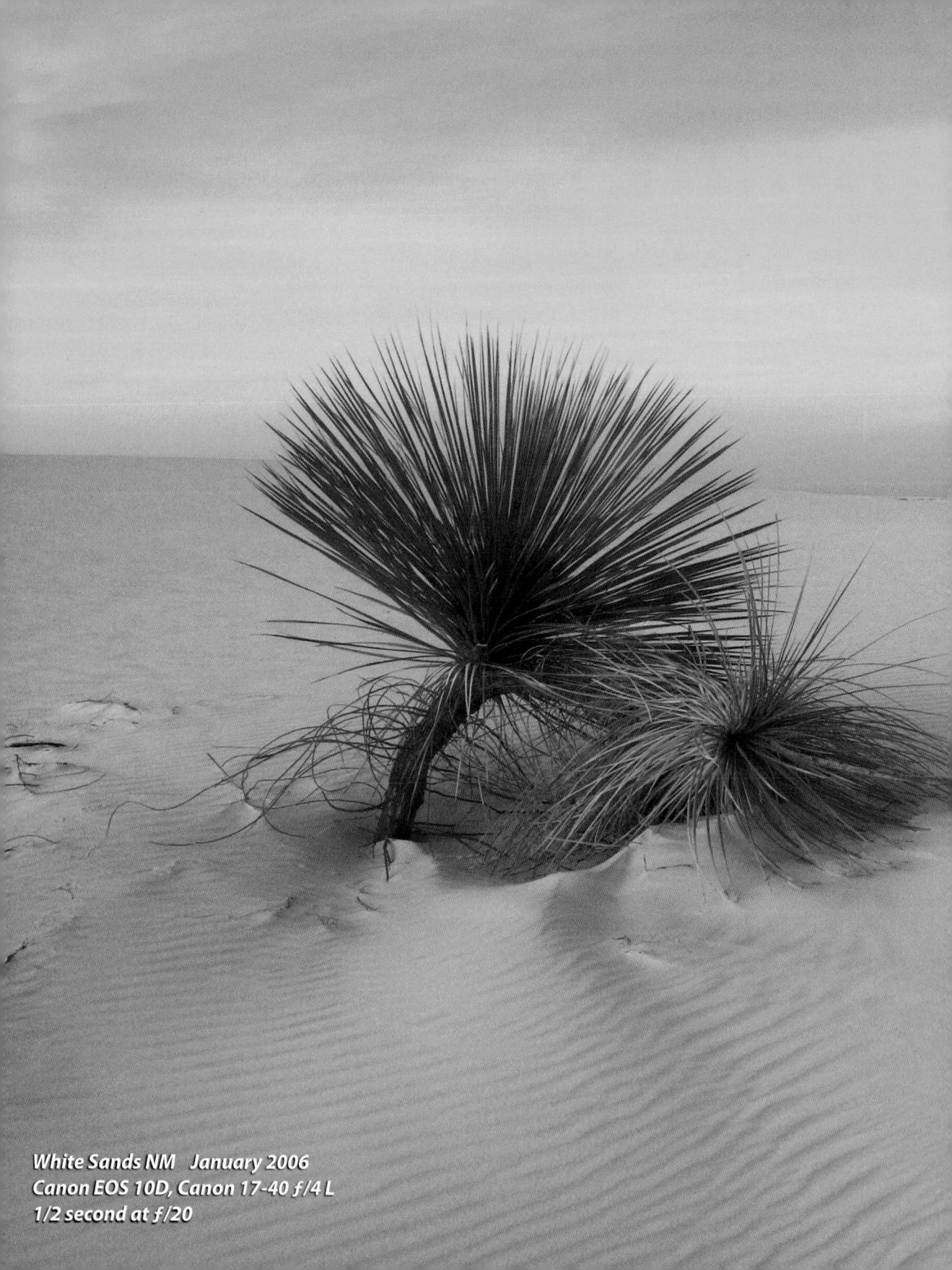

The Lightroom Application Window

When you launch Lightroom, the main window opens with the same settings and image selections that were in use when you last quit the program. (See Figure 3–26.)

SCREEN MODES

The main Lightroom application window has three screen modes:

- 1. **Standard:** a floating, resizable window. May or may not fill your entire screen. Resize the window by clicking and dragging its sides or corners. Move the window by clicking and dragging the title bar at the top.
- 2. **Full Screen with Menubar:** fills your screen with the Lightroom application window. This window is not resizable.
- 3. **Full Screen:** like #2, but the main menu bar at the top of the screen is hidden. (This is my preferred screen mode.) As needed, put your mouse cursor at the top of the screen to access the menu bar. When you're finished, move away from the menu bar and it becomes hidden again.

To cycle through the three screen modes.

To enter Full Screen mode and hide all panels. Pressing this shortcut again will enter Standard screen mode.

Closing the main Lightroom window quits the application.

LIGHTS OUT

Lights Out dims or hides all the interface elements, showing only the photographs (see Figure 3–27). If no photographs are selected, all the thumbnails will remain visible in Lights Out. If one or more photos are selected, those will remain visible while the unselected photos will be hidden. There are three Lights Out modes:

- Lights On: this is the default state, where all interface elements and
 photographs are shown at full strength.
- **Lights Dim:** the interface is dimmed (by a percentage you can set in Lightroom Preferences).

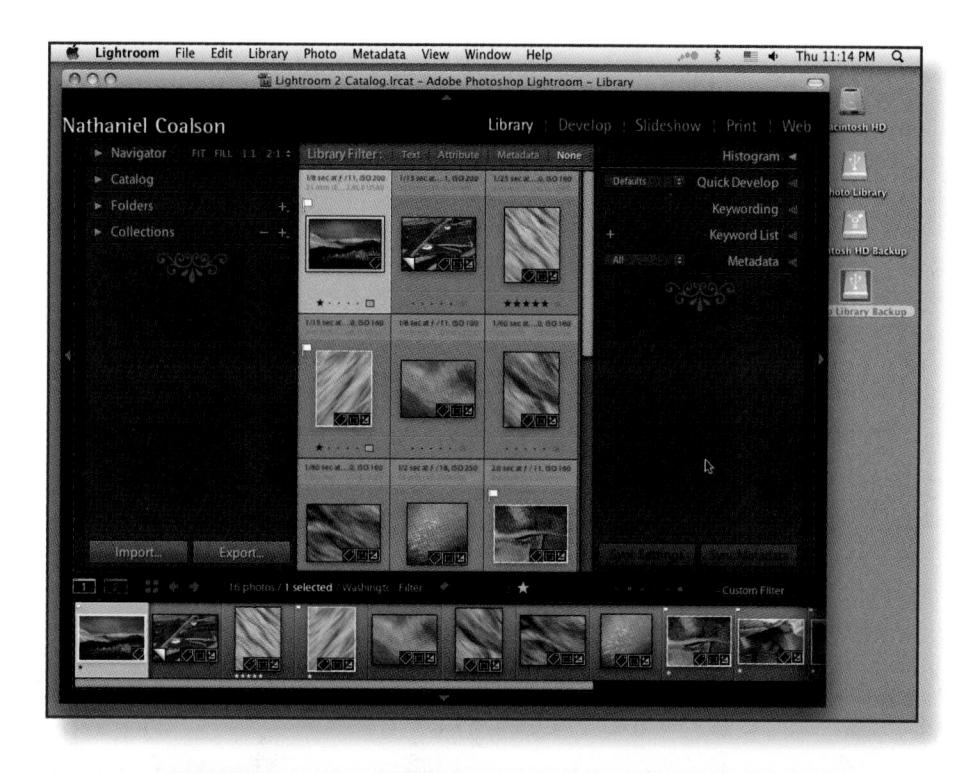

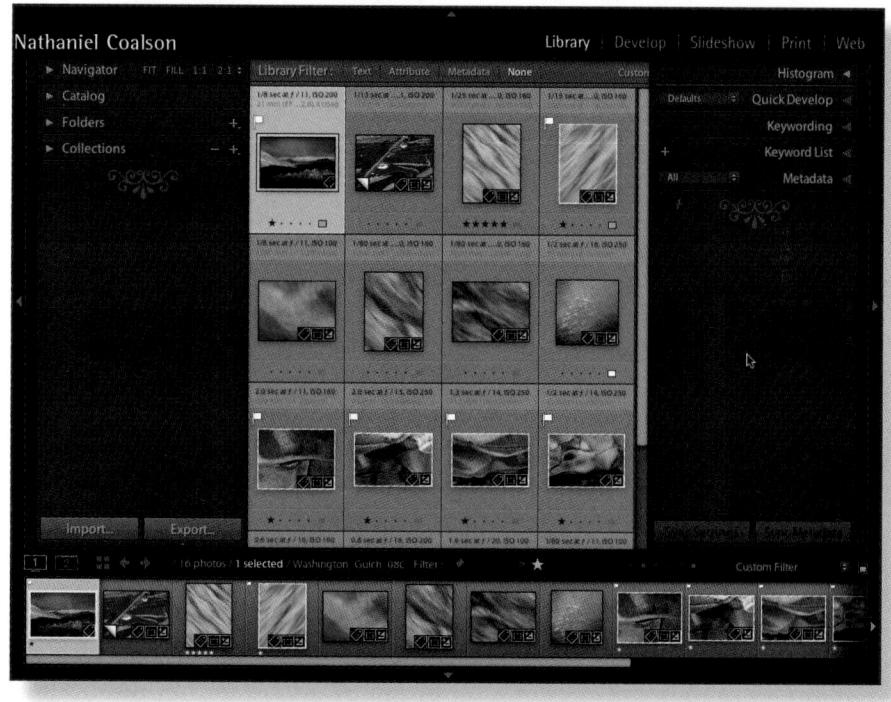

Figure 3–26: The main Lightroom application window in Standard and Full Screen modes

3

• **Lights Out:** all interface elements are hidden (by a solid color, also specified in Preferences).

To cycle through the three Lights Out modes.

Also hide the panels

Lights Out is especially useful with all the panels hidden.

₩+, or Ctrl+,

To open Lightroom Preferences.

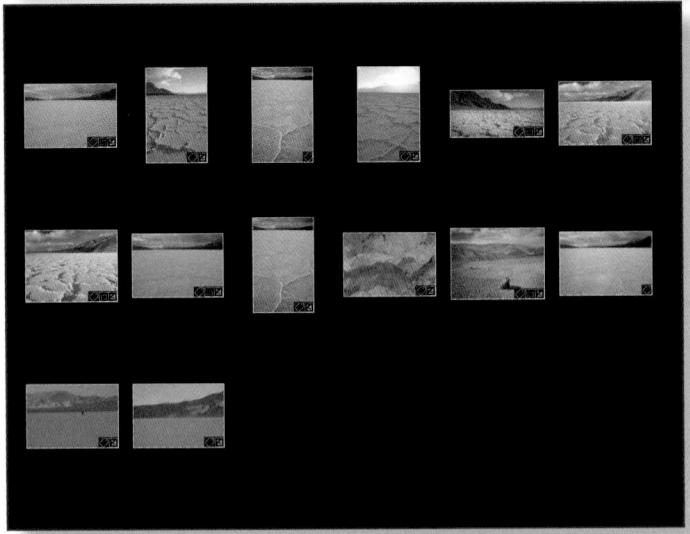

Figure 3–27: Lights Dim (panels showing) and Lights Out (panels hidden)

THE SECONDARY WINDOW

Lightroom 2 and higher offer support for dual monitors and, even with only one display, you can use the second window in a variety of ways. The second window (see Figure 3–28) is a limited version of the main Library window and has its own layout and controls. Open the second window by clicking the button on the upper left side of the Filmstrip. See Chapter 6 for more about working with the second window.

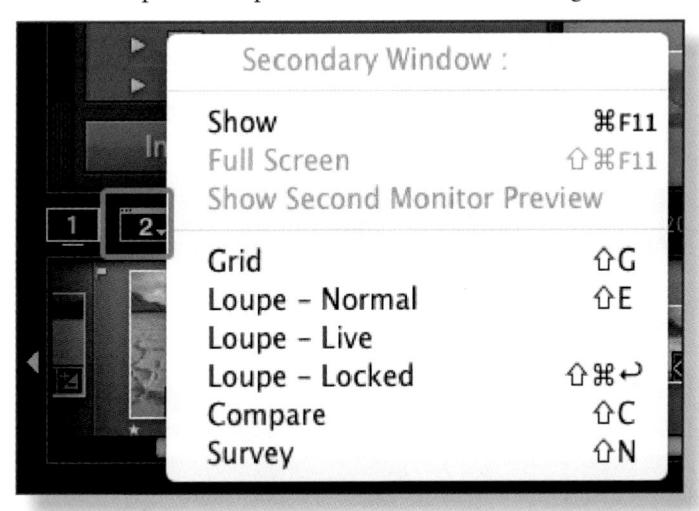

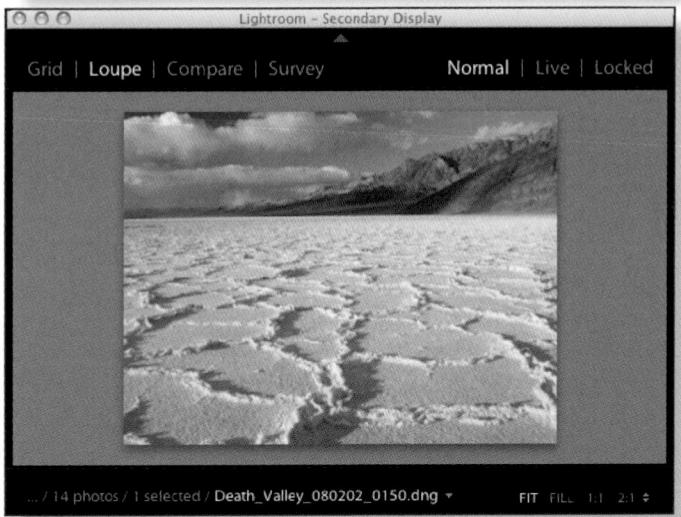

Figure 3-28: Opening the secondary window

Chapter Summary

Lightroom offers many innovative new ways to work with your images. Gaining speed and efficiency in the workflow requires mastering these new controls. Take the time to explore, investigate and memorize Lightroom's software controls and keyboard shortcuts. Your work will become easier and more fun.

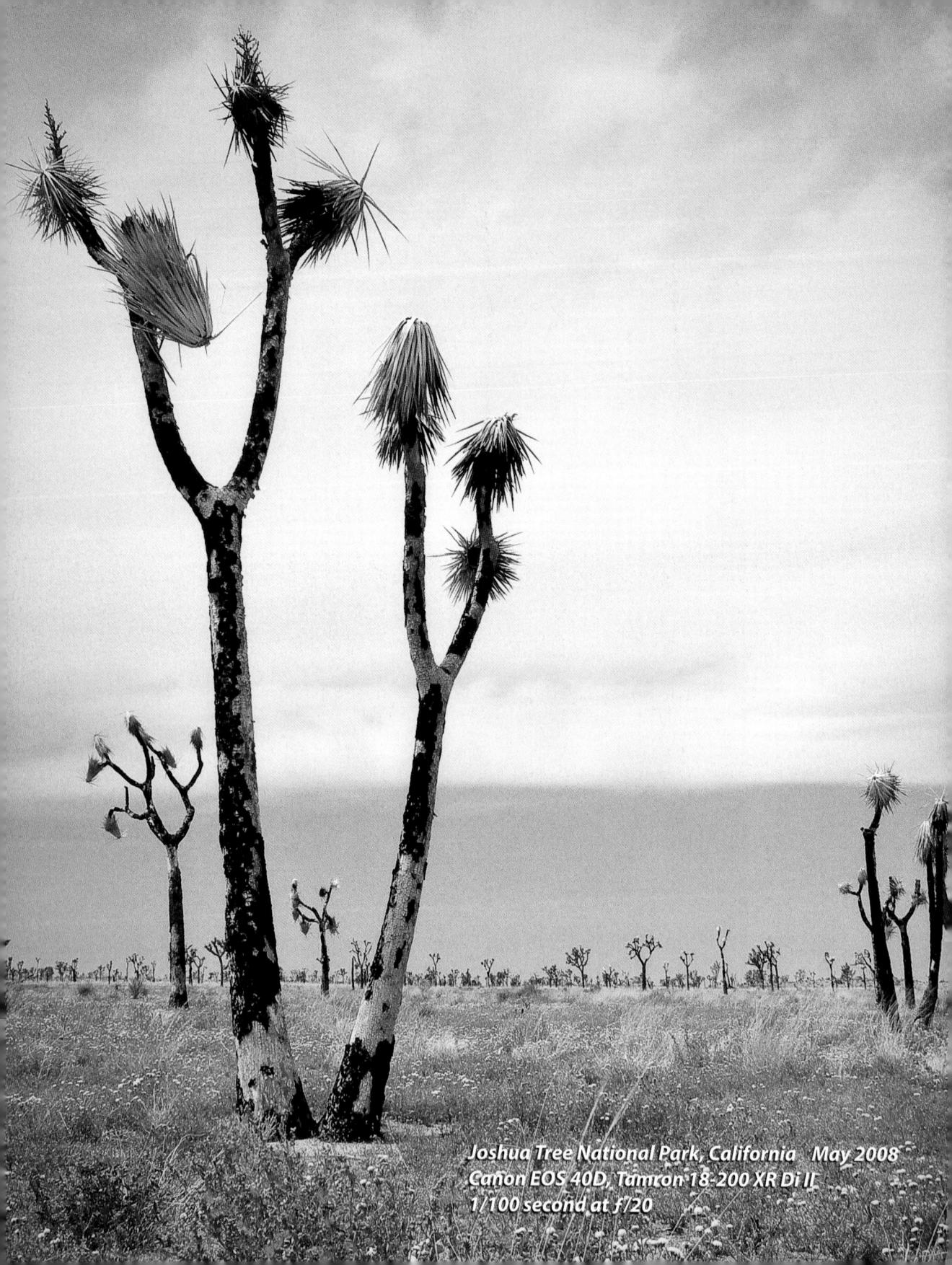

CHAPTER 4 DIGITAL IMAGE CAPTURE

A great photographic print begins with a great capture. The camera settings you choose and the amount of image data recorded determine the image's potential for high quality processing. Most important is an accurate exposure captured as raw camera data. Feed Lightroom lots of clean image data and you may be surprised at what you can do with your photos.

Capturing high quality image data

The professional digital photography workflow starts with the best possible capture. This means capturing the maximum amount of data possible and storing it in a way that preserves all of the original information.

With these factors in mind, our workflow will begin with images minimally processed in the camera. We'll refer to this simply as raw capture. Regardless of your camera model or file formats and extensions (.NEF, CR2, etc.), starting your workflow with raw captures will give you the most flexibility and highest quality throughout the processing pipeline.

Process on the computer, not in-camera

Though many current camera models offer varying levels of processing within the camera itself (brightness, contrast, color and sharpness controls, black and white conversion, etc.) it's almost always best to do the image processing on your computer, not in the camera. With raw capture, any in-camera processing effects will only be recognized by that camera-maker's software; not Lightroom.

HOW A DIGITAL CAMERA CAPTURES AN IMAGE

Similar to the way a digital image file is made of pixels, the sensor on a digital camera is comprised of *photosites*, whose data are later rendered into pixels. During capture, the photosites record the amount of light (photons) striking them and the camera's image processing system converts the analog electrical signals from the sensor to digital data.

In most cameras, filters over each photosite determine whether the incoming light is recorded as red, green or blue. Due to this, the filtered photosites on the image sensor do not correlate precisely to the pixels in the final image; there are twice as many green photosites as there are red and blue. This filter design is called a *Bayer mosaic color filter array* (see Figure 4–1). Nearly all digital cameras produced today use Bayer filters; a couple of rare exceptions are the Foveon X3 sensor and the RGBE (red, green, blue, emerald) sensor developed by Sony.

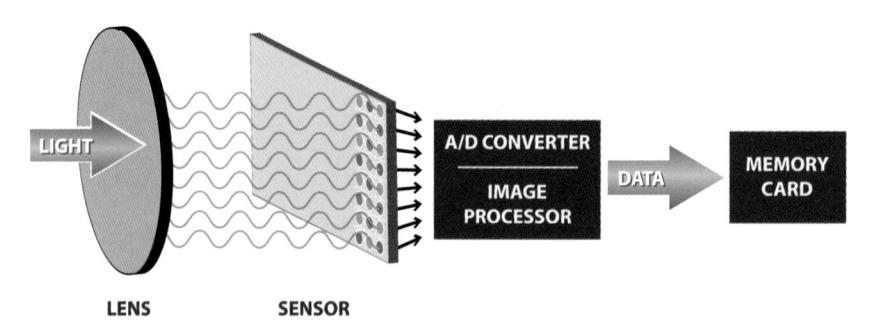

Figure 4–1: Photons being captured by sensor; Bayer filter array; analog-to-digital processing

RAW IMAGE CAPTURE

The camera's data processor records three grayscale images, one for each of the RGB filtered photosites. The capture then requires *interpolation*, either in the camera or computer, to render the multicolored pixel values in the digital image. This rendering process is called *demosaicing* and is one of the key variables in how different cameras and software programs render raw capture data.

The captured data can be saved as a raw camera file and/or immediately processed in the camera to produce a JPG file. Some cameras also offer the option to save captures in TIF format, a few of which contain raw data, too. If your camera is set to capture JPG only, the raw data is not saved.

In all but a few specific situations, it's best to always capture in raw format. A raw file from your camera provides much greater quality than any other format because it retains all the information from the original sensor data.

It's important to understand that "raw" doesn't necessarily mean, "totally unprocessed". Every camera must perform some encoding of the sensor data in order to create the raw file and record it onto the memory card in a proprietary format from the camera manufacturer.

Camera bit depth

Most DSLR cameras capture raw images in 12- or 14-bits per channel, though today there are a few new models coming out that capture in true 16-bit. Scientific cameras can use much higher bit depths.

Most JPG formats can only contain 8-bit data; this is one example of the advantages to capturing raw.

During processing, Lightroom uses all the available data in an image file regardless of its original bit depth.

Camera resolution and raw file size

The number of photosites on the sensor determines the resolution of the raw files produced by the camera. The relationship between sensor resolution, file resolution and file size is roughly equivalent. For example, a camera with a 10 MP (megapixel) sensor will produce an image containing approximately 10 million pixels with a raw file size somewhere around 10 MB (megabytes). On most dslrs, along with the raw image data, a small JPG preview is stored inside the raw file and a small amount of lossless compression takes place on the raw data. Processing your photos in Lightroom, there's usually no real benefit to capturing raw+JPG.

4

Also, raw image data is *linear*, which means that more photons striking a photosite will result in more data being captured. Put another way, darker areas of a capture contain less image data than lighter areas.

These factors are the reasons why you will see raw files of varying file sizes, even though they may seem to have been captured identically from the same camera (see Figure 4–2). More data coming from the sensor will result in larger raw file sizes, and similarly, files with lots of detail may be slightly larger than those with less detail, due to interpolation and compression.

Figure 4–2: Both captures made with Canon EOS 10D. Raw file for the top image is 6.1 мв; bottom image is only 3.7 мв
Further in the workflow, a raw capture of 10 MP rendered in an 8-bit uncompressed format such as TIF will be around 30 мв, or three times the raw file size (for the three RGB channels). Rendered as 16-bit RGB the file would be 60 мв.

Camera raw is not Photoshop .raw

The raw file format available when saving files from Photoshop is *not* the same as that of camera raw files. Never attempt to use the Photoshop raw file format in the digital photography workflow.

WHY NOT JPG?

When you capture a JPG a lot of processing occurs as the file is rendered in the camera and saved to the memory card. This processing might include brightness/contrast, color adjustments, sharpening, resampling and the specified compression level (JPG "quality" setting). The JPG file format is always compressed using *lossy* algorithms, which means that as the file is saved, large amounts of data are being discarded. This data can never be recovered. Even at the highest quality settings, you can lose up to thirty percent of the original sensor data when capturing straight to JPG versus raw (see Figure 4–3). At lower quality settings, you could be throwing away as much as ninety percent of the original sensor data when capturing JPG.

Figure 4–3: TIF at top; JPG at bottom

Situations when JPG might make sense

Some photographers, especially wedding and event shooters, may prefer to capture JPG for its smaller file sizes, faster times writing to the memory card and (potentially) less need for post-processing. With current cameras and software this is, most often, no longer necessary.

In the early days of digital photography cameras were slower at handling the amount of data necessary to save raw files. Also, there were relatively few software applications capable of efficiently processing raw captures. Most were proprietary programs that came bundled with the camera. Canon's Digital Photo Professional and Nikon's Capture NX are examples of programs designed specifically to convert proprietary raw data from the camera to a computerfriendly format suitable for editing. How times have changed.

Now, using Lightroom, you can edit raw and JPG files using the same tools. So if you're currently committed to JPG or have lots of JPGs in your archives it's not necessarily a problem. But be aware that when your camera renders and saves a JPG file—even at highest quality—you're losing a lot of information from the image that cannot be restored later.

In my opinion, there are only a handful of situations where capturing JPG might make sense for a minority of photographers, but for each of these situations a different solution at key points in the workflow would mitigate the necessity for JPG and facilitate raw capture. See Table 4–4.

Situation where JPG may be tempting	Alternative allowing raw capture		
Running out of room on memory card.	Always carry enough memory cards for the shooting session, and/or download to laptop or portable storage frequently during shoot. For smaller files, use SRAW if available.		
Camera can't save raw files fast enough for shooting conditions.	Get a better/newer camera and/or faster memory cards.		
You like the way photos look when rendered by the camera.	Use Adobe DNG Profiles to replicate the look of in-camera processing in Lightroom.		
You need to send files to a client or a lab right away.	Batch convert your raw files to JPG in Lightroom immediately after shooting.		

Table 4–4: Situations where JPG capture might be tempting; alternatives that provide higher quality.

Chimping during a capture session

Chimping refers to the process of reviewing images on the camera during the shoot (because of the noise happy photographers make when they find shots that excite them). Unless you need to confirm composition or exposure, or you absolutely must delete some images to make room on a full card, avoid excessive chimping. It slows the workflow and can be unproductive, not to mention increasing the possibility of missing the next shot while reviewing previous ones. Plus, it's very difficult to make good editing decisions using the LCD screen on your camera.

Don't delete files from cards during a shoot

This introduces the possibility of accidentally deleting something important. If you always carry enough memory cards with you and/or download frequently to a hard disk during shooting you won't need to worry about making critical editing decisions while shooting.

Try to not let memory cards get completely full

This introduces the possibility of data corruption as the camera tries to write data to the card when there's not enough room. Keep track of your available storage and change cards before they get completely full.

Digital exposure

It may seem counter-intuitive, but with the all-digital workflow it's more important than ever to get the shot right in the camera. For starters, precise cropping and straightening is an important consideration: if you nail the composition in the camera and don't need to crop later, you'll preserve all the original pixels and maintain the largest possible file size. Also, rotating an image by arbitrary amounts (besides 90-degree increments) during processing may slightly soften an image as the pixels are interpolated to their new positions. Though you can easily crop and rotate in Lightroom (and sometimes it can't be avoided), try to get the crop and rotation as close to perfect as you can when making the shot.

EXPOSE CAREFULLY

With digital capture, achieving a correct exposure is essential for an image to reach its full potential. To allow the most flexibility in editing and the highest possible quality, take care to get the exposure as close to perfect as you can. Of course, sometimes we all end up with captures with incorrect exposures, and even with correct exposure some scenes/subjects will naturally be darker than others. Just understand that darker captures contain less data than do brightly-lit ones.

More light=more data

An under-exposed capture contains much less data than does a properly exposed one. And it's much easier to process a slightly over-exposed image than it is to fix one that's under-exposed. See Figure 4–5.

Figure 4–5: Over- and under-exposed captures and file sizes. Both images were captured on a Canon EOS 5D Mark II. The difference in exposure resulted in file sizes of 19.03 мв (left) versus 17.66 мв (right). The capture on the left has much more potential for processing.

Meter carefully

The spot where you meter the scene makes a big difference in how a camera or handheld light meter calculates exposure settings. Meter the spot in the scene that you care most about getting accurate exposure for. In other words, don't take a meter reading from the very brightest or darkest points in the scene; it will throw off the exposure values.

Usually you can select a single focus point that you want the camera to use when calculating the exposure. When this is not possible, you can reposition the camera just to meter a spot in the scene, then make note of the settings and enter them in manual mode (or use exposure lock). Finally, recompose the shot while retaining the correctly metered settings. Don't let the camera make bad metering decisions for you!

MAXIMIZING DYNAMIC RANGE

A camera's *dynamic range* is the range of tones, lightest to darkest, that the sensor is capable of recording. Most properly-exposed digital photographs will contain a fairly wide dynamic range: deep blacks all the way to nearly pure white. Some cameras have the capacity for more dynamic range than others but, in general, all modern DSLRs can capture approximately the same range of tones.

Bracket exposures

In cases where you're not sure of exposure accuracy, bracket: make several captures using different exposure compensation settings to ensure at least one of the shots is correct. See Figure 4–6.

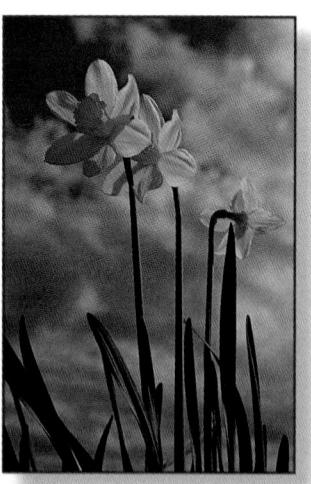

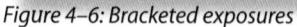

High Dynamic Range (HDR)

Some scenes contain a wider dynamic range than the camera is capable of recording. In these cases, bracket several half and/or full stops *under* and *over* the metered exposure settings and combine the exposures in post-processing. This technique is called HDR (High Dynamic Range) imaging and is discussed in Chapter 7.

CAMERA HISTOGRAMS

All current DSLR cameras are capable of showing a histogram for each captured image. The histogram is a bar graph showing the relative distribution of the brightness levels of pixels in the image (see Figure 4–7). There's no such thing as a "correct" histogram, so don't be too concerned about the histogram's overall shape.

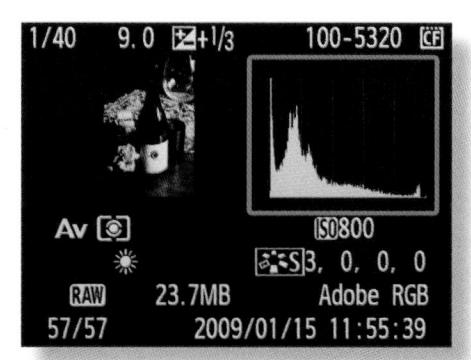

Figure 4–7: Camera Histogram

However, in most captures where you'd expect to see a full range of tones (from deep blacks to bright whites) you should see image data extending most of the way across the histogram's horizontal axis. A wide histogram indicates a capture with high contrast and a wide dynamic range; a narrow histogram indicates a capture with low contrast and limited data.

While shooting, periodically check your camera histograms to be sure you're getting the results you expect and, if necessary, adjust your exposure settings.

Expose to the right

The term "expose to the right" refers to the practice of making exposures with a very slight overexposure in order to capture the most possible data. This means that the bulk of image data will be weighted toward the right side of the histogram without clipping highlights (see next section). This ensures the most possible data being captured by the sensor.

CLIPPING

In a digital image, *clipping* refers to pixels with values of either pure white or solid black. Tall spikes at the extreme left or right ends of the histogram indicate clipping (see Figure 4–8). Also, some cameras show "blinkies" in the camera preview to indicate areas of clipping (usually highlights only).

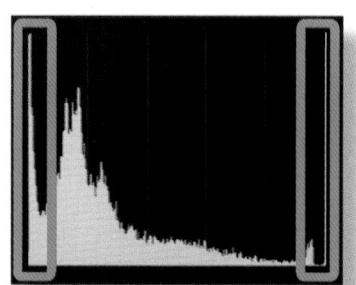

Figure 4–8: Spikes at either end of the histogram indicate clipped highlights and/or shadows.

The result of clipping is referred to as "blown out highlights" and "plugged shadows". In both cases there's a loss of image detail, so most often clipping should be avoided. But there are exceptions. A small amount of clipping in the shadows can add "punch" to a high-contrast print. And clipping can be used as a creative tool. Still, it's usually better to avoid any clipping in the original capture whenever possible. Creative clipping can be introduced in post-processing.

Histograms are processed by the camera

In order for the camera to display a histogram for a raw capture it must perform some image processing. Therefore, the camera histogram represents what the data would look like if it was captured as JPG. Camera histograms are rarely spot-on when compared with the histograms in Lightroom. Most notably, cameras often indicate highlight clipping that in post-processing will not be a problem. So use the camera histogram only as a general basis for making exposure decisions.

Lightroom offers several adjustments to deal with clipping, including highlight Recovery and a Fill Light control that opens up shadows. These are discussed in detail in Chapter 7.

Camera settings

With raw capture, some camera settings do not affect the actual capture data—the values for those settings are simply included in the file metadata, and can be changed with software later. Proprietary settings such as those that affect color rendition or convert a color capture to black and white will be ignored by Lightroom.

COLOR SPACE

If you're capturing raw, the color space setting on your camera doesn't matter. It will have no effect on the rendered capture.

But if you are capturing JPG this is an important decision because, during rendering in the camera, the image color data will be encoded to fit within the selected color space. Most DSLRS offer the choice of SRGB and Adobe RGB (1998):

- For the widest range of colors and the most flexibility for post-processing JPGs, use the Adobe RGB (1998) color space.
- If you're sending captured files directly to a lab for printing on a laser imager such as LightJet or Frontier with no post-processing of the files prior to output, use srgb.

Color spaces and profiles come into play again further down the image-processing pipeline, where they become more important. This is covered in Chapter 8.

WHITE BALANCE

The white balance settings on your camera and in Lightroom are designed to compensate for *color casts* caused by the color of light in the scene (see Figure 4–9). In other words, white balance settings can be used to neutralize any color tint present in order to "accurately" render colors in the scene. But as is the case with all processing decisions, white balance can also be used as a creative tool. Unless you're doing commercial work where precise reproduction of specific colors is essential, use your eye to determine what looks right.

Figure 4–9: White balance examples: Tungsten (around 2800k), Daylight (around 5000k), Shade (around 7000k)

As with in-camera color spaces, if you're capturing raw the white balance selection on the camera is not critical. In a raw capture the white balance setting is tagged in the file's metadata but the colors in the raw image data are not actually modified in any way.

The selected white balance setting will show in Lightroom "As Shot"; you can then edit white balance infinitely in post-processing.

The white balance conundrum

After years of testing every available method of setting white balance I now almost always use the Daylight preset except when shooting indoors under tungsten light (when I use the Tungsten setting) or studio lights (when I may set a custom white balance). Although I always fine-tune the white balance in post-processing, I've found it's helpful to see color represented in-camera as it appears to my eye while shooting in order to make better exposure decisions.

Daylight white balance will faithfully render a scene warm, neutral or cool, depending on the lighting conditions. For example, shooting the first light of sunrise, the color of the light is very warm (yellow). Using Daylight white balance preserves this. Conversely, shooting in mid-day shade, the light is very cool (blue). Again, Daylight will preserve this. I want to retain these natural color-casts to use as my starting point for processing. Keeping my camera set on Daylight records what the scene looked like to me at the time of capture.

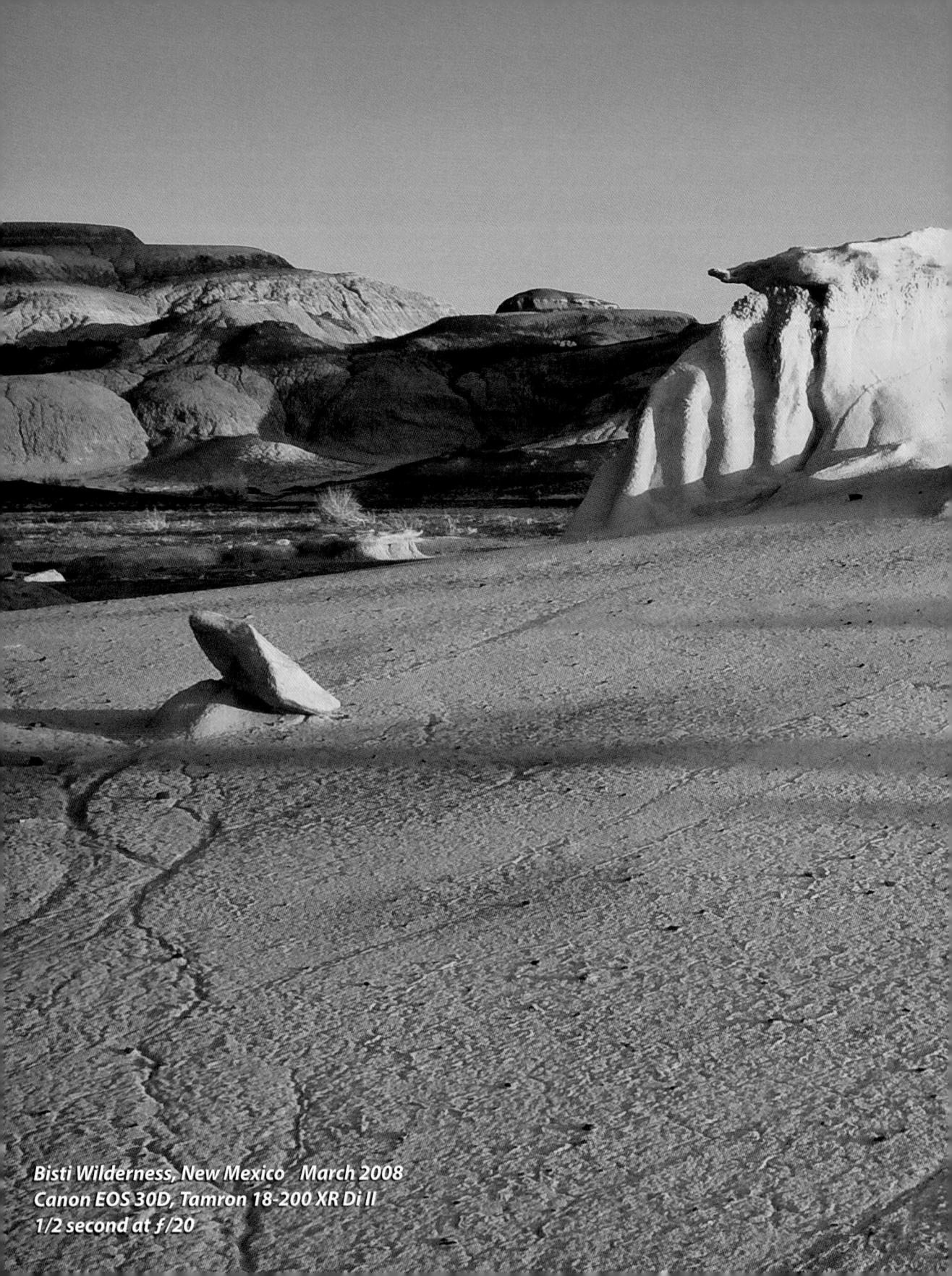

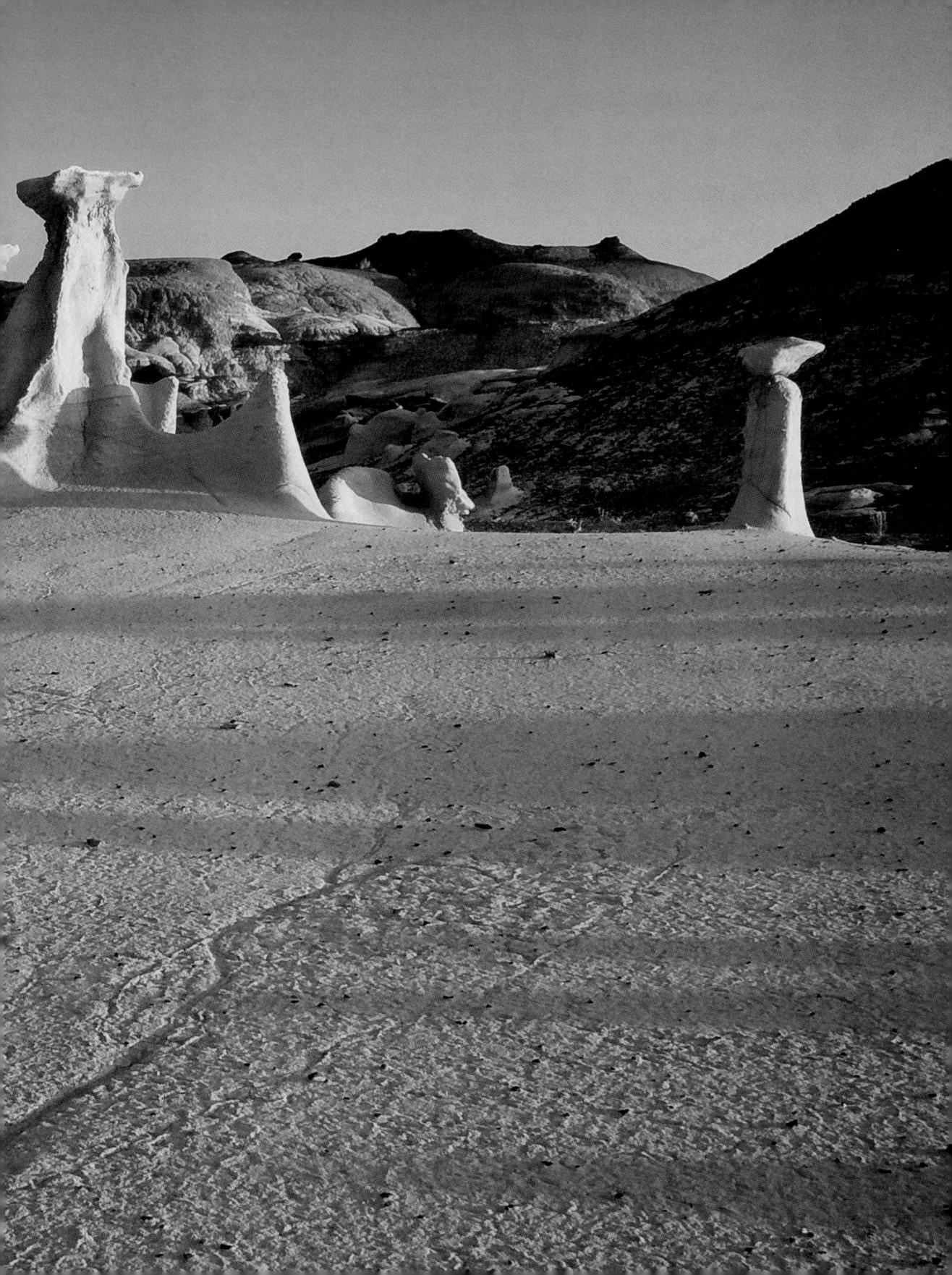

ISO SETTING

The 150 setting on your camera adjusts the light sensitivity of the sensor by amplifying its analog signals before conversion to digital data. Higher isos provide faster shutter speeds and allow shooting in lower light but the amplification process also introduces *noise* into the capture (see Figure 4–10). Noise is a digital artifact that appears as grainy, dark specks and/or soft colored blobs in the image. Obviously, this is most often undesirable (but of course, like every other facet of digital imaging, noise has potential creative applications). Though modern DSLRS have greatly improved performance at high Iso settings, for the best possible captures with the cleanest data you should always use the lowest 150 setting possible that produces acceptable shutter speeds for the situation.

Getting sharp captures

Most often the goal is to get the shots as sharp as you can, unless you're using camera blur as a creative technique. Ensuring sharp captures involves different considerations depending on the subject and circumstances.

Figure 4–10: ISO and effect on noise levels. Top image is ISO 400; bottom is ISO 1250. These samples were made from very small cropped sections of captures made on a Canon EOS 5D Mark II. These cuts are at near pixellevel; at full size, even the image at 1250 is workable.

HANDHELD SHOOTING

Handheld shooting offers the ability to rapidly change subjects and composition and to respond creatively to a dynamic situation. Even when shooting landscapes or still life, I will often work my compositions handheld until I find what I'm looking for, then put my camera on a tripod to make the final shots.

For sharp handheld shots you really need to pay attention to your shutter speeds. The formula for determining the minimum shutter speed necessary for sharp focus is based on the focal length used. For example, if you're shooting at 60mm, the minimum shutter speed for a sharp shot would be 1/60 of a second. At 120mm, the minimum shutter speed would be 1/120. Of course, this is just a general rule-of-thumb; there are techniques and image stabilization hardware that allow you to achieve sharp shots shooting handheld at even slower shutter speeds.

Shooting handheld in the studio is made easier by the strong output of—and control over— the studio lighting. Outdoors, it's more important to practice steady shooting techniques. Hold the camera with both hands and your left hand supporting the lens from underneath (not on top of it). Use a fairly wide stance with your elbows at your sides and time your breathing with the shooting.

Burst capture

When shooting handheld in all but the brightest light I recommend that you use continuous (or "burst") mode and for each composition fire off several frames instead of just one. When reviewing your handheld shots on the computer, you will often find that one capture is sharper than the others. This is especially useful when capturing moving subjects. This technique can also be applied when panning on a tripod.

USING A TRIPOD

In situations where your subject is stationery, when you're working in low light, or need longer shutter speeds, always use a tripod. Using a tripod helps eliminate blur caused by camera shake and allows lower ISO settings, improving the quality of the capture.

For the sharpest images possible when using a tripod, I also recommend you use a remote cable release and mirror lockup. See your camera documentation.

SHOOTING TETHERED

With a computer in the studio or a laptop in the field you can set up an automated workflow where as each capture is made it's automatically downloaded from the camera and imported into Lightroom. Because of the cable typically required for this, it's referred to as *shooting tethered*. Though some late-model, professional cameras now feature wireless file transfer, for our purposes, this would still be considered shooting tethered. I cover shooting tethered in more detail in Chapter 5.

Using lens filters in the digital workflow

Even with all the processing capabilities available in Lightroom there are still times when traditional lens filters are essential to getting the shot. In all cases, to get the best capture with the most data, you should never modify the light coming through the lens any more than is absolutely necessary.

POLARIZING FILTERS

A polarizer removes glare in the scene by realigning light waves as they come through the filter. The effect of polarizing filters can't be exactly replicated in software, though there are some simulated effects and workarounds that approximate the look of polarized light. See Figure 4–11.

Figure 4–11: Effects of polarizing filter. Left image is not polarized, right is polarized.

Always carry a polarizer

This is one filter I never leave home without. When shooting in bright sunlight I most often have a polarizer attached to the lens. This gives me the choice of whether or not to fully- or partially-polarize a shot depending on my intentions.

NEUTRAL DENSITY (ND) FILTERS

ND filters cut the amount of light entering the lens, resulting in longer exposure times; ideally, without introducing a color cast. In bright light this is essential for exaggerating the impression of time, such as the smooth flow of a stream or waterfall (see Figure 4-12). There's no way to get that soft look without a long shutter speed.

Figure 4–12: Example use of neutral density filter to increase shutter speeds and capture the appearance of flowing water

All NDs are not created equal

Some inexpensive neutral density filters are not truly "neutral". Look through your ND filters at various directions to a light source to determine whether they will actually introduce an undesirable color cast.

OBSOLETE LENS FILTERS

With the advent of digital photo processing, many previously common lens filters are no longer necessary:

- Color-correcting filters such as warming and cooling filters can easily be simulated in Lightroom.
- The effects of split (graduated) neutral density filters can be done in post-processing (using Lightroom and Photoshop) with better results. Using bracketing and HDR blending techniques eliminates the need for split NDs.
- If you like to keep a **uv** (**ultraviolet**) **filter** on your lens to protect its surface, make sure to remove it before shooting; we want to modify the light as little as possible during capture. The negligible improvement that a uv filter can provide in cutting haze is almost always outweighed by the softening and loss of contrast that may be imparted by the filter.

Think about post-processing while you are shooting

Once you get comfortable with changing settings on your camera while shooting, start to consider how you will process the file later. Taking production issues into account while you're photographing will help you get better captures and make post-processing easier.

Workflow: Digital Capture Checklist

- Check that your memory card has adequate space available. If files from a previous shoot remain (that have already been transferred to computer) reformat the card in the camera.
- Make sure your camera is set to capture in raw format.
- Select the appropriate white balance setting for the lighting conditions (or just use Daylight).

- 4. Check the Iso setting and make sure it is set to the lowest setting possible for the current conditions. Change the Iso as necessary while shooting to ensure adequate shutter speeds.
- Check the camera's shooting modes (aperture priority, shutter priority, manual mode, single or continuous capture, etc.) and change as appropriate during shooting.
- 6. Carefully meter the scene/subject.
- 7. Be sure your metered shutter speeds are adequate for handheld shooting or lock the camera down on a tripod.
- 8. During shooting, periodically check the camera histogram for proper exposure.
- 9. Bracket exposures to ensure you get an accurate exposure and adequate dynamic range for the scene.
- 10. When a memory card is full, immediately transfer its contents to a computer or portable storage device. If this is not possible, put the full card in a card wallet face down to indicate it is full and should not be used until its files have been transferred.
- 11. When the shoot is complete, prepare to perform an Import to Lightroom (see Chapter 5).

Chapter Summary

For the highest quality captures you need to carefully select the proper settings on your camera and confirm their effects on the captured images as you shoot. The correct settings will vary depending on the situation, but the best images will be produced with a combination of settings that provides the most possible data. Correct exposure, low noise and sharp focus are primary considerations. And to process your photos in the Lightroom workflow, always capture raw.

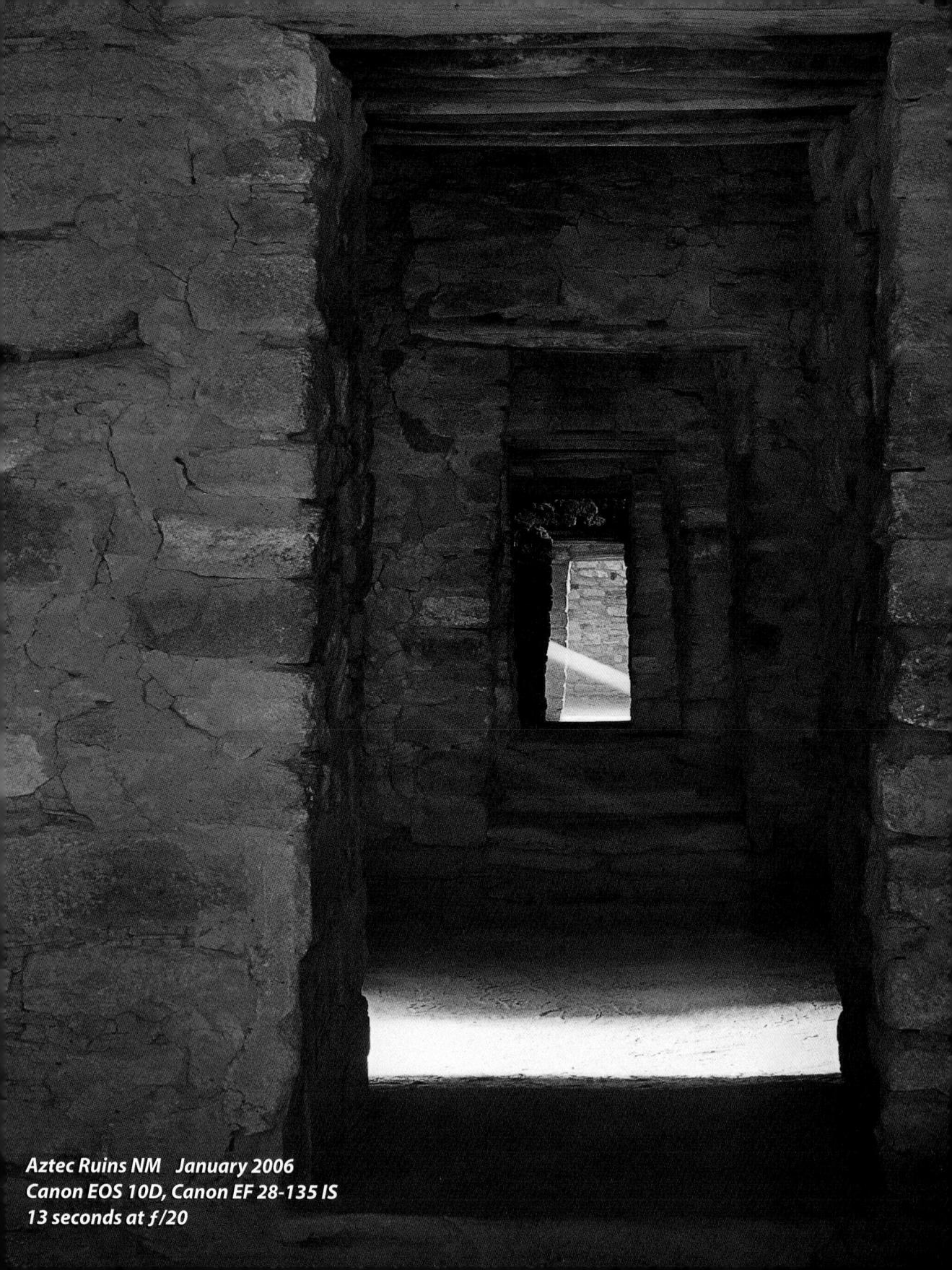

CHAPTER 5 IMPORT PHOTOS INTO LIGHTROOM

To work with your photos in Lightroom you must first import them. Beyond simply adding photos to the Lightroom catalog, there are many other batch processing options available during an import, such as copying and renaming files, converting file formats, embedding metadata and applying Develop adjustments.

In addition to showing how to efficiently import photos, this chapter describes best practices for designing folder and file systems and establishing naming conventions—both critical aspects of managing your photo library.

5

Lightroom Data Architecture

Image files must be *imported* into Lightroom before you can work with them.

Prior to importing photos into Lightroom, you should establish a system for organizing and naming your files. Setting up a well-organized digital storage system for your photographs will make your work easier and give you peace of mind. With a solid information architecture in place, you can accelerate your import process dramatically.

First, let's take a look at how the Lightroom program works with its database and your image files on disk (see Figure 5–1). Then I'll present some techniques for organizing your files and folders.

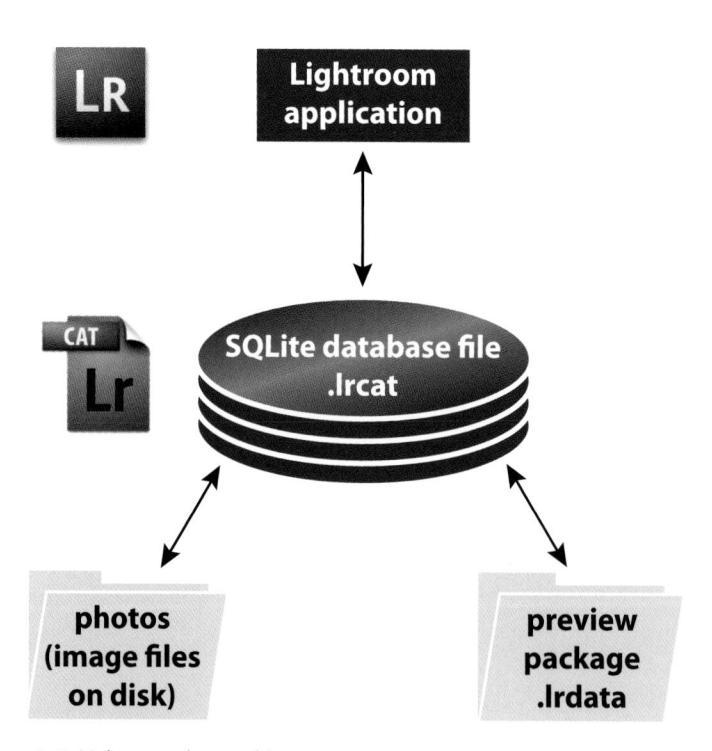

Figure 5–1: Lightroom data architecture

LIGHTROOM CATALOGS

Importing image files adds them to the *Lightroom catalog*: a database that stores information about the files and the adjustments you've made to them. Any time you're working in Lightroom, you're working within a catalog.

Lightroom catalogs are stored on the computer's hard drive as squite files with the extension .lrcat (see Figure 5–2).

▼ Lightroom 2 Catalog	Today, 5:01 PM		Folder
Lightroom 2 Catalog Previews.Irdata	Today, 3:41 PM	3.58 GB	Adobe Lightroom Data
Lightroom 2 Catalog.lrcat	Today, 4:49 PM	685.6 MB	Adobe Lightroom Library
Lightroom 2 Catalog.lrcat.lock	Today, 11:56 AM	4 KB	Document

Figure 5–2: Lightroom database, previews and lock file indicating the database is in use

The catalog's location on disk

When the Lightroom application is first installed, it creates an empty catalog file in these default locations:

- Mac OS X: User\Pictures\Lightroom 2 Catalog\Lightroom 2 Catalog.lrcat
- Windows: User\My Documents\My Pictures\Lightroom 2 Catalog\ Lightroom 2 Catalog.lrcat
- Windows Vista: User\Pictures\Lightroom\Lightroom 2 Catalog\ Lightroom 2 Catalog.lrcat

If you've never moved the default catalog and haven't created a new one, you will be working within the default catalog.

You can store a catalog on a drive separate from the image files. The name and location of catalog files have no direct effect on Lightroom's operation, so you can name your catalog whatever you like and put it wherever you choose. I keep my master catalog on the same external hard drive with the image files, because I believe it makes sense to keep a catalog file with the image files it contains.

Hold the Option or Alt key when launching Lightroom

To see the Open Catalog... dialog box. You can load the default catalog, select another catalog or make a new one.

Using multiple catalogs

You can use one or many catalogs to manage your photo library (though as of this writing, the Lightroom application can only have one catalog open at a time). For example, some photographers might use different catalogs for work and personal photos, or a unique catalog for each specific client. With temporary working catalogs you can maximize the potential of your workflow. Regardless of the catalogs you may employ for specific purposes, for most photographers, using a single, "master" catalog for the complete library of photos is the best solution.

A single image can be imported into any number of catalogs—but this is something you need to do deliberately and carefully. Working on the same file—or worse yet, copies of the same file—in different catalogs can lead to disaster.

One example of how using multiple catalogs can greatly enable your workflow is when traveling, and using Lightroom on a laptop, then returning home to your main computer. These scenarios are discussed further in this chapter.

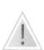

Always know the name and location of the catalog you're using

Many photographers have had big problems unknowingly using more than one catalog! As you can imagine, this can result in significant confusion and frustration. The easiest way to ensure that you're in the catalog that you intend is to check the name of the catalog, which is located in the window title bar in Lightroom's standard window mode. You can also view the name and location of the current catalog in the Catalog Settings dialog box (accessed from the Lightroom menu on Mac OS X or the Edit menu on Windows).

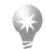

Use meaningful names for catalogs

If you use multiple catalogs, name each one for its specific purpose and keep the names simple and functional. For example, if you're shooting a wedding, name the catalog for the client.

If you use just one catalog, sticking with the default name is fine!

Use caution when renaming existing catalogs or preview packages on the desktop

... unless you don't mind rebuilding all your previews. The catalog and the preview package have a symbiotic relationship; the locations of the preview files are stored in the catalog. If you rename the catalog or its preview package in Finder or Explorer, Lightroom won't be able to match them up and will need to rebuild the previews for all the photos in the catalog. Of course, this isn't always necessarily a problem. Plus, you can always export new catalogs from existing ones, giving the new catalog a unique name during the export. See Chapter 8 for more about exporting.

Find catalogs and eliminate unused ones

To find all the Lightroom catalogs on your computer, search in Finder or Explorer for folders and files containing the file extension .lrcat.

Double-click a catalog anywhere in the file system

Opening a Lightroom catalog in Finder or Explorer will launch the Lightroom application and load that catalog. Extending this method, you could place an alias or shortcut on your desktop to ensure you load the correct catalog when Lightroom starts.

With Lightroom running, you can use the Open Catalog... command to load a different catalog. Lightroom will quit and reopen with the selected catalog.

👂 Move data between catalogs

You can use multiple catalogs for different purposes. If you need to combine data from multiple catalogs, use the Export from Catalog and Import from Catalog menu commands. See Chapter 8 for more about this.

Database corruption

If you don't have a lot of experience using databases—especially for image editing and management—it may come as a shock to you if a problem with the Lightroom catalog makes your photos inaccessible. It is entirely possible that a Lightroom catalog could become corrupted and not be able to be opened or worked with in any way. But in the vast majority of cases, a problem with the Lightroom catalog does not necessarily indicate a problem with the image files. (Of course, in some cases an image file could itself be corrupt.) It's essential that you practice solid backup strategies when working with your Lightroom catalogs and the image files. If you do, you really won't have much to worry about. A recent backup (or several backups) removes much of the pain of something going wrong. Backups are discussed further in this chapter.

IMAGE FILES

During an import Lightroom reads the data from the image files being imported and creates records for them in the currently-open Lightroom catalog. File names, folder locations and metadata are all stored in separate tables in the database. The image files on disk are not stored in the database. Think of the Lightroom catalog like a department store catalog: it contains all the information about the items but not the items themselves.

In Lightroom, everything is done by reference: when you work on a photo, the changes you make are stored in the catalog (and can be embedded in the image files as metadata) but the **image data in the original files is never altered.**

Image file formats

Lightroom can import, process and export the following types of files (refer back to Chapter 1 for more about file formats, if necessary):

- Camera raw
- DNG (Digital Negative)

Image file formats, continued

- TIF (TIFF)
- PSD (with Maximize Compatibility enabled in Photoshop preferences)
- JPG

Batch file conversions

You can convert files from one format to another during import. You can also convert raw files already in the catalog to DNG from within Lightroom, and export any file in the catalog as a new file in one of these formats. Exporting files into other formats is covered in detail in Chapter 8.

LIGHTROOM PREVIEWS

As Lightroom reads pixel data from files, image previews are created, which are then also referenced by the database. The previews are temporary files rendered in several sizes. Lightroom also creates previews, whenever necessary, while working in the modules.

Image preview files are stored outside the database in a separate package (refer to Figure 5–1). When you're working on an image in Lightroom, its preview is continually updated; the image file on disk is not changed. Lightroom's previews are:

- Minimal: used for thumbnails
- **Standard:** used for larger Loupe, Compare and Survey views until a higher zoom ratio requires 1:1
- 1:1: pixel-for-pixel preview used when zooming in close to a photo

Previews can be purged, deleted and re-rendered at any time, provided the affected files are online; Lightroom can't build new previews from files on unavailable volumes.

Digital Photo Storage

The hard disk system you use to store and archive your photo library requires careful planning, consideration and maintenance. Independent from any software you choose to process your photos, your image files must remain intact, accessible and secure now and in the future. You and your heirs must be able to manage your digital photographs quickly and easily for decades to come, underscoring the need for reliable systems for storing your photo files. It's essential that you plan out your storage system carefully, accounting for your current needs and budget along with a plan for growth.

Single-user environment

If you're the only one working with your image files your storage system can be very simple with few components. You can use internal or external hard disks or network storage. With the rate of advancements in disk drive systems and the corresponding increase in image file sizes it's important to create a cohesive plan for your image library.

Plan to upgrade your storage system every 16-18 months or sooner as you collect more images and as file sizes increase.

Use dedicated disk drives for your image library

It's better to *not* store your image files on your system disk. I recommend you store your photos and Lightroom catalogs on disk drives used only for that purpose. If you currently are storing your photos on a single internal disk, I recommend you set up new drives to use only for your imaging work.

Whenever possible it's easiest to use just one large disk for your entire image library. Fewer, larger disks are easier to manage than many small ones. A single disk also provides for easier backups. As your library grows and your disks fill to capacity, I highly recommend transferring everything to larger drives.

External USB 2.0 or FireWire (IEEE 1394) drives provide fast read/write times and can be easily moved to another computer as needed.

Workgroup environment

There are situations that benefit from, or require, the use of image files distributed over multiple drives and network servers. Lightroom handles this with ease, but with conditions. In a single Lightroom catalog, you can access image files stored on multiple disks and from network drives (though catalogs themselves must be on local drives). Search online for more about sharing Lightroom catalogs in network environments.

BACKUPS

People accidentally lose important computer data every minute of every day. Usually it's because of user error (deleting something unintentionally) but equipment failure is also common.

I can't over-emphasize the need for creating a practical system for backing up your work and updating your backups *very* frequently. When a hard drive fails mechanically or its data become corrupted, if you're prepared, you will be back on track quickly. Otherwise, be prepared to say goodbye to your photos.

In any photo storage setup, each primary disk should have, at minimum, one exact replica that is continually updated. There's more about backups at the end of this chapter.

Naming Your Image Files and Arranging Them in Folders

Your image files will be contained in folders, of whose structure you need to be acutely aware. Before importing photos into Lightroom it's best to establish a system for organizing your folders and files on the hard drive. Otherwise, you're likely to waste a lot of time looking for images, moving files around, and wondering which file is what.

How we arrange and name our files is one of the more subjective aspects of the digital photography workflow. While it stands to reason that you should use a system that fits your personal preferences and style of working, with all the variables involved, following a few standard guidelines will make your system easier to manage.

FOLDER STRUCTURES

Deciding how to organize the folders in your image library can be the most daunting aspect of designing a *digital asset management* (DAM) system, but with careful consideration, you can implement a system that will serve you well for years. Figure 5–4 shows an example from my current folder structure. Here are a few things to keep in mind:

- 1. The number of folders in your image library will increase dramatically over time. **The system must scale** effectively with this growth.
- 2. Use as few folder levels as are necessary to support your organizational structure. The number of nested folders (folders within other folders) can easily get out of hand; you don't want to have to "drill down" through many levels of folders to get to an individual file.

Plan your photo folder architecture carefully. Consider what should be at the top level, what's beneath that, and so on. For example:

```
2007
091507_Grand_Tetons
052107_Elizabeth_New_House
100807_Maine
```

```
United_States
Colorado
Maggie_Homecoming_2008
San_Juans_Summer_2008
Silverton_080705
Silverton_080706
```

- All the files from a single shoot should be contained in one folder. Files from longer shooting sessions, such as multiple-day trips, can be separated by folders named for days and/or locations.
- 3. **Keep original and derivative files in the same folder.** In general, it's best to not use separate folders just for different image file types, such as one folder for DNG, another for TIE, a third for JPG, etc. It's much easier to have all your files from a single shoot in one folder. The exception to this would be cases where you're exporting files for a particular purpose, such as sending to a client, etc. This is covered in Chapter 8.

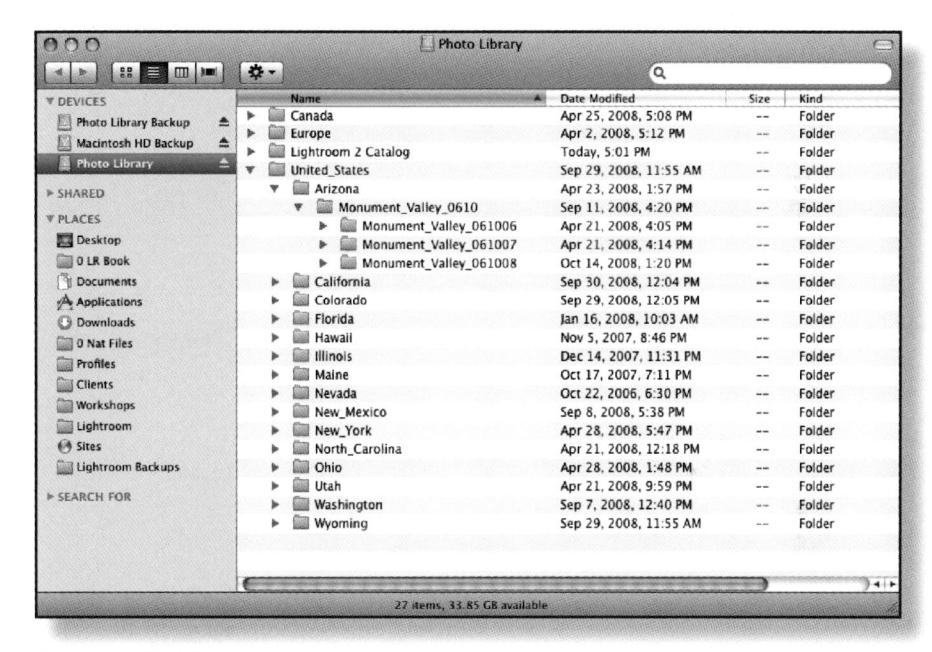

Figure 5-4: My folders 1

Reworking your existing folders

The most important aspect of organizing your image library is to get everything into one place. If you have disorganized files and folders in different locations, start by putting them all into one top-level folder. Call it "Photo Library" or "My Photos"; whatever you like. You can use your User\Pictures folder temporarily for this, but eventually, I strongly recommend moving your master photo library off your system disk. Keeping your image library on a separate disk from your system makes managing and backing up your photo library easier, and also allows you to make updates to your operating system and applications without affecting your images.

Once everything is in one main folder rearrange/rename the subfolders to fit your new system. Do as much organizing of your files as you can before importing them into Lightroom.

Organizational work within Lightroom

Some of your reorganizing may be more easily accomplished in Lightroom, after importing files. See Chapter 6 for information about moving and renaming files once they're in the catalog.

Think first, then act

Take some time to give all of this some thought and thoroughly visualize your new system before implementing it. Write it down, sketch it out, and discuss it with your colleagues. Carefully consider your options before committing to your new convention—especially before you start to rename existing files and folders. You don't want to get halfway into the process and realize you've overlooked an important detail and need to start over. One of the hallmarks of an efficient workflow is to not have to go back and change conventions later.

GUIDELINES FOR FOLDER AND FILE NAMING

Even in this age of metadata, where software can perform all kinds of functions using information embedded inside image files, the names you give your files and folders is still very important.

The main reason careful naming matters is the frequent need to find, open and save files using your computer's file system. Navigating through dialog boxes, copying files between media and sending images as email attachments are commonplace activities. Using well-conceived names will make these tasks much easier. Name your folders and files using the following guidelines.

- 1. Use as few characters as necessary to provide all the pertinent information about the contents of the file or folder. Ideally, try to keep your base file name under 26 characters, because as you create master and derivative files their names will become longer with codes or special designations. Keep it simple.
- **Use Internet-friendly file and folder names.** When it's time to share files, having used Internet-friendly names from the start is a big time saver. Most importantly, don't use spaces in names; use dashes or underscores to separate words instead. Don't use special characters like "/", "\$", "@", "%" and no punctuation. Parentheses () and apostrophes 'should be avoided.

Wrong: Sam's Birthday 04/18/08 Right: 041808_Sam_Birthday

- 3. Use the same base file name for all the images from a single shoot. Differentiate them with a serial number at the end of each file name.
- 4. The names of your folders should be consistent with the names of the files they contain.

RENAMING PHOTO FILES

The automatic file names the camera assigns to files are not useful in our workflow. Therefore, one of the key steps in the import process is to rename the files to something more meaningful. Your base file name should contain:

- 1. The date the photo was taken;
- 2. The subject or location of the photograph or an identifier such as client name, etc.; and
- 3. Serial (sequence) number.

Example folder and file names

```
yyyymmdd_location_sequence
20081025_bryce_canyon
20081025_bryce_canyon_001.tif
20081025_bryce_canyon_002.tif
20081025_bryce_canyon_003.tif
```

SUBJECT-SUBJECT-MMDDYY-SEQUENCE CLIENT-SHOOT-052603 CLIENT-SHOOT-052603-01.jpg CLIENT-SHOOT-052603-02.jpg CLIENT-SHOOT-052603-03.jpg

Location_yymmdd_sequence_code Vernazza_080224

> Vernazza _080224_0001.dng Vernazza _080224_0002.dng Vernazza _080224_0002_M.tif Vernazza _080224_0002_700px.jpg Vernazza _080224_0003.dng

> > 79

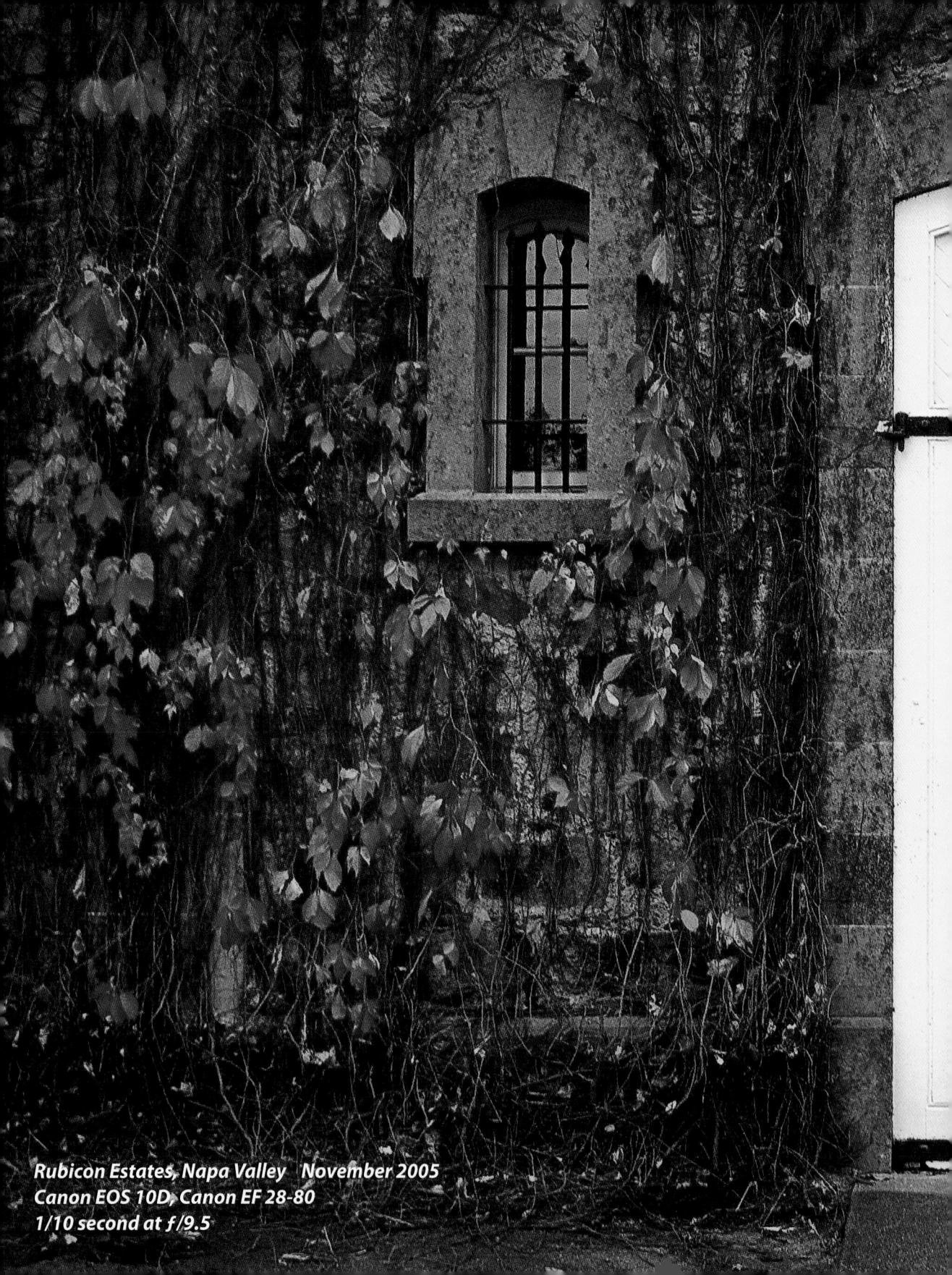

The third set of previous examples is the convention I use. I start my names with the subject or location, because it's more important to me than when the photograph was made. When I'm looking for something, I like to have my folders organized alphabetically by subject. For example, if I'm looking for a photo I made in Colorado, it's easy to remember the location as the Great Sand Dunes National Park, but I wouldn't necessarily remember the dates I was there.

I also append a code to the end of the names of derivative files, such as "M" for Master (for layered composites), pixel dimension of the longest side (usually for Web JPG files), or text indicating the purpose of the file. This illustrates the importance of keeping your base file names short.

Do what makes sense to you

Many photographers like to organize their folders by date first, beginning with top-level folders for each year. It really doesn't matter, as long as your system is consistent.

Getting your old files up to date

If you have large numbers of files in your historical archives that you don't feel deserve your taking the time to change their names, don't worry too much about it now. The important thing is to nail down a system and use it going forward. After you've lived with it for a while, you can decide if anything needs reworking and if older files should be renamed to fit the new conventions.

Converting an entire image library

In the Fall of 2006, I converted my image library (then around 15,000 images) to DNG. I had been shooting raw for several years and also had innumerable derivative files all over the place that needed to be cleaned up.

During the process of converting my camera raw files to DNG, I renamed the files and put everything into a new folder architecture. I used Bridge and Adobe Camera Raw for the majority of this work, which took the better part of three months to complete. A couple of months after the transition was complete, Lightroom 1 was released and I imported everything into my first Lightroom catalog.

Now, my image library is comprised of original DNG files plus any derivative TIF, PSD and JPG files exported from those DNGS (see Figure 5–5). Every photo file on my hard disk (now around 35,000 files) is in my Lightroom catalog. I keep all the files from each shoot (original and derivative) in a single folder.

Figure 5–5: My folders 2

Import Photos into Lightroom

Importing deserves as much—or more—attention as other parts of the workflow. The care you take completing an efficient import will determine the ease or difficulty of the rest of the workflow. Plan your imports carefully, and you will benefit from one of Lightroom's key strengths: batch processing.

ABOUT BATCH PROCESSING

Usually you'll import multiple image files all at once (though you can and sometimes will import just one photo). This is the first instance of batch processing in our workflow. When processing many images during a single operation, the choices you make become increasingly important. Effective batch processing requires planning ahead, thinking carefully about the software settings and considering the effects of your actions before going forward. After you've run through the import process a few times, you'll know the key settings to check and double-check (and triple-check) before clicking the Import button.

Really think about what you're doing

If importing is done incorrectly it can lead to disastrous results: lots of wasted time and potential loss of files. Be sure you understand the key points of this chapter before doing the import workflows presented.

SETTING UP THE IMPORT

When you initiate an import (or synchronize, see Chapter 6), Lightroom presents a dialog box where you configure the settings for the current import operation. Depending on whether you're importing photos from a memory card, a folder on the hard disk, importing from another catalog, or synchronizing, the options available on the import screen will differ.

> #+Shift+I or Ctrl+Shift+I

To begin the import process, this shortcut, used from anywhere in Lightroom, first opens a file dialog box asking you to choose what folder or files to import. (You have to choose the import source before you'll see the actual Import dialog box.) Navigate to the folder that contains the files to be imported and click Choose or Select All Files in Folder to be presented with the Import screen.

Next, adjust the settings for this import using the popup menus and text boxes on the Import screen (see Figure 5–6). **Confirm your import settings every time.** Go through the controls in the import screen methodically—from top to bottom and back again—and apply the settings appropriate to the photos affected by the current import.

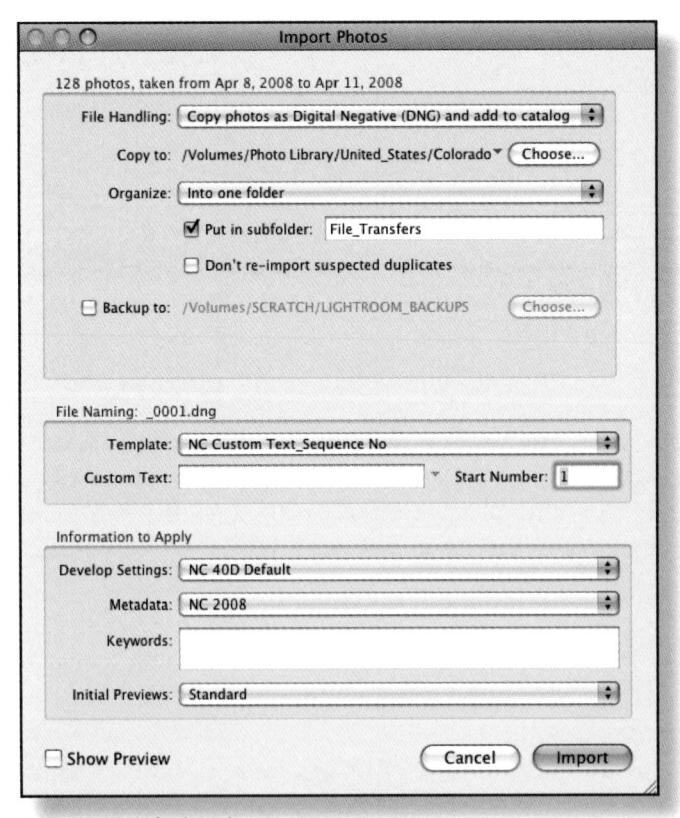

Figure 5–6: Default Lightroom import screen

Take your time

Be sure you've correctly configured all the options in the import screen before executing the import.

Import screen retains settings from previous import

The settings from the previous import will remain in the import screen until you change them. It's critical to go through all the settings on the import screen before every import and change settings according to the current import.

Following are instructions for setting the options in the Import screen.

FILE HANDLING

When planning an import, the first thing you will need to decide is how Lightroom will handle the files. Are you copying the photos from one place to another? Do you want to rename the files or convert their formats? Maybe you want to leave the files just as they are and just bring them into the Lightroom catalog for editing. Think about the image files and their relationships to one another and decide how the files should be handled. The Lightroom import scenarios you'll encounter most often are:

- Importing existing images stored on a hard drive, leaving the files in place where they are on the disk.
- Copying new images from your camera's memory card to a hard disk and importing them.

In addition to these two simple examples, you will also encounter myriad other (and more complicated) circumstances when importing photos into Lightroom. Some of these scenarios are outlined toward the end of this chapter.

At home versus on the road

Your import processes will often be different when you're traveling—working from a laptop computer—than when you're at your main desktop workstation. If you use only a laptop, all the time, you may only need one import workflow. Otherwise, if you're using multiple computers, expect that your imports will be different from one computer to another depending on the location of your main image library and the current task at hand. See the workflows toward the end of this chapter for information on using Lightroom with multiple computers.

PRESETS AND TEMPLATES

Generally speaking, *presets* store settings; *templates* store formatted layouts. This distinction is not critical; throughout Lightroom you'll see frequent references

to presets and templates and the use of one term versus the other is somewhat inconsistent. What's important is to recognize that presets and templates can save you lots of time by applying previously saved settings to batches of files.

Finding your presets in the computer's file system

Preferences→Presets tab→Show Lightroom Presets Folder...

File naming templates

One of Lightroom's most useful batch processing capabilities is renaming files. With file naming templates you can set up a standardized base file name using whatever conventions you prefer. The templates are then used to rename files during import, or later in the Library module. The filename template editor window (see Figure 5–7) is accessed from the Filename: menu on the import screen or the Metadata panel in Library (see Chapter 6).

The filename template editor provides a wide range of controls to set up your template. Enter type directly in the text box and/or click the Insert buttons to put tokens in the name. A token is a preformatted type of information, such as date, sequence number, etc. Carefully construct your base file name template in the text box. When it's the way you want it, save it from the Preset menu at the top.

Custom Text

The Custom Text token allows you to manually enter text for part of your base file name during each import.

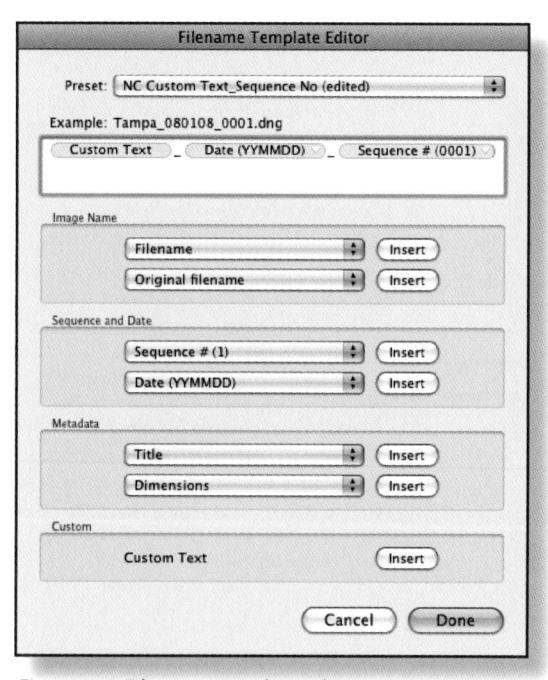

Figure 5-7: Filename template editor

Metadata presets

Select a metadata preset to be applied to the files being imported. You can embed your copyright notice, contact information and other optional information. This saves a lot of time by averting the need to manually apply metadata later.

Select a preset from the popup menu or create and modify presets using the Edit Metadata Presets window, accessed from the import screen (see Figure 5–8).

You can also apply and edit metadata presets on the Metadata panel in Library (see Chapter 6).

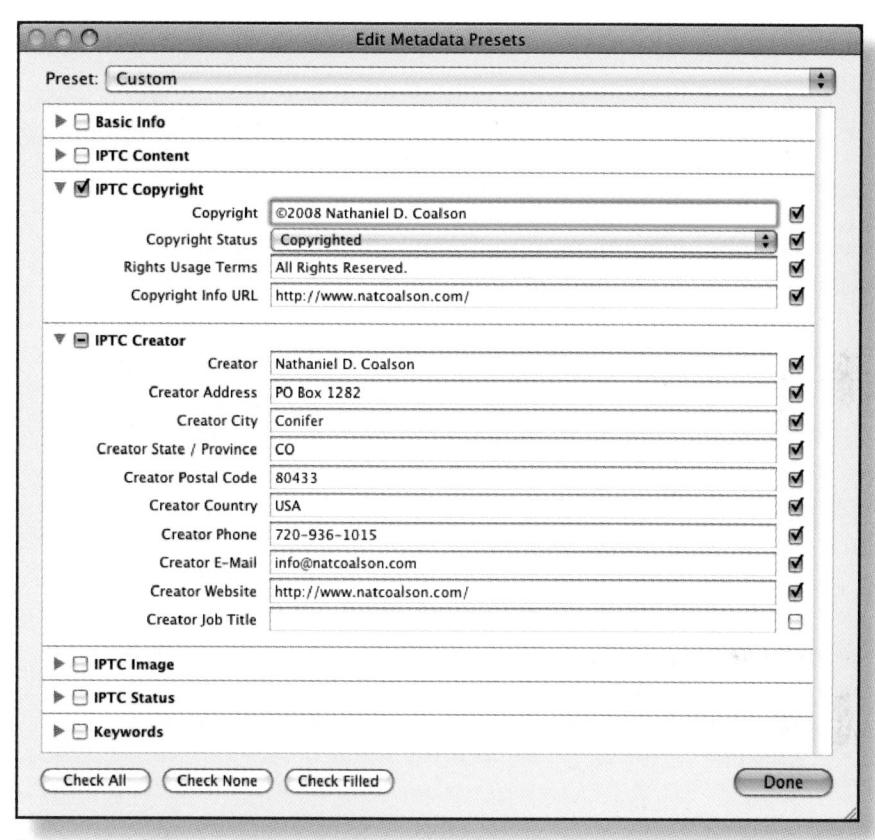

Figure 5–8: Editing a metadata preset

Always include a copyright notice

At minimum, be sure a copyright notice containing your name and the year the photo was made is embedded in all your photos.

Develop presets

Develop presets allow you to automatically apply Develop module settings to photos as they are imported. This provides more control over your baseline image settings at the outset of the editing workflow and saves time in processing.

You can't configure Develop presets from the import screen; you must do this in the Develop module (see Chapter 7) prior to starting an import. Before you

start saving Develop presets, you will likely need to manually Develop quite a few photos and take note of the common settings you frequently apply to determine the adjustments to include in your presets.

One preset is not always enough

A Develop preset applied on import need not be the final stage of applying presets to an image. After it's been imported, in the Develop module you can apply additional, multiple presets. Note that if two consecutive presets both contain a setting for the same adjustment, the latter will override the former. For more information about Develop presets, see Chapter 7.

KEYWORDS

Always apply at least two descriptive keywords to your files as they are imported.

PREVIEWS

Lightroom can build screen previews of various sizes from the files as they are imported. You can choose which preview sizes are built by selecting options in the Import dialog box.

Workflow: Copy files from your camera and import them into Lightroom

You can use Lightroom to handle the transfer of files from your camera (memory card) and subsequently import the new files the Lightroom catalog.

The required step for this is to have Lightroom copy the files to the hard disk. The optional (and recommended) additional import steps are:

- Rename the files:
- Convert raw files to DNG:
- Apply a Develop preset; and
- Add metadata (copyright and keywords).

If you do all the above, your new photos will come into the Lightroom catalog loaded with metadata and looking closer to the way you want them. This will allow you to move directly to editing the shoot (see Chapter 6) and get files into processing as quickly as possible.

Treat JPG as separate files

If you capture raw+JPG, and want to import both files for each capture, you need to specify this in Lightroom Preferences→Import.

IMPORT RAW IMAGES FROM MEMORY CARD, CAMERA OR REMOVABLE DISC AND CONVERT THEM TO DNG

As soon as possible after as you've completed a shoot (or filled a memory card), get the files transferred to the computer, renamed, converted to DNG and into the Lightroom catalog. See Figure 5–9.

- Launch Lightroom and make sure the correct database is loaded.
- Insert the memory card into a card reader (this is faster and safer than transferring from your camera itself). Lightroom will usually detect the card/camera and open the Import dialog box. If not, click the Import button (or use the shortcut) and navigate to the folder containing the files to be imported. Select the source folder with photos to be imported and click Choose.

Set the Import dialog box options:

- 3. File Handling: select Copy Photos as Digital Negative (DNG) and Add to Catalog. Or, if you prefer to transfer your camera raw files without converting, use Copy photos to a new location and add to catalog.
- 4. **Copy To:** click the **Choose** button (or click the folder name to select from a list of recent locations). Select the top-level folder where the **files should be placed.** As necessary, make a new folder during this step.
- Organize: select Into one folder.
 - **Put in subfolder:** Depending on the parent folder you've already specified above, you may want to enable this option. Use the text box to set the name for the new subfolder.
- 6. **Don't re-import suspected duplicates:** uncheck this option. Usually, we don't want Lightroom deciding for us what's a duplicate and what's not at this point.
- 7. **Eject card after importing:** if you need to do more than one import from the card, leave this unchecked. Otherwise, check the box so when the import is complete you can take the card out of the reader immediately.

- 8. Backup to: leave unchecked, unless you want to make a backup of the original files prior to being copied/imported. The converted DNG files will not get backed up with this option. It's better to do your backup immediately after importing. Be sure that any backups you do are to a separate hard disk than where the working copies are being saved.
- 9. **File Naming→Template:** select a template from the menu or create/edit templates by selecting Edit... from this menu (see Figure 5–7).

After selecting a template, customize the variables in the file name. If the template uses the custom text token, type in the text field.

- 10. **Develop Settings:** choose a preset to apply to the files during import (optional; see Chapter 7 for more information about Develop Presets).
- 11. Metadata: select the template or make a new one if necessary.
- 12. Keywords: enter words and phrases descriptive of this group of images.

13. Previews

a. Minimal

Select this to have your import complete in the fastest time possible. Only small thumbnails will be generated during the import. When you begin working with your images, Lightroom will generate previews as necessary on-the-fly. Working on the files in Lightroom you may notice slight delays in the response of the program as previews are built.

b. Embedded and Sidecar

Select this option to have Lightroom read in any existing previews and use the current previews if they are up-to-date or generate new ones if not. This is particularly intended for raw and DNG files.

c. Standard

Select this option to have Lightroom generate thumbnails and standard-sized previews during Import.

d. 1:1

Select this option to have Lightroom render 1:1 previews (the largest preview size) during import, in addition to thumbnails and standard previews. This can significantly extend the time required to complete

the import. However, you can begin working on the images while previews are still being generated.

- 14. **Show Previews:** check this box to see thumbnails for the photos being imported.
 - a. Optionally, make selections from the thumbnails. Thumbnails with the checkbox ticked will be imported; those unchecked will not. If appropriate, select groups of files that will all have the same metadata and keywords applied and make sure their checkboxes are ticked to import. To import everything from the card leave all the thumbnails checked. I usually import all the images from a shoot because I don't want to make editing decisions during import. The exceptions are obviously bad captures (my blurry foot shots).
- 15. Click the Import Button or press **Return/Enter** to begin the import.

When the import is completed, Lightroom will display the imported images in Library Grid using the Previous Import image source (see Chapter 6).

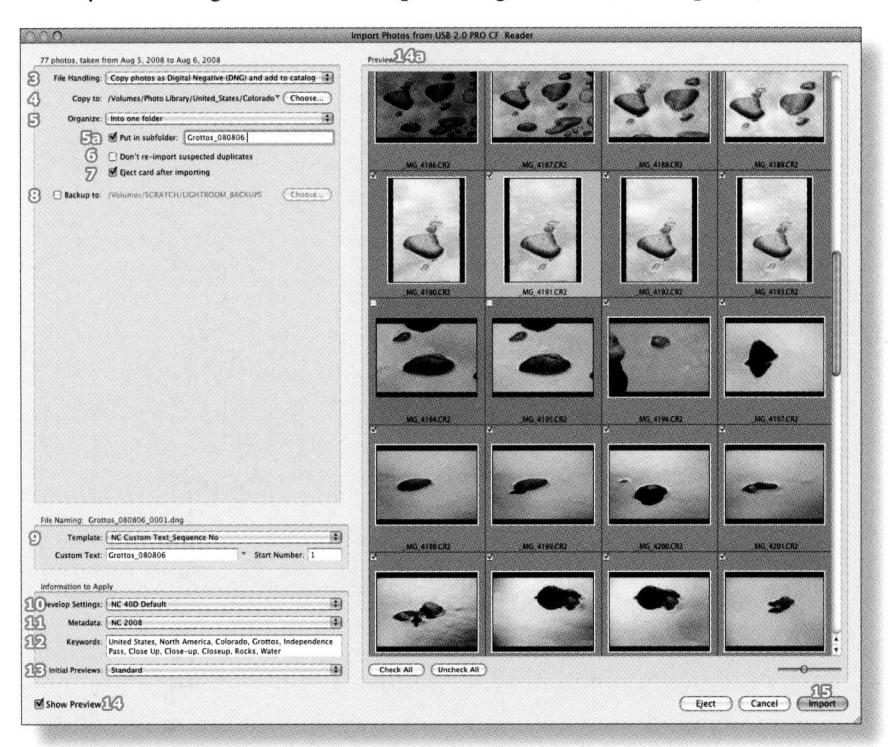

Figure 5–9: Import dialog box with settings for copying files from camera and importing to Lightroom

Show import dialog when a memory card is detected

This setting, in Lightroom Preferences→Import, is intended to open Lightroom and open the import screen when you insert a memory card or connect a camera directly to your computer. Understand, however, that this is also controlled by your operating system, and other programs can get in the way. For example, if you install software like Downloader Pro or Photo Mechanic, these applications will set themselves to be the default program to launch when a memory card is loaded. To change the system settings on OS X, use the Image Capture application preferences and specify Lightroom as the application to launch when a memory card is loaded. On Windows, use the Autoplay control panel.

Maximize the Import dialog box to full screen

This hides the rest of the Lightroom interface, allowing you to concentrate on the import tasks, and provides more room for thumbnails and longer text fields in the dialog box.

Selecting thumbnails versus checking them

You can click thumbnails to select them in the Preview area or the import screen, but it's only the checkbox in the upper left corner of each thumbnail that determines whether it will be imported or not.

Drag the slider below the thumbnails

To change thumbnail size.

\implies lpha, Ctrl or Shift to select multiple thumbnails

To check or uncheck multiple images, select the images with the mouse cursor then tick the checkbox on any one of them. All the selected imaged will become checked/unchecked.

Have Lightroom do as much as possible during an import

Lightroom is a robust, batch-processing application with many options designed to save you time. The more functions you have Lightroom perform, the less work you'll have to do later.

Convert to DNG during import

Converting your files to DNG at the start of the workflow will make the rest of your work easier.

🐶 Use subfolders instead of New Folder...

If, rather than making a new folder in the Copy To: selection, you create a subfolder in the import screen, you can more easily match the name of the folder with the base name of the files going into it: copy/paste the text between the two fields.

Make sure the file names have the same base name as the folder

After import save metadata to files

If you've applied any metadata during import, save it out to the files immediately after the import is done.

hleht pprox pprox

To save the metadata to all the files in the Previous Import source. See Chapter 6 for more information about Saving Metadata.

Back up the newly copied files immediately

After your copy/import procedures have completed, confirm the integrity of the files (usually, just quickly scrolling through them is sufficient) and make a backup right away. Make sure to back up to another media source, such as copying to a hard drive or burning a CD/DVD. Backups made on the same hard disk are not really backups.

Mever modify or delete the files on the card using your computer

Your computer file system and the file system on the memory card do not necessarily cooperate. Never manipulate the files on your memory card in any way, including deleting, moving, renaming or modifying folders. This dramatically increases the risk of data corruption. Most importantly, never format the card using your computer. This can render the card unreadable by the camera.

Reformat the card in the camera

After transferring your files from the card to a hard disk and confirming backups, reformat your memory card in the camera before each new shooting session.

What happens during the import

Depending on the type of import you're doing and the options you've selected, Lightroom will read each of the files in the selected folder(s), generate new files as necessary and create records in the database for all the photos.

As soon as you start the import, the import screen closes, and the Library module loads with the Previous Import image source selected (see Chapter 6). Photo thumbnails begin appearing in Grid view as the files are imported.

The progress indicator at the top left of the Lightroom program window (be sure the top panel is visible) shows the approximate amount of processing remaining in each stage of the import—reading files, converting to DNG, rendering previews, etc.

Stopping an import in progress

If you start an import and realize you made a mistake, or change your mind about something, it might be best to let the import finish and clean up after-the-fact.

Stopping an import in progress increases the likelihood of bad data in the Lightroom catalog (especially if Lightroom crashes while trying to stop the import) and brings into question the accuracy and completeness of the files in subsequent imports.

For these reasons, you might want to be a bit conservative with the number of files you try to import at one time.

If you decide to stop an import in progress, click the X next to the progress indicator. After clicking, wait for Lightroom to finish what it's doing, then remove the incorrectly imported files from the catalog (see Chapter 6 for information about removing/deleting files).

Start working in Library right away

You can begin working on photos as soon as they appear in the Library Grid view. You do not have to wait for the entire import to complete in order to start editing and/or processing photos already in the catalog. You can also switch from Previous Import to another image source or any other module while an import is in progress. See Chapter 6 for information about working in Lightroom's Library module.

Workflow: Import existing files from your hard disk

It's likely you've had many photos on your hard drive prior to using Lightroom. The next step to building your complete Lightroom catalog is to get all of your historical photo archives (as appropriate) into the database. During this process you can determine whether or not to make any changes to the files to conform to your current conventions.

When importing existing images from your hard drive, you have two basic choices:

- Just import the files, not modifying them in any way; or
- Process the files somehow during the import. This could include renaming, changing formats, applying metadata, etc.

Parent folders get added too

When you import a set of photos, the folder that contains them is entered into the catalog also.

IMPORT IMAGES FROM A HARD DISK WITHOUT MODIFYING THE FILES

The most basic kind of import is to just get the files into the catalog, nothing more. See Figure 5–10.

- 1. Launch Lightroom and make sure the correct catalog is loaded.
- In the Library module, click the **Import** button in the left panel, or use the shortcut. Navigate to the folder containing the images to be imported. Select the entire folder or individual images. Click Choose.

Set the Import dialog box options:

- 3. **File Handling:** from the popup menu, select **Add photos to** catalog without moving.
- 4. Subfolders list: All Folders should be checked, unless there's something that you specifically want to exclude from this import. You can select/deselect folders, or check/uncheck them to include or exclude them from this import. Your changes will be shown in the thumbnails.
- Don't re-import suspected duplicates: uncheck this option.
 We don't want Lightroom deciding for us what's a duplicate and what's not at this point.
- 6. **Develop Settings:** None*
- 7. **Metadata template:** None*
- 8. **Keywords:** Leave blank*
- 9. **Initial Previews**

Choose from the following options:

a. Minimal

Select this to have your import complete in the fastest time possible. Only small thumbnails will be generated during the import. When you begin working with your images, Lightroom will generate previews as necessary on-the-fly which may cause slight delays in the response of the program as previews are built.

Embedded and Sidecar

Select this option to have Lightroom read in any existing previews and use the current previews if they are up-to-date or generate new ones if not. This is particularly intended for raw and DNG files.

c. Standard

Select this option to have Lightroom generate thumbnails and standard-sized previews during Import.

d. 1:1

Select this option top to have Lightroom render 1:1 previews (the largest preview size) during import, in addition to thumbnails and standard previews. This can significantly extend the time required to complete the import. However, you can begin working on the images while previews are still being generated.

- 10. If no thumbnail previews are being shown on the right side of the window, tick the checkbox at the bottom left for **Show Preview**.
- 11. **Preview:** select/deselect thumbnails for images to be imported (optional). Usually you'll want to import all the selected photos. The "Check All" and "Check None" buttons make selections easier.
- 12. Click the **Import** button.

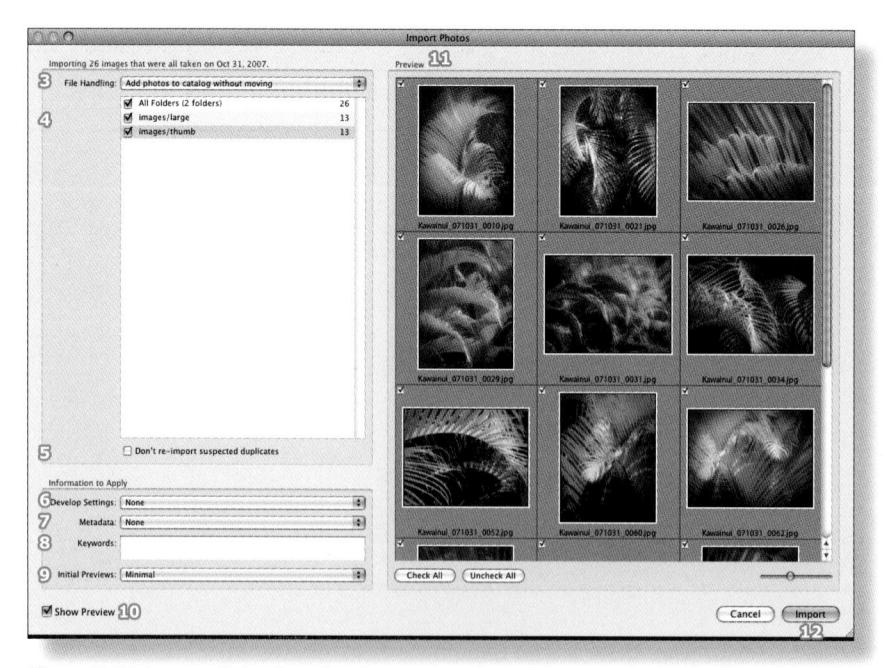

Figure 5–10: Import dialog box showing settings for importing existing files from hard disk

*When importing existing files from disk, be careful applying metadata
Usually you shouldn't apply metadata presets to existing files from your hard
disk during import because the files might already contain custom metadata.
The import screen doesn't indicate whether or not custom metadata has already
been applied to the files being imported, and if the files do have custom metadata
applied, it isn't shown. For these kinds of images, it's safer to apply presets after
import: review the files in Library and then add your metadata as necessary.

If you are certain that no custom metadata has been applied to the files or you're okay with overwriting it, you can apply your metadata template, add keywords (and even Develop presets) for the group of images to be imported. Just be careful with this.

Option+Click or Alt+Click thumbnails To select and check/uncheck simultaneously.

Import multiple folders at once To import photos from a folder plus the subfolders underneath, choose the parent folder and all its subfolders will also be imported.

Press Return or Enter To start the import.

Lightroom reads XMP If you're importing raw files and they have .xmp sidecar files, Lightroom will read the metadata settings from them and the images will come into Lightroom with those settings applied. Same with DNG.

Camera raw edits With camera raw files that have been previously worked on, but *do not* have sidecar files, those previous edits *will not* come into Lightroom. Make sure any time you're working on raw files in other software that you save out the metadata to sidecars.

Backup right away Sync your backups immediately after an import completes.

Drag and drop folders onto Lightroom With Lightroom running in standard window mode, reduce the size of the window so you can see your desktop. Drag and drop files and/or folders either onto the Lightroom window or the program icon. The import dialog box will open with the images selected, ready to complete the steps described above.

Vacaville, California August 2006 Canon EOS 30D, Canon EF 28-135 IS 1/160 second at f/5.6

Workflow: Shooting Tethered with Auto Import

Introduced in Chapter 4, shooting tethered allows immediate, automated transfer of files from your camera to your computer as they are captured. The main purpose of this is to review images on larger, more accurate displays than the camera's LCD provides. Also, shooting tethered with auto-import into Lightroom provides the fastest way to batch process new captures into your catalog.

Lightroom support this scenario (see Figure 5–11), with a few caveats:

- As of this writing, you must use the software that came with your camera to auto-transfer the files to the computer. Lightroom can't do this on its own.
- The processing options for Lightroom's handling of auto-imported files are somewhat limited when compared with a normal import.

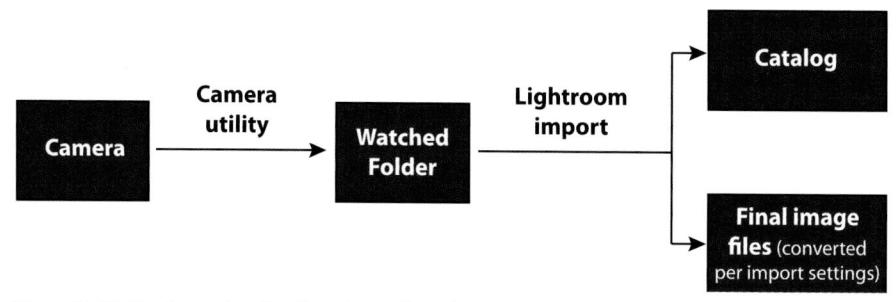

Figure 5-11: Configuration for shooting tethered

The steps to set up shooting tethered into Lightroom are:

- In Lightroom, select File→Auto Import→Auto Import Settings (see Figure 5–12).
- 2. Specify a folder on your hard drive for Lightroom to use as the source for Auto Import (the "watched folder").
- 3. Specify the destination for Auto Imported photos to be moved to (usually within your master image library folders).
- 4. Configure your file naming, Develop presets, metadata and keywords, etc. as appropriate for the upcoming Auto Import session.
- 5. When you're finished configuring the Auto Import settings, click OK.

- 6. In Lightroom, select File→Auto Import→Enable Auto Import.
- 7. Connect your camera to your computer using the specified cables (usually USB).
- 8. Configure the utility software that came with your camera to autotransfer new captures from the camera into the watched folder you specified in Lightroom.
- 9. As you capture images with your camera, they will be automatically transferred to your watched folder. Lightroom scans the watched folder and when new files are detected they will be processed and imported according to your Auto Import Settings. Each new photo will be shown in Library Loupe view as it is imported.

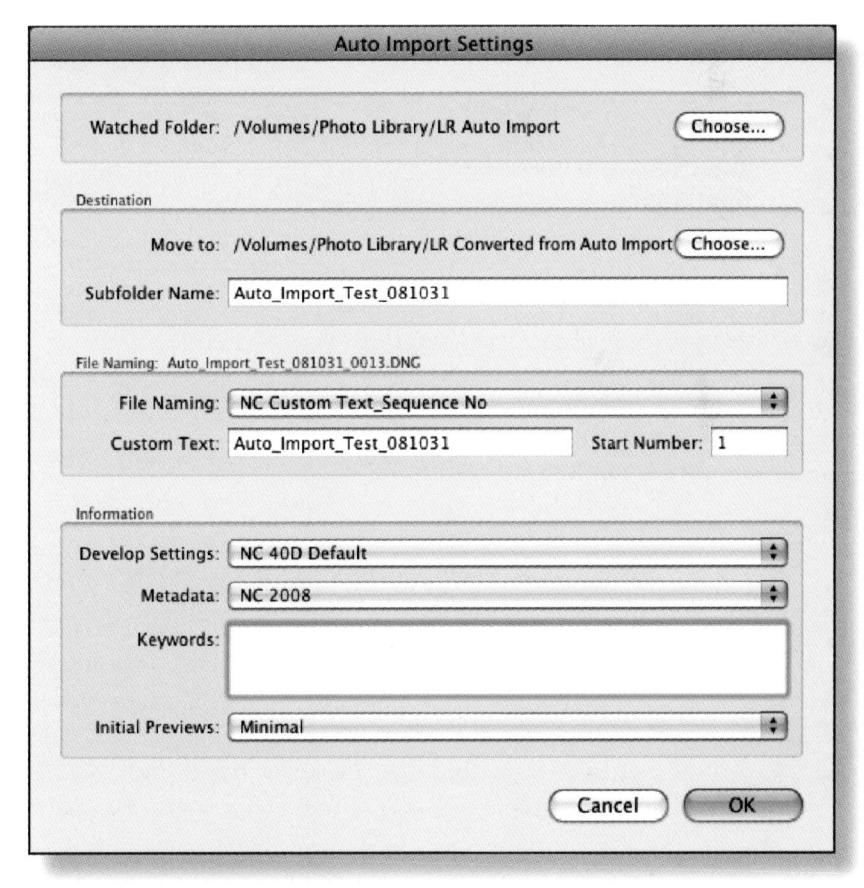

Figure 5-12: Auto Import Settings

Alternative Import Workflows

Sometimes a "straight import" is not the most efficient way to go. With an import doing copy/convert/rename etc. you have numerous options available. Again, think carefully about how you want the files handled, consider all the separate steps of processing the files, and make your import settings accordingly. Customizing the import options to do complex batch processing during import will speed up your work dramatically. Below are a few examples of scenarios you're likely to encounter.

Copy files to a new location and add to catalog

Select this option from the File Handling menu. This directs Lightroom to copy the selected files to another folder or disk, then import the copied files. The original files will remain as they were, and will not be imported.

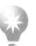

Copying files allows you to rename them

Regardless of file formats, if you have Lightroom copy the files during the import you have the option to batch rename them. This has many potential uses.

Move files and import

This is similar to copy and import: Lightroom copies the selected files to a new location and imports the copies. But Lightroom then deletes the old files at the original location. So be careful with this one!

Copy photos as Digital Negative (DNG) and add to catalog

You can do this even for camera raw files already on the hard drive. This allows you to convert your camera raw files to Adobe's DNG format and subsequently import the resulting DNG files. If the raw files have sidecars, those edits will be integrated into the new DNG. You can then decide whether or not to keep your original camera raw files.

Copy now, import later

If you're away from your main computer, shooting in the field, there will be times when you need to copy files off a card as quickly as possible and come back to complete import operations later. The fastest solution for this is to only copy your raw files to a temporary, working folder on your computer and come back later to finish DNG conversion, renaming, metadata, etc. during a complete Lightroom import operation. This scenario is a hybrid of the two main import workflows described in this chapter: you will be converting, renaming etc. to produce new files from those already on your hard drive.

This optional workflow has many other potential applications. For example, using Lightroom's import functions, you could perform the same basic steps to

- Convert your raw library to DNG;
- Copy files from one disk or folder to another while adding keywords and other metadata; or
- Just move and rename a batch of files.

Import Workflow for Road Trips

Following is the set of procedures I use when out shooting on location, using a laptop computer. Depending on your own computer hardware and software setup, you can follow this workflow verbatim, or use it as a basis for developing your own methods. In any event, the basic steps remain the same:

- 1. On my laptop, I create a new, empty Lightroom catalog for each trip.
- 2. While on the road, I import all new captures into the trip catalog.
- 3. After returning home, I import the photos (and accumulated metadata) from the trip catalog into the main, "master" catalog.
- After confirming the import and making backups, I delete all the image files and temporary trip catalog from the laptop, which is then ready for the next trip.

Following is the sequence of steps in detail. First, set up a temporary trip catalog:

- On the laptop, launch Lightroom while holding down Option or Alt key.
 (Note: on Windows, launch Lightroom first, then quickly press the Alt key.)
 - In the resulting dialog box, select "Create New Catalog".
 - Or, with Lightroom already running, select File→New Catalog.
- The dialog box that appears is asking you to give the catalog a name. This will also be the name given to the folder containing the catalog and preview files.
 - Using your standard naming convention, give the catalog a name. For example, New_Mexico_0901. Do not specify a file extension.

- 3. Make sure that your target destination for the new catalog is a place you can easily find it. Always using the same location, such as your Dekstop or Pictures folder, makes this easier.
- 4. This will create a new folder, with the specified name, on the desktop. Inside that folder will be the new Lightroom catalog, named, for example, New_Mexico_0901.lrcat.

During the trip:

- 1. Import images from memory card(s) into the trip catalog using the same methods and settings you would at home.
- 2. As necessary, create subfolders for individual days or locations. Just be sure that all the image files/folders are put in the main trip folder.
- 3. Verify your imports, making sure that all the desired files have been imported/converted, etc.
- 4. You can process your files as you see fit during the trip. Remember to save out your metadata as you work (see Chapter 6 for more about this).
- 5. Make regular backups of your trip folder onto a portable hard drive (or flash drive). You can do this with drag-and-drop or with dedicated software. Just be sure your backups all remain current during the trip.
- 6. After backing up your imported files, reformat your card in the camera before the next shooting session.

Upon returning to your main computer:

- Be sure that the trip catalog on the laptop is fully up-to-date and backed up onto the portable hard drive. (Make sure all metadata has been saved to DNGS.)
- 2. Prepare to transfer/import the files to your main computer, in one of two ways:
 - a. Connect the external, portable hard drive and use the backup files to import to your main catalog; or

 Connect your laptop and the other (desktop) computer over a network

(Using the backup drive is usually faster and easier; just make sure it's identical to what's on your laptop's internal drive!)

3. From within your main catalog, select File→Import from Catalog. Navigate to the trip catalog folder, select the .lrcat file, and click Choose (or double-click it) to select it as the import source.

In the Import from Catalog dialog box:

- 1. Enable Previews to see the image thumbnails (optional).
- File Handling: Select "Copy new photos to new location and import". (You could also manually copy the trip files to your main drive, in which case you would select "Add new photos to catalog without moving" instead.)
- 3. If you're having Lightroom perform the copy for you, in Copy to: select "Choose"; navigate to your main photo drive and select the parent folder that the trip folders will be placed into.
- 4. Click "Import".
- 5. After the import has completed, locate the new folders/photos in the Folders panel. (If you had Collections in the trip catalog, those will be imported as well.) Confirm the names and locations of the folders and the number of photos is consistent with the original trip files. If anything is out of place, you can rename folders and/or drag and drop to rearrange them (see Chapter 6) or perform additional imports.
- 6. Synchronize the backups for your main photo library.
- Wipe all files and folders for the trip from your laptop and portable drive.

See Figure 5–13 for an example screenshot of the Import from Catalog dialog box.

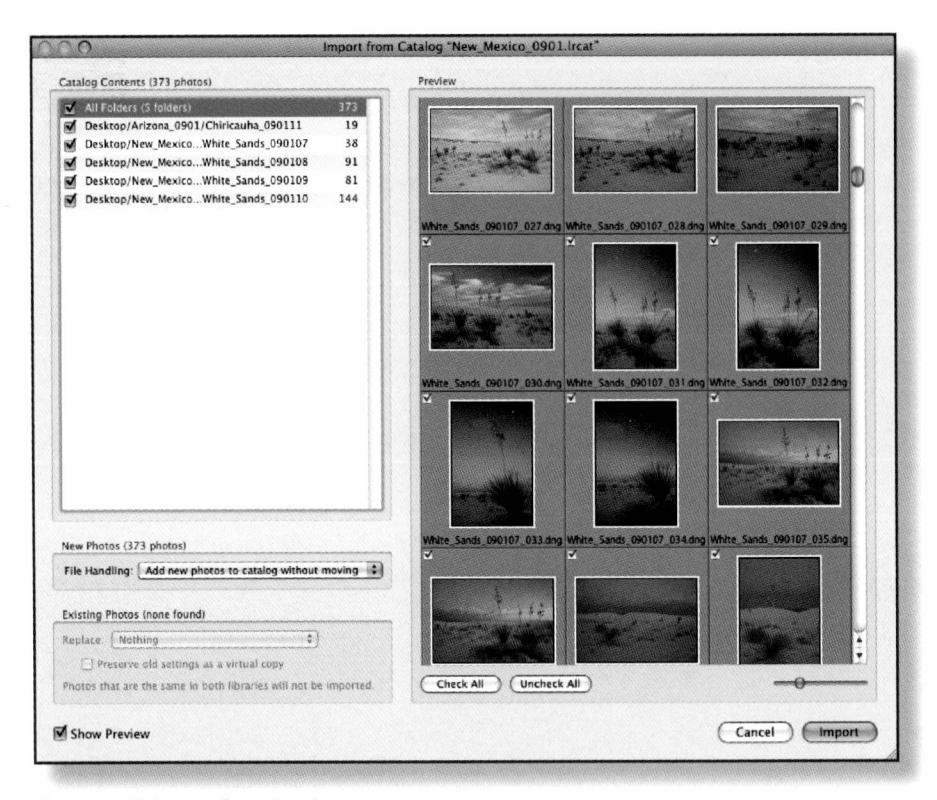

Figure 5–13: Import from Catalog screen

Catalog and Image File Backups

Every computer user knows that backing up your files is critical. Still, I'd be negligent if I didn't remind you *to actually do it*. Religiously. In the digital photography workflow there's absolutely no excuse to risk losing all your work. Update your backups after every work session!

BACKING UP LIGHTROOM CATALOGS

Lightroom offers the ability to test the integrity of the database and make a backup of the catalog file when starting the program; you should frequently allow these backups to be performed. During this process, only the Lightroom catalog is backed up—the image files and preview packages are not.

Opens the Catalog Settings dialog box. On the General tab, set the backup frequency to **Every Time Lightroom Starts.** You can always skip backups if you choose. But at least this way, Lightroom reminds you!

Backups are performed when Lightroom starts. (You may want to quit and relaunch Lightroom after a major work session, just to do a backup.)

When Lightroom launches and asks if you want to do a backup, you can specify the location for the backups. The backups are placed in subfolders named with the date and time.

Only keep the most recent one or two backups

Go to your backups folder to periodically delete old ones.

Drag-and-drop backup

You can also back up your Lightroom catalog and previews by dragging and dropping the main catalog folder onto another hard disk; this is a fine way to do it. However, keep in mind this skips the data testing stage that Lightroom performs when it performs a backup.

BACKING UP IMAGE FILES

Always maintain at least two copies of your image files on separate hard disks. Set up two hard drives, one as the master working library and the other as its mirror image (see Figure 5–14). If possible, store a third backup at an alternate location. Update these backups frequently.

Backup after import

During any import in which files are being copied, Lightroom offers the ability to make backups of the files being imported. However, it is the *original* files that get backed up, not the new copies. For this reason I recommend you manually do a file backup immediately *after* imports are completed.

Syncing drives

Use backup software that can *synchronize* data between hard drives. **Sync your master and backup drives after every work session.** You can also set up the software to automatically sync at specific times. (For Mac, I recommend Carbon Copy Cloner and ChronoSync; similar software is available for Windows. See the Resources list in the Appendix.)

Figure 5-14: My drives

Solid state media for backups

With the recent growth in capacity, solid state (flash) drives, such as removable us "thumb drives", "jump drives", etc. provide a good option for either temporary backups or permanent archival. (With no moving parts, they may survive longer than magnetic hard drives.)

Chapter Summary

Taking great care during the import process will make the rest of the workflow much easier. Establish and follow a consistent system for naming and organizing your files. Do as much batch processing as possible during each import operation... and back up your work regularly!

CHAPTER 6

ORGANIZE YOUR PHOTOS IN LIBRARY

Managing many thousands of images is a common task for the modern photographer and needn't be difficult. From your first look at a batch of new photos through editing and longterm archival Lightroom gives you all the tools you need to organize your entire photo library, identify your best photos and find any image fast. Use the shortcuts and tips in this chapter to accelerate your editing and cataloging tasks.

Image Sources

All the organizing and editing in Library is done using *image sources*. Sources determine which photos are shown in the Grid, Loupe and Filmstrip views (see Figure 6–1). Lightroom's image sources and locations are:

- Catalog Panel: built-in sources with predetermined criteria.
- Folder Panel: representations of the actual folders on your hard disk.
- Collections Panel: virtual groups of photos within the Lightroom catalog.
- **Keywords Panel:** if a photo has keywords applied they can be used to define or refine sources.
- Filter Bar: filters are most effectively used to refine the other image sources.

Figure 6–1: Library left panel with multiple folder sources selected, Filter bar (top) and Grid view

₩+Click or Ctrl+Click on multiple sources

You can combine multiple sources, from multiple panels, to create the exact selection of photographs you want to work on.

Recent Sources menu

The Source Indicator is shown in text along the top of the Filmstrip. Clicking on this opens the Recent Sources menu. Use it to jump to any of the twelve most recently used sources plus the built-in Catalog sources. See Figure 6–2.

Figure 6–2: Source Indicator with Recent Sources menu

CATALOG PANEL SOURCES

The Catalog panel lists several predefined sources. The basic rules for Catalog sources can't be changed but filters can be applied to refine them (discussed later in this chapter). Lightroom's Catalog panel (see Figure 6–3) contains the following image sources:

All Photographs

Shows all the photos in the catalog.

Quick Collection

Shows all the photos in the Quick Collection.

Previous Import

Shows all the photos added to the catalog during the most recent Import or Sync.

Additional Sources Sometimes on the Catalog Panel

Depending on the condition of your catalog and the work you've done, sometimes Lightroom will show additional sources on the Catalog panel, including:

- Missing Photos
- · Error Photos
- Previous Import from Catalog
- Previous Export
- Previous Export to Catalog

Keep an eye on what's listed in the Catalog panel.

Other temporary sources may also appear in this list from time to time. The Catalog panel can alert you to potential problems in addition to providing quick ways to retrieve photos you've recently worked with.

> #+Control+1 or Ctrl+Shift+1
To open or close the Catalog panel.

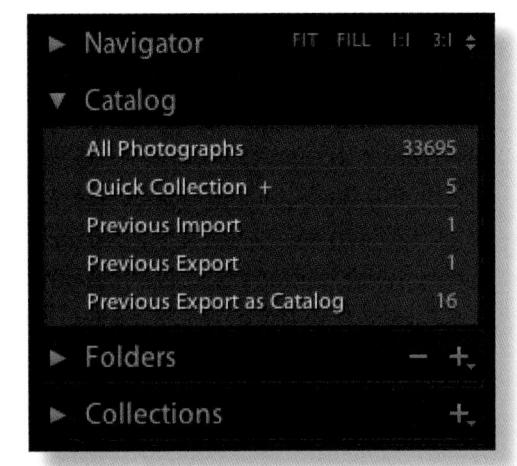

Figure 6–3: Catalog panel sources

FOLDER PANEL SOURCES

The Folders panel shows the disk and directory structures containing the photos that have been imported into Lightroom. The Folders panel does not show image files; as you select folders their contents are shown in the *Grid*, *Loupe* and *Filmstrip* (all of which are discussed further in this chapter).

≫ #+Control+2 or Ctrl+Shift+2

To open and close the Folders
panel.

Resize panel groups by dragging their edges

Wider panels show longer folder names (see Figure 6–4).

HARD DISK DRIVES AND VOLUMES

At the top level of the folder/file hierarchy is the *volume*. A volume is usually an individual hard disk

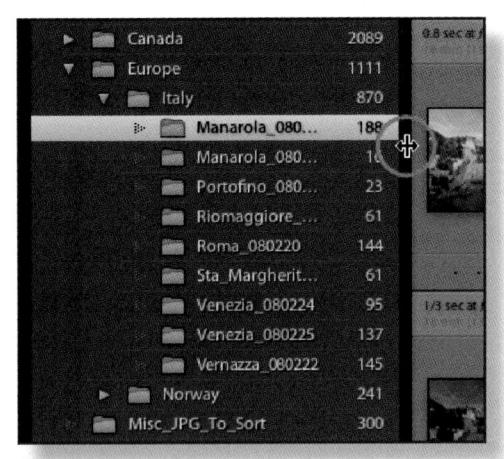

Figure 6–4: Resizing panels to show more text

drive but can also be a partition on a single disk or a multiple-disk array. You can import files from optical media such as CDs and DVDs but won't be able to save any metadata to them as you work. Removable volumes, such as CDs, DVDs and USB "thumb-drives" should not be used for storage of your master image library but can be useful in file transfer and maintenance.

Volumes shown in Lightroom correspond directly to the volumes in your computer operating system (Mac os x Finder or Windows Explorer). Volumes are listed in the Folders panel with their folders underneath (see Figure 6–5). A single Lightroom catalog can contain images from any number of volumes—as you Import images from folders on different drives, each volume gets added to the list in the Folders panel.

Each volume has its own Volume Browser, which shows the status of the volume and optional statistics. Click the volume name to hide and show its folder contents.

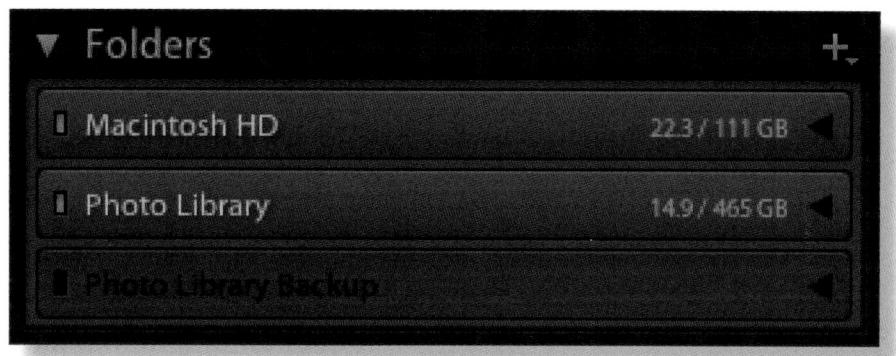

Figure 6–5: Volume browser with disks online and offline

By default, the Volume Browser also shows the available free space and the volume size. This can be changed (see Figure 6–6). Normally there's a green "light" at the left of the Volume Browser indicating the volume is online with available free space. If the light is yellow or red, free space on the volume is low. If a volume is dimmed in the list, that volume is offline.

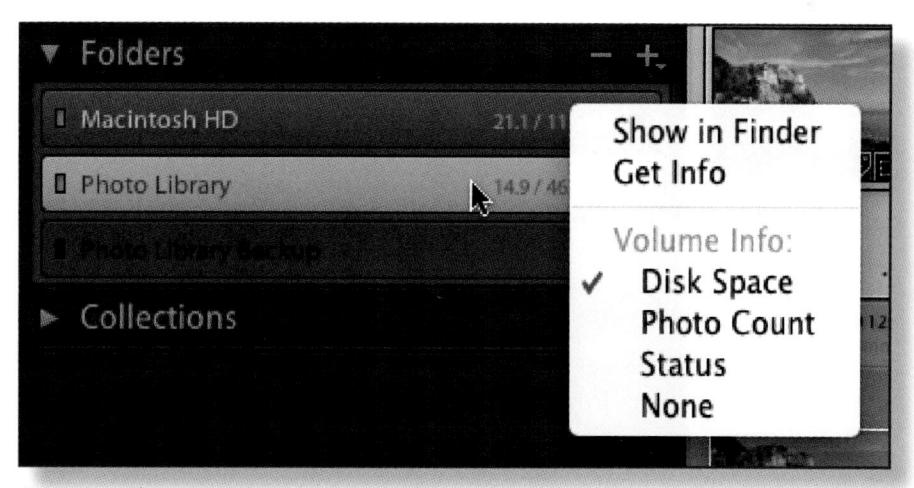

Figure 6–6: Changing Volume Browser display options

Control+Click or right-click on the Volume Browser header

To change the Volume Browser display or to show the volume in the Finder or Explorer.

Offline/online

A disk volume that is connected and available to the computer is *online*. A volume that is not available to the computer is *offline*.

In Lightroom you can work with photos from offline volumes in Library, Slideshow, Print and Web, where Lightroom will use rendered previews if they are available.

You can't process images from offline volumes in Develop, and a few other controls are unavailable. This is because when processing an image, Lightroom renders new previews after each change is made, which requires re-reading the data from the actual image.

Volumes not listed in the Folder panel

Lightroom will not provide access to volumes or their contents until you do an Import. If a volume is not listed in the Folders panel, it's because no photos from it have been imported.

FOLDERS AND SUBFOLDERS

Immediately after Import you'll begin editing your images within their folders (see Figure 6–7). A folder is the second-most basic kind of image source, after

the All Photographs source. When you Import a photo into Lightroom, the folder that contains it will also be added to the Folders list. You can directly manipulate the Folder hierarchy on disk from within Lightroom.

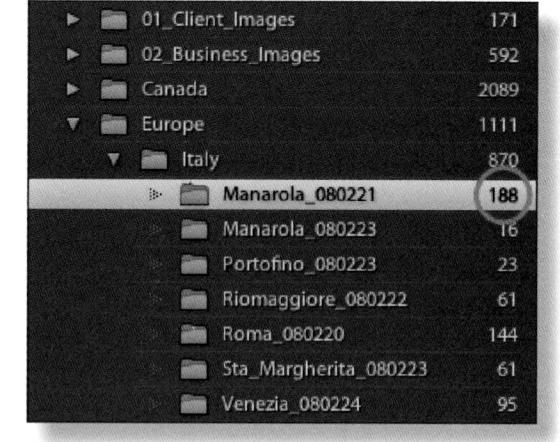

Figure 6–7: Folders and subfolders; photo count shows the number of images in each folder

Don't stay in folders too long

As you move through the workflow, you should use other sources, especially collections and smart

filters (discussed in detail later in this chapter).

Folders are the basic repository for holding your photos on the hard disk, and within Lightroom, you can do a lot of work from within a folder. But as you move through the editing workflow, it's likely that tasks requiring more refined selections and the creation of derivative files for specific purposes will arise. For efficiency, these situations often benefit from the creation of other "virtual" organizational structures within the Lightroom catalog. If you find yourself working a lot in the Folders panel, try to put your favorite photos in Collections, and work from there instead.

Also, Smart Collections (also detailed in this chapter) can provide enormous time saving advantages when working with your files under different kinds of production requirements.

Control+Click or right-click the folder name, choose Add Parent To add the parent folder of the selected folder to the Folders panel.

Include Subfolders

When the *Include Subfolders* menu option is active (this is the default; see Figure 6-8), selecting a folder in the Folders panel will show its contents and also the contents of any subfolders it contains.

Depending on your folder structure this may be neither necessary nor desirable; showing all the contents of subfolders slows Lightroom's performance as it reads the files in the subfolders and generates previews.

With the Include Subfolders option disabled, selecting a folder will only show the contents of that folder and not of the subfolders. This can dramatically improve performance and give you a more accurate read on the contents of specific folders.

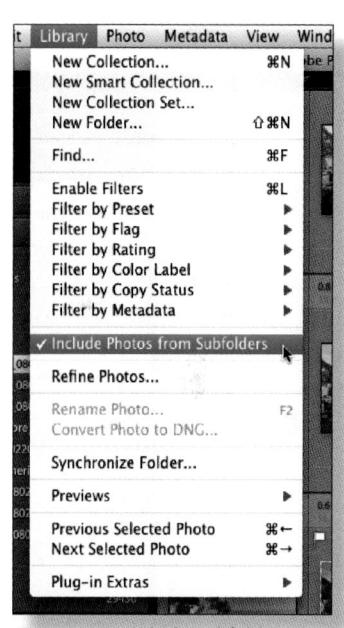

Figure 6–8: Include Subfolders menu command

A potential drawback to doing this is that the file counts of parent folders are affected (see Figure 6–9, next page). For this reason, I normally work with Include Subfolders enabled and turn it off temporarily as needed.

Synchronizing Folders

If you've made changes to the contents of a folder outside Lightroom, such as adding or removing images, renaming files, etc., you should synchronize the folder in Lightroom. Synchronize Folder compares what's in the catalog with the contents of the folder on disk and allows you to update the catalog accordingly.

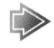

Control+Click or right-click on the folder name

Choose "Synchronize Folder..." from the contextual menu (see Figure 6–10). Press Return or Enter to sync the Folder.

Figure 6-9: File counts affected by disabling Include Subfolders

Show the Import dialog box when synchronizing

Enable the option to show the Import dialog box during synchronization unless you are absolutely certain of what you're syncing. Metadata entries remaining from your Previous Import, such as keywords and copyright notice, can be inadvertently applied to photos added to the catalog during the sync process. Check those fields before executing the sync. It's also a good idea to see some image previews before bringing new files into the catalog.

Figure 6–10: Folder contextual menu; Synchronize dialog box

Finish the Job

If you use Adobe Bridge, Adobe Camera Raw, Photoshop or Elements to edit photos outside the Lightroom catalog you'll need to synchronize them in Lightroom when you're done.

Adding Folders

When you add new folders in Lightroom they are created on your hard disk.

Type the folder name and press Return or Enter.

₩+Shift+N or Ctrl+Shift+N
To make a new folder.

MANAGING FOLDERS AND PHOTOS

Before importing photos into Lightroom, it's a good idea to first organize them as much as possible on the hard disk. But once photos are in the catalog, it's usually best to manage them entirely from within Lightroom.

Move and rename folders and photos within Lightroom

...not in Finder or Explorer. This ensures that Lightroom can keep track of all the files in its database. You can drag and drop photos between folders and this will also move them on disk.

Renaming Folders

Renaming a folder in Lightroom renames it on disk.

Control+Click or right-click on the folder name

Choose Rename from the contextual menu. Type the new name and press Return or Enter.

Removing Folders

Removing a folder from the Lightroom catalog does just that—the folder and its contents are removed from the Lightroom database only. The folder and any files it contains are not modified on the disk.

Control+Click or right-click on the folder name

Choose Remove Folder from the contextual menu. Press Return or Enter to finish.

! Removing Missing Folders

If the folder is missing (shows a question mark on it) you will not receive a dialog box confirmation when removing it. Be certain the missing folder shouldn't be relinked instead; see next section.

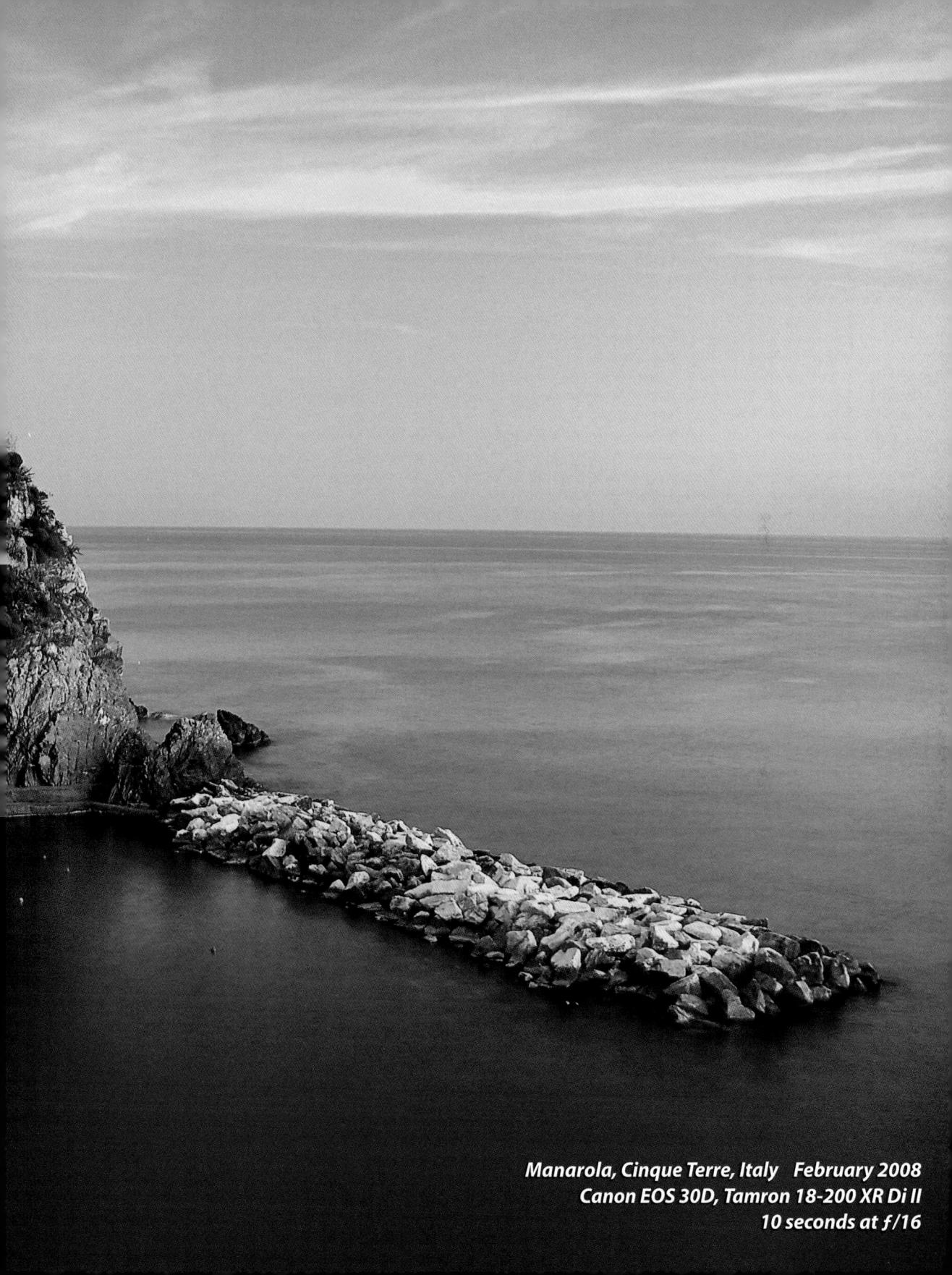

Finding a Folder on Your Hard Disk

You can locate a folder anywhere on your hard disk.

Control+Click or right-click on the folder name

From the contextual menu choose Show in Finder or Show in Explorer.

Finding a Photo on Your Hard Disk

You can locate an image file anywhere on your hard disk.

₩+R or Ctrl+R

To go to a selected file in Finder or Explorer.

Finding a Photo in the Lightroom Folders List

Occasionally, when working in a source other than a folder, you may need to find the folder, within Lightroom, that contains the image.

Control+Click or right-click the image

From the contextual menu choose Go to Folder in Library.

Renaming Photos

Renaming photos in Lightroom also renames the image files on disk (see Figure 6–11). Renaming files is something you should consider carefully; if a batch of images is improperly named, you should rename the files correctly as early as possible in the workflow.

▶ F2

Select Custom Name from the File Naming drop-down menu and enter the name in the Custom Text field or use one of the other file naming presets.

Rename a Batch of Images

If you wait to do your file naming until after Import, you can rename photos after removing rejects. This will keep your numbering sequence unbroken.

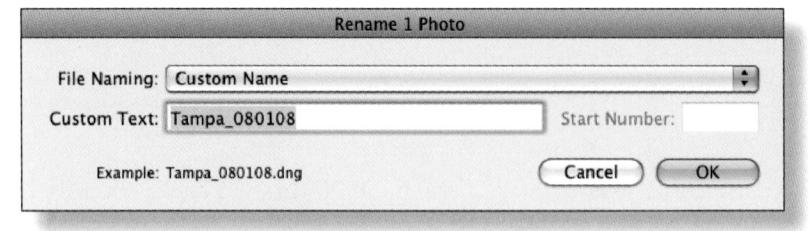

Figure 6–11: Rename File dialog box

Removing Photos

You can remove images from Lightroom without affecting them on the hard disk or you can use Lightroom to delete files from the disk (see Figure 6–12).

Select the image(s) and press Delete

A dialog box appears giving you three options:

- **Delete from Disk:** Remove the photo(s) from the Lightroom catalog and move the image file to the system trash.
- **Remove:** Remove the photo(s) from the Lightroom catalog but leave the image on the disk.
- Cancel and do nothing.

Removing Missing Files

If the photo is missing (shows a question mark on top right of the thumbnail) you will not see a dialog box confirmation before it is removed from the catalog. Consider whether it should be relinked instead (see next section).

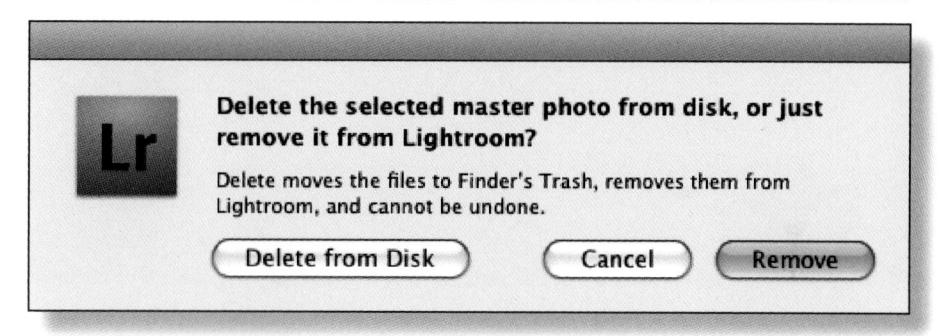

Figure 6-12: Delete dialog box

Delete Rejected Photos removes all photos in the current source that are flagged as reject. If you're working in a collection, the photo(s) is/are removed from the collection only. In any other source, the rejected photos can be removed from the catalog or deleted from disk.

Be careful when deleting folders or photos

If you remove a folder or delete a photo from Lightroom but haven't saved out the Lightroom metadata first, those changes will be lost. You can re-import the files, but the existing data will be purged from the database and you can't undo the removal.

Deleting Photos from the Master Photo Library

Many photographers permanently delete rejected images to conserve disk space and maybe also to conserve a little ego (none of us wants to look at our worst images). If you choose to do this, I recommend giving it some time before you do.

During editing it is faster, cheaper, easier and safer to simply hide unwanted photos from view rather than actually delete them. Deleting images in the heat of the moment introduces the risk of accidentally trashing something important. If you wait to do it at a later date you're less likely to make a mistake.

Plus, we can often learn more from our failures than from our successes. Trashing your worst shots right away can cramp your creative development and impede the learning process. Keep the bad photos for a while and take the time later to really understand what worked and what didn't. Think about how you would do it differently next time.

In my twenty-plus years of professional imaging work, managing huge volumes of digital files, there have only been a handful of times when I accidentally deleted something that I shouldn't have... and for which there was no backup. It always happened in the midst of the production workflow, when I was doing several things at once and not paying enough attention to what I was doing. So for now, I keep everything but the most obvious wasted pixels and I go back later to permanently delete photos that really deserve it.

As your image library grows to tens or hundreds of thousands of images, it may become necessary to delete unwanted images in order to save potentially significant amounts of disk space. Plan to come back to your library periodically in the future to re-confirm your editing decisions and delete unwanted files for good. You'll have better perspective with the benefit of hindsight. For now, just use the Lightroom image sources to hide the images you don't care about.

DEALING WITH MISSING FOLDERS AND PHOTOS

The names and locations of your image files and folders are recorded in the database at the time of Import. If you move or rename files and folders outside of Lightroom, especially when Lightroom is not running, the database may not automatically update and you will need to relink the files. Also, under certain conditions, it is possible that the files haven't moved but Lightroom has somehow lost track of them. Whatever the reason, if Lightroom can't locate a file or folder, you'll receive notification. Usual causes and remedies for broken links:

 The file or folder was moved or renamed outside Lightroom: relink the files from within Lightroom.
- The volume is offline: connect the hard drive(s) to the computer.
- Something is wrong with the database: verify, repair and/or update it.

Don't leave broken links hanging around

If you have missing folders or photos showing in your catalog, you should either relink them or remove them. Database housekeeping is essential: when using any database-enabled program (like Lightroom) it's important to keep the database as clean as possible, with no extraneous image data or records known to be bad. This will improve performance, speed backups and generally make the program more pleasant to use.

Finding Missing Folders

If a folder name contains a question mark (see Figure 6–13) it means the folder and its contents cannot be located by Lightroom. To Develop or Export images you will need to relink the folder.

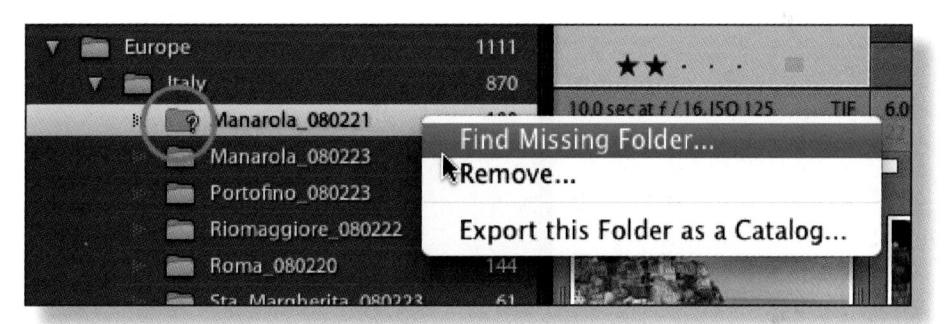

Figure 6–13: Folder with question mark icon; Find Missing Folder on contextual menu

Control+Click or right-click on the folder name

Choose "Find Missing Folder" from the contextual menu. Navigate through the dialog boxes to find the missing folder and click Return or Enter to finish. Lightroom will update the links in its database.

Update Folder Location

Choosing this command from the folder contextual menu allows you to point Lightroom to a different source folder on the hard disk.

Finding Missing Photos

If a thumbnail contains a question mark, Lightroom can't find the image file on disk and you cannot process it in Develop (see Figure 6–14, next page).

Click the guestion mark on the thumbnail Navigate through the file dialog boxes to find the image file on disk. Press Return or Enter to relink the photo.

Finding one missing file finds the others

Once you've relinked a missing folder or file to the correct location on your hard disk, Lightroom will find and relink all the others if possible.

KEYWORD SOURCES

You can create image sources using the Keywords panel (see Figure 6-15). When you place your cursor over a keyword an arrow appears to the right. Click the arrow to view images containing that keyword.

Figure 6-14: Thumbnail with question mark indicating the original file is missing or offline

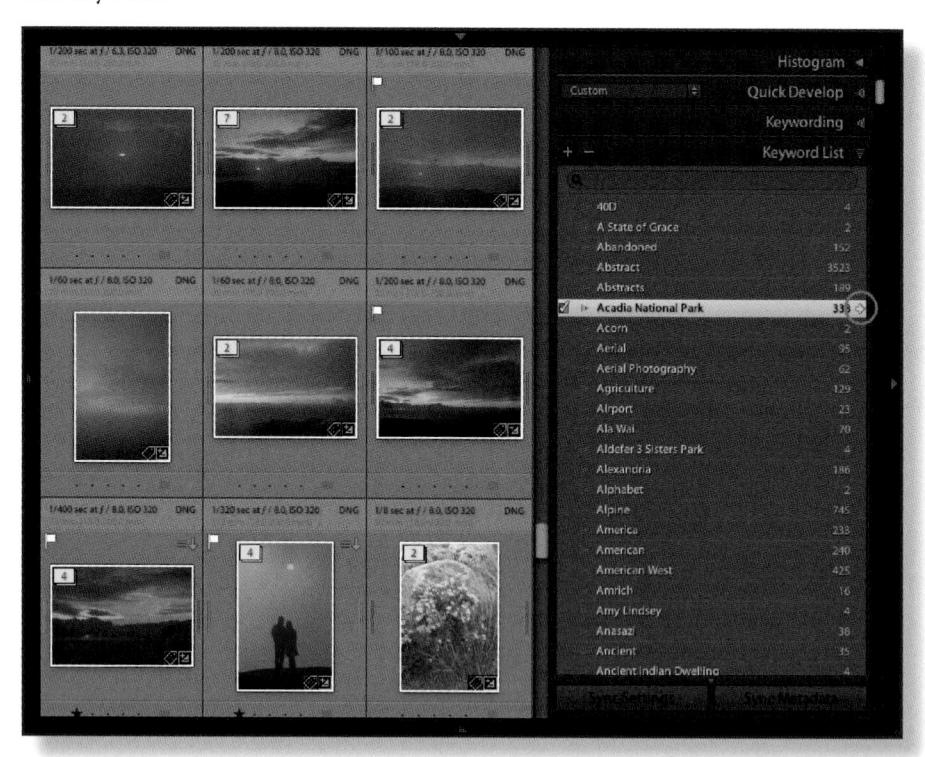

Figure 6–15: Using a keyword to refine a source

For multiple keywords, use the text filter

To set up image sources using multiple keywords use the Filter Bar controls (discussed later in this chapter).

COLLECTION AND FILTER SOURCES

In addition to the ability to manipulate actual files and folders on disk from within Lightroom, there are even more powerful options for finding, organizing and sorting your photographs using *virtual* sources created in the database.

Collections are like "virtual folders"; they exist only in the Lightroom database. A single photograph can be a member of any number of Collections without requiring additional copies of the file on disk. Collections are an example of Lightroom's ability to reference a single image in multiple ways from within the database.

Filters define image sources using criteria you specify and are usually used to refine other, higher-level sources.

Collections and Filters are discussed in detail later in this chapter.

Working with Thumbnails in Grid View

Much of your work in Library will be done using thumbnails. In Library, the Grid view (see Figure 6–16) shows thumbnails in rows and columns. Thumbnails are most useful when applying settings to multiple photos or when contemplating photos and their relationships to one another. Also, your initial rounds of editing can primarily be done using thumbnails; they are good indicators of strong composition, as you're not distracted by minute detail. Lightroom provides lots of control over the presentation and functionality of thumbnails.

G

To go to Library Grid from anywhere in Lightroom.

Panning in the Grid

Position your mouse on the border between thumbnails—the cursor turns into a hand and you can scroll the Grid up and down. See Figure 6–16.

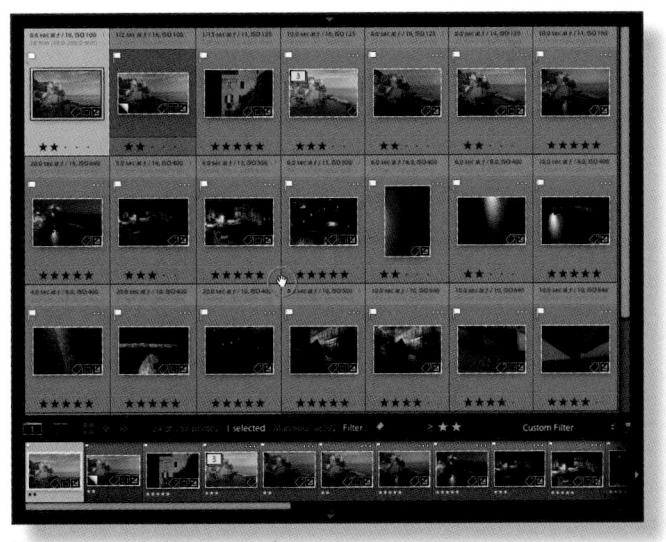

Figure 6-16: The Library Grid; panning

Page Up and Page Down in Grid

To jump between full-screen sets of thumbnails use the Page Up and Page Down keys.

CHANGING THUMBNAIL SIZE

Though you can also change thumbnail size by dragging the slider on the Toolbar, this shortcut is much faster.

> - and =

To change thumbnail size in the Grid, press - (dash) to make thumbnails smaller or = (equals) to make them larger.

Smaller Thumbnails in Filmstrip

Like the other panels, you can resize the Filmstrip by dragging its (top) edge. This changes the size of thumbnails in the Filmstrip.

SORT ORDER

Working in most image sources you can change the order in which the thumbnails are shown. The Library Grid toolbar contains a menu for selecting the sort order. The button to the left (labeled az) reverses sort direction. See Figure 6–17.

User Order

This is a special kind of sort order where you can rearrange the thumbnails however you want by

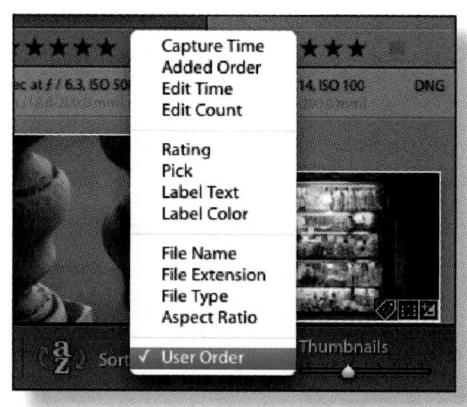

Figure 6–17: Sort direction button, sort order menu and thumbnail size slider

dragging them around. User sort order is only available in Folders and Collections (not Smart Collections) sources.

Click and drag thumbnails to arrange them

Click and drag with your mouse to rearrange the thumbnails (see Figure 6–18). This will automatically set the Sort Order menu to User Order.

Drag using the center of the thumbnail image

There are two parts of the thumbnail; the image and the gray area surrounding it. They behave differently and provide different options. When selecting or dragging photos, always click on and drag from the image part of the thumbnail.

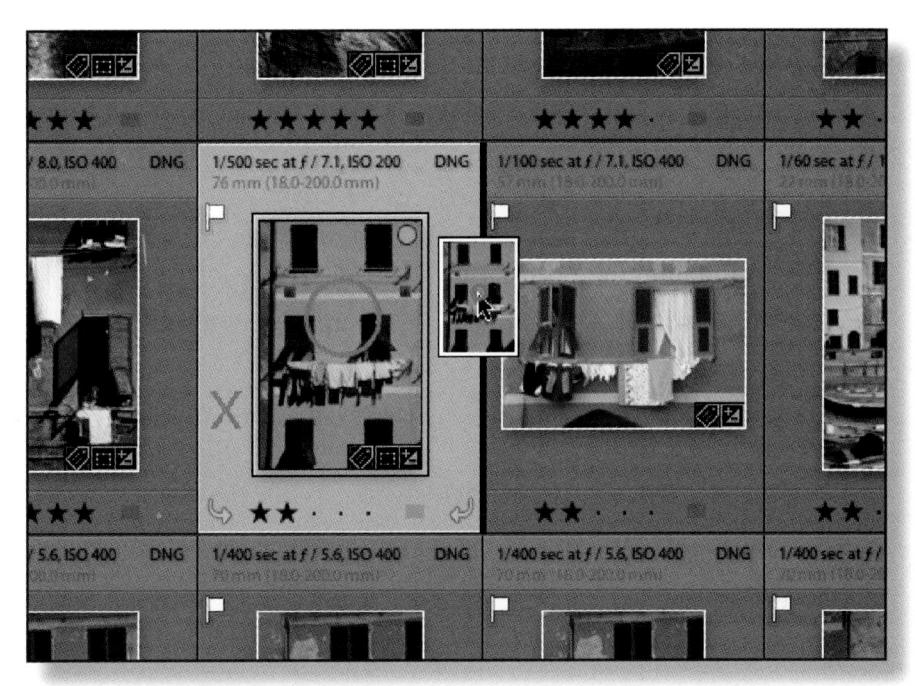

Figure 6–18: Drag from the center of the thumbnail, not the gray area around it

Strange Sort Orders

Image files that get added to the catalog during editing or synchronizing (often with varying file types) may appear in the Grid in an order that can be confusing. If you look for a photo thumbnail in a certain place in the order and it's not there, try looking at the last images in the source. Newly added photos often end up there. Once you find the new photos at the end, you can modify the sort order or tag them differently to change where they appear in the sort order.

THUMBNAIL BADGES

In Library Grid, the thumbnails by default will show one or more small badges when any metadata (keywords, cropping and/or Develop adjustments) has been applied to that image. See Figure 6–19.

Click a Badge To edit the image using that tool.

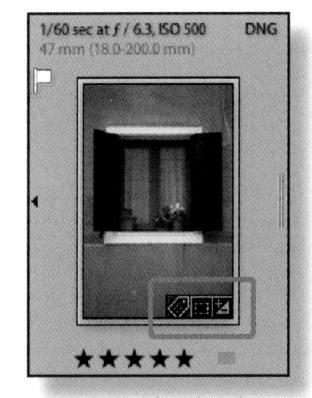

Figure 6–19: Thumbnail badges: keywords, crop and adjustments

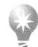

Badges in the Filmstrip

The icons in the Filmstrip can show badges, too; configure this in Preferences Interface. Note that some Filmstrip badges won't show if the thumbnails are very small.

GRID VIEW STYLE

There are two styles of Grid thumbnails: *Compact* and *Expanded* (see Figures 6–20 and 6–21). Both can be customized using View Options (see Figure 6–22).

Figure 6–20: Compact thumbnail (above)

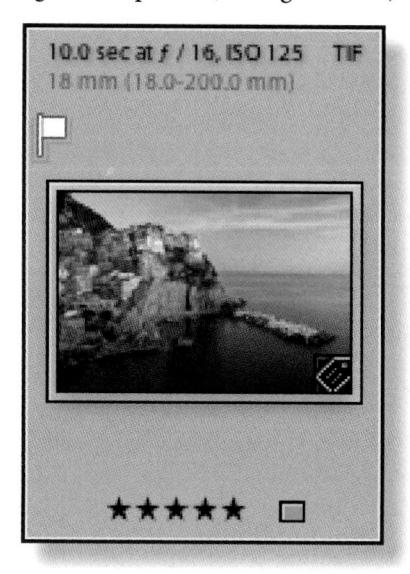

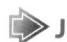

To cycle through the Grid thumbnail view styles.

> X + Shift+H or Ctrl+ Shift+H

To switch between compact and expanded Grid thumbnails.

GRID VIEW OPTIONS

This window configures the display of the thumbnails in Grid view and the Info Overlays in Loupe view. The information you choose to show depends a lot on personal preferences and circumstances. My favorite settings and their effects are shown in Figures 6–22 and 6–23.

> X+J or Ctrl+J

To open the View Options window. Click the buttons at the top to switch between Grid and Loupe views. When you're done changing the settings, close the window.

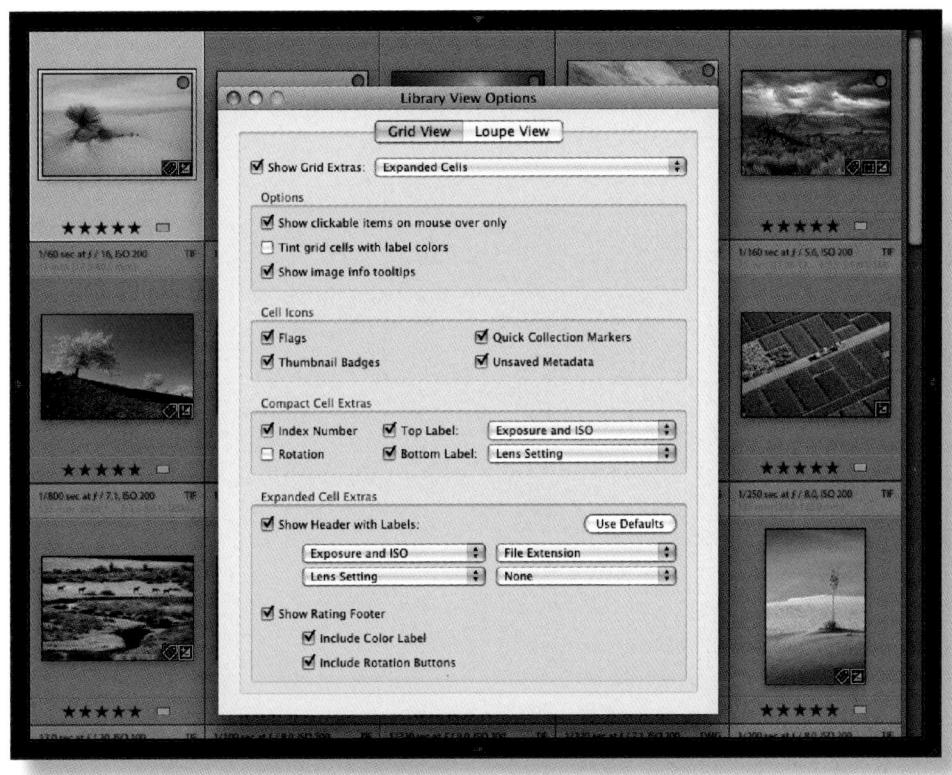

Figure 6–22: Library View Options (Grid)

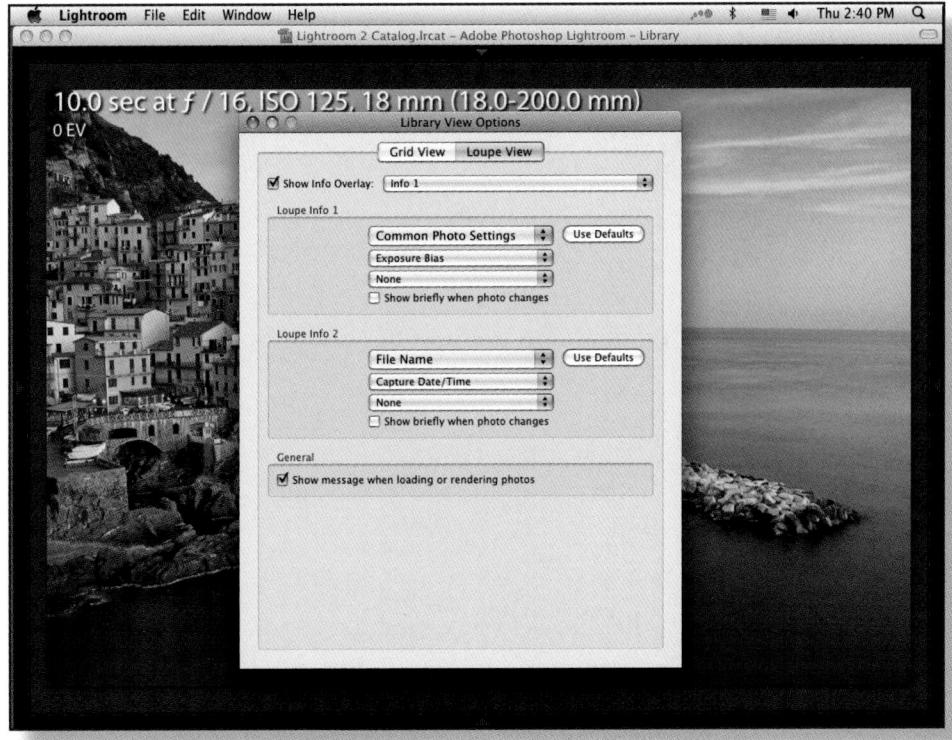

Figure 6–23: Library View Options (Loupe)

Selecting and Deselecting Images

Most operations in Lightroom require one or more images to be *selected*. The order in which they are selected is important. While the most obvious way to select images is to click them, there are faster, easier ways.

By default, when you switch between image sources, the first sorted image in the new source becomes active. It's important to understand that most of the time, there is at least one image selected, even if only by default.

The Grid and Filmstrip show the same selections. Selected photos are highlighted in light gray to stand out against the other unselected photos. See Figure 6–24.

X

Select images using Arrow Keys

In the Library Grid you can quickly select images using the arrow keys on your keyboard—left, right, up, down. In all modules, use the left and right arrow keys to move through images in the Filmstrip. Hold Shift while pressing the arrow keys to select multiple contiguous images.

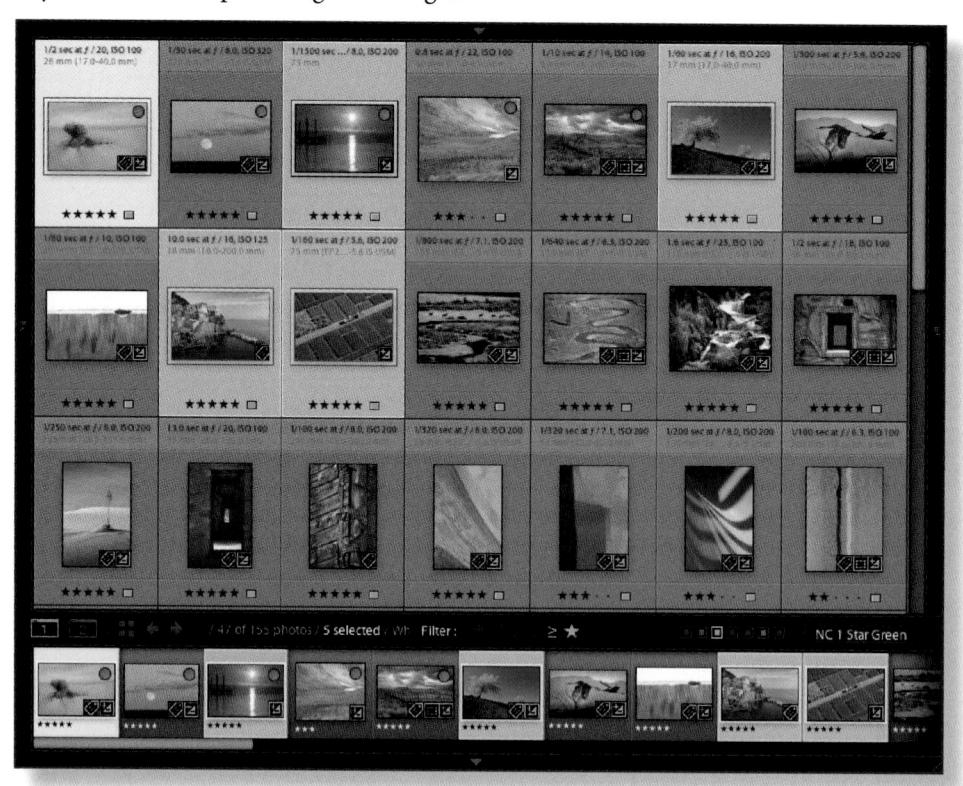

Figure 6–24: Multiple images selected in the Grid and Filmstrip

THE ACTIVE PHOTO (MOST SELECTED)

When multiple photos are selected, the first one selected is most selected and referred to as the *active* photo. The active photo is highlighted brighter than the others and has unique properties within the selection. Most importantly, it behaves as though no other images were selected. The active photo is:

- Used for data in the histogram panel;
- Processed in Develop; and
- The photo whose settings can be synced or copied and pasted to other images.

> #+Left/Right Arrow or Ctrl+Left/Right Arrow

To change the active photo with multiple photos selected.

SELECT ALL

There are many situations where you will want to select all the images in the current source, such as adding to a collection, modifying keywords and Saving Metadata to File.

> X+A or Ctrl+A

All images in the current source become selected (see Figure 6–25); the most recently selected image (if applicable) becomes the active photo. If no image was previously selected, the first image in the source order becomes the active photo.

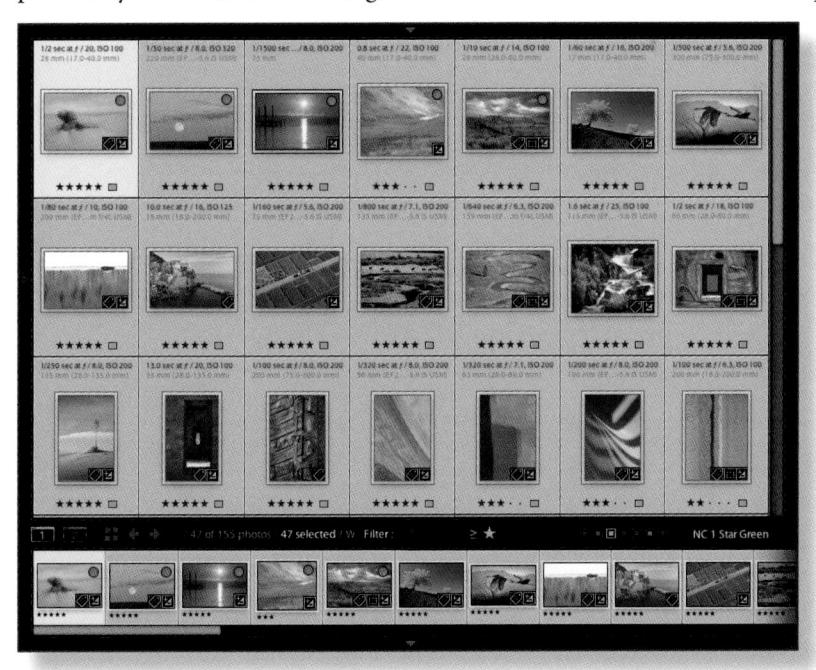

Figure 6–25: Select All. The Active photo (first in the order) has a brighter border than the others.

SELECT NONE

This is one of the most important commands used throughout the editing workflow. It's a very good habit to deselect any previously selected images before moving on to work on others; otherwise, you might accidentally apply an adjustment or other changes to a photo without intending to.

₩+D or Ctrl+D

Deselects all photos in the current source. See Figure 6–26.

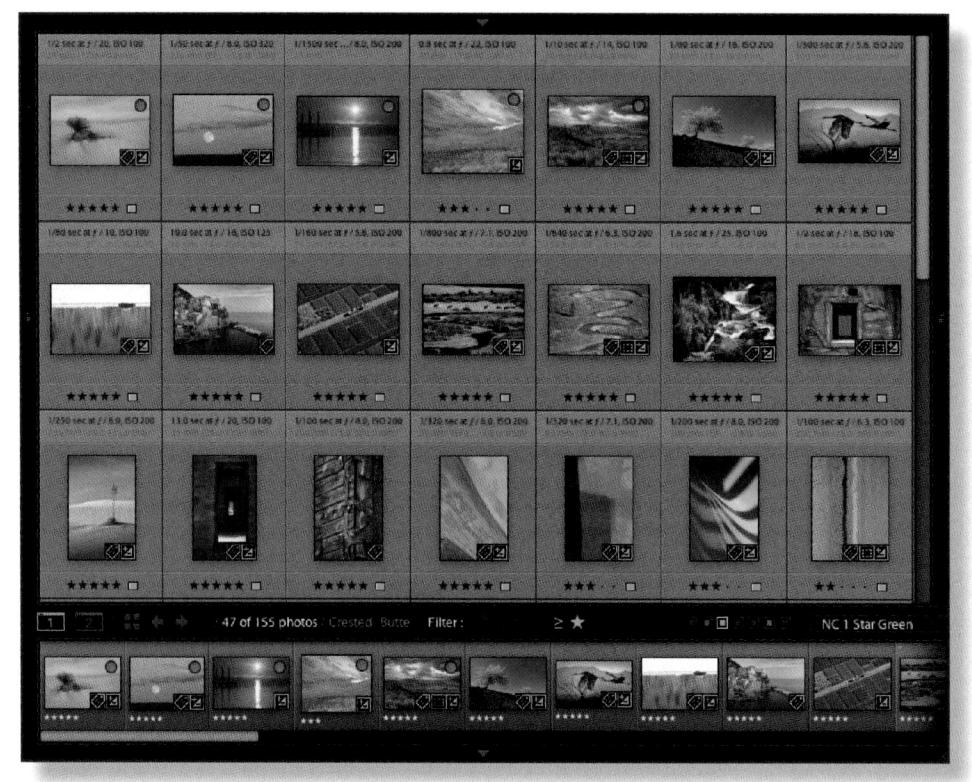

Figure 6-26: No photos selected

ADD, SUBTRACT, INTERSECT

These specialized selection commands allow you to make complex selections quickly based on several criteria. Selections are *Boolean*; think of them in terms of yes/no, on/off or active/inactive. You can start with one selection and then modify it to include only the images you want.

There are a host of selection commands and shortcuts under the Edit menu in Library.

In all cases, using any selection command always inverts the selection status of the image: unselected images will become selected; selected images will become deselected.

Know what's selected

Keep track of your selections at all times. When scrolling in the Grid or Filmstrip it's possible to have images selected but not visible on the screen. This can cause trouble; you could apply changes to photos that you didn't mean to. Pay careful attention to which, if any, images are selected at all times and be deliberate in managing your selections.

> #+Click or Ctrl+Click

To add to or subtract from a selection hold the ♯ or Ctrl key and click additional thumbnails in either the Grid or Filmstrip. See Figure 6–27.

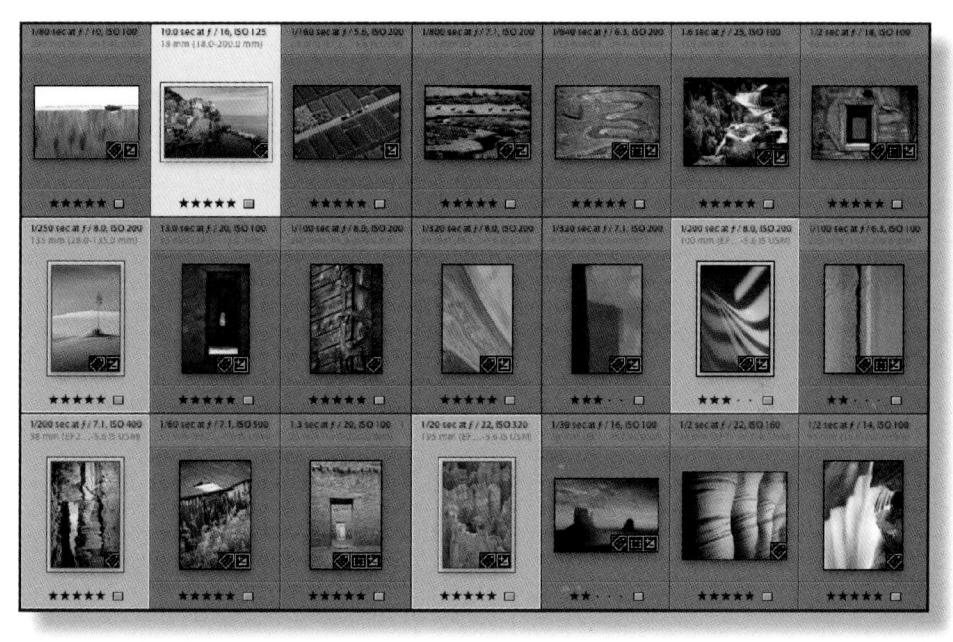

Figure 6-27: Non-contiguous selections

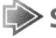

Shift

To add a contiguous range of photos to a selection. With one image selected, hold the Shift key on your keyboard and click another thumbnail. All the images between the two will become selected. See Figure 6–28.

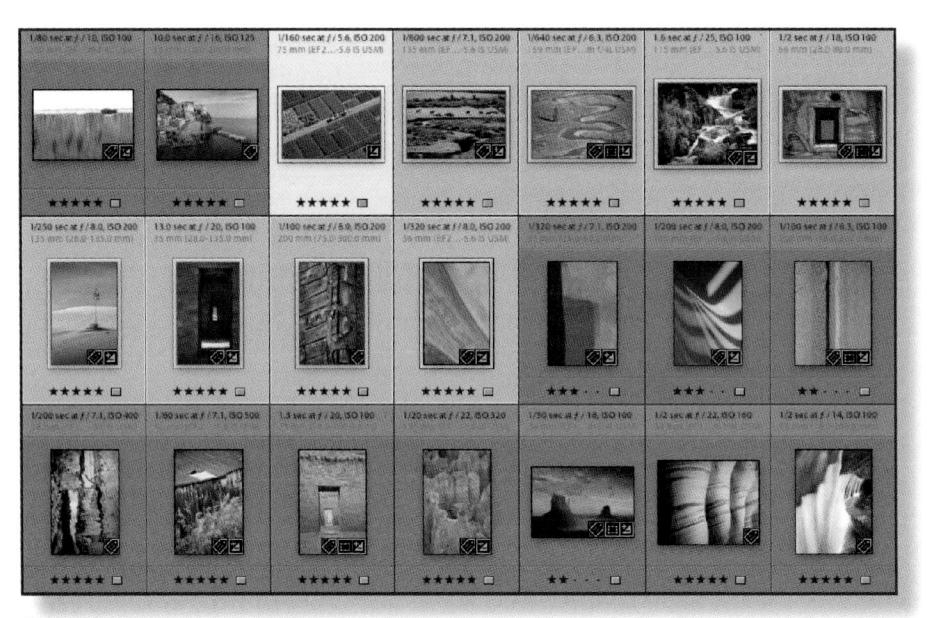

Figure 6–28: Contiguous selections

Grouping Thumbnails into Stacks

Think of these like stacks of good, old-fashioned slides. Stacking images saves space in the Grid and is useful in cases where you've shot a sequence of similar images and want to group them together. A stack can be collapsed to save space or expanded to show all the photos in the stack (see Figures 6–29 and 6–30). Stacking images saves lots of time during editing.

I often capture a sequence of photos of the same composition with only the light in the scene changing over time. By stacking these together I can clean up my thumbnail Grid view during editing. When I'm ready to choose the *champion* shot (the winner between several

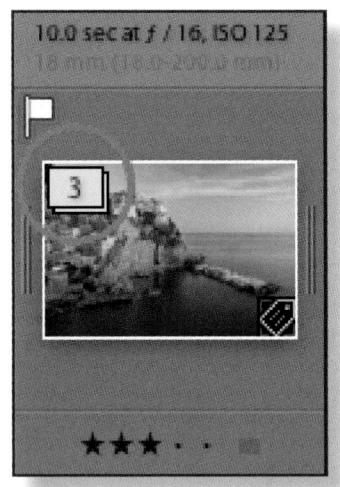

Figure 6–29: Stack collapsed, photo count

competing shots) I expand the stack to finish editing those photos. When I'm done choosing my final selects, I move the champion to the top of the stack and collapse it again.

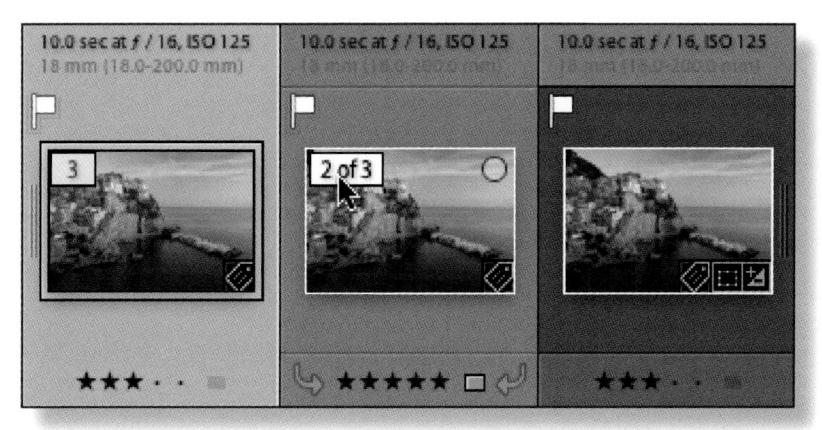

Figure 6-30: Stack expanded

₩+G or Ctrl+G

Select the images to stack and press the keyboard shortcut. The first image selected (the active, or "most selected" photo) will go at the top of the stack by default, but you can change the stacking order at any time afterward. The top image in a stack shows the photo count for the stack in the upper left corner of the thumbnail. Click this to expand and collapse the stack.

Limitations to stacking

Stacks are not available in collections, and a single photo can only be a member of one stack. If you try to make a stack and it doesn't work, it's likely because the current source doesn't allow stacking or that one or more of the images already belongs to another stack.

Apply attributes to stacked photos

When filters are applied, unflagged and unrated images within a stack won't show, which can cause confusion. To avoid this, make sure all the photos in a stack are marked with the same attributes (see Figures 6-59 through 6-62).

Select all the images in a Stack

With the stack expanded, click the photo count badge to select all photos in the stack. See Figure 6–31.

Figure 6–31: Clicking photo count badge selects all photos in the stack

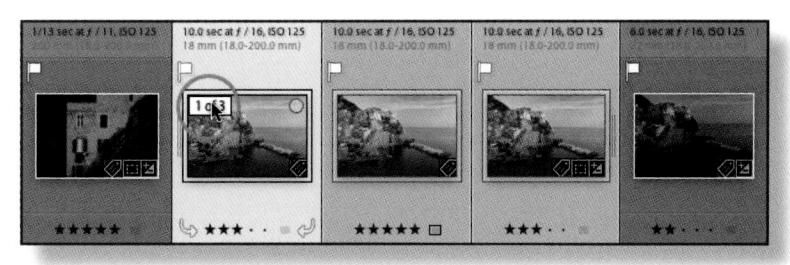

Right-click or Control-click on stack photo count badge

Opens the stack contextual menu.

Changing the Order of Images within the Stack

To change the stacking order of images you must first expand the stack. Click the photo count badge or the two thin lines at the right edge of the top image in the stack. Use the arrow keys to select the image you want to reposition and use the following shortcuts to move the image within the stack.

Shift+S

Move to top of stack.

> Shift+[

Move up in stack.

Shift+1

Move down in stack.

Auto stack by capture time

First, choose a folder, collection or other image source, then control+Click or right-click on one of the thumbnails. From the contextual menu, choose Stacking→Auto Stack by Capture Time. Set your desired time interval and press Return or Enter. Lightroom will create stacks in the current source for all photos matching the criteria.

Rotating and Flipping Images

You can rotate and flip images when viewing either Grid thumbnails or Loupe previews. In Grid, the thumbnails show arrows for rotation (this option can be configured to show the rotation arrows all the time, or just when hovering your cursor over a thumbnail). Click on the arrows to rotate the image by 90-degree increments (see Figure 6–32).

To rotate an image by an arbitrary amount, use the Crop/Straighten Tool (see Chapter 7).

≫ #+[or Ctrl+[

To rotate clockwise in 90-degree increments.

Figure 6-32: Rotate icons

> #+] or Ctrl+]

To rotate counter-clockwise in 90-degree increments.

To flip images, choose Photo→Flip Horizontal or Photo→Flip Vertical Individual photos can be mirrored around their horizontal and vertical axes. (This is different than View→Mirror Image Mode, which affects all the images in the current catalog.)

Working with Large Previews in Loupe View

Loupe view displays a single, large photo (see Figure 6–33). You can zoom in and out of the Loupe preview using preset *zoom levels* that are based on ratios of image pixels to screen pixels. When the image is magnified you can *pan* the image to examine different parts of it more closely.

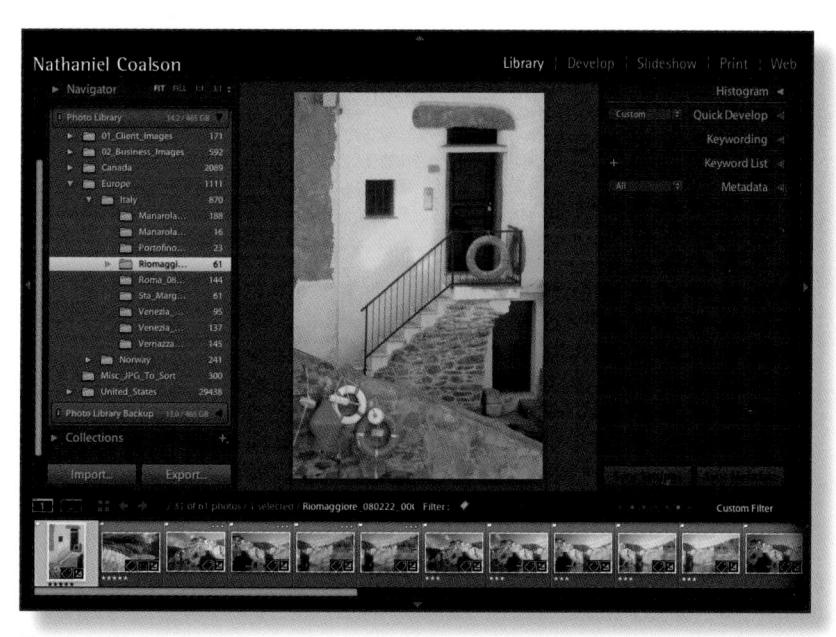

Figure 6-33: Loupe view

ZOOMING IN AND OUT OF IMAGES IN LOUPE VIEW

Lightroom gives you several ways to zoom in and out of images. Each method has its own utility; in some situations one way is easier or faster than the others, so it's worthwhile to learn all the methods for zooming.

Click-release versus click-hold

You've probably already figured out that you can click the Loupe preview to zoom in and out with each click. Try this, too: Click *and hold* the mouse button to zoom in, and *without letting go*, drag the hand tool to move around the preview. Then release the mouse button to zoom back out to the previous view.

Zooms in using the four levels shown on the Navigator panel header. See Figure 6–34.

Figure 6–34: Navigator Zoom Ratios

> %+- or Ctrl+-

Zooms out using the four levels shown on the Navigator panel header.

Toggles between Fit or Fill and the most recently used zoom level.

Return or Enter

Cycles between Grid, Loupe and 1:1 zoom.

x 🗼

Zooms to last used zoom level and position.

Panning the image in Loupe View

When you're in any zoom ratio except Fit, you can pan around the image by clicking and dragging with the hand cursor. See Figure 6–35.

Zoom clicked point to center

Preference setting that re-centers zoomed images around the clicked zoom point. Go to Preferences Tweaks.

To scroll through a Loupe preview

Figure 6-35: Hand cursor

in columns determined by the zoom ratio, the width of the Loupe preview and side panels. When you get to the bottom of the image, pressing Page Down will again jump to the top of the next "column".

SHOWING PHOTO INFO IN LOUPE

Optional text overlays provide statistics about the image file, capture settings and other useful information.

To cycle through the two available info overlays and no overlay. See Figure 6–36.

Figure 6–36: Loupe view with Info Overlay 1

第+J or Ctrl+J

To change View Options.

Comparing Two Images

Compare view lets you evaluate two images side by side. See Figure 6–37, next page.

Select two photos and press C. The active photo becomes the *select* and the second image becomes the candidate.

Figure 6-37: Compare view

Tab and Shift+Tab

To hide the side panels or all panels. In Compare and Survey views it's helpful to hide the panels to allow maximum room for the images.

Link Focus

With Link Focus, you can zoom into the exact same place on both images to check for critical focus, examine small details, etc. In Compare view, make sure the Toolbar is visible and click the lock icon to enable Link Focus (see Figure 6–38). You can zoom in and out and pan both images at the same time.

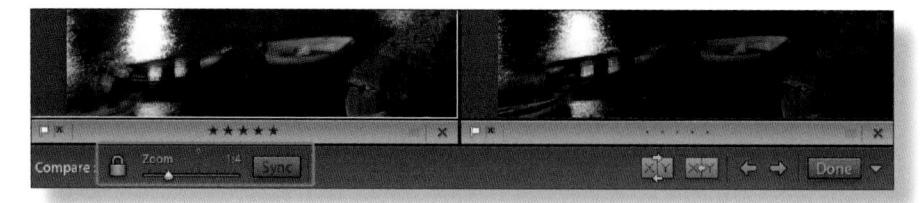

Figure 6–38: Link Focus

L

Cycles through the three Lights Out modes. In Compare and Survey views, use Lights Out to dim or black out the entire screen except for the images (see Figure 6–39).

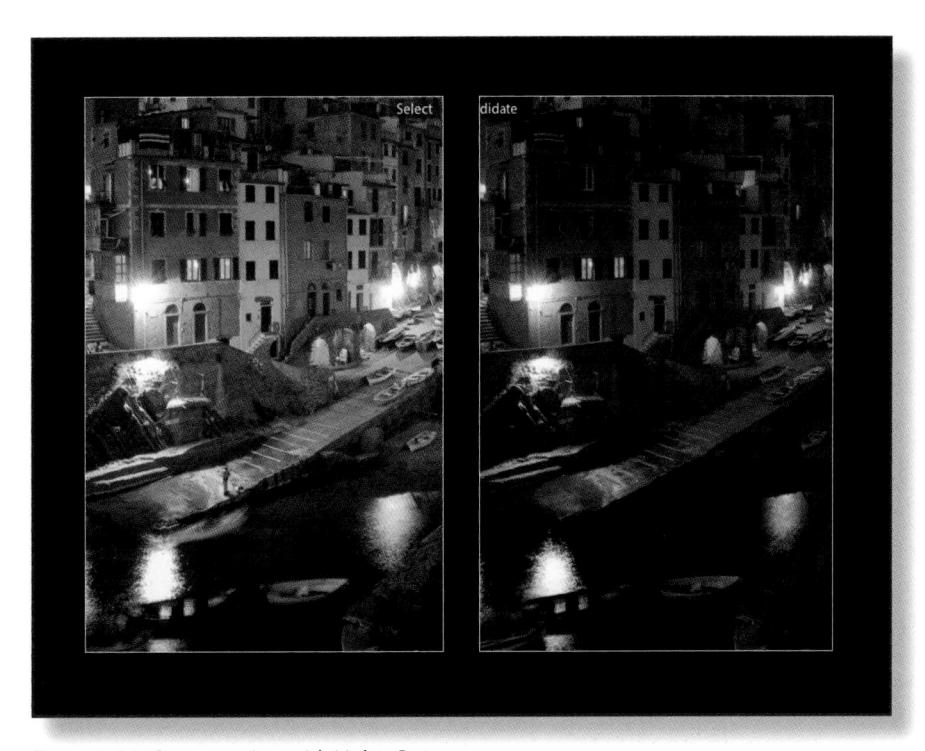

Figure 6–39: Compare view with Lights Out

Changing photos in the Select and Candidate positions

The toolbar in Loupe Compare contains buttons for switching or swapping photos in both select and candidate positions (see Figure 6–40). Hover over each button to see its tool tip.

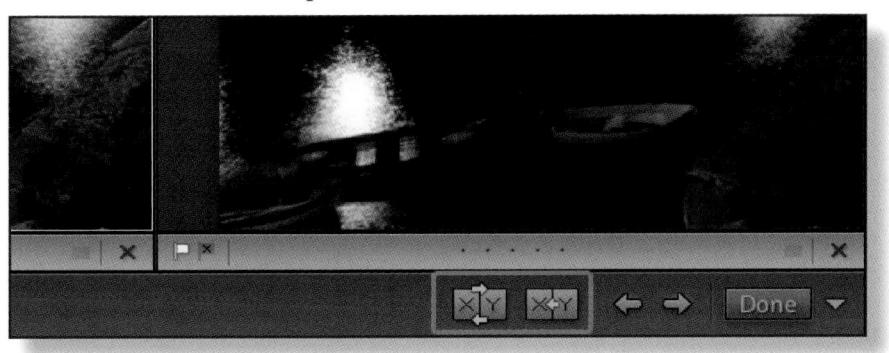

Figure 6–40: Toolbar buttons to change select and candidate photos in Compare view

Left and Right Arrow Keys

With two images loaded in Compare view, use the left and right arrow keys to load different images from the Filmstrip into the Candidate position.

6

Comparing More than Two Images

Survey view is for comparing more than two images. Selected images are scaled automatically to fit in the Survey window (see Figure 6–41). Survey is usually most useful up to 8-10 images; for more than that you're usually better off using the Grid.

Select multiple images from the Grid or Filmstrip and press N. Once in Survey view, you can add, remove or rearrange the previews. Drag a preview to put it in a different position. To remove a photo from Survey click the X in the bottom right corner of each image (put your cursor over the images to see the controls) or deselect from the Filmstrip.

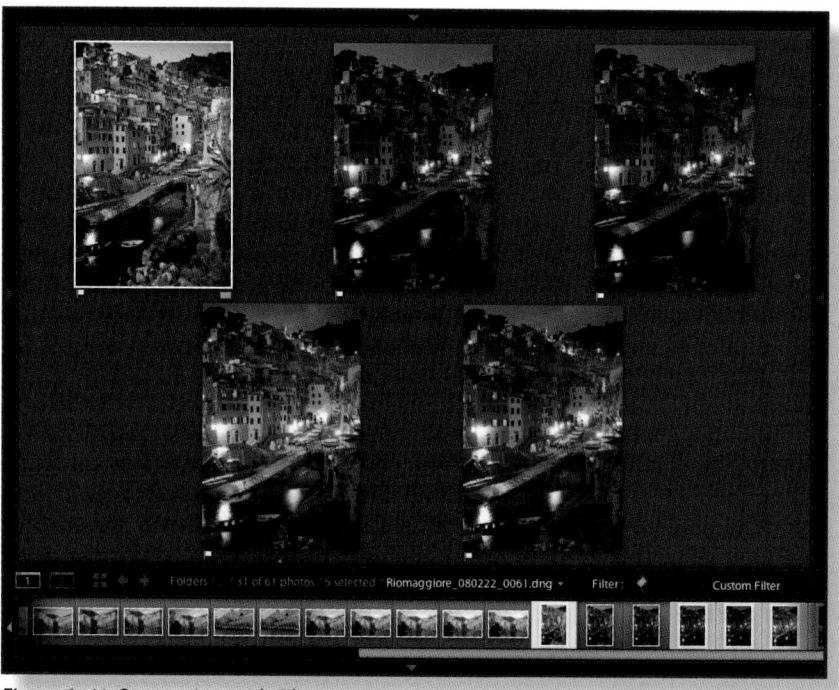

Figure 6-41: Survey view with Filmstrip

Note: In Survey, the active (most selected) photo is indicated by a white outline. Clicking a photo makes it the active photo.

Begin the following sequence by selecting multiple images in the Grid or Filmstrip, then

To hide all panels (press twice if necessary).

To show the photos in Survey view.

...then L twice

To enter Lights Out.

Toolbar or Not Toolbar?

I usually hide the toolbar in Compare and Survey views, but there are times when the toolbar is required to carry out certain tasks. In all modules, at all times, don't forget to hide and show the toolbar often, either to make more room for photos or to access program features not found anywhere else in the interface.

The Secondary Display Window

Lightroom 2 and higher offers support for a secondary display that can be configured

separately from the main window.

Open a second window

Click the secondary display button on the top left of the Filmstrip. See Figure 6–42.

You don't need to use two monitors to benefit from Lightroom's support for a second window. You can resize

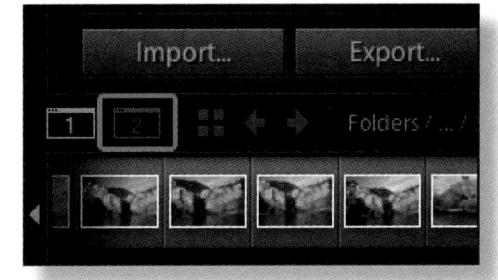

Figure 6-42: Secondary display button

and reposition the second window as you see fit (or, of course, put it on a second monitor). At the top left of the second window are the same view modes as the main window:

Grid, Loupe, Compare and Survey (see Figure 6–43).

> Shift+E

Enable Loupe view in the second window.

Figure 6-43: Second window

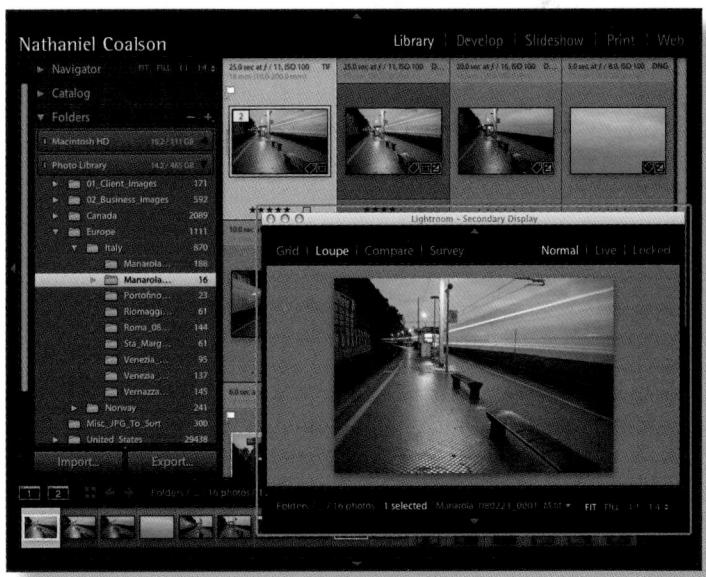

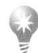

Live Loupe

At the top left of the second window, choose Loupe. At the top right, choose Live. Move your cursor over the thumbnails in the main window and the second window will instantly show each photo under the cursor.

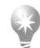

Locked

At the top left of the second window, choose Loupe. At the top right, choose Locked. Locked mode retains the same image until you explicitly choose to update it. This can be helpful in client reviews, as you can push images to the second display only when you intend to. Control+Click or right-click on a thumbnail for the contextual menu and choose Lock to Second Window.

Metadata

Metadata is one of the great strengths of digital photography. It's textual information embedded in the file, but invisible in the photo, that describes various aspects of both the image file and the imagery itself. Metadata is essential when sharing or distributing your photos with anyone else; it helps people find the pictures they want to see and identifies you as the creator of the photo.

Don't skimp on metadata. Start applying metadata to your photos during Import and continually add and refine photo metadata throughout editing and processing—especially keywords on your final selects. (Keywords are used by all kinds of search engines, including Web services like Google Images, and make it easier to find your own images by subject.)

Though you'll also reap immediate rewards, keep in mind that much of the work you do today is intended to save time and effort later. The effort is worthwhile. Make it a habit to constantly improve the metadata in your photos.

THE METADATA PANEL

Lightroom's Metadata panel (on the right panel group in Library) contains information about the digital image file: name, location on disk, capture settings, etc. as well as custom metadata added by you.

You can change the metadata shown on the panel by choosing from the popup menu (see Figure 6–44).

> \#+4 or Ctrl+4

To open the metadata panel.

show All metadata fields From the options popup menu,

popup menu, select "All" to see all metadata fields available in the panel.

Metadata panel actions

The buttons to the right of many of the items in the Metadata panel provide shortcuts to a range of editing and updating features. To see the function of a button, place your cursor over it without clicking and wait a few seconds for a tool tip to appear. Pay

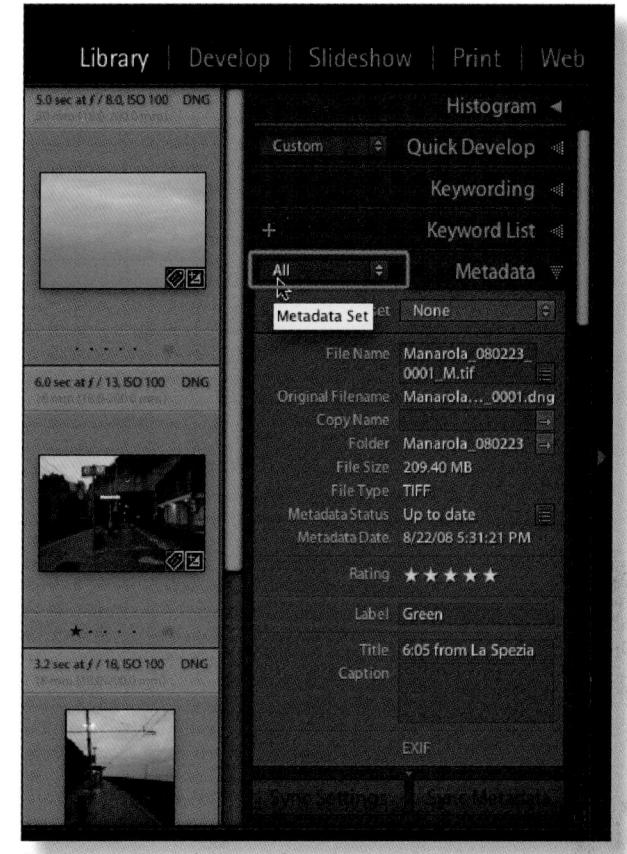

Figure 6-44: Metadata panel, options menu

special attention to right-facing arrows: these provide time saving shortcuts to useful functions.

TITLE AND CAPTION

You enter data in these two fields yourself. I recommend at least giving final selects unique titles; along with custom captions, they are also very helpful in preparing to present your work using the Slideshow, Print and Web modules. Title and Caption are also extremely beneficial for search engine indexing and ranking of images on the Web.

EXIF

The camera writes EXIF metadata into the image file when you take the picture. EXIF includes all the camera settings at the time of capture. Most EXIF

6

metadata cannot be edited in Lightroom but it can be very useful when making processing decisions. Some examples of EXIF metadata shown in Lightroom (see Figure 6–45a):

- Camera model
- · Capture time
- Resolution
- Aperture
- Shutter speed
- Lens used
- · Flash on or off
- Exposure compensation setting

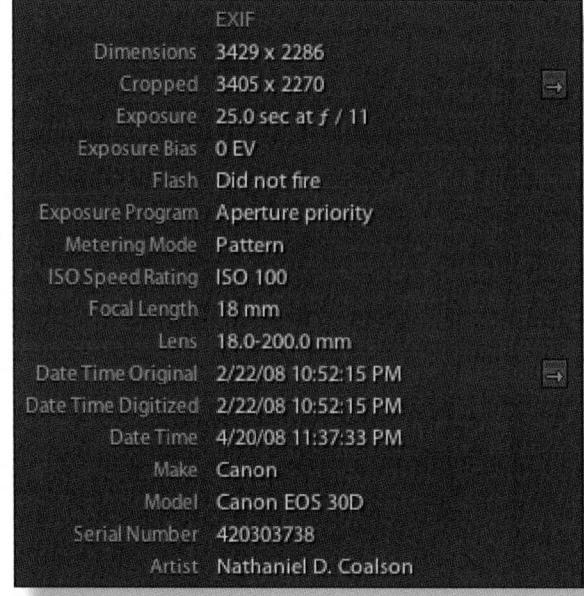

Figure 6-45a: EXIF metadata

And others (depending on your camera)

Choose Metadata→Edit Capture Time

If the clock on your camera was incorrect at the time of capture, the wrong time zone was selected, or your image file does not have a date embedded, you can change the image capture time here.

IPTC

IPTC metadata is comprised of a wide range of standardized categories for information about an image. The most important fields—author, creator, copyright notice, contact information and keywords—are but a few of the many types of IPTC metadata available. Lightroom shows IPTC metadata at the bottom of the Metadata panel and provides controls to edit these IPTC metadata categories:

- Content
- Copyright

- Creator (embedded by camera, if available)
- Image
- Status

Add copyright metadata to every image

Even if you apply no other custom metadata this is the one section you really must complete to protect your rights as a photographer:

- Copyright Status: choose Copyrighted, Public Domain or Unknown
- Copyright: type your copyright text here, i.e. © 2008 Nathaniel D. Coalson. (On Mac, press Option+G for the copyright symbol. On Windows, type Alt+0169 on the numeric keypad.)
- Rights Usage Terms: enter "All Rights Reserved" or "no use without written permission", etc.

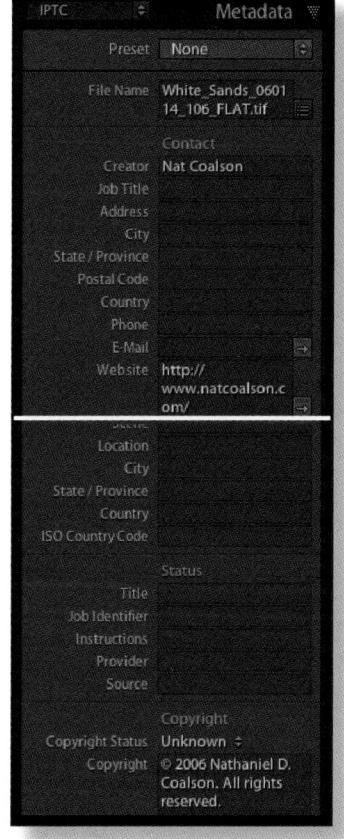

Figure 6-45b: IPTC metadata

GPS AND ALTITUDE

If there is GPS and/or altitude metadata embedded in the file, Lightroom will display it here (see Figure 6-46). If no GPS and/or altitude metadata is found, the fields do not show in the panel.

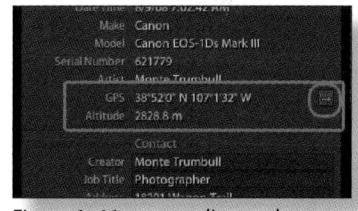

Figure 6-46: GPS coordinates; button links to Google Map services

Jump to Google Maps

Click the button next to the coordinates. This opens a Web browser and loads the GPS location on the Google Maps Web site.

AUDIO FILES

If you recorded voice notes with your image files, Lightroom will show and play them here (see Figure 6-47). Some cameras support recording; otherwise, you can pair a separately recorded audio file. The base filename of the audio clip

6

must match that of the image file for Lightroom to find it. If no audio sidecar file exists for a photo, the field doesn't show in the Metadata panel. Click the button next to the audio clip filename to play the file.

METADATA PRESETS

As with all Presets in Lightroom, these save huge amounts of time. You can create and modify your metadata presets from the menu on the Metadata panel (see Figure 6–48).

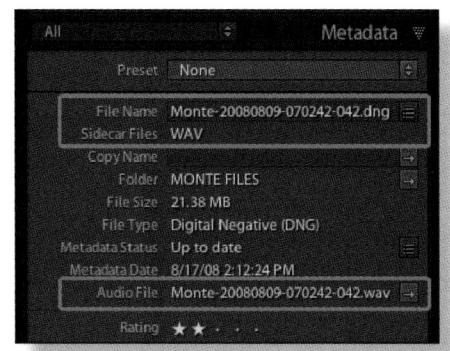

Figure 6-47: Audio file associated with photo

Set up standardized metadata presets

Establish and use a consistent system for your metadata presets; use the same diligence as with your file and folder systems. Give your presets clear, consistent names.

I use my initials at the beginning of all my custom presets and templates, so they are grouped together in alphabetical lists and I can find them easily. I use a different preset for each year of copyright; all the other information in the template remains consistent throughout my metadata presets.

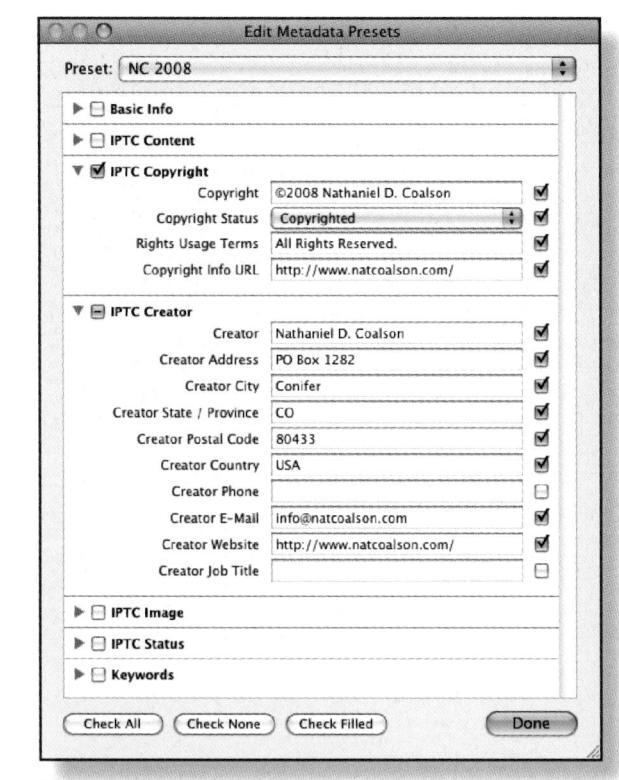

Figure 6–48: Metadata Preset

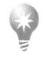

To see the presets saved on your computer, choose Preferences→Presets ...then click the button "Show Lightroom Presets Folder".

Sync Metadata

Used to synchronize metadata (but not Develop settings) between multiple photos. The settings from the active photo will be applied to the rest of the selected photos. In the Synchronize Metadata window, tick the boxes for the metadata to be synced. Anything that remains unchecked will not be modified in the target photos. See Figure 6–49.

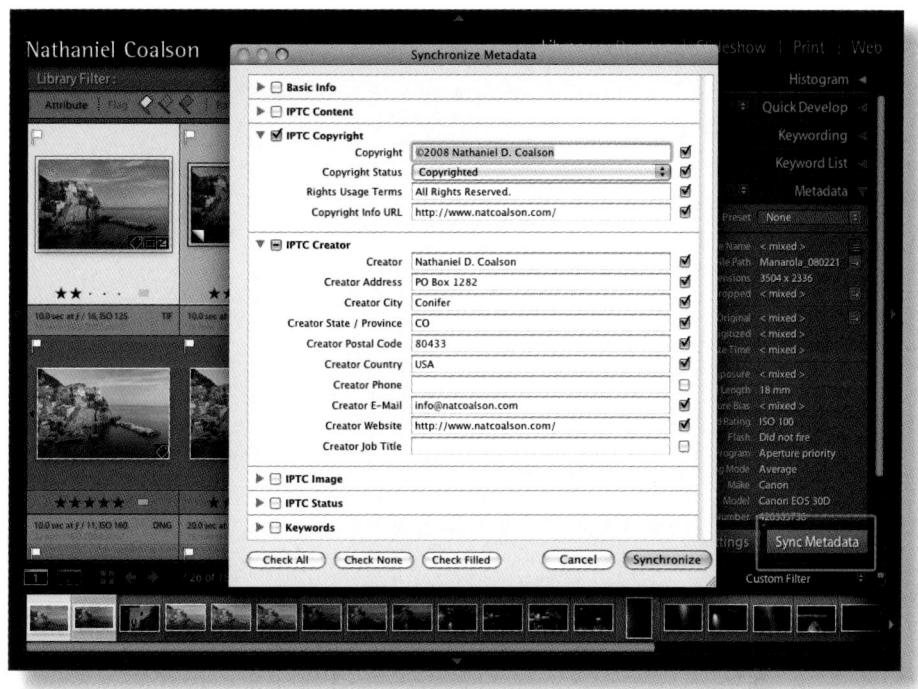

Figure 6-49: Sync Metadata button and dialog box

METADATA STATUS

This indicates the state of the photo's actual metadata as compared to Lightroom's stored version of it. If there is a conflict, Lightroom displays a status indicator in the Metadata panel and optionally on the thumbnail also (see Figure 6–50, next page).

It's possible that changes have been made outside Lightroom that the application is not yet aware of; sometimes Lightroom doesn't know the current status of the file's metadata and you won't see an indicator.

Up to Date: as far as Lightroom knows, all is OK: what's in the file matches the Lightroom metadata.

Has Been Changed: metadata in Lightroom is out-of-sync with the metadata contained in the file. This can mean either that Lightroom data is newer or the file's

6

is newer; take the time to investigate before changing anything. Reading Metadata from File or Saving the Metadata to File changes this indicator to *Up to Date*.

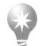

Show unsaved metadata

Press ## J or Ctrl+J to show View Options (see Figure 6–51) and click the checkbox to enable

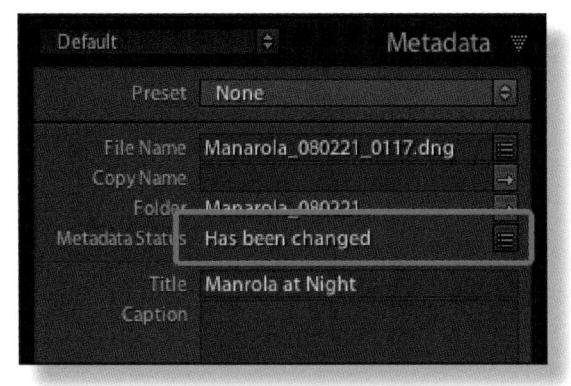

Figure 6-50: File Metadata Has Been Changed

the badge that shows unsaved metadata. This will display a special icon on the thumbnail when the file metadata is different than the metadata in Lightroom. Clicking the icon saves metadata to the file.

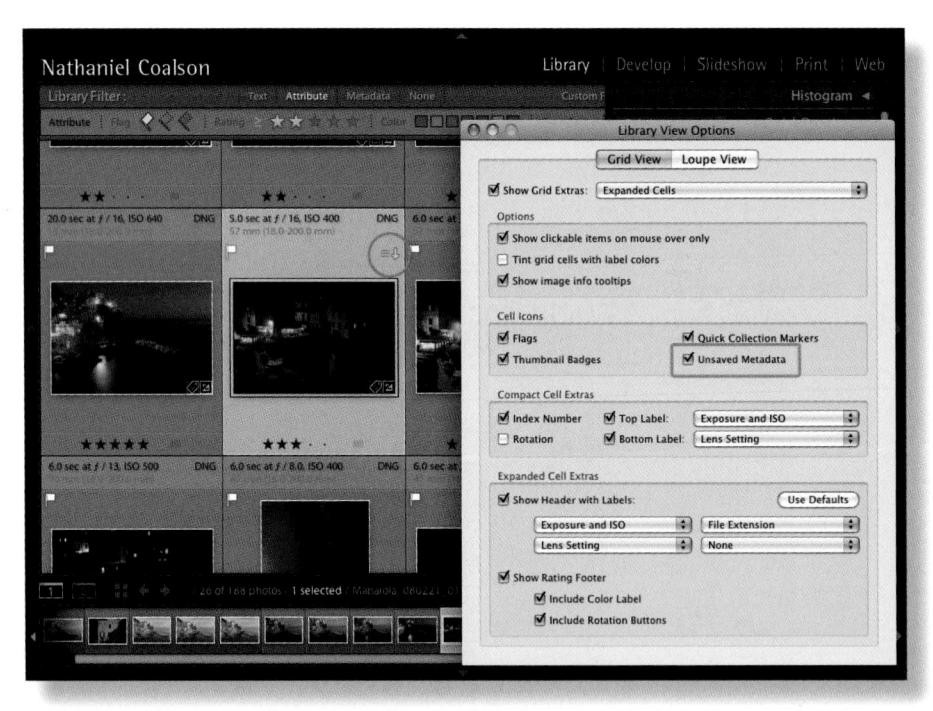

Figure 6–51: Show unsaved metadata; thumbnail badge

What's the correct version?

Whenever you're changing file metadata it's important to understand exactly what version is correct before proceeding. Other software can change your image file metadata even if you don't actually open the file using that software. Bridge is one such application; building previews for image files in Bridge often will alter file metadata, resulting in a conflict with Lightroom. If you know the metadata in Lightroom is the most current, save it out to the file. Otherwise, spend some time verifying the files in question to figure out when and how the metadata was changed before reading metadata into Lightroom. Of course, if you only use Lightroom for processing your photos, you won't need to worry about this.

SAVING METADATA TO FILES

To save all the current Lightroom metadata out to the image files on disk, use the Save Metadata to File command. This writes all the Lightroom metadata, including Develop settings and keywords, to the files. If your files are DNG, TIF, PSD or JPG, the metadata is written directly into the image files. Native camera raw images use XMP sidecar files to store the metadata. See Figure 6-52a.

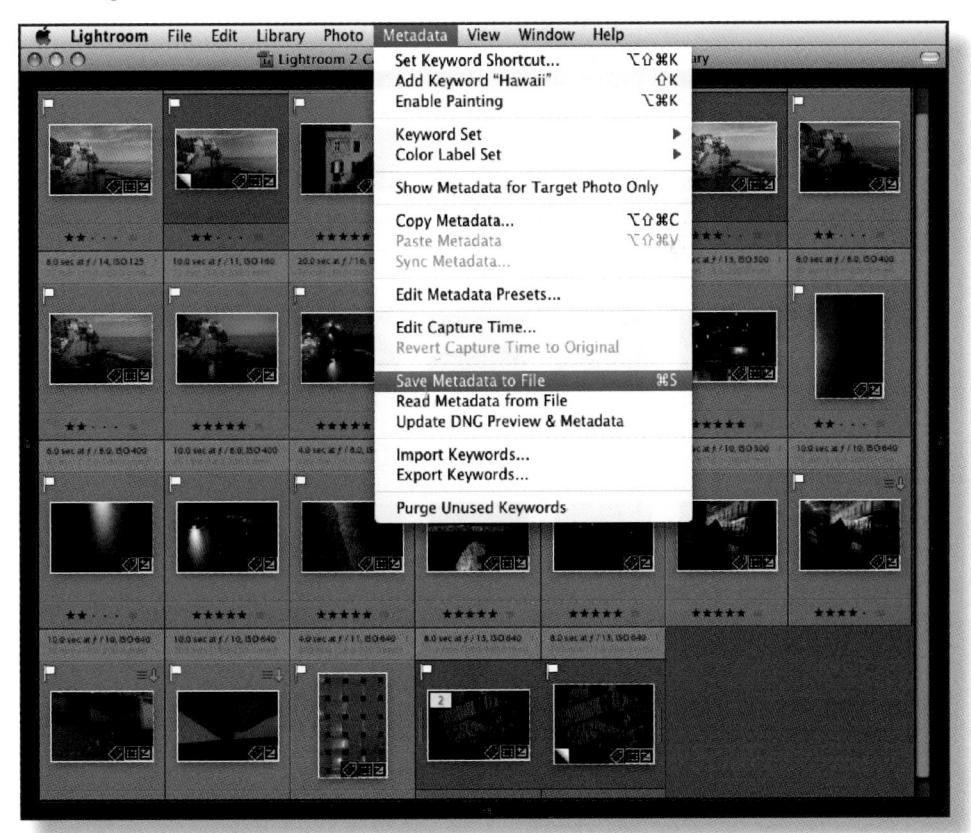

Figure 6-52a: Save Metadata to File

≫ #+S or Ctrl+S

Saving your work is as important in Lightroom as in other software applications, but it's all too easy to work on and on without Lightroom prompting you to save. Though all your changes are automatically saved into the database, they are *only* in the database until you save the changes out to the files and/or export new files. So save often!

⚠ Don't use Automatic Save

Lightroom offers the option to automatically save your metadata to the files as you work. I generally don't recommend this. First, many computers will experience a decrease in performance with this option enabled. Second, even on a fast machine, I don't want Lightroom accessing my files that frequently. Lightroom will save out the metadata after every change made to any setting. That much file access increases the possibility of file corruption. Usually it's better to just regularly save out the metadata yourself; an exception may be when managing photos in workgroup environments. To see whether Lightroom is automatically saving metadata, check the option in Catalog Settings as shown in Figure 6-52b.

Figure 6–52b: Automatically save XMP option in Catalog Settings

READING METADATA FROM FILES

If you've edited your file outside Lightroom (such as in Bridge, Adobe Camera Raw, Photoshop etc.) and want to update Lightroom to show the latest changes, you can read in the metadata from the file (see Figure 6–53). This will overwrite the photo's metadata in the Lightroom catalog.

Figure 6-53: Read Metadata from File

! Confirm your decision

Be careful using this command; it will overwrite all your current Lightroom metadata for selected images. Be sure it's what you really want to do before going ahead.

Keywords

Second only in importance to the copyright notice, keywords are essential metadata for every photo. These are words and short phrases, separated by a commas, which describe the content, theme, or subject of the image. You can work with keywords on both the Keywording panel and the Keyword List panel (see Figures 6–54 and 6–58).

KEYWORDING STRATEGIES

Every image in your catalog should have at least a few keywords assigned to it, and usually the more, the better. Years from now, finding a specific image in your catalog will depend on the richness of metadata available, especially keywords.

Though an image can have many, many keywords, it's also good practice to be selective with the words you use. Consider keywords that a viewer unfamiliar with the photograph might use to describe it.

As important as the choice of words is, it can also be tricky. For example, if you make a photograph of a crowded city street, can you justify adding a keyword for every single item shown in the picture? Does this add real value, or are general descriptions enough?

It's up to you to decide how far to go with keywords; the point is, use them. Take control of your keywording and managing your photos will be much easier.

Start adding keywords at the very beginning of the workflow and continue adding and refining your keywords for selects as you move them through the pipeline. Your final selects should be keyword-rich by the time you're done processing them.

At times, you may feel that keywording is taking too much time. This work will pay off later, so stick with it. Use all Lightroom's shortcuts and features, and your keywording will be much easier.

Apply keywords to as many photos as possible at one time

As you go through your editing workflow, apply keywords in progressively finer and finer detail. Start with the most generic terms that apply to the most photos and gradually add more specific keywords to individual photos.

Don't use keywords as you would a collection

Your Keyword List can be used as an image source; clicking on the arrow button next to a keyword shows the photos with that keyword applied. But don't be tempted to use it this way all the time. Keywords are usually most effective when used along with filters as a method of refining another source. To assemble and manage sets of related images, use collections instead.

KEYWORDING PANEL

The Keywording panel contains text entry fields for you to add, remove or modify keywords by typing, as well as Keyword Suggestions and Keyword Sets. See Figure 6–54.

>#+2 or Ctrl+2

To open and close the Keywording panel.

Click the small black triangles

To see all the options in the Keywording panel. See Figure 6–54.

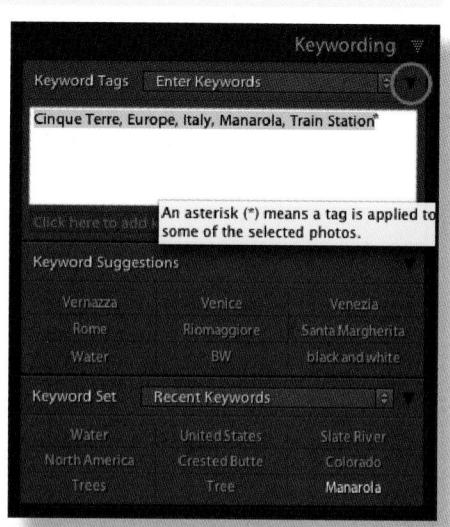

Figure 6-54: Keywording panel

Modify Keywords

All the keywords applied to a photo are shown in the top portion of the Keywording panel. Use the large text box to add, change or delete keywords. With multiple photos selected, keywords with an asterisk are only applied to some of the selected images.

Add Keywords

If you only want to add keywords (not change or delete them) use the following shortcut.

⋙ ∺+K or Ctrl+K

Puts the mouse cursor in the Add Keywords text field. Enter new keywords to be added to the photo, separated by commas. Press Return or Enter to commit the changes.

Return or Enter

Always remember to press Return or Enter when you're done typing text into any field in Lightroom.

To leave a text field without committing the changes.

Keyword Suggestions

As you keyword various photos, Lightroom keeps track of other images to which you've applied similar keywords and intelligently provides keyword suggestions based on your previous input. Click a suggested keyword to apply it to the selected photo(s).

Figure 6–55: Keyword Suggestions

Keyword Sets

Keyword Sets are designed to speed your work when adding keywords to photos with similar topics (see Figures 6–56 and 6-57). Each Keyword Set contains up to nine words. There are several built-in keyword sets and you can also create your own. When you load a keyword set from the popup menu the keywords in that set are shown. You can then click the keywords to add them to selected photos, or use the keyboard shortcuts for Set Keyword (see next section).

Set Keyword

The nine most Recent Keywords (or a Keyword Set) can be applied to selected photos using keyboard shortcuts or the Photo→Set Keyword menu.

Option+1-9 or Alt+1-9
Applies the corresponding keyword to the selected photo(s).

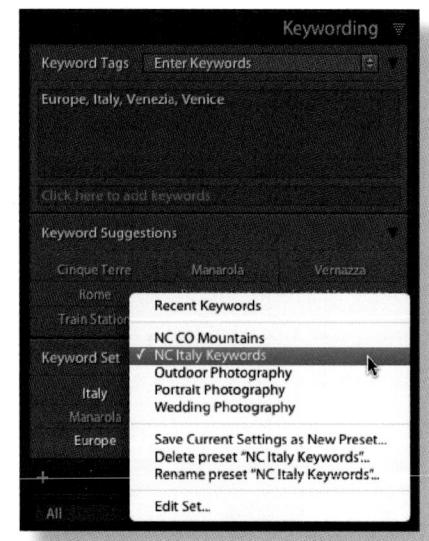

Figure 6-56: Keyword Sets

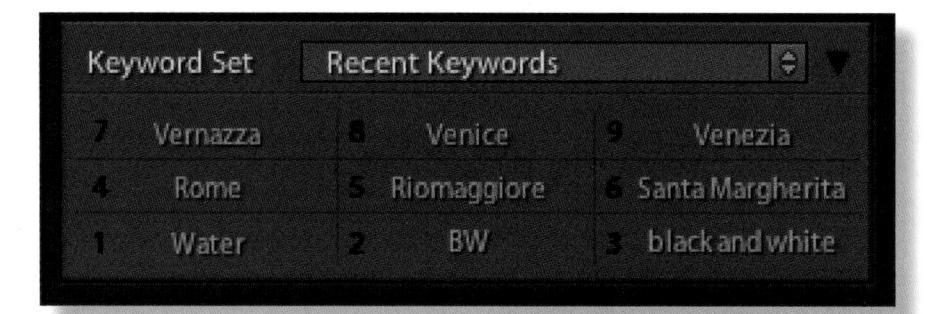

Figure 6-57: Set Keyword

KEYWORD LIST PANEL

The Keyword List panel (see Figure 6–58) shows a list of all the keywords in the catalog. As you add keywords to photos they are automatically added to this list. You can use the Keyword List to create image sources using keywords. When images are selected, the Keyword List panel indicates which keywords are applied to the selected photo(s). A check mark indicates all the selected photos contain the keyword; a dash indicates that keyword is only applied to some of the selected

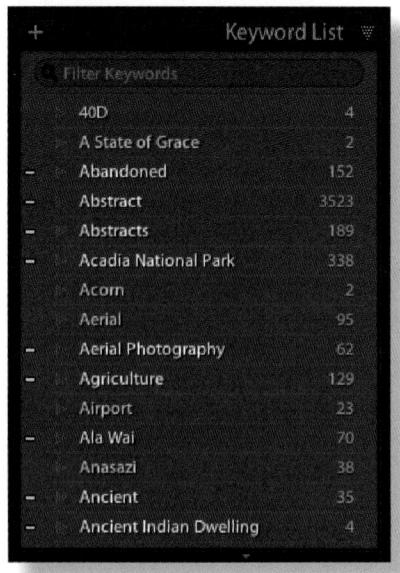

Figure 6-58: Keyword List panel

photos (like the asterisk in the Keyword Tags field). You can add or remove keywords to or from a photo by clicking the check box to the left of the keyword.

> **#+3 or Ctrl+3**

To open and close the Keyword List panel.

Managing your Keyword List

It's a good idea to do some of your keywording work separately from other photo editing tasks. The keywords stored in your Lightroom catalog have a unique, important place in the workflow and deserve regular attention all their own. Periodically update your Keyword list: check for typos and spelling errors, set up parent/child hierarchies, keyword sets and synonyms and purge unused keywords.

Control+Click or right-click on a keyword

To open a contextual menu containing commands for working with keywords.

Drag and drop to nest keywords

You can create keyword hierarchies, constructed of parent- and child-level keywords. Using hierarchies can speed the application of groups of common keywords to many photos at once. For example, dragging and dropping a bottom-level child keyword also applies all the keywords above it in the hierarchy.

Synonyms

When you create a new keyword in Lightroom you have the option to include synonyms for the word. Lightroom uses synonyms to create suggestion lists and heirarchies.

▶ Metadata→Purge Unused Keywords

This menu command automatically removes unused keywords from the Lightroom catalog.

Import/Export Keywords

You can import and export lists of keywords to and from Lightroom and these days many photographers are sharing keyword lists with each other. There are several popular Web sites for obtaining lists of keywords (see the Resources section in the Appendix).

Metadata→Import Keywords...

To import keywords into your catalog.

Metadata→Export Keywords...

To export keywords from your catalog.

Rating Photos with Lightroom Attributes

Assigning Lightroom's attributes to photos lets you quickly and easily sort them in many ways. Lightroom's photo attributes are:

- Star ratings
- · Color labels
- Pick flags

STAR RATINGS

Star ratings (see Figure 6–59) are designed to be used as a heuristic ranking model: five stars is better than one. By default, photos come into the database with no stars (unless they had stars applied in another program).

Most photographers begin rating with one star, going up to two, etc. to a maximum of 5. I know some people who start at 3 and go up or down from there. You can use whatever system you choose, but there's a practical reason for an ascending order of ratings. In any case, using a standard system can speed up your workflow and ease decision-making.

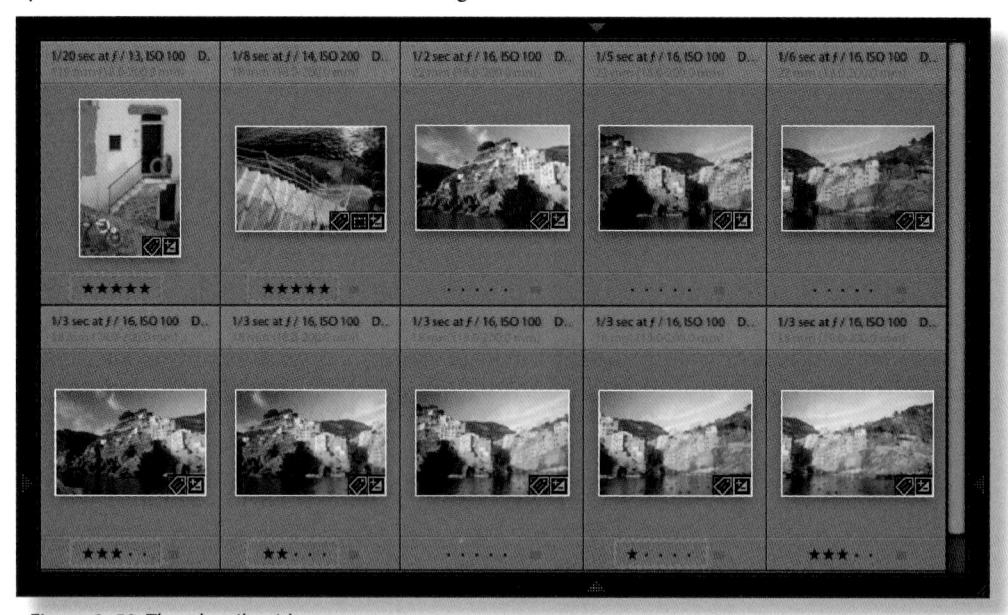

Figure 6-59: Thumbnails with stars

Numbers 1-5

Sets the rating to that number of stars. You can also apply ratings by clicking the stars on the thumbnails.

p [and]

Increases or decreases rating incrementally.

p 0 (zero)

Sets the rating to no stars.

Shift+0-5

Sets rating and selects next photo.

COLOR LABELS

You can apply a color label to an image to indicate a specific meaning for the photo (see Figure 6–60). For example, a photographer might apply a green label to indicate portfolio images exported from a collection. You could mark a set of images blue to indicate they are to be stitched into a panorama. Or mark photos purple to indicate they had been reviewed by a client. You can make Color Label Sets that have different colors or definitions. Care should be taken to use color labels appropriately (for special photo designations) and not use them in cases where another attribute would be better

Figure 6–60: Thumbnail with color label

Numbers 6-9

Red is 6, yellow is 7, green is 8, blue is 9. Purple doesn't have a shortcut. You can also apply standard color labels by clicking the color labels on the thumbnails.

Shift+6-9

Assigns the color label and selects next photo.

Color Label Sets

Choose Metadata→Color Label Set to edit the current set or make new ones.

Use standard color names

On the Metadata panel, you can type any text into the Label field, but the five standard colors listed above are the only ones that will show a color on the thumbnail. The important thing to understand is that the Label field is editable text (whereas flags and stars are invariable) and you can enter anything you want for the label definition. But if you want the thumbnail to show a color you have to use the standard color names.

Photo→Auto Advance

With Auto Advance enabled, as you apply attributes to images in Library (flags, stars etc.) Lightroom automatically selects the next unrated image in the current source.

Disappearing thumbnails

During an edit, if you change any of the attributes of a photo and it disappears from view it's because filters are enabled. Change or disable the filter set (discussed in the next section).

APPROVING PHOTOS WITH PICK FLAGS

Pick flags (and their opposites, reject flags) represent the simplest form of editing decision—yes or no. Note that flags are based on the source in which they are applied. For example, if you apply a pick flag to a photo in a folder, and then put that photo in a collection, the photo will be unflagged in the collection. (Of course, you could reapply the flag in the collection.) This is intended behavior; flags are meant to be used in source-specific editing.

Marks the photo with a pick flag. As you navigate through your images using the arrow keys, press P for any image you want to flag. You can also apply a pick flag by clicking the flag icon in the top left of the photo's thumbnail. See Figure 6–61.

Shift+P

Marks the photo with a pick flag and automatically advances to the next unflagged photo.

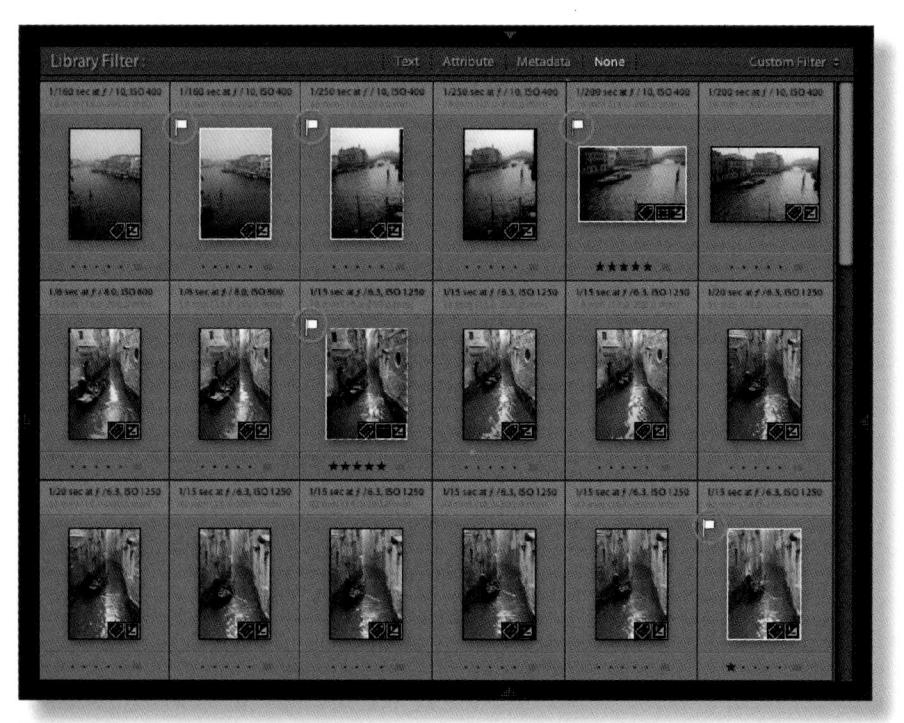

Figure 6-61: Thumbnails with pick flags

Pick flag status is not written to XMP metadata

For this reason, I prefer to use stars for editing, as the star ratings are saved out to the files and can be read by other software.

MARKING REJECTED PHOTOS

Using the reject flag allows you to speed the removal of unwanted photos from your catalog. Thumbnails for rejected photos are dimmed in the Grid View.

Marks an image as reject. See Figure 6–62.

Shift+X

Marks the photo with a reject flag and automatically advances to the next unflagged photo.

After marking photos as rejected you can delete them with this shortcut or by selecting Photo→Delete Rejected Photos.

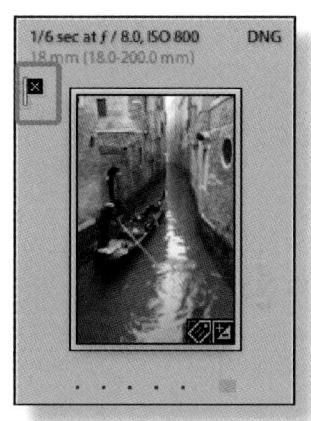

Figure 6-62: Reject flag

Keeping only your picks with Refine Photos

If you use Reject Flags, Refine Photos helps facilitate automated mass-deletion of photos from your Library. When you run Refine Photos, images that had Pick Flags will be set to Unflagged, and previously Unflagged photos will be made Rejected. You can then use Photo→Delete Rejected Photos to quickly remove all the rejects from the current source.

➡ Library→Refine Photos

To run the Refine Image command.

Removes all flags from the image (marks it as unflagged).

Using Filters to Create and Modify Image Sources

Filters are one of the most powerful and important features in Lightroom. Applying filters creates compound image sources; typically you will start from a folder or collection source and then add filters to see only the photographs you want. You can set up filters using many criteria. Filters can be combined and can also be saved as presets for later use.

6

Filter settings are specific to the folder or collection source to which they are applied, and are saved automatically, so different sources can have different filters enabled.

Filters are most useful for quickly creating or temporarily refining other sources. Care should especially be taken to not rely on filters in cases where a collection would be more appropriate.

Filters are accessed via the Filter Bar; see Figure 6-63.

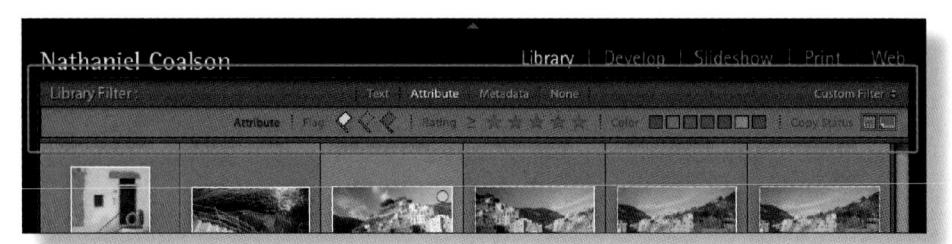

Figure 6-63: Filter Bar at the top of the Grid

To hide and show the Filter bar.

Make the window larger to see the entire Filter Bar

If the main Lightroom application window is not wide enough, the right side of the filter bar will not be visible.

TEXT

The Text filter is a search engine. It's usually most useful for searching keywords or file names, but it can also find a string of text contained—or not contained—anywhere in the file data. Use the menus to set up your search criteria (see Figure 6–64), type in the text to search for and press Return or Enter to execute the search.

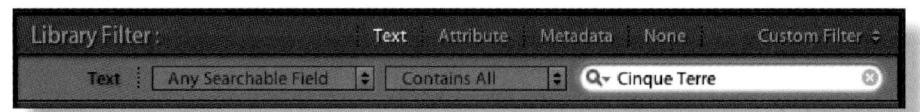

Figure 6-64: Text filter

Opens the Text filter bar (and on Mac OS X, inserts the cursor in the text search field, too). Type a string of text to search for and press Return or Enter.

Add photos to a collection after filtering

After you've performed a search for keywords or text (or any other complex filter operation) put the filtered results in a collection to work with them further. Collections are discussed later in this chapter.

ATTRIBUTES

This is the core set of Lightroom editing filters: star ratings, pick flags, and color labels (see Figure 6–65). With just these three basic attributes you can differentiate between photos in many ways.

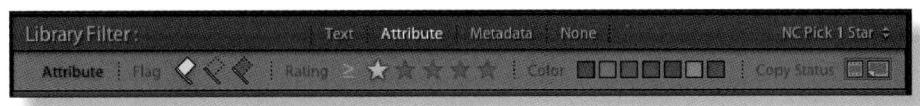

Figure 6-65: Attributes filters

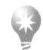

Selecting multiple attributes

Click the attribute buttons in the Filter Bar or Filmstrip to create a combined filter.

Copy Status

The Copy Status filter works based on whether the instance of the image is a master photo (an actual file on disk) or a virtual copy (that exists only in the catalog). With this filter you can show only master photos, only virtual copies or both. See Figure 6–66.

Figure 6-66: Virtual Copy badge and Copy Status metadata filter

METADATA

With metadata filters you can create image sources based on any file metadata, including EXIF information such as exposure setting, lens used, etc. See Figure 6–67.

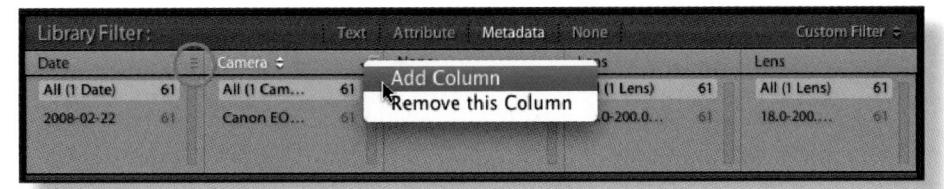

Figure 6-67: Metadata filters and column options

Add or remove columns from the metadata filter or change their content

Place your cursor over the column header in the metadata filters and a small icon appears at the right (see Figure 6–67). Click this menu to add or remove columns. Click the column header to select what kind of metadata that column uses.

Shift and Control or Ctrl

To select multiple criteria within the metadata columns. Shift selects a contiguous range of options. Control or Ctrl selects individual, non-contiguous criteria.

Combine multiple filters

As you move across the top of the filter bar you can cumulatively add filters to the current set. A highlighted label indicates that filter is active. Click the name of the filter to enable or disable it in the current filter set.

Shift

Hold Shift when clicking the filter names to show controls for multiple filter types at the same time.

NONE

Clicking None on the Filter Bar (see Figure 6-68) deactivates the current filter set.

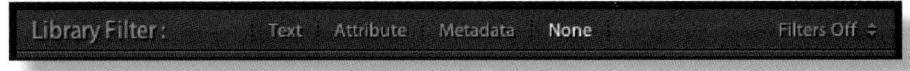

Figure 6-68: None filter option

FILTERS CONTROLS ON THE FILMSTRIP

At the top right of the Filmstrip is a second set of filter controls (see Figure 6–69). These provide essentially the same on/off functionality as the filter bar and you can select saved filter presets, but you can't configure complex metadata filters here.

The Filters Switch

The filters section on the Filmstrip includes a switch that disables or enables the current filter set. This is the same as clicking None on the filter bar. The switch does not modify the filter set; it only turns it on and off.

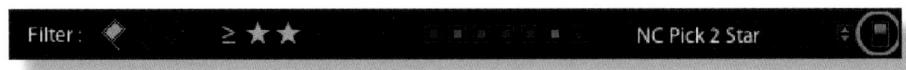

Figure 6-69: Filter controls on Filmstrip; filter switch

Instead of using the switch, use this keyboard shortcut to enable and disable Library filters. This does not alter the current filter set; it only turns it on and off. *Note*: these switches perform the same function in Develop—enabling and disabling the effects of a single panel.

Don't modify filters just to turn them off

If you want to temporarily show photos that don't match the current filter set, don't modify them, disable them. For example, if you have a filter enabled to only show picks and need to see the unflagged photos, don't remove the pick flag from the filter; just turn the filter off. This allows you to keep filter sets intact for later use.

SAVING FILTER PRESETS

To save a filter preset, click the menu at the right side of either the top Filter Bar or the filters section on the Filmstrip. From the menu, select Save Current Settings as New Preset.

Photo Collections

Collections are one of Lightroom's most useful features. Think of them as "virtual folders": these groupings of images exist only in the Lightroom database. You can make collections for any purpose, subject or topic you like and you can use as many collections as you need (see Figure 6–70). A photo can be a member of any number of collections, and deleting photos from one collection doesn't affect it in others. You can group your collections together in *collection sets*.

> \mathfrak{\text{\$\mathfrak{#}}} + Control + 3 or Ctrl + Shift + 3

To open and close the Collections panel.

COLLECTIONS

These "regular" collections are those you create yourself. They aren't based on any specific criteria

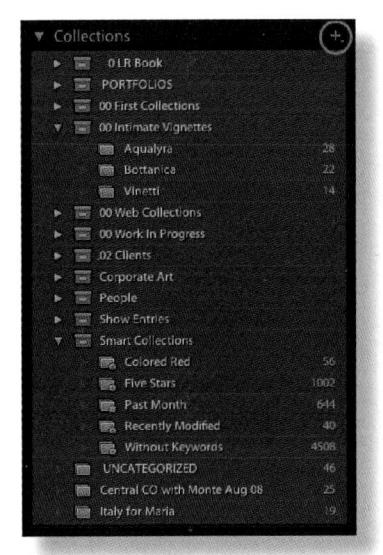

Figure 6–70: Collections list; new collection button

(as opposed to a smart collection, see next section). You can create collections and add photos to them however you see fit. For example, I've set up collections for client work, portfolios, show entries and Web galleries. I have other collections for work in progress and uncategorized images. Using collections (instead of the original folders) assures me that editing for those photos was completed, and I'm now working only with the final selects. You can add original photos and virtual copies to collections.

Make a new collection and add photos to it

Click the + button on the Collections panel header and choose Create Collection.

6

Type a name for the collection and configure the other options to your liking. For example, if you have images selected, you can automatically add them to the new collection. Press Return or Enter to finish.

To add more photos to the collection, drag their image thumbnails onto the collection in the panel or use the Target Collection option (see Figure 6–72).

≫ #+N or Ctrl+N

To make a new collection.

Control+Click or right-click on a collection

To access many commands on the collections contextual menu.

Deleting photos from a collection

To remove photos from a collection, select the photo in the collection and press Delete. This will immediately remove a file from a collection without presenting a confirmation dialog box. (This is undo-able; just be sure to undo the removal before going on to other work.) Deleting the photo from a collection doesn't affect instances of the photo in other collections.

Moving and Copying Photos Between Collections

Drag and drop a photo onto a collection to add it to that collection. The photo still remains in the previous collection; to remove it, you must delete it from there.

Control+Click or right-click on thumbnail, choose Show in Collection
To see what collections the photo belongs to. See Figure 6–71.

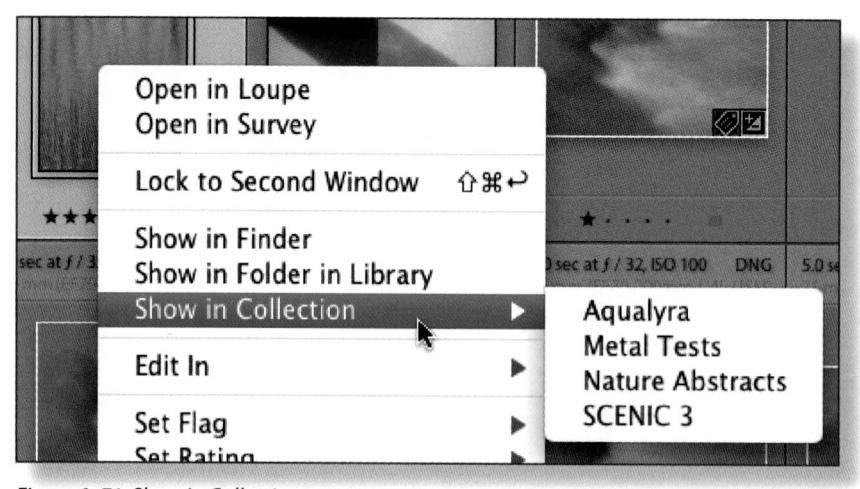

Figure 6-71: Show in Collection menu

When adding a photo to a collection doesn't work

If you try to add a photo to a collection using any of the available methods, and you're not able to, it's because the photo is already in that collection.

OUICK COLLECTION

The Quick Collection is a built-in collection that is best used as a temporary holding place during editing or organizing. For example, you could add multiple photos to the Quick Collection as an intermediate step to getting them all into one permanent collection. There is only one Quick Collection available in each catalog. Access the Quick Collection in the Catalog panel.

В

To add or remove photos from the Quick Collection (or Target Collection, Figure 6–73). Photos that are in the Quick Collection or targeted collection show a gray dot on the top right of the thumbnail image (see Figure 6–72).

Set as Target Collection

You can specify any existing collection as the destination for photos when the B key is pressed. Control+Click or right-click the name of the collection and choose Set as Target Collection from the contextual menu (see Figure 6–73). A white plus symbol next to the collection indicates it is targeted. Pressing B will now assign photos to the target collection, not the Quick Collection. To turn targeting off, uncheck the option from the

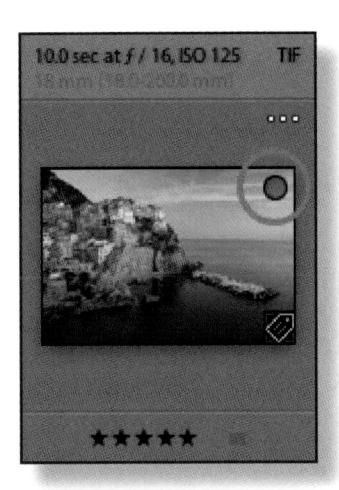

Figure 6–72: A gray dot on the thumbnail indicates photo is in either the Quick Collection or a custom Target Collection

menu and the Quick Collection will become the target collection again.

Use the Painter to Add a Photo to a Collection

With a custom Target Collection set, use the Painter to quickly add photos to a collection simply by clicking thumbnails. The Painter tool is discussed later in this chapter.

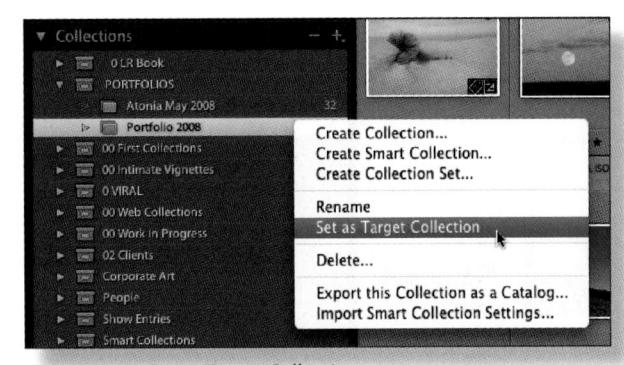

Figure 6-73: Set as Target Collection

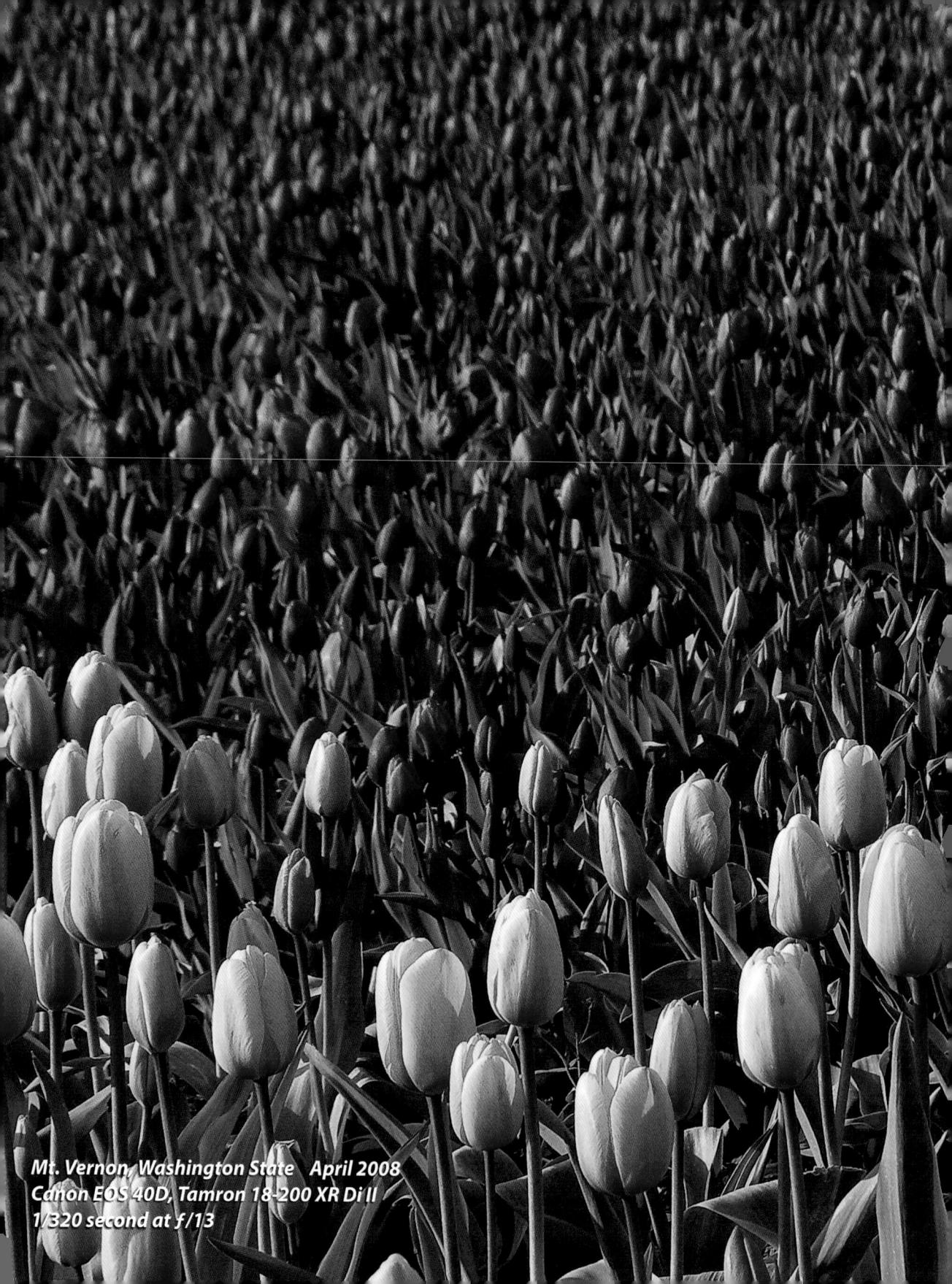

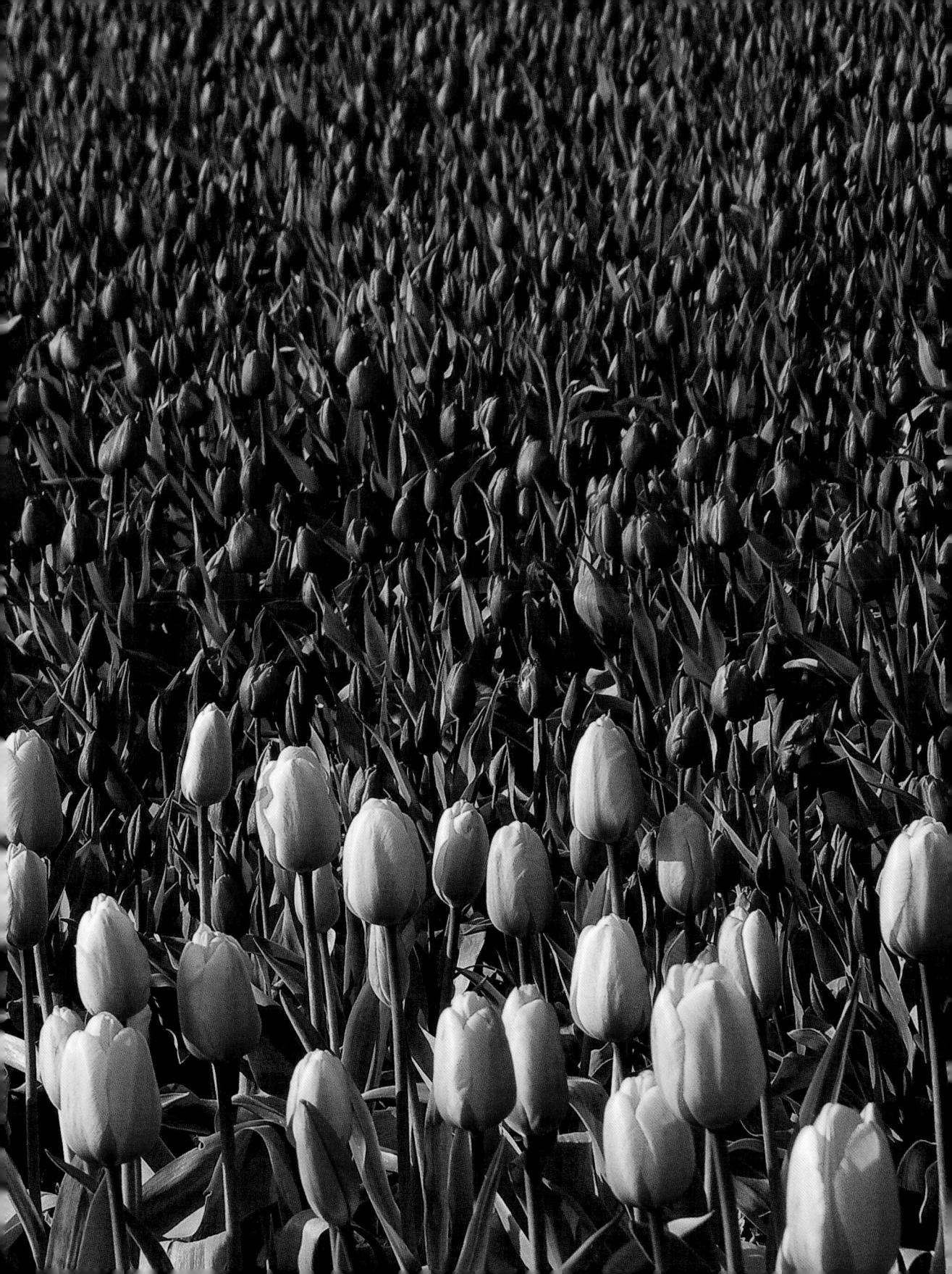

SMART COLLECTIONS

Smart collections (see Figure 6–74) are configured with options similar to filters. You can set up smart collections to source images from anywhere in the catalog, using a wide variety of metadata criteria.

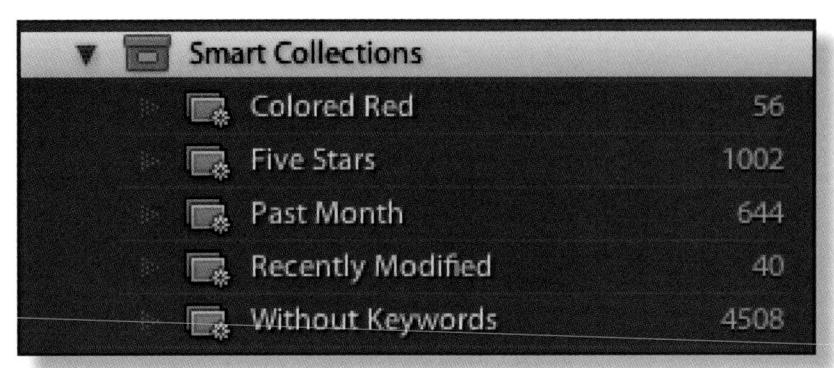

Figure 6-74: Default Smart Collections list

Make a new smart collection

On the Collections panel, click the + button and choose Create Smart Collection. Type a name for the collection and configure the rules to your liking. Use the plus or minus buttons to add or remove criteria (see Figure 6–75). Press Return or Enter to create the smart collection.

Note: Since they work from photo metadata, you can't directly add or remove images from smart collections.

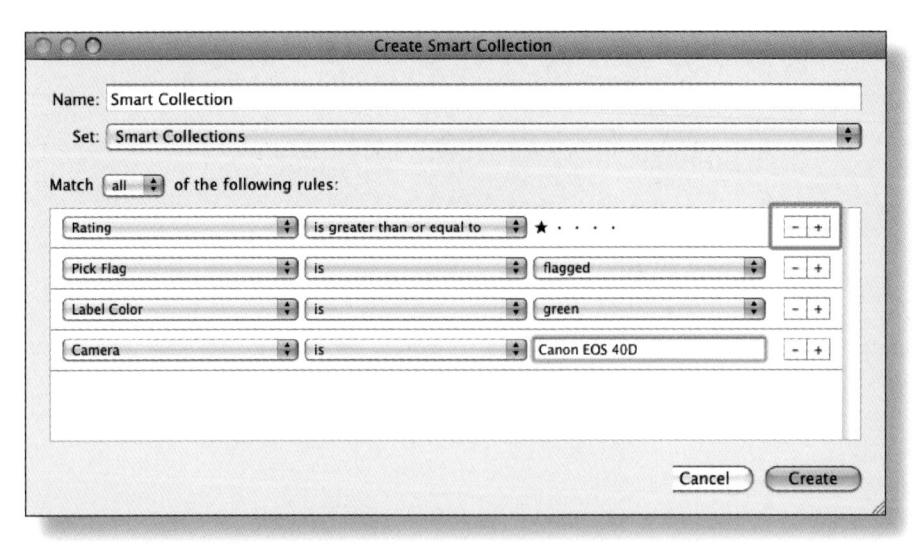

Figure 6–75: Smart Collections criteria

To provide additional, "advanced" options when adding criteria to a smart collection.

Import and Export Smart Collections

You can easily transfer your smart collections settings between computers using Import and Export Smart Collections. Control+Click or right-click on the smart collection name and choose Import or Export from the contextual menu.

COLLECTION SETS

Like folders contain image files, collection sets contain collections and smart collections. Put another way, a collection set is the parent and the collection is the child. Deleting a collection set will also delete the collections within it. Figure 6-76 shows collection sets (circled in red), each with several collections nested inside.

Figure 6-76: Collection sets; Collections panel menu

Make a new collection set

Click the + button on the collections panel header and select Create Collection Set.

Drag and drop collections

You can drag collections within the panel to rearrange them or nest them under different collection sets.

Processing Photos in Library

There will be times when you want to start processing a photo right away. You can make basic adjustments to your images in Library prior to processing them fully in Develop. There are several ways to apply adjustments to photos in the Library module.

HISTOGRAM

Processing decisions can be aided by evaluating the Histogram, a bar graph showing the digital color values contained in the photo (see Chapter 7).

> \#+0 or Ctrl+0

To open and close the Histogram panel in the Library module.

QUICK DEVELOP

The Quick Develop (see Figure 6–77) contains a limited subset of the image adjustment controls in the Develop module. Quick Develop settings can be applied to multiple images at once, whereas changes you make to Develop adjustments affect only the active image. With one or more photos selected, click the buttons in the Quick Develop panel to adjust settings. Right-facing arrows increase the value for each setting; left arrows decrease the value. Hold your cursor over each setting to see tool tips.

Quick Develop adjustments are best done using a large Loupe preview, but can be applied to thumbnails and small previews, too.

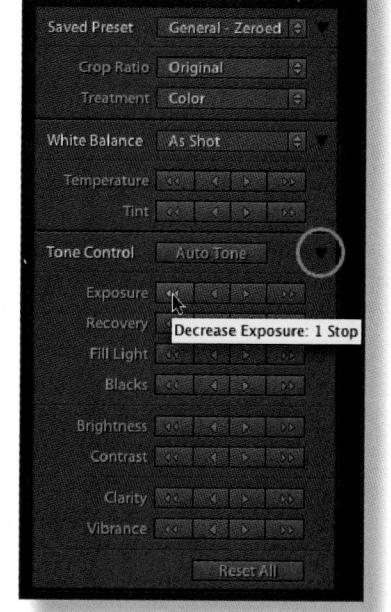

Figure 6–77: Quick Develop panel with settings expanded

≫ #+1 or Ctrl+1

To open and close the Quick Develop panel.

Show all the Quick Develop settings

Click the black triangles to access all the settings on the Quick Develop panel.

Option or Alt

...to temporarily reveal more controls on the Quick Develop panel.

🦪 Adjust multiple photos at once

Select multiple images in Library, change the settings on the Quick Develop panel, and all the selected images are adjusted in amounts relative to each photo's current settings.

■ 第+' or Ctrl+'

To make a Virtual Copy of the image file. Use Virtual Copies to make variations of a photograph. Virtual Copies exist in the Lightroom catalog only; they are cached versions of the file on disk, rendered with Lightroom processing instructions overlaid. You can use Virtual Copies for whatever purposes you like. There are several Develop processes that are especially well-suited to using Virtual Copies: Grayscale variations, Cropping variations, etc. See Chapter 7 for more about Virtual Copies.

Convert selected photo(s) to grayscale (black and white, see Chapter 7).

Apply Crop Presets in Quick Develop

To quickly Crop one or more photos, select them, and choose the desired preset (or custom option) from the Crop Ratio menu in the Quick Develop panel. Note that the applied crop will be centered on all the images; you can then go into Develop to adjust crops for individual photos as necessary.

Use Quick Develop to apply adjustments for Print

Because the Quick Develop adjustments are relative, they can be very effectively used to prepare batches of previously-processed photos for printing. See Chapter 9.

SYNC SETTINGS

In Library, you can synchronize Develop settings between multiple photos. When you Sync Settings, the settings from the active photo will be applied to all the other selected photos.

> #+Shift+S or Ctrl+Shift+S

Select multiple images in Library and click the Sync Settings... button. A dialog box appears, allowing you to choose what settings to sync (see Figure 6–78). Press Return or Enter to apply.

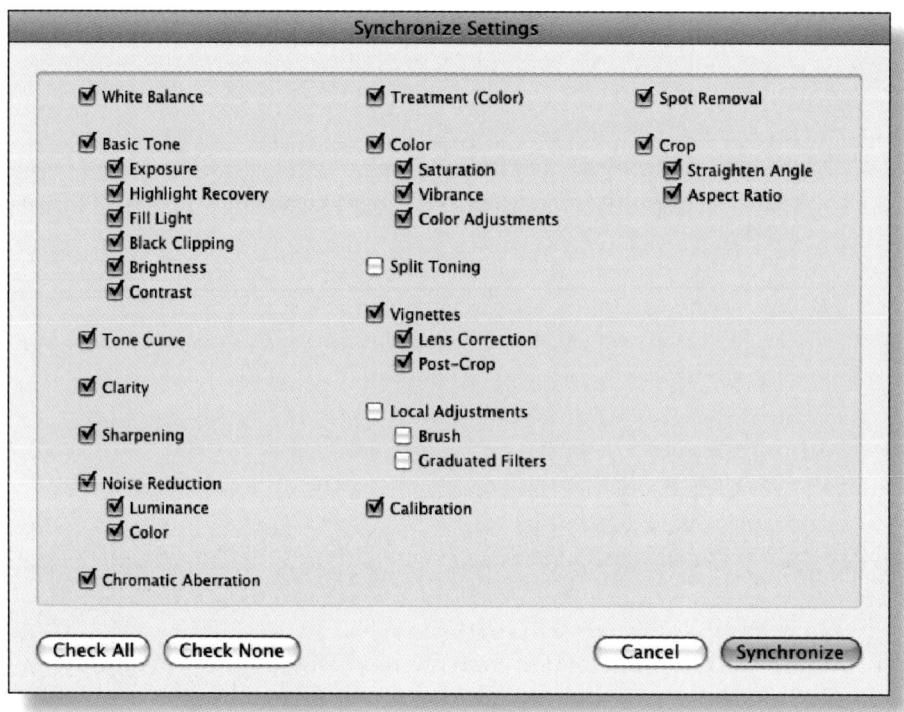

Figure 6–78: Sync Settings dialog box

COPY/PASTE SETTINGS

Copy/paste settings are similar to Sync Settings (Develop settings only, not other metadata or keywords). You can copy settings from one photo and paste them to another (or multiple) photo(s). The Copy Settings dialog box is identical to Sync Settings in appearance and function.

第+Shift+C or Ctrl+Shift+C

Select an image, then press the keys to open the Copy Settings dialog box. Choose what Develop settings to copy from the selected photo.

\Longrightarrow ...then \Re +Shift+V or Ctrl+Shift+V

Select one or more images that will receive the pasted settings. Pressing the Paste shortcut applies the copied settings to all the selected photos. Only settings that are different will be pasted.

RESET SETTINGS

The Reset Settings command restores all the Develop settings to the Lightroom default. (Note that this is not the same as Zeroed and the Lightroom default can be overwritten.)

Save a Snapshot First

As with all settings adjustments in Lightroom, resetting is undo-able, but you might consider making a Snapshot first in case you want to easily restore the settings later. Do this in Develop (see Chapter 7).

Reset All

This button on the Quick Develop panel will reset settings for all the photos selected when in Grid view, or the photo showing when in Loupe view (see Figure 6–79).

REMOVING ALL DEVELOP SETTINGS

Use this to remove all Develop adjustments from one or more images.

Quick Develop Panel: Preset menu

Choose General – Zeroed from the menu to remove all Develop settings from the image (see Figure 6–79). All other metadata remains intact.

FAST METADATA CHANGES WITH THE PAINTER

The Painter is an extremely powerful way to modify photo settings and metadata. With it you can add, remove or change all kinds of metadata and Develop adjustments very

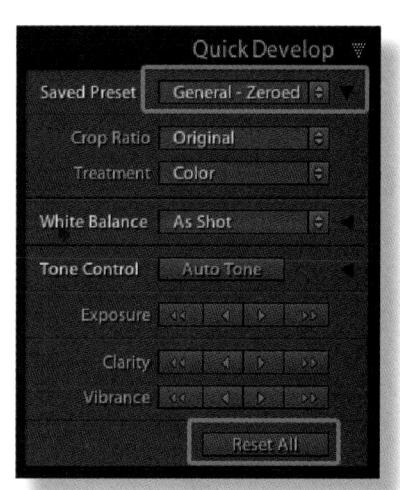

Figure 6–79: Quick Develop panel preset menu

quickly. To use the Painter first be sure the Toolbar is showing (T). See Figure 6–80.

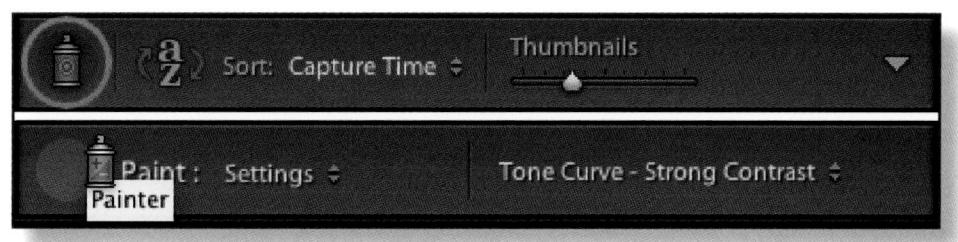

Figure 6-80: Painter and controls on the Toolbar

● Option+#+K or Alt+Ctrl+K

From the Paint: popup menu choose what kind of settings you want to modify, then configure the options for what you're applying. Click on thumbnails in the Grid or Filmstrip to apply the setting(s).

A Changing something you didn't mean to with the Painter

With all the power of the Painter comes some risk; if you're not paying attention, it's very easy to accidentally do something you didn't intend to. For many criteria the Painter is a toggle control (on/off, yes/no, etc.). This means if the specified Painting criterion is already met for a given photo, clicking with the Painter will reverse the condition. For example, if you're painting with the keyword "Cinque Terre" and the image already had that keyword applied, it will be removed. The Painter cursor changes to an eraser to show you this is happening, but it's very subtle and easy to miss.

Paint Target Collection

In Painting mode you can put photos in the Target Collection. This can be much faster and easier than dragging and dropping or using the contextual menus (though in most cases I still prefer the B key shortcut).

CONVERTING RAW FILES TO DNG

You can convert camera raw files to DNG from within the Library module, without needing to do an export.

► Library menu→Convert Photo(s) to DNG

In the dialog box (see Figure 6–81), apply the settings for the conversion. (I usually recommend using the default settings.)

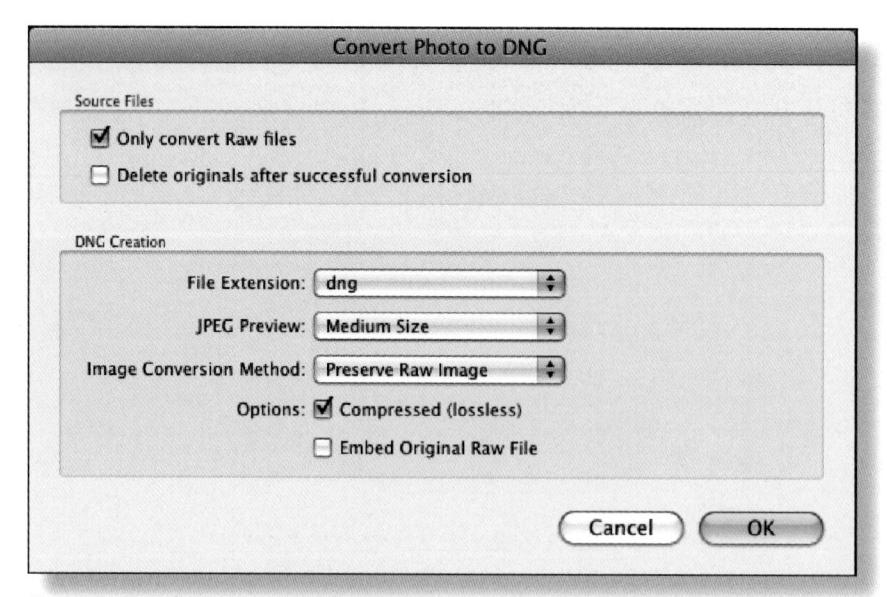

Figure 6–81: Default DNG conversion settings

Workflow: Editing the Shoot

After importing photos into the catalog, it's time to edit the shoot. The goal is to go from the many images captured during a session to only the few, best photographs—those chosen to continue through the processing pipeline. The photo editing process is *iterative*: we review photos in multiple *passes* of editing until they are distilled down to the final *selects*.

Figure 6–82: Photo editing workflow

YEA OR NAY

During each round of editing, decide whether each image stays or goes. ("Maybes" stay, at least for the current round.) Try to look at the photographs as if someone else made them. Be your own toughest critic—you have too many good shots to waste time on bad ones! Move through your editing quickly, without over-analyzing. (But also learn from your failures by going back to study them later.) Is the shot successful or not? Or does it have less-than-obvious potential that can be brought out in processing? Clearly define your reasons for giving each photo a thumbs-up or thumbs-down. Use the fundamentals of photography to make your choices: interesting subject or theme, strong composition, workable exposure and ample image data.

Evaluate similar photographs *heuristically* (ranked in ascending order) to determine the best and ignore the rest. Don't fret over your decisions. You can always come back later to confirm your initial choices—and you always have the prerogative to change your mind. For each pass, the editing steps are:

- 1. **Review:** evaluate all the photographs on their strengths and potential. Concentrate on simply deciding if each photograph works or it doesn't.
- 2. **Rate:** apply Lightroom attributes (stars, flags and/or labels) to differentiate selects from rejects.
- 3. **Save:** save Lightroom metadata to the image files on disk.
- 4. **Filter:** show only the selects that have survived the round.
- 5. **Repeat:** continue editing until only your best work remains.

Edit: First Pass

With all photos from the Import showing in the Library Grid (see Figure 6–83), hide the panels, and go through the shoot quickly. Apply one star to the best of this round. Optionally mark with a reject flag any photos you want to delete. Switch to Loupe, Compare or Survey views as needed to evaluate larger previews. Apply Quick Develop adjustments as appropriate to make editing decisions, but don't get mired in processing at this point. When you're done with the first pass, Save Metadata to File, then apply a filter to show photos with one star only (see Figure 6–84). If you edit your work tightly, this may be as far as you need to go in the editing process, and you can begin processing your selects.

Don't use the Previous Import source for editing

Following an import, switch to the Folder source to edit the photos.

#+Shift+F or Ctrl+Shift+F

To enter full screen mode and hide all the panels.

Use the arrow keys to move between images

In the Library Grid you can move left, right, up and down to select images with your arrow keys. At all other times (and in other modules) use just the left and right arrows to select images in the Filmstrip.

Save your work frequently

After each round of editing, but before filtering, select all your images and Save Metadata to File. This ensures that ratings and any Quick Develop adjustments are saved on disk as well as in the Lightroom catalog.

Selects all the images in the current source then saves all Lightroom metadata to the files on disk.

#+G or Ctrl+G

If you have sequences of similar images in the shoot, group them into stacks during the first or second pass. This saves screen space and processing time during the edit.

Edit: Second Pass

If necessary, repeat the review and rating process to further refine your choices. Selects that make it through the second pass get two stars. You can also Delete Rejects at this point. When you're done, filter for two stars.

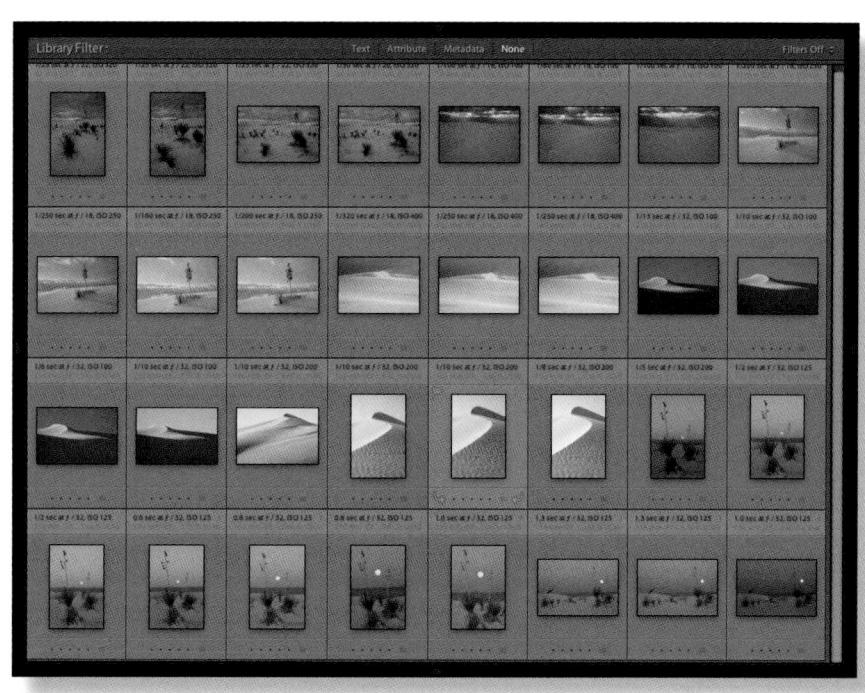

Figure 6–83: Newly imported photos showing in Grid view

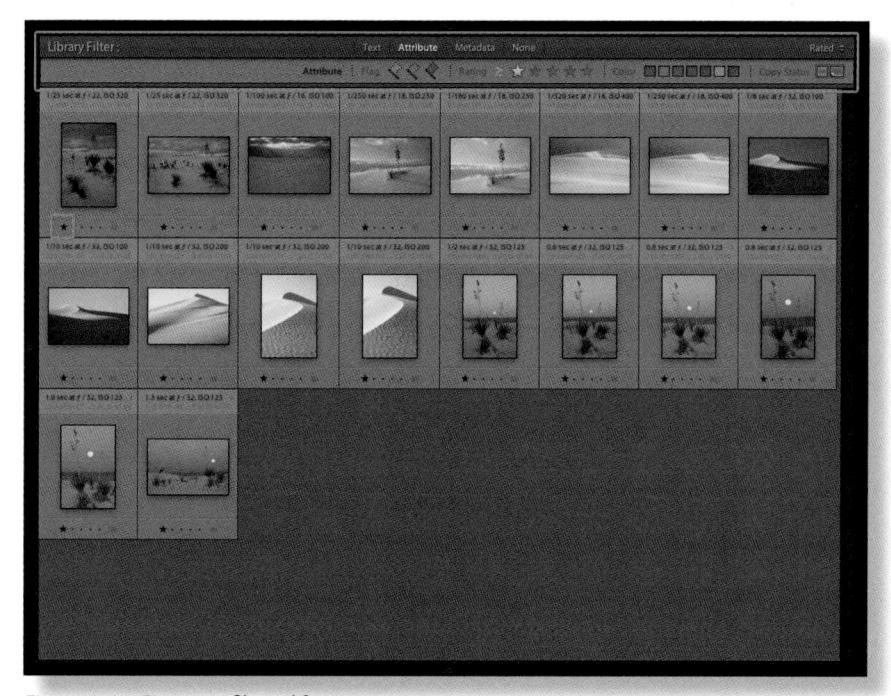

Figure 6–84: First pass filtered for one star.

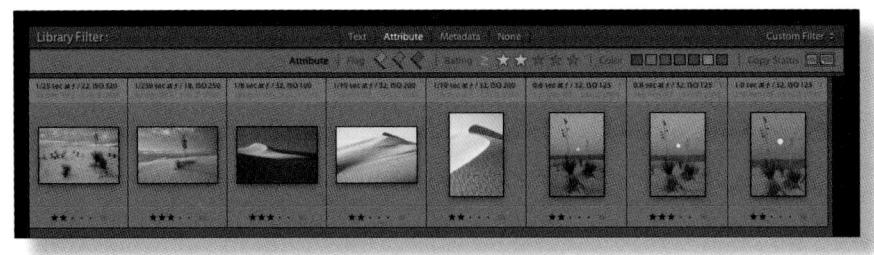

Figure 6-85: Second pass filtered for two stars (and higher).

Edit: Additional Passes

Continue to review and rate, applying three, four, up to five stars to the selects for each round. Repeat the process only as many times as necessary to get to your final selects (see Figure 6–85). Sometimes one pass is all that's needed, other times you might need to go through the shoot six times. Whatever the case, be sure that when you're done editing you have only your best work remaining.

Whatever labeling you prefer, do your best to use a consistent system of rating your photos. For example, all images with one star should have the same significance in your catalog.

I capture many images during each shooting session, and lots of these are very similar, with only small differences in composition, lighting and exposure. Typically, my final selects have three stars, and maybe a pick flag—indicating four rounds of editing.

During all editing, remember that you can undo and redo steps!

₩+Z or Ctrl+Z

To undo the last step. Repeat the keystroke to go as far back as necessary.

#+Shift+Z or Crtl+Shift+Z

To redo steps that were undone.

Do minor processing during editing

Sometimes you will want to do some processing to make a decision about how to rate an image. With Lightroom you can make quick adjustments to photos as you edit the shoot. Use the controls on the Quick Develop panel in Library or jump to the Develop module (see Chapter 7) to process photos during editing.

Refrain from deleting questionable photos during editing

It slows the workflow, plus you might make a mistake. If you want to delete images, consider coming back later to do so. Better decisions might be made with some time gone by.

Edit: After Final Pass, Add Selects to a Collection

When you get to the point where you have a strong representation of final selects, put them all into either an existing collection or a make new one. All further work on the selects should be done from collections. Photos in the collection are the only images approved to continue to Develop (but you can always return to the folder if necessary to hunt for a better version of a particular image, etc.).

You can use the same basic steps for every edit. Lightroom is flexible; the order in which you perform editing tasks is less important than is the use of a consistent system.

Chapter Summary

Gaining control over the many ways to organize your images in Library is a fundamental aspect of working efficiently in Lightroom. If you think a task in your workflow takes too long or has too many steps, chances are there's an easier way. Strive to effectively use Lightroom's attributes, filters, collections and stacks and your editing work will become less tedious and much more fun.

PROCESS YOUR PHOTOS IN DEVELOP

The Develop module is Lightroom's processing powerhouse. Here is where you perfect your image with the freedom of non-destructive, metadata-based adjustments.

As with other modules, using presets in Develop improves productivity immensely. But Develop also offers numerous other processing features and time saving shortcuts, many of which are less than obvious at first glance.

Plan for Processing

After you've edited the shoot, identified your selects and put them into a collection, it's time to make each photo look as good as it can. Obviously, this involves many variables, and what works in one instance won't necessarily work in another. Some images will require very little processing, and others more, but even with the greatest care at the time of capture every raw image stands a chance of being improved—often significantly—during processing. To get the best results with the least amount of effort, follow a standard set of procedures for all your processing.

EVALUATING THE PHOTO

Before beginning your processing in Develop, take a few minutes to evaluate the image and make a plan for the work required. (You can also do this in Library, as the last step of editing.) If you like, jot down some notes to help visualize the sequence of steps you will perform.

As every image is unique, each will benefit from different enhancements to help the photograph look its best. These decisions are highly subjective; the choices you make must reflect your creative vision of how the image should look.

However, there are some common criteria to use when determining the appropriate improvements to a photo. Some enhancements, like noise reduction and sharpening, are quite objective, as there are established standards of technical and aesthetic quality to consider. For example, in most cases, we would agree that digital noise is undesirable and should be minimized; or, many people would agree when a photo looks "crooked" or "blurry". Of course there are exceptions to every rule. The creative decisions you make should be guided by your (or your client's) preferences and the requirements for the job at hand.

Keep in mind that every step of the workflow affects and is affected by every other step. For example, sharpening the image may increase noise. Adjusting color may affect apparent contrast, etc. So it may be necessary to go back and forth between steps to perfect the image.

As you're looking at the photo, go through the following checklist and make your plan for processing. Remember that repeatedly following the same sequence of steps will help you work more efficiently, more effectively and with greater creative freedom.

Learn to differentiate between technical and aesthetic characteristics

Critiquing photography—whether your own or someone else's—requires analysis of the effectiveness of the photograph's creative impact as well as the technical execution. Though neither necessarily takes precedence, artistic and technical
considerations should be evaluated independently. Technical characteristics include resolution, sharpness, and the presence of artifacts, etc., while compositional choices and the portrayal of subject matter are more aesthetic.

Crop and rotation

As the first step in evaluating each image, carefully consider whether it could be made stronger with different cropping (see Figure 7–1). Since cropping removes parts of the photo—and thus changes the composition—this can be the most significant modification you make to an image.

Are there distracting elements along the edges or in the corners? Are there areas of empty space that detract from the main subject? How is the overall balance of the composition? If the photo had been shot in landscape orientation (horizontal), would a portrait (vertical) crop make it better? How about a square crop?

Also decide if the image looks "straight"—especially if there is a prominent horizon line or a strong edge that should appear level to convey the right "feel" for the image. You may need to rotate the image slightly (which requires cropping). Alternatively, would the photograph be more interesting if it was rotated even more?

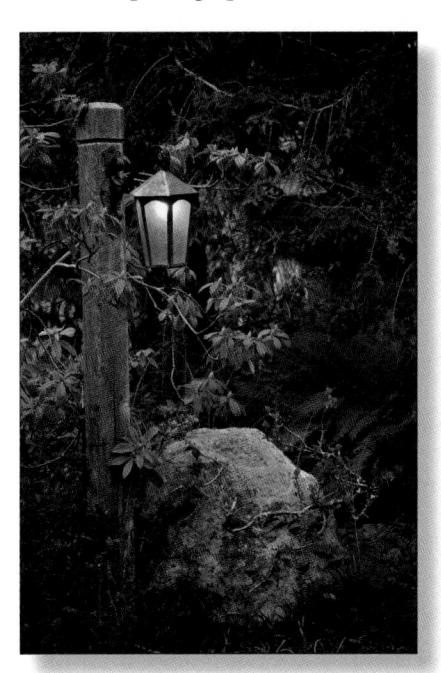

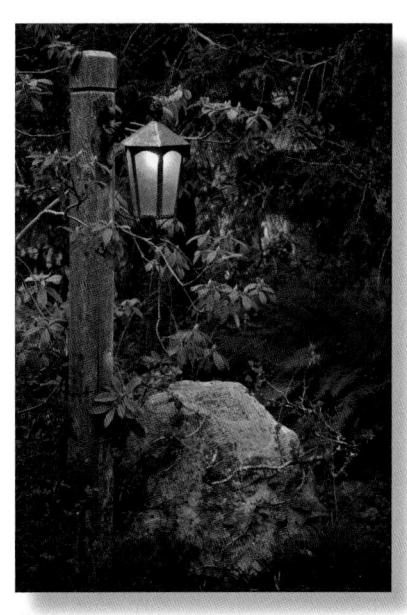

Figure 7–1: Improvements with crop and rotation

Crop in-camera

It's always best if you don't have to crop or rotate in post-processing; in both cases, you'll lose image data. Also, when rotating a photo other than in ninety-degree increments, the image will be subtly softened by interpolation (see Figure 7–2).

While shooting, whenever possible, slow down and take your time to perfect your compositions.

Figure 7-2: Loss of sharpness caused by arbitrary rotation

Image size and file resolution

Lightroom always processes (and crops) images using the full resolution of the files; there are no resizing/resampling controls within Lightroom. Don't be at all concerned with the size or resolution of the image when you're working in Develop. Resizing/resampling should only be considered during export or presentation (see Chapters 8 and 9).

Tone and contrast

Tone refers to the range of dark to light values in the image, without regard to color. An image containing tones from very bright whites to very dark blacks has a wide tonal range. Most "properly exposed" photographs can be expected to show this, but of course, some images will naturally have a narrow tonal range. More than any other aspect, tone sets the mood of the photograph.

An image with an overall light, bright appearance is referred to as a *high key* image whereas one with mostly dark tones and deep shadows is *low key*.

The tonal data captured is dependent on the accuracy of the exposure. Is the photograph underexposed or overexposed? Is it too dark, or too light, overall? See Figure 7–3 for some examples.

Contrast refers to the relationships of dark tones to light tones. Does the image "pop" with depth and dimension? Or does it appear flat and dull? A *high contrast* image contains a strong variation of light to dark tones, whereas a *low contrast* image has tones compressed to a narrow range (see Figure 7–4).

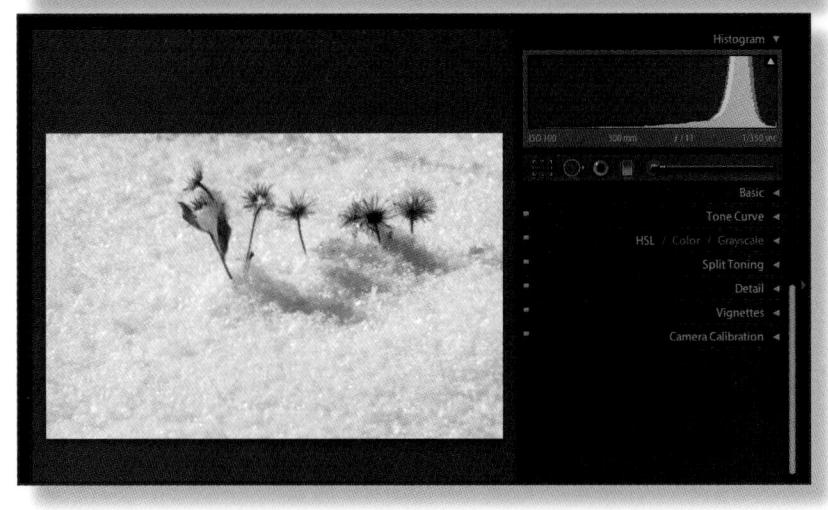

Figure 7–3: Tone and exposure samples: low key (top), normal (middle), high key (bottom). Note histograms, discussed further in this chapter.

7

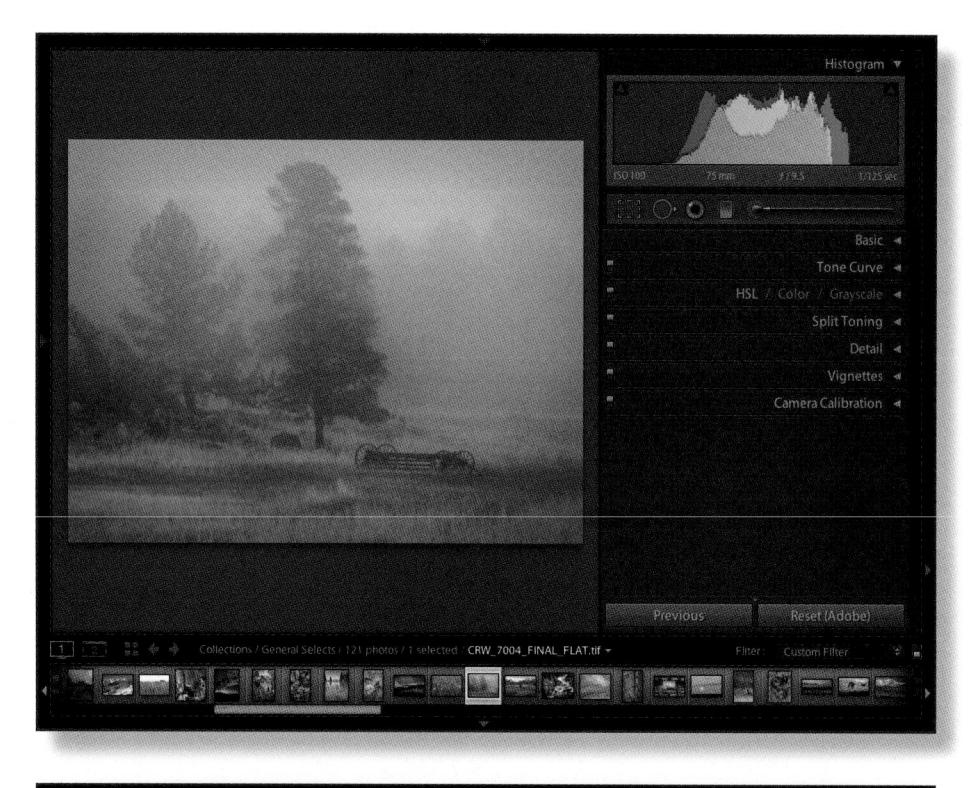

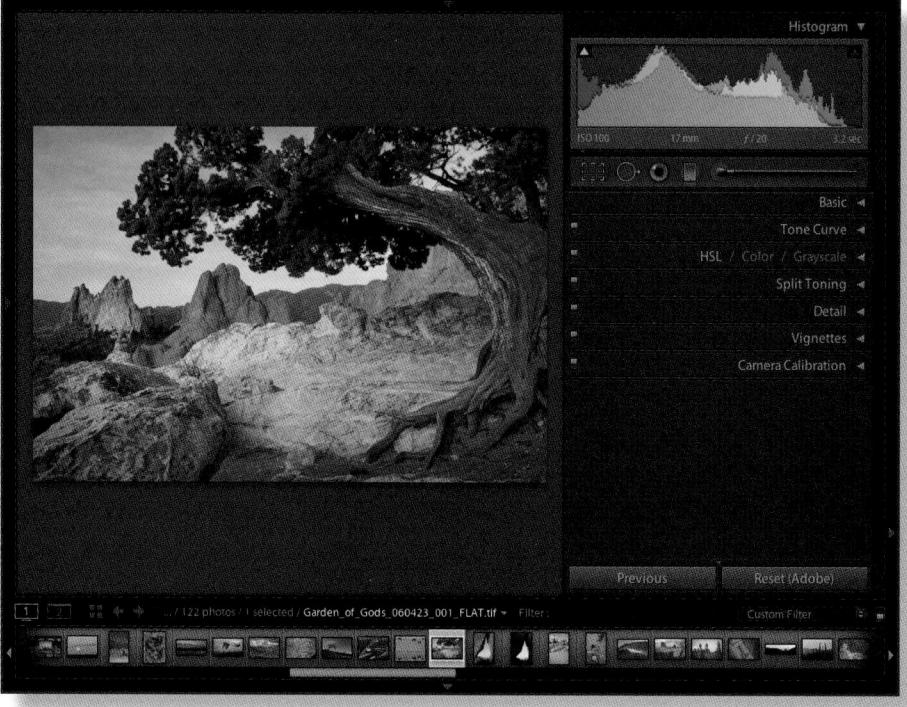

Figure 7–4: Contrast examples. Top photo is low contrast; bottom is high contrast. Note histograms.

Evaluate the tones of elements in the photo relative to one another. Using the elements in the scene, decide what should be brighter, what should be darker, and how all the tones should fall in between. Finish evaluating tone and contrast before moving on to color.

Color

Do the colors in the photo look "correct" (see Figure 7–5)? Are the colors vivid and bright, or dull and lackluster? Would the image be stronger as black and white?

Evaluate global color accuracy first, and then consider adjustments to specific colors.

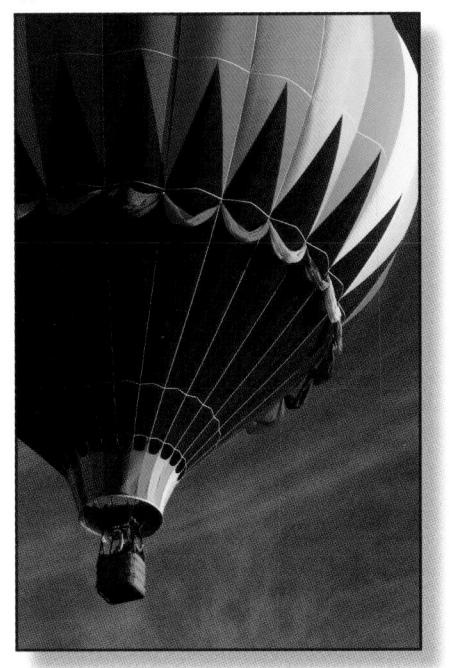

Figure 7-5: Good color, bad color

Noise and other artifacts

In a digital image, an *artifact* is an undesirable element caused by some aspect of the imaging process. Artifacts can be introduced at any stage from capture through final processing and should be carefully avoided and corrected whenever possible.

Digital *noise* (see Figure 7–6) is a common artifact that appears as small dark speckles and/or soft colored blobs in the image. Noise is typically introduced at high Iso settings; during long exposures and exposures made in low light;

7

and in captures that are underexposed. A little noise here and there will not always present a problem; the main issue is whether or not the noise will be visible when the image is printed. Zoom into the image to check for noise.

Another artifact common to many digital captures is *chromatic aberration* ("CA"; see Figure 7–7). Though it appears as a digital artifact that should be corrected, CA is caused by an analog source: the camera lens. Finding

Figure 7-6: Noise

and fixing CA in Lightroom is covered later in this chapter.

Figure 7-7: Chromatic aberration; note red and cyan fringes.

Potential for dodge and burn

Dodging is selectively lightening a local area of the photo; burning is darkening. Most photographs benefit from some amount of dodging and/or burning (see Figure 7–8). Ansel Adams has been quoted as saying his photographs were "never finished until he burned the corners", a common technique that helps keep the viewer's eye within the frame. Evaluate whether or not the photo could be enhanced with localized adjustments. For example, are there light or dark areas that distract from the subject? Could the appearance of depth and dimension be strengthened? Dodging and burning can help in these situations.

Figure 7–8: Left photo is original; right photo has received dodging and burning

Sharpness

Is the image in focus? If not, you might choose to work with another capture. With rare exceptions, a photo captured out of focus can't be fixed with sharpening in post-processing. Conversely, the appearance of sharpness in a capture made in perfect focus can be enhanced dramatically.

Zoom in to various levels to check for sharpness in key areas and consider whether some parts of the image need more sharpening than others (see Figure 7–9).

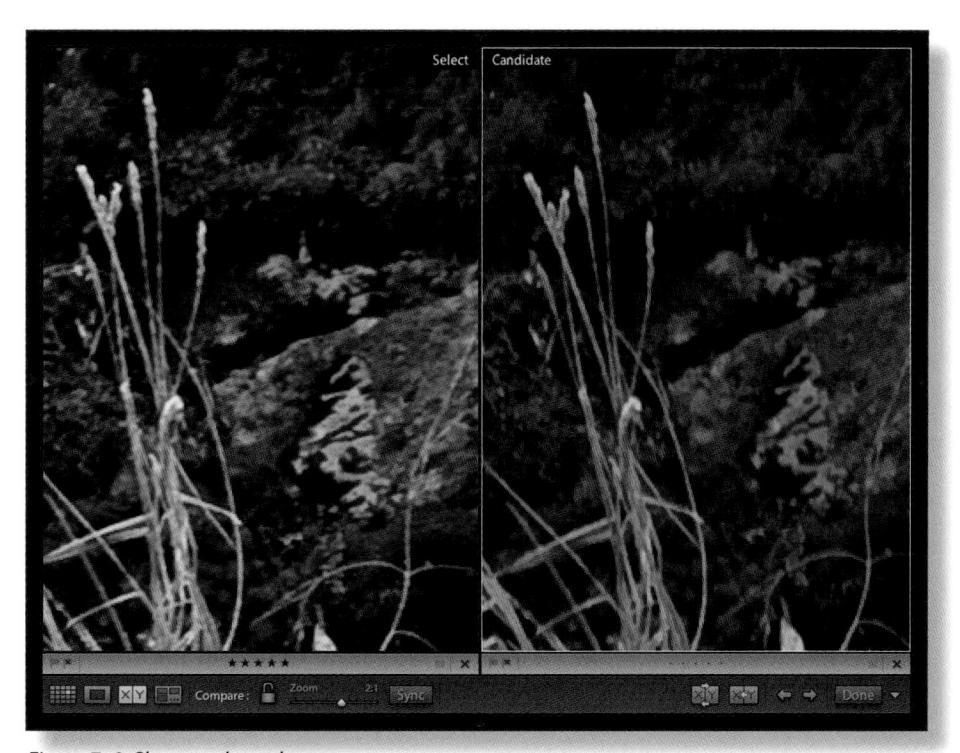

Figure 7-9: Sharp and not sharp

Fake focus

In some cases you can make the subject of a slightly soft photo appear sharper by slightly blurring other areas.

Retouching

Are there elements in the image you'd like to remove or otherwise clean up? Examples are spots caused by dust on the sensor, a branch appearing to stick out from someone's head, red-eye from flash, etc. (see Figure 7–10). Determine what elements you want to remove from the photo. Plan to re-assess the need for retouching after completing all the other steps; as you work on the image you're likely to discover artifacts and other flaws you didn't notice earlier.

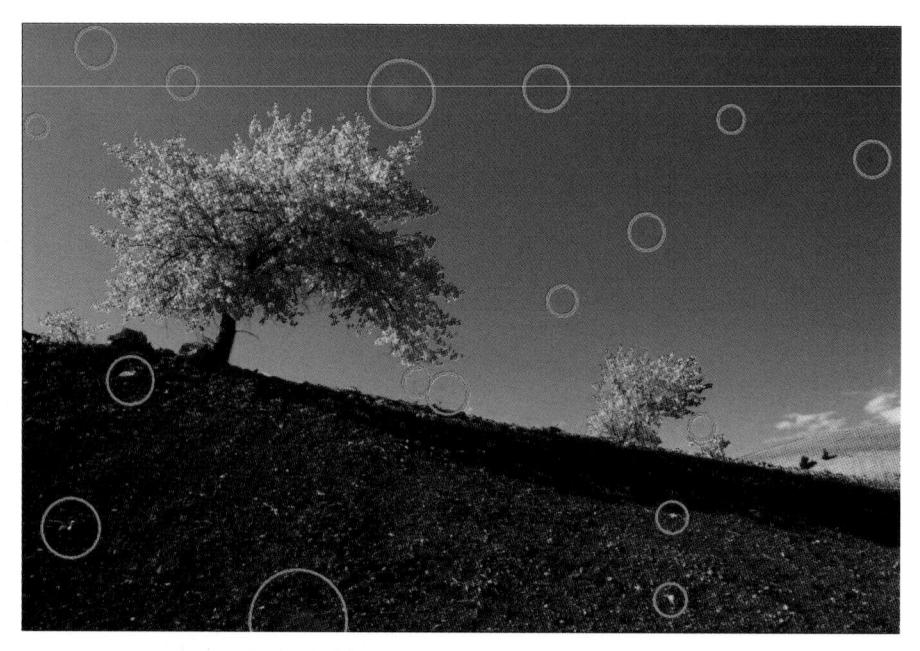

Figure 7–10: Objects needing retouching

LIGHTROOM DEFAULTS

When you import DNG or camera raw images, Lightroom must *render* the capture data to generate previews. This means that every raw capture coming into Lightroom is receiving some kind of processing, even if you don't apply any adjustments yourself. In these cases, Lightroom will render the captures using the *Lightroom defaults*.

Unfortunately, the Lightroom defaults may render your DNG and raw images with less than optimal quality. This can skew your perception of what data the capture contains and what needs to be done during processing.

By default, TIF, PSD and JPG files are *not* adjusted when they come into Lightroom. Their settings are *zeroed*; no processing is being done to the image at all. However, this, too, can be changed.

Make your own defaults

Work with your photos for a while to determine the Develop settings that provide the optimal rendering for the majority of your files, then override the default settings to create your own, new baseline for rendering newly imported images. The procedures for doing this are covered in detail later in this chapter.

MAINTAINING MAXIMUM QUALITY

As has been discussed in previous chapters, one of the primary goals of digital image processing is to retain as much data as possible from the original capture throughout the imaging pipeline. Regardless of the types of adjustments you make or special processing effects you apply in Lightroom (or any other software), it's usually best to process your images as non-destructively as you can.

This requires you to plan several steps ahead as you adjust images and, in general, to perform your processing tasks in a consistent sequence.

The order of tasks

As a metadata editor, Lightroom's Develop controls can potentially be adjusted in any sequence you like. You can go back and forth between panels and settings to progressively refine your image; Lightroom will apply the adjustments to the final image in the ideal way to maintain the most possible data. However, the order in which you perform your image editing tasks is important for several reasons.

- Different adjustment controls affect image data in similar ways. For example, increasing the Brightness value and adjusting the midpoint of the Tone Curve produce similar changes in the appearance of the photo.
- **Some adjustments affect others.** Continuing the example above, *increasing* the Brightness value and *decreasing* the midtone areas of the Tone Curve would produce counteracting adjustments.
- Tone and color should be evaluated and adjusted independently. You'll often find that once you get the tones right, the colors will also fall into place. For this reason, it's best to do as much tone correction as possible before moving on to adjust color. (The occasional exception is white balance, discussed in more detail later in this chapter.)

• Work gets done faster if it's done [essentially] the same way every time. Though some images will require more work and additional processing steps than others, following a consistent sequence of steps allows you to be more efficient through repetition. This allows you to spend more time on the photographs that really benefit from additional attention.

Don't make one adjustment that counteracts another

This wastes time and data and diminishes quality. As you're processing a photo, take care that the adjustments you make don't actually put you further from your goal. Use as few adjustments as necessary to achieve the desired appearance, and always use the best tool for the job.

ABOUT COMPOSITE IMAGES

Any photo that uses more than one original capture is called a *composite*. Lightroom currently can't produce composites. To combine multiple images you need to get them out of Lightroom and into other software, like Photoshop. Processing individual images destined to become part of a composite requires special consideration. If, during processing, you start thinking of combining multiple exposures—in any fashion and for any reason—you'll need to start considering export operations. This is covered in Chapter 8.

For now, as you're looking at processing single images in Develop, learn to make the most of the tools available. You may find that in some cases—especially those that at first glance appear to require blending exposures—can be fully accomplished in Lightroom.

You will find images that in the past may have required compositing now can be successfully processed with just one capture in Lightroom.

🦪 Process as far as you can in Lightroom

Many photographers who have been using Photoshop or other image processing software for a long time have a natural inclination to do a minimal amount of work in Lightroom, wanting to switch to the other program as soon as possible to finish the photo. I believe if you're one of these people, you're cheating yourself.

Practice processing the image as far as you possibly can, using Lightroom alone, before switching to another program...you won't regret it! When you've mastered the Develop controls in Lightroom you need not spend nearly as much time in other software.

At the end of this chapter I've included instructions for Lightroom's roundtrip processing procedure for editing photos in Photoshop.

Developing Photos

For each photo, use your evaluation checklist to decide what processing needs to be done to finish the photo. Go through your processing methodically, taking the time to finish each photo before moving onto the next. In some cases, batches of images can be Developed the same way; Lightroom accommodates this with ease.

Always perform the major adjustments first and work your way to the fine details

Start your photo processing by doing the *global* adjustments—those that affect the entire image—and progressively work towards fine tuning the details (local adjustments). For example, do your retouching after adjusting tone and color.

Most Lightroom Develop settings are absolute

The Develop slider adjustments are absolute values. For example, if the Exposure is set at +.25 and you change it to +.50 the resulting value is +.50, not +.75. (The exceptions are the Quick Develop adjustments in Library.)

If it doesn't improve the image, turn it off

When experimenting with adjustment controls or applying settings with the intention of achieving a specific effect, if you find that the adjustment is not an improvement, undo the adjustment or reset the slider to its default.

UNDO/REDO

Unlimited undo and redo removes the fear of experimentation. In Develop you can't irreparably harm an image—but you can surely make it look bad! Lightroom maintains an unlimited history of all the processing work you do on an image from the import forward. So feel free to play!

To undo the last operation. Continue pressing to go further back in History.

> #+Shift+Z or Ctrl+Shift+Z

To redo the last undone operation.

Don't use undo/redo like before/after

Lightroom offers better controls for seeing the image with and without an adjustment... read on!

APPLYING CAMERA **PROFILES**

As mentioned earlier in this chapter, the initial previews you see will be created using the Lightroom defaults unless you change them. Therefore, as a starting point for establishing the best possible default rendering for your photos, first apply a camera profile from the Camera Calibration panel (see Figure 7–11).

Note: camera profiles can only be applied to camera raw and DNG images.

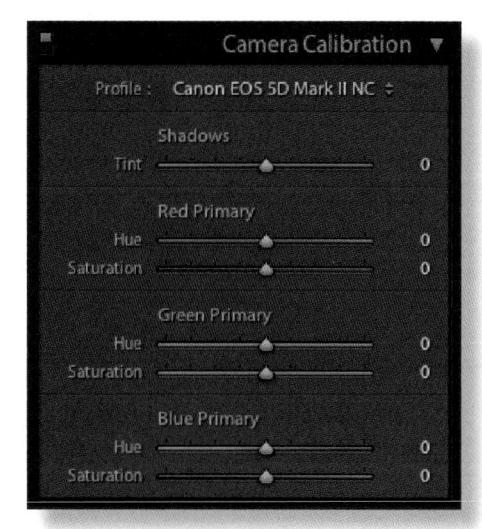

Figure 7–11: Camera calibration panel; camera profile menu

With the current camera profiles installed (see below), Lightroom will automatically show the profiles applicable for the camera model used to make the original capture. However, Adobe has not produced profiles for every camera available on the market and likely never will. If your camera is not listed, you can use the default Adobe profiles or create your own.

> \#+7 or Ctrl+7

To open/close the Camera Calibration panel.

Hide panels you're not using

Adjust panels to make more room for the photo; I usually hide the left panel and show it temporarily to work with presets (see Figure 7–12).

Installing/uninstalling camera profiles

At the time of this writing, Adobe's camera profiles are automatically installed when you install Lightroom (version 2.2 and higher), DNG Converter (v5.2 and higher) or Adobe Camera Raw (v5.2 and higher). If you installed earlier versions of these products, you might have the old, beta profiles still installed on your system. These can be removed by deleting them from the folder; however, be aware that any presets made using those beta profiles will no longer function correctly.

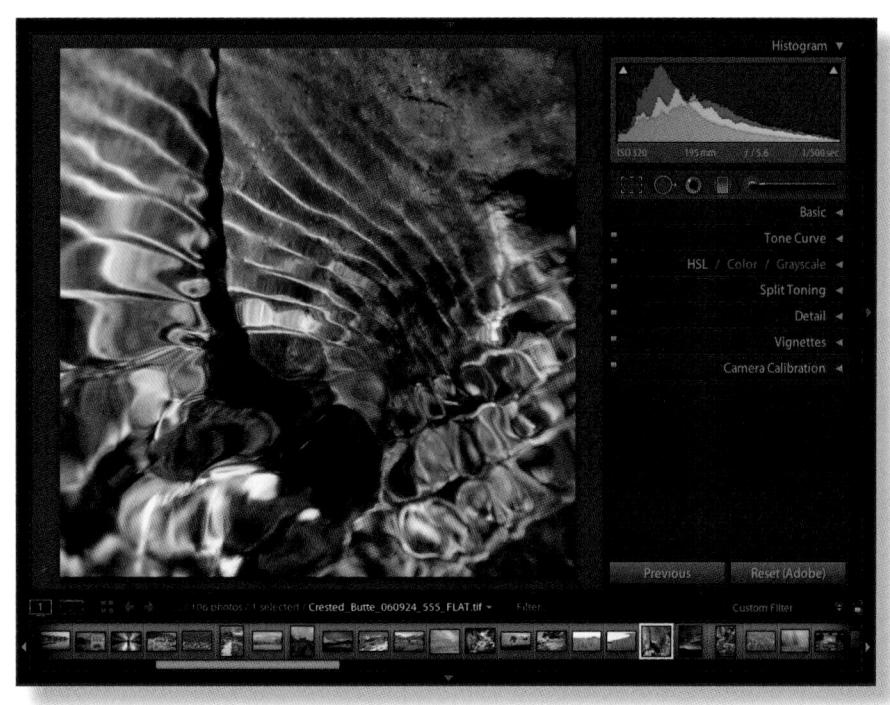

Figure 7–12: My panel setup for working in Develop

The locations of the camera profiles are:

Mac os x: /Library/Application Support/Adobe/CameraRaw/CameraProfiles

Windows Vista: C:\ProgramData\Adobe\CameraRaw\CameraProfiles

Windows 2000/xP: C:\Documents and Settings\All Users\Application Data\Adobe\ CameraRaw\CameraProfiles

Some images benefit more than others from different profiles

Try each of the various profiles until you get the best results. This will dramatically improve the baseline rendering of your captures!

Make your own camera profiles

Though the Adobe profiles can often get very close to the optimal rendering on many images, you will achieve the best results by profiling your own camera. More information and instructions for doing this are at Adobe's DNG profile editor Web site, listed in the Appendix.

About the camera calibration sliders

Prior to the relatively recent introduction of camera profiles, the Camera Calibration slider adjustments were commonly used to apply baseline rendering values stored in Develop defaults. Determining the optimal settings for these sliders required running a complex, third-party script that evaluated a captured target and generated the numbers to enter for the adjustments.

In my opinion, camera profiles have made the Camera Calibration slider adjustments obsolete and I generally recommend you don't make adjustments to these sliders or use them in presets. However, due to the fact that many Lightroom users have processed photos and created presets using these sliders in the past, it's likely that they will remain a part of Lightroom, at least in the near-term.

CROPPING

Before you go much further into processing, take a few moments to crop and/or straighten the photo as necessary. (Note that because all digital images are rectangular, straightening a photo *always* involves cropping.) Be willing to crop photos in Lightroom whenever it makes an improvement.

Lightroom's crop and straighten tools are in the *tool strip* on Develop's right panel group, just below the Histogram (see Figure 7–13). Activating the tools opens the *tool drawer* underneath the tool strip. The tool drawer contains all the controls for each tool.

Click the crop tool button in the tool strip (or use the shortcut) to enable the crop overlay, which is then displayed over the image. Drag the corners or the sides of the overlay to adjust the crop. The crop overlay remains straight and centered in the image preview area; the photo moves underneath it.

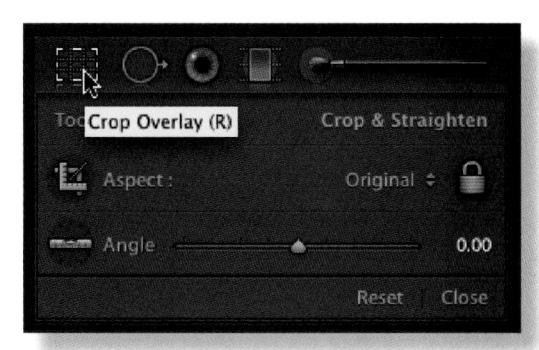

Figure 7–13: Activating the crop overlay

Drag the photo to reposition it within the crop overlay.

To activate the crop tool (from any module).

н

To toggle hiding/showing the grid in the crop overlay.

To cycle through the following overlays (see Figure 7–14). These are based on long-held principles of design and are included to aid composition while cropping:

- Rule of Thirds
- Golden Ratio
- Diagonal Lines
- Triangles
- · Golden Mean
- Grid

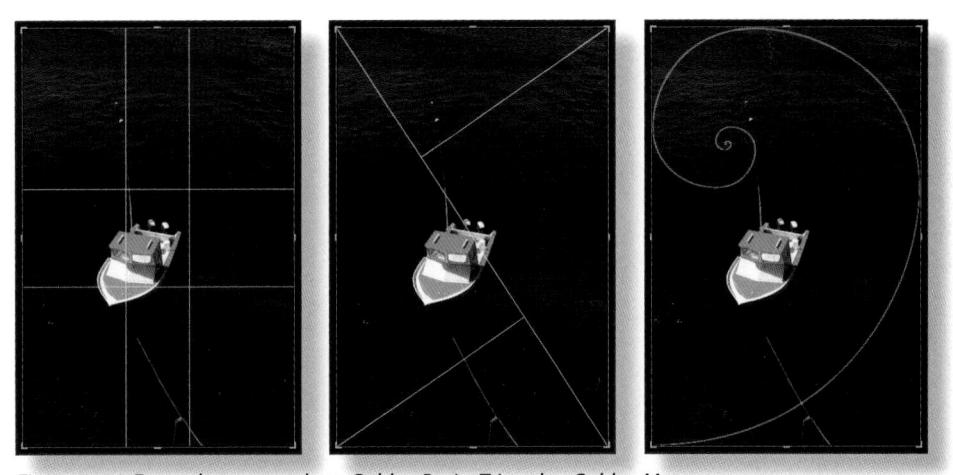

Figure 7-14: Example crop overlays: Golden Ratio; Triangles; Golden Mean

Shift+O

To flip the crop overlay (only visible with asymmetrical overlays).

Esc

To cancel cropping without applying the changes.

Enter or R

To apply the crop when you're done adjusting.

Use Lights Out when cropping

Press L twice to black out everything on your screen but the image—it's much easier to see how the cropped image will look.

Aspect ratios

The aspect ratio of an image refers to its length and width, expressed as a ratio. For example, 2:3 means that the photo's short side is 2 units and the long side is 3 units. (The units of measurement can later be translated into real world measurements. such as size in inches for printing.)

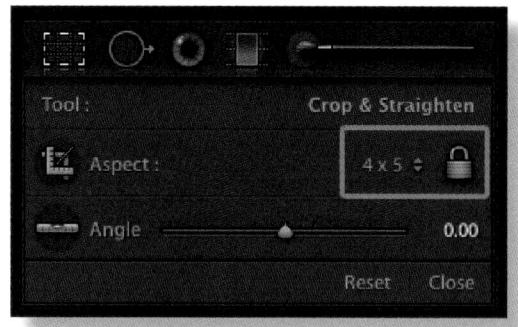

Figure 7–15: Padlock button and aspect ratios

When cropping in Lightroom, you can *constrain* the crop to a precise aspect ratio or apply a free form crop that is not locked to any aspect ratio. The padlock button (see Figure 7–15) toggles whether or not the crop overlay is constrained. Next to it, a popup menu allows you to choose a ratio or to create your own.

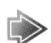

Notion or Alt

To crop from the center of the photo.

Toggles the padlock to lock the aspect ratio.

To apply the most recently used (locked) aspect ratio to the current photo.

🐶 Use standard aspect ratios when possible

In Lightroom you can crop a photo any way you like, without regard to specified aspect ratios. It's always best to let the composition of the image determine the optimal crop. However, your plans for printing and framing the photo may introduce other constraints. For example, using a 4:5 aspect ratio will allow an 8x10 print in a 16x20 frame. Think about how you will finish the photo and when appropriate use a standard aspect ratio.

Rotating and straightening

You can rotate your photo to make it appear more level, or you can use rotation as a creative effect.

The easiest way to arbitrarily rotate the photo is to place your cursor outside the crop overlay; the cursor turns into a curved double-arrow. Click and drag to rotate the photo under the crop overlay (see Figure 7–16).

Alternatively, you can use the following methods for rotation:

- Click and drag with the Straighten tool;
- Drag the Angle slider; or
- Enter a numeric value in degrees (see Figure 7–17).

₩ or Ctrl

To temporarily switch to the Straighten tool while the crop overlay is active.

Use overlays to assist with rotation

If you want to straighten a horizon or other prominent line in the photo, use the grid overlays to help line things up.

Changing orientation

You can use the crop tool to turn a landscape-oriented image to a portrait and vice versa (see Figure 7–18). First, select an aspect ratio and be sure the padlock button is closed. Then, with the crop overlay visible, drag a corner either horizontally or vertically, depending on what orientation you're changing to. For a horizontal change, drag up or down. For vertical, drag left or **right.** As you approach the center of the photo, the crop will snap to the opposite orientation. Continue cropping as usual. (This isn't the easiest technique to get the hang of; keep trying!)

Figure 7–16: Rotating with the cursor

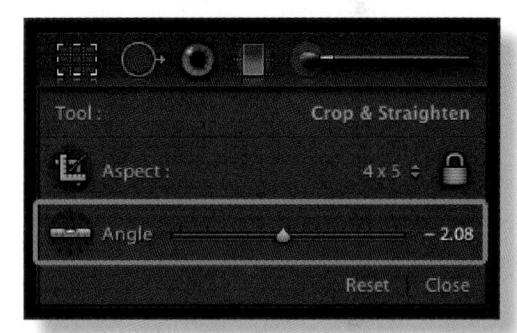

Figure 7–17: Straightening tools

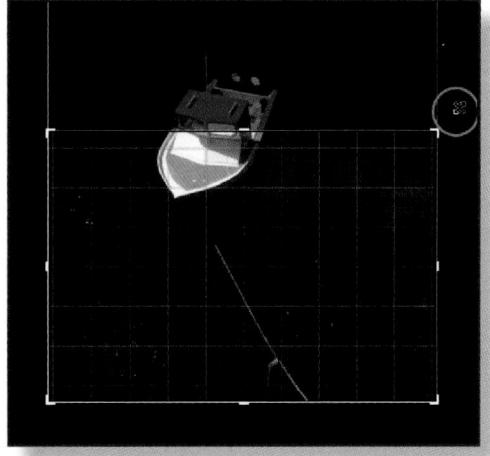

Figure 7–18: Changing orientation using the crop overlay

The crop frame tool

With the crop frame tool (see Figure 7–19), you can draw a freehand crop in either portrait or landscape orientation. When using the crop frame tool, the aspect ratio controls apply in the same way as when manipulating the crop overlay directly.

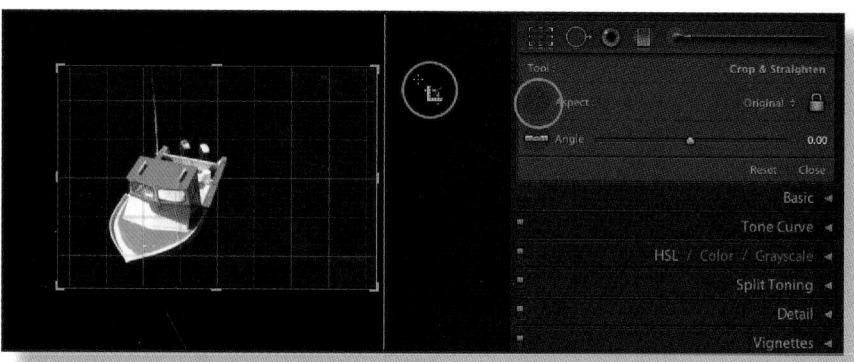

Figure 7-19: Crop frame tool

Resetting the crop

To reset the crop overlay to its original settings, click the Reset button in the tool drawer or use the following shortcut. (Note: both crop and rotation will be reset.)

To reset the crop.

ADJUSTING TONE AND CONTRAST

After cropping, the next processing tasks to perform are tonal adjustments.

Every capture contains a finite amount of data, with dark and light and levels in between, and though some contain a wider range of tones than others, once you get the file into Lightroom the goal is to optimize the captured tones to meet your vision of what the final photograph should be. Whether the finished photo ultimately reveals a wide range of tones or a narrow one (see Figure 7–20), always try to make the most of the available data.

This requires first determining where the black and white points should fall and, based on that, how the rest of the tonal data should be distributed throughout the image. This takes practice; evaluating the image and knowing where to place the tones for best effect is not a simple or automatic process. Fortunately, there are some long-held standards you can use to guide your decision-making:

• Shadow (black point): in the RGB color model, solid black has the same numeric value in all three channels. Some images can benefit from having some pixels set at solid black; others, not. In Lightroom's Basic panel, the Blacks slider adjusts the black point, transitioning up toward the midtones.

- Highlight (white point): highlights are the brightest spots in the photo. In
 some cases, the brightest pixels might be pure white; again, equal in all color
 channels. However, to show detail in highlights, they need to contain some
 pixels with values at some levels less than pure white. Lightroom's Exposure
 slider adjusts the white point, transitioning down toward the midtones.
- Midtones: this refers to tones in the middle of the scale—halfway between solid black and pure white. (This is not the same as middle gray or neutral gray.) The Brightness slider adjusts midtones in Lightroom, transitioning down toward the black point and up toward the white point.

The actual numeric values of the pixels in these zones will vary depending on the color model used. This is why the terms *shadows*, *highlights* and *midtones* are used to generally describe the same places on the tone scale, regardless of color model or numeric values.

Again, keep in mind that tone is separate from color. All you should care about at this stage is how light or dark a particular element or group of elements in the photo should be. Use your intuition. Take as much time as necessary to get the tones right—the remainder of processing becomes easier.

Figure 7–20: Left photo has a wide tonal range; right photo has a narrow tonal range.

Reading the Histogram

The Histogram (see Figure 7–21) is a bar graph showing the distribution of tonal values in the image. The black point is at the left side of the horizontal axis; the white point is at the right. Midtones are at the middle of the horizontal scale. The values displayed on the vertical axis represent the relative number of pixels at each tonal level.

7

There is no such thing as a "correct" Histogram. As every image is different, every Histogram will be unique. However, the shape of the Histogram can help you make decisions about how to process the tones in an image. Usually, the width of the data shown in the Histogram is more important than the height; the Histogram for an image with a wide tonal range will show data distributed over the length of the horizontal axis, whereas a photo with limited dynamic range will show all the data clustered in one area of the graph.

The colors in the Histogram represent pixel values for each of the RGB channels and their complements: cyan, magenta and yellow. Gray represents areas of overlapping pixel values for all three channels.

As you move your cursor within the Histogram, tone ranges are illuminated that correspond with the Tone sliders in the Basic panel (which also become illuminated).

At the bottom of the Histogram is an information display. Its default state shows key settings of the capture. As you move your cursor over the photo the readout changes to show the values for each channel, in percentages. (In Lightroom's color model, pure white is 100% and pure black is 0%.)

● 第+0 or Ctrl+0

To open and close the Histogram panel.

Click and drag in the Histogram

To adjust the image tones based on the Lightroom-defined tonal ranges.

Figure 7–21: Histograms for sample photos (this page and next page)

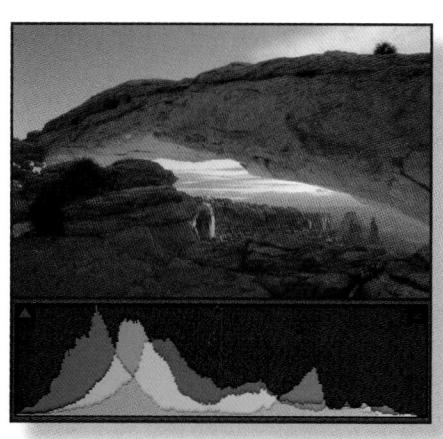

Clipping

Clipped highlights are pure white; clipped shadows are solid black. Both result in a loss of detail, so clipping should be identified and dealt with appropriately on each image. On the Histogram, clipping is shown by tall spikes at either end.

The triangles at each end of the Histogram activate *clipping indicators* overlaid on the image preview (see Figure 7–22). Place your cursor over a clipping indicator to temporarily see the clipping preview; click an indicator to toggle it on and off. In the preview, blue indicates black point clipping;

Figure 7–22: Clipping and clipping indicators

red shows white point clipping.

The red and blue displays are brightness (luminance) clipping indicators. They will appear even if clipping is only present in one channel. To see clipping in individual channels, use the Option/Alt method, discussed later in this chapter.

You can use the Exposure, Blacks and/or Recovery sliders to reduce or eliminate clipping, as appropriate for each photo.

To hide and show luminance clipping in Develop.

Optimizing tonal values

Working with a raw capture, you may be very surprised at how much tonal data you can pull from what originally appears as a low contrast image. With just a few adjustments, you can maximize a photo's dynamic range and increase contrast with dramatic results.

Start by adjusting the black and white points then focus on the midtones. Finally, fine tune smaller tone zones to your liking.

Lightroom provides controls on several panels to adjust the tones of a photo:

- Basic panel: Exposure, Blacks, Fill Light, Recovery, Brightness and Contrast sliders;
- **Tone Curve** panel: adjust tones using sliders, direct manipulation of the curve and the targeted adjustment tool (see next section); and
- HSL panel: allows you to adjust tones in the image based on color range.

Start by adjusting tones using the Basic panel:

Step 1. Set Exposure and Blacks

Use **Exposure** to adjust the white point and the range transitioning down toward the midtones. This will have a major effect on the overall brightness of your photo.

Then use **Blacks** adjustment to adjust the black point and shadows, which will add contrast to the photo. Typical Blacks values might fall between 5 and 10; for some images you may go much higher.

Adjust the two back and forth, playing them against each

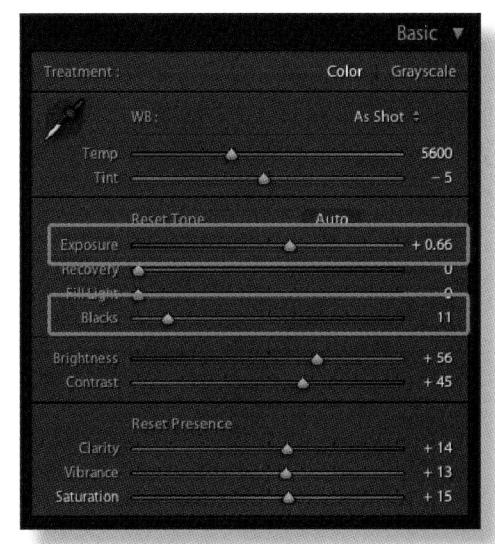

Figure 7–23: Exposure and Blacks

other, to create the starting tone range for the image. Stretch out the tonal range to increase contrast and your photo will look better immediately. Periodically check the Histogram and watch out for clipping. I like to get as much contrast as I can using Exposure and Blacks before going on to the other adjustments (see Figure 7–23).

7

₩+1 or Ctrl+1

To open/close the Basic panel.

The most important step in successfully processing your photos

Spend a few minutes working both the Blacks and Exposure sliders before moving on.

These two sliders make the biggest difference in the overall rendering of the image.

₩ Hold Option or Alt while dragging Exposure and Blacks sliders
While adjusting Exposure and Blacks, holding the Option or Alt key will display
where clipping is present in individual channels (see Figure 7–24).

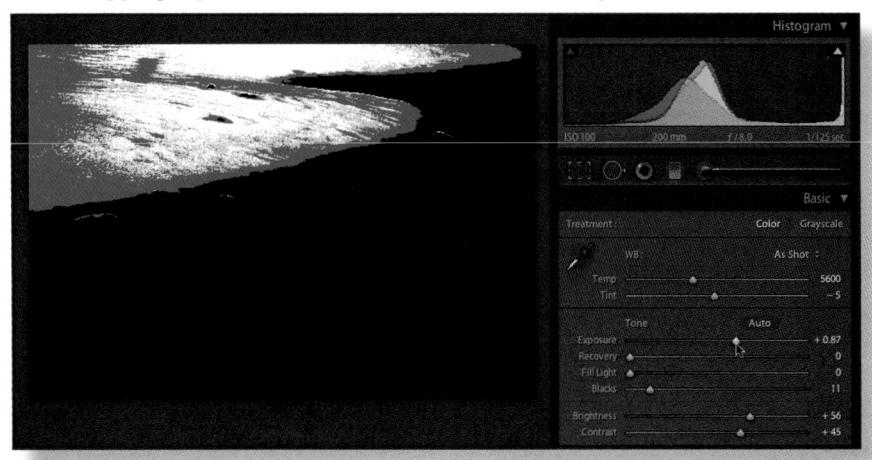

Figure 7–24: Clipping shown in individual channels by holding Option or Alt key while dragging sliders

Step 2. Set midtones using Brightness

The **Brightness** slider (see Figure 7–25) adjusts a relatively wide range of tones in the image by manipulating the midpoint. Like Exposure, increasing or decreasing Brightness has a big impact on appearance of the overall image. (However, it's important to keep in mind that the Brightness and Exposure are manipulating different sections of the tone range.)

Whereas deciding on Blacks and Exposure can be easy, placing the

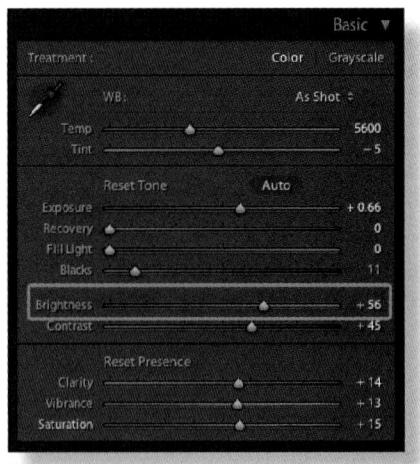

Figure 7-25: Brightness

midtones is somewhat trickier. For starters, black and white are absolute; the midtones span a range. Determining what values in the scene should be placed at midtone is part of the fun and challenge of processing.

Fixing Over- and Under-Exposure

Depending on the image, and whether it's over- or under-exposed, you must work the Blacks and Exposure, bit by bit, to gain the ideal tonal range. Don't expect to do everything with just one slider!

- For overexposed images, try decreasing Exposure as the first step, then increase Blacks. Use Recovery to reduce white point clipping (see below).
- For underexposed images, decrease Blacks if possible and increase Exposure. (Note that for some sliders there is no negative value offered; for example, the lowest you can go on Blacks is 0.)

Widen panels for more precise control

You get more precision from the sliders in Develop's right panel group by making it wider. Click and drag the edge of the panels to change their widths.

Handling highlight and shadow detail

If your photo contains clipped highlights, you can often recover some tonal information using the **Recovery** adjustment on the Basic panel (see Figure 7–26). The Recovery slider instructs Lightroom to apply data values from channels that are not clipped into the channel(s) that is/are clipped. The exceptions are cases where all three channels are clipped to pure white, in which case Recovery won't help. The result of Recovery is most often a very light, neutral gray replacing the pure white pixels, but at higher amounts, Recovery also affects a significant range of highlight values in addition to pure white (see below).

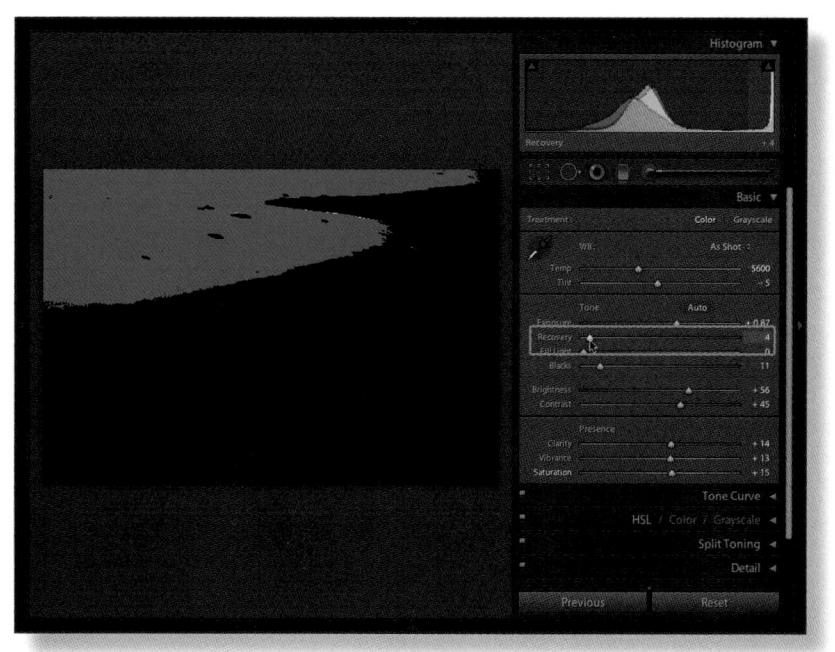

Figure 7–26: Recovery

Fill Light brightens dark shadow areas but leaves the black point alone. Use Fill Light to open up shadows and reveal more detail (see Figure 7-27).

⚠ Don't overdo Recovery or Fill Light

Going too far with these controls is easy to do and causes a loss of overall contrast in the image. Except for extreme cases, or images you're stylizing for effect, you shouldn't usually use values over +20 on the Recovery or Fill Light sliders. Instead, try to use the Tone Curve to get more control over those tonal ranges (next section).

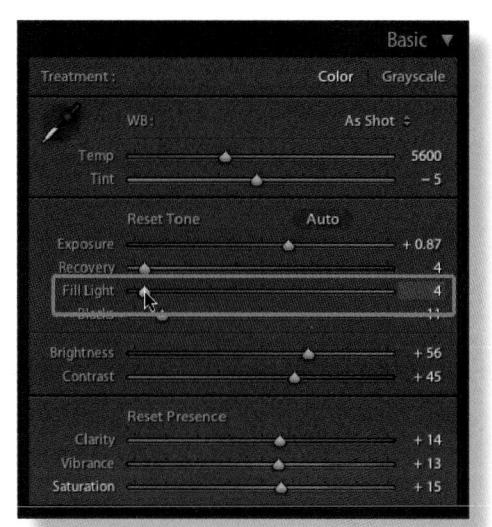

Figure 7-27: Fill Light

Move between adjustments using the keyboard

Click on the name of a slider to highlight it. You can then modify the selected adjustment using the following keyboard shortcuts.

To go to the next adjustment in the active panel.

To go to the previous adjustment in the active panel.

To decrease the value of the active adjustment.

To increase the value of the active adjustment.

Shift+- and Shift+=

To increase the adjustment amount.

To reset the active slider.

Fine-tuning contrast to make the photo POP!

A photo that shows great depth and clarity does so through the use of contrast, especially across the midtones. The placement of smooth, subtle transitions against strong, hard edges is key to making a photo pop. Lightroom provides several powerful controls to place the tones in your photo just where you want them.

Step 3. Adjust Contrast

This simple slider on the Basic panel (see Figure 7–28) conceals a lot of power. Unlike the crude, old-school controls in programs like Photoshop, Lightroom's Contrast and Brightness adjustments have been programmed from scratch and can be used to great effect. The Lightroom default for Contrast is +25; my personal default starts with Contrast at +35 and I adjust up or down from there as appropriate for each photo.

Clarity

Also in the Basic panel, the Clarity slider adjusts contrast—but only in the midtones (see Figure 7–29). Increasing the Clarity value can enhance contrast and the appearance of sharpness, while negative amounts

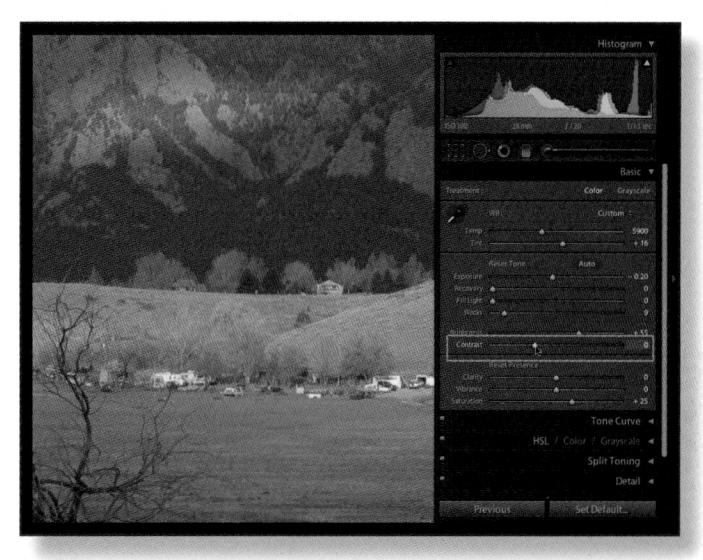

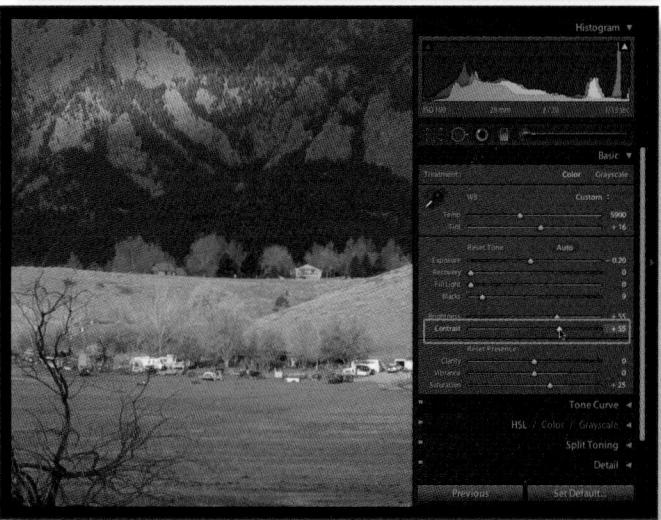

Figure 7-28: Contrast slider and its effects

create a lower contrast, "softer" look. Some images benefit greatly by increasing the Clarity slider; others, not as much. Photos with strong edges and details containing relatively high contrast, such as buildings and architecture, are good candidates for increased Clarity amounts. Portraits may benefit from negative Clarity settings.

7

Setting Clarity too high can result in visible halos along edges; keep an eye out for this. I recommend that you try adding Clarity to your photos to determine the proper amounts and what kinds of images work best with this adjustment.

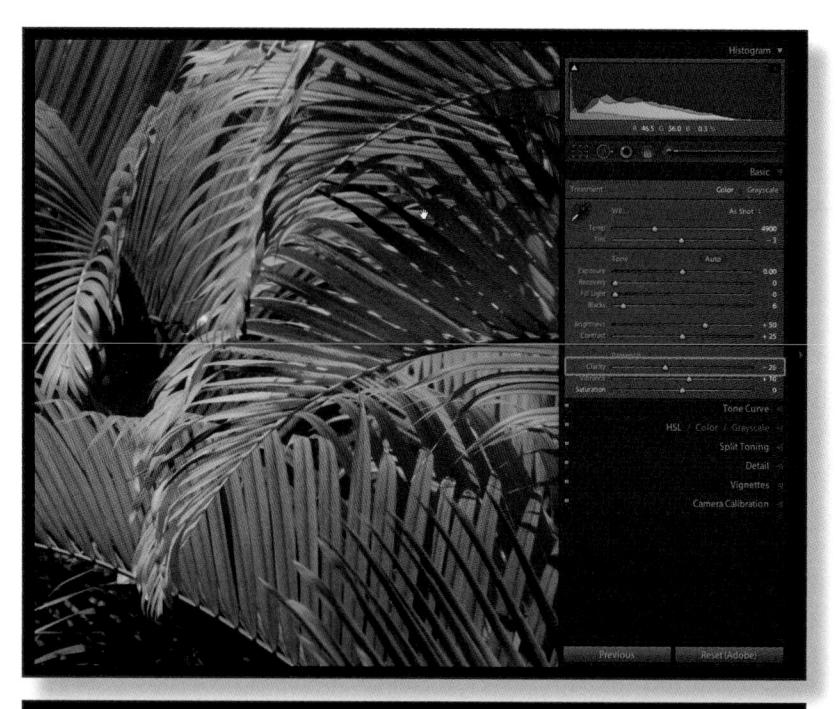

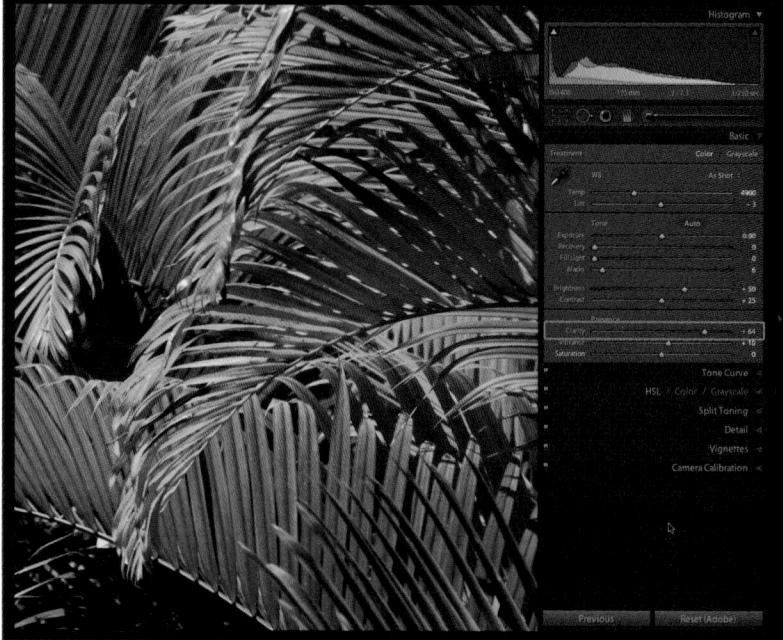

Figure 7–29: Clarity slider and its effects

Try negative Clarity

Negative Clarity values create a soft, otherworldly effect that is beautiful for some images. I particularly like to use negative Clarity on black and white photos. Give it a try!

Keep working the Basic adjustments

Get as close as you can to your desired result with the controls on the Basic panel before moving on to settings in the other panels.

Tone Curve

After adjusting the settings on the Basic panel, you can further refine the photo's contrast by manipulating specific tone ranges with the Tone Curve panel (see Figure 7–30).

If you've used curves in Photoshop or other software, the Tone Curve panel will be familiar to you. The horizontal axis represents the original, unaltered values in the image, with the black point at the left and the white point at the right. The vertical axis represents the adjustments you make. The background of the curve box shows a histogram and a highlighted area indicating the minimum and maximum range of curve adjustments based on the split controls in effect (see below).

However, unlike Photoshop, Lightroom's Tone Curve is *parametric*: it adjusts sections of the tone scale, rather than from individual points. This provides smoother transitions between tone ranges and reduces the possibility of introducing undesirable hue shifts and banding (*posterization*).

Adjust the curve to increase or decrease contrast in specific areas of the tonal range. Positive values lighten tones and negative values darken them. The steeper the curve (or section of the curve), the higher the contrast. The flatter the curve, the lower the contrast. A typical example of this is the application of an "S" shaped curve, which increases contrast in the photo by lightening highlights and darkening shadows. Thus, the midtone section of the curve displays a steeper slope than before the adjustment. And viola increased contrast. I typically start with these custom default settings: Highlights: 0; Lights: +5; Darks: -5; Shadows: 0; and Point Curve: Linear.

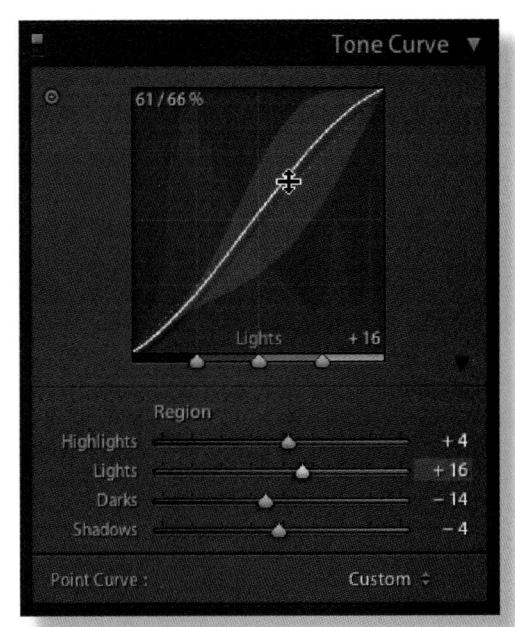

Figure 7-30: Tone Curve panel

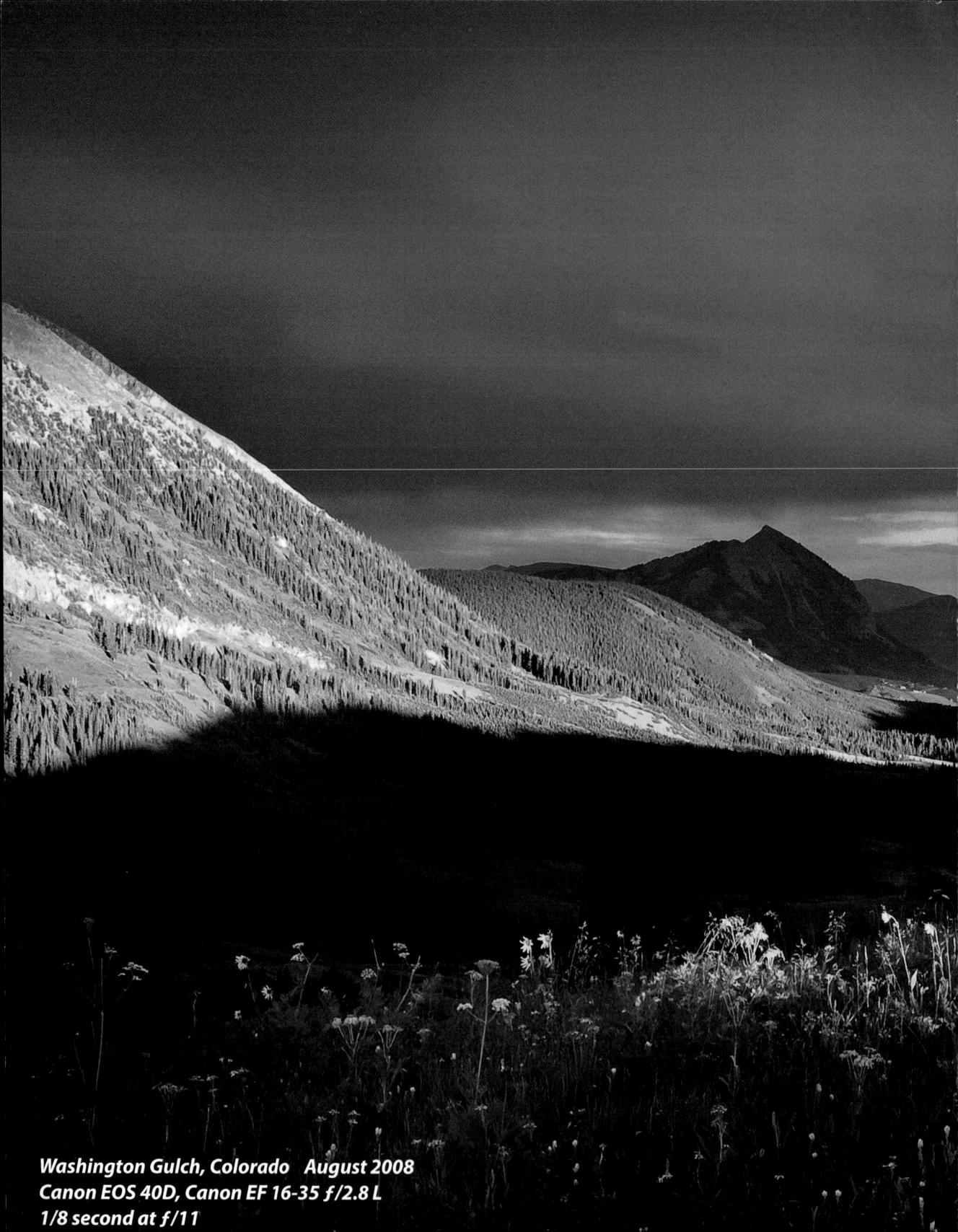

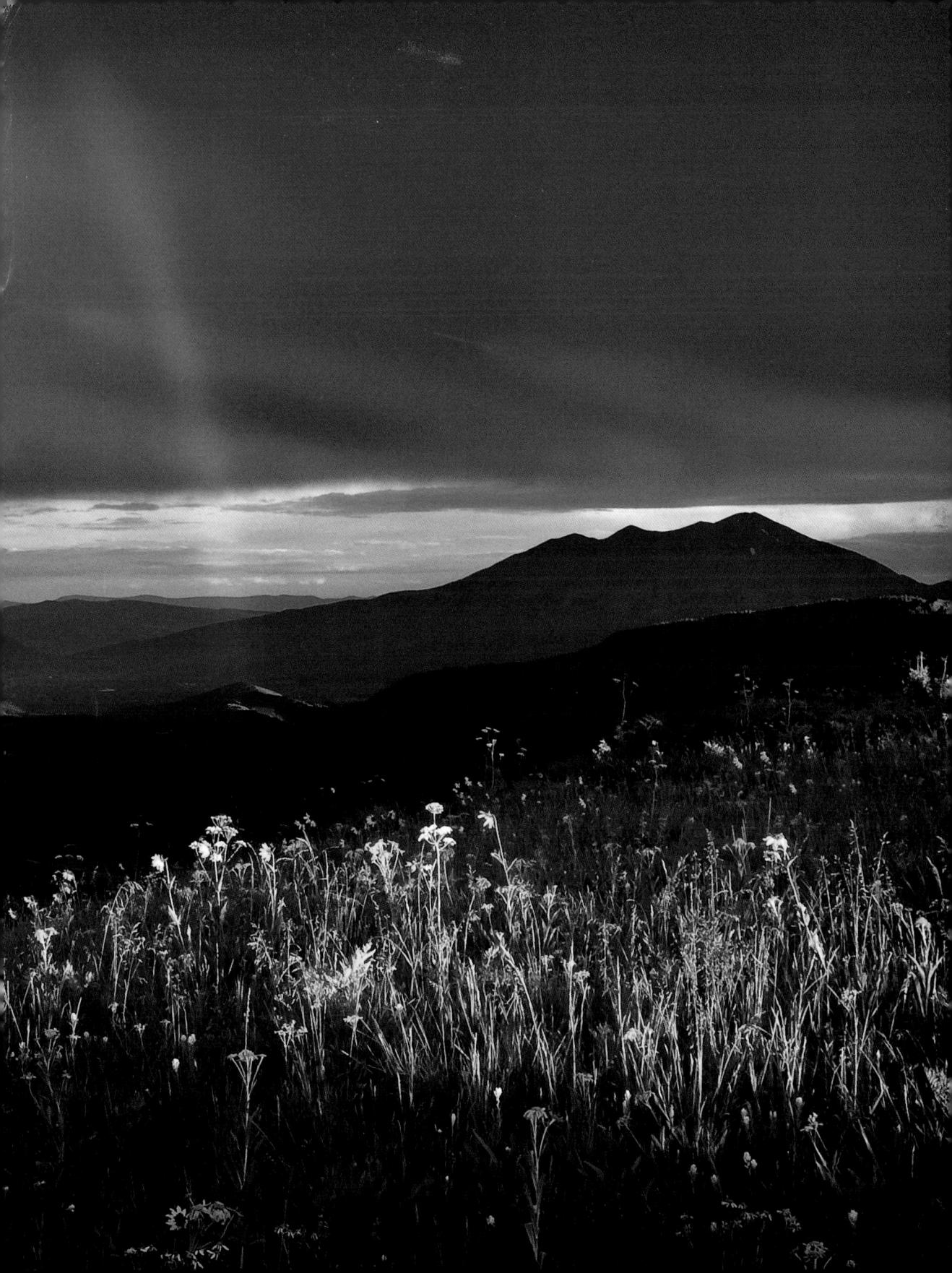

₩+2 or Ctrl+2

To open/close the Tone Curve panel.

Expand the Tone Curve panel
Click the triangle button to show the range sliders (see Figure 7–31).

You can adjust the Tone Curve in the following ways:

- Select an option from the Point Curve menu: Medium Contrast, Strong Contrast or Linear.
 (I always start with Linear.)
 Applying a point curve setting affects the curve but not the region slider values.
- Drag the sliders to adjust the four tone ranges independently: Highlights, Lights, Darks, Shadows. The curve will be adjusted accordingly.
- Click and drag on the curve itself: up to lighten, down to darken.
- The Targeted Adjustment tool: click the bull's-eye to activate it, then either click and drag up or down in the image, or use the up and down arrow keys. See the next section for more information about the Targeted Adjustment tool.

The *split controls* on the bottom axis of the curve box define the range of

Figure 7-31: Tone Curve sliders

Figure 7-32: Split controls

adjustment for each of the four regions (see Figure 7–32). As you drag the split controls, the slider background adjusts to display the range of tones available for each region. Using the split controls you can achieve very precise control over the curve adjustment.
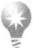

Opening up shadows with the split controls

In my work, I rarely find adjusting the split controls is necessary. One exception, though, is in opening up shadow detail, especially in preparation for printing. Changing the balance between Darks and Shadows can often provide the exact amount of control required to keep shadows from "blocking up". I'd much rather use the Tone Curve for this than the Fill Light adjustment, whose operation and results I consider crude by comparison.

Soft contrast

Some photos look best with a low range of contrast. Imagine a shot of a foggy morning at the lake. This kind of image naturally has a low range of contrast, and thus, probably shouldn't "pop". Always make your processing decisions based on the theme, subject and mood that you want to portray with the photo.

Applying a custom Point Curve

If you have Photoshop, you can apply a custom Point Curve in Adobe Camera Raw. When the file is read into Lightroom, that Point Curve data will be respected (and shown in the parametric curve display).

Double-click to reset sliders

If you change your mind after adjusting a slider, double click the name of the slider to reset it to its default value.

Reset all the sliders in a panel section

To reset all the sliders in a section to their default values, either double-click the name of the section, or hold the Option or Alt key; the name of the panel section changes to Reset. Click to reset all the adjustments in that section.

∺+S or Ctrl+S

As you're processing photos, remember to frequently save out your metadata!

TARGETED ADJUSTMENTS

The Tone Curve, HSL and Grayscale Mix controls provide a targeted adjustment tool that you can use to edit the image interactively (see Figure 7–33). Click the target to activate the tool. Position your cursor in an area of the image that you want to adjust. You can then use your mouse or the keyboard to modify the adjustment. With the mouse, click and drag up or down to increase or decrease the adjustment, or use the up and down arrow keys (my preference).

When you're done, click the target again (or use the shortcut or press Esc) to deactivate the tool.

To activate/deactivate the targeted adjustment for the Tone Curve.

₩+Option+Shift+H or Ctrl+Alt+Shift+H

To activate/deactivate the targeted adjustment for Hue.

₩+Option+Shift+S or Ctrl+Alt+Shift+S

To activate/deactivate the targeted adjustment for Saturation.

61/66%

Tone Curve

To activate/deactivate the targeted adjustment for Luminance.

**#+Option+Shift+N or Ctrl+Alt+Shift+N

To deactivate all targeted adjustment tools.

ADJUSTING COLOR

Are the colors in the photo accurate? Or is there a *color cast* present (a noticeable tint affecting the entire image)? A digital capture made using the incorrect white balance setting will introduce a color cast to the photo.

For example, you've certainly seen photos made indoors that appear very yellow, shot under tungsten light (standard bulbs). This is because the white balance used was intended for daylight, which has a much cooler color. Yellows and oranges are warm colors; blues and purples are cool colors.

Assess the colors in the image to determine if there is a color cast and decide what to do about it. It will be most noticeable in areas of the photograph you know should be neutral (containing the same or very similar color values). For example, a pixel with the values 26%, 26%, 26% in the RGB channels is neutral.

Bear in mind that, like all other adjustments, white balance is usually subjective and you shouldn't worry too much about whether the white balance is "correct".

What matters most is that you like the way the picture looks.

However, in situations where you need to precisely reproduce color (such as product or fashion photography), a reference target must be included in the photo in order to correctly neutralize the white balance. Popular reference targets include the ColorChecker from X-Rite and WhiBal cards from RawWorkflow.com.

White balance

After the camera profile is selected, the white balance adjustment has the largest effect on the overall rendering of the image. Maybe surprisingly, even black and white (grayscale) images are affected by the white balance settings.

After making tone adjustments, adjust the white balance to remove any apparent color cast and fine-tune the rendering of color in the image (see Figure 7–34). You can also use white balance to creatively warm or cool the image for effect. In Lightroom, white balance can be adjusted using the:

- Temperature and Tint sliders, and numeric entry. Note that the sliders show the color effect of moving them a certain direction;
- · Popup menu containing white balance preset values; and
- · White balance eyedropper.

Try the white balance presets first

The fastest, easiest way to hone in on your desired white balance is to select from the preset values in the popup menu. While doing so, pay attention to each preset's effect on the settings. (This is a good

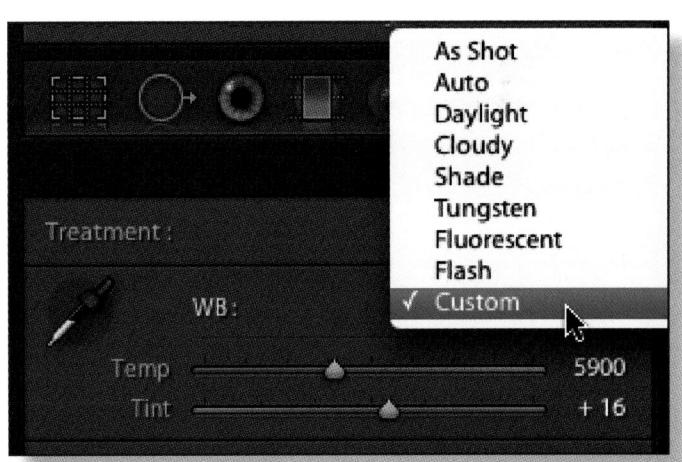

Figure 7-34: White balance

way to learn the numeric values for specific lighting conditions.) After choosing the preset closest to your desired look, fine-tune the white balance using the sliders and/or numeric entry.

₩

To activate the white balance Eyedropper (from anywhere in the Library or Develop modules). Move the cursor around the image; a small grid overlay appears, depicting enlarged pixels under the cursor (see Figure 7–35). If the Navigator is visible, it will show a dynamic preview of the white balance that would result from clicking in a particular spot. Click on an area of the image that you believe should be neutral gray and the white balance will be adjusted to neutralize that area. Other colors in the image will be adjusted accordingly. Press W again or press Esc to deactivate the tool.

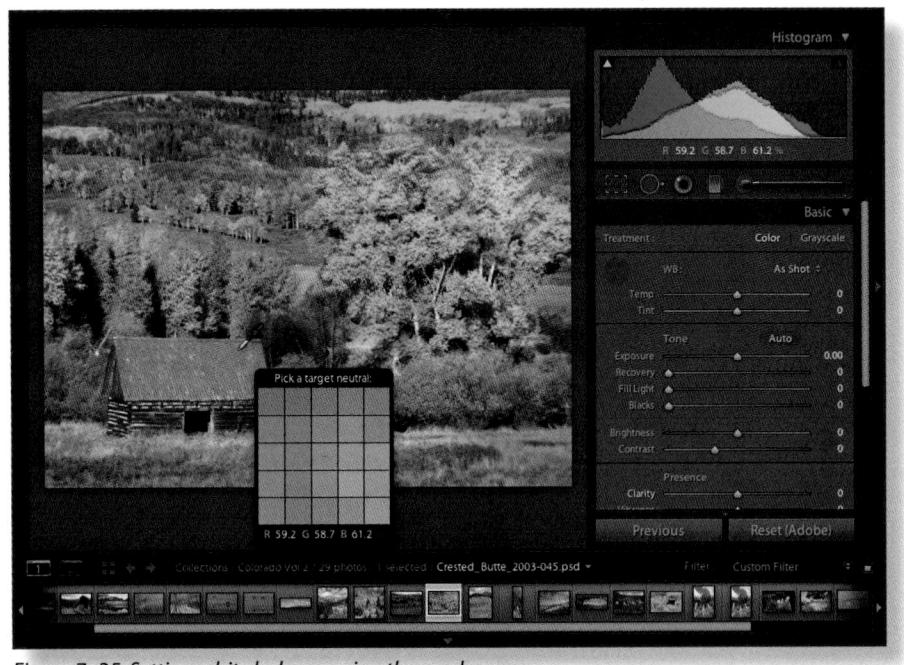

Figure 7–35: Setting white balance using the eyedropper

Sometimes white balance should be adjusted before tone

Whenever possible, adjust the tones on the image before white balance. However, in some cases, the white balance may be so far off it may be difficult or impossible to properly evaluate tone. A strong color cast in an image can affect the perception of both tone and contrast. In these situations it is best to adjust the white balance before adjusting tone.

Simulating a warming filter

The easiest way to warm an image in Lightroom is to adjust the white balance. Like many of the sliders in Lightroom, the background of the slider shows you what effect moving the slider a certain direction will produce. To warm the image, simply drag the Temperature slider to the right.

Saturation

After setting white balance to adjust global color rendition, consider whether you want to increase or decrease saturation. Saturation refers to how vivid and pure a color is (as opposed to neutral gray; see Figure 7–36). A photo that appears very bright and colorful is highly saturated. Some images benefit from increasing the saturation; others may look better with decreased saturation. Again, a creative choice.

Drag the Saturation slider one direction, then the other, to see its effect on the photo. Stop where you like.

Vibrance

The Vibrance control in Lightroom works similarly to Saturation, in that it makes colors more or less vivid, with a couple of important differences.

First, Vibrance will not affect colors that are already highly saturated. This helps avoid that over-saturated, neon effect. Second, the Vibrance control is designed to not affect (Caucasian) skin tones—peachy, orangey shades will not receive the increased saturation. For example, if you're processing a photo of a group of people outside in a park on a sunny day, increasing Vibrance will help push more color into the blue sky and green grass, without turning the people's faces pumpkin orange (see Figure 7-37).

Figure 7-36: Global saturation adjustment

Figure 7-37: Vibrance adjustment

Global adjustments to Saturation and Vibrance

Because these two adjustments are applied globally, it's very easy to overdo them with destructive effect on the appearance of the photo. (Set the Saturation and Vibrance sliders all the way to the right to see what I mean.)

In this age of digital photography, in my opinion, there is a preponderance of oversaturated, garish images out there. Of course, sometimes this is the appropriate treatment for the photo, but more often, I believe, the photographer doesn't intend it.

In critiquing images from my group classes and sessions with private students, over saturation is the single most common flaw I see in the processing. I recommend that as you're mastering Lightroom, and processing larger numbers of your own photos, you apply Saturation and Vibrance with a certain measure of restraint. Like all digital image processes, color saturation is a tool that must be used wisely.

If you find that you're pushing Saturation or Vibrance over values of +20 or so, stop and think more about it. Unless you're looking for a certain effect, +20 is usually the maximum amount you should need. Choosing a different Camera Profile might be a better way to go.

Selective color adjustments

In addition to the global Saturation and Vibrance settings, you can adjust colors in the image based on their named *hue* (orange, purple, aqua, etc.). These colors may seem arbitrary, but quite the opposite is true: Lightroom's color ranges are based on the standard color wheel, which is divided into distinct hues that blend together in between. The defined colors are:

Red

Green

Purple

Orange

Aqua

· Magenta

Yellow

• Blue

You may be surprised to find that all the colors in your photos fall into one of these hues, sometimes with slight overlaps into neighboring colors. Lightroom provides controls for adjusting both specific color hues and blended combinations.

With the HSL panel (see Figure 7–38) you can adjust the following components of individual color ranges in the image.

- Hue: the named color. Adjust the sliders to push the hue toward the colors at either end of the slider.
- Saturation: the purity of the color.
 Adjust the sliders to increase or decrease saturation.
- Luminance: brightness of the color.
 Adjust the sliders to lighten or darken the color.

The HSL panel is comprised of three sets of controls; click the names in the panel header to access the various types of adjustments:

- HSL: this is the default set of controls in the panel for working on a color photo. The three color components are separated into groups; click each adjustment name to access the sliders for that set of controls (see Figure 7–39). Click All to show all the controls on one (very long) panel.
- Color: these controls mimic the standard HSL sliders; they're just arranged differently. Adjusting the sliders in the Color mode also adjusts them in the HSL view, and vice versa. Click a color swatch to show all three component sliders for that color (see Figure 7–40). Again, click the All button to see all the controls at once.
- **Grayscale:** when working on a grayscale image you can adjust the brightness of the original color components of the photo here, resulting in different grayscale conversions (see Figure 7–41).

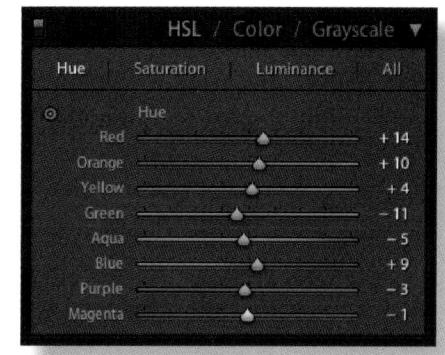

Figure 7–38: HSL panel

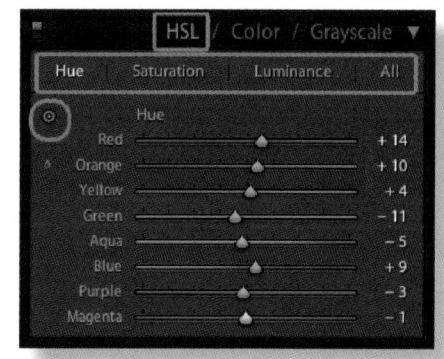

Figure 7–39: HSL adjustments

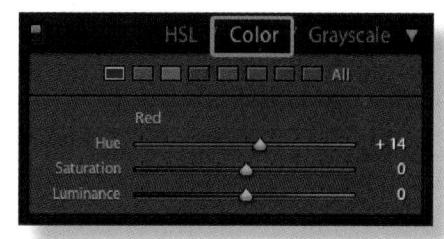

Figure 7-40: Color panel adjustments

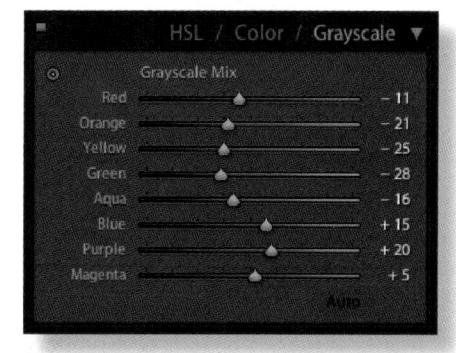

Figure 7-41: Grayscale panel adjustments

To open/close the HSL panel.

W Use targeted adjustments in HSL

You can quickly and easily adjust colors in the photo (including darkening and lightening them) with the target adjustments, available in each of the HSL panel sections. This is much easier than adjusting sliders directly. More importantly, when you use the targeted adjustment tool in HSL; several sliders are often adjusted at once. This provides much more accurate adjustments and allows you to fine-tune colors by directly manipulating them in the preview.

Watch for noise

When adjusting colors in the HSL panel, keep an eye out for the introduction of noise as a result. This especially applies when lowering Luminance, such as when darkening skies.

Hiding and Showing Panel Adjustments

Most of the panels in the Develop module include a small button (like a switch; see Figure 7–42) to temporarily hide and show the effects of that panel's adjustments. Like a light switch, up is "on" and down is "off". Rather than Before and After or Undo/Redo, you can use this to show all the effects of only a single panel. This is especially useful with the HSL panel. Note that turning on and off a panel's adjustments is tracked in history, is undoable and can be saved as part of a preset.

Figure 7-42: Panel on/off switch

Converting a photo to black and white

This can be one of the most fun and creatively rewarding aspects of working in Lightroom. Starting with a color original, it's possible to produce stunning black and white photos. And no doubt some images work much better in black and white than in color.

In Lightroom, black and white images are referred to as *grayscale*. However, this is a bit of a misnomer. An original image in RGB mode remains RGB after the conversion to grayscale in Lightroom; even when exported. The tones in the image are simply converted to equal values in all three channels. (This is very different from the Grayscale mode in Photoshop, which only contains one channel.) Keep in mind that the color components are being turned into gray levels, but Lightroom still processes them based on their original, named hue values (red, purple, aqua, etc.).

There are several ways to turn a color image into black and white in Lightroom. However, this is a case where the fastest method doesn't always produce the best results:

- Fastest: click the Grayscale button the Basic panel, the HSL panel header, or the Quick Develop panel in Library, or use the shortcut. You can then edit the Grayscale sliders on the HSL panel to your liking (see Figure 7–43).
- **Best:** make the grayscale conversion by desaturating all the colors, individually, first. In the HSL panel, set all the Saturation values to -100. Then use the Luminance sliders to brighten or darken the converted grays. This gives you the maximum amount of control over the placement of tones in relation to their original color values (see Figure 7–44). You can tweak the Hue sliders a bit, too, for the most control over the conversion.

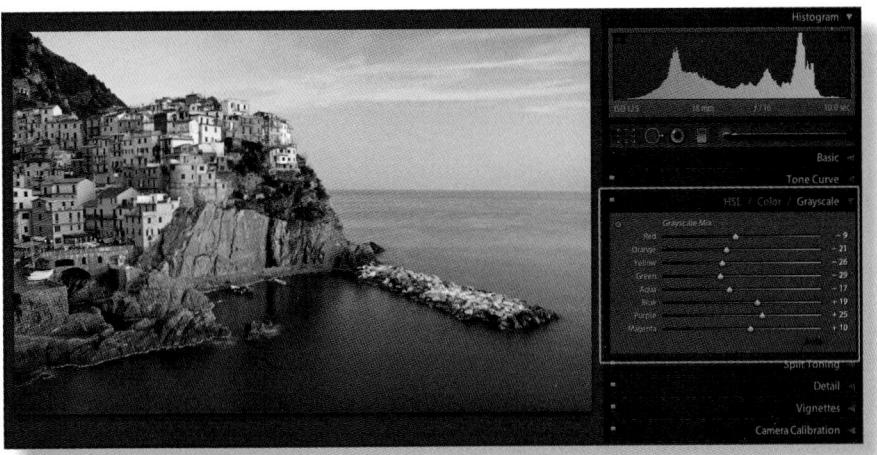

Figure 7-43: Automatic Grayscale conversion; adjusting with Grayscale panel sliders

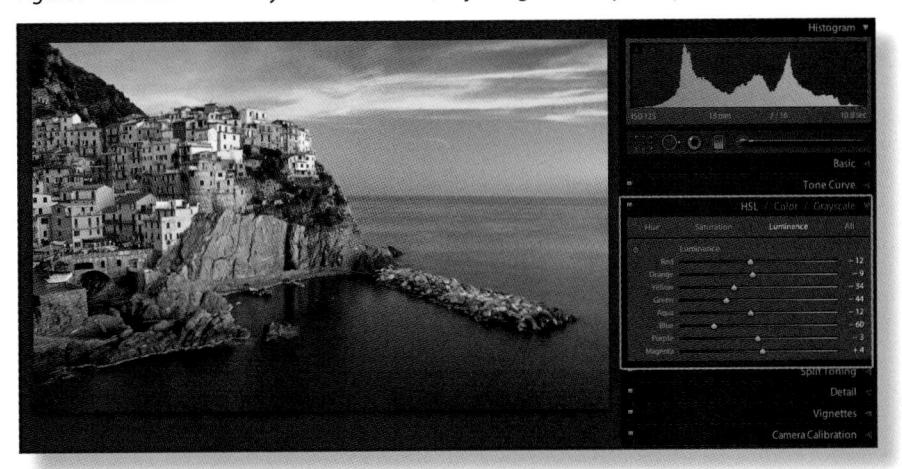

Figure 7–44: Conversion to Grayscale and adjustment using the HSL panel

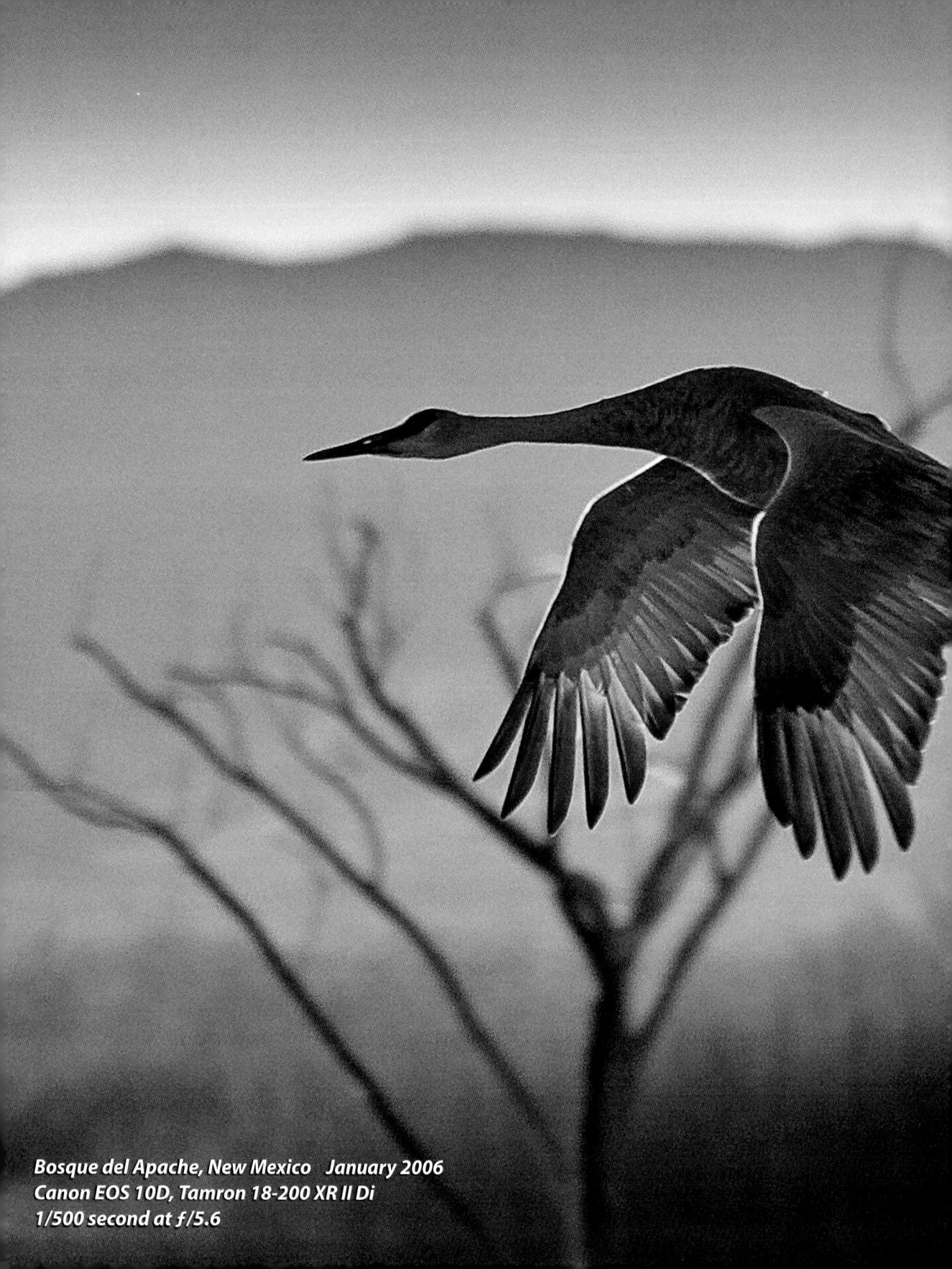

To automatically convert a photo to Grayscale. You can then adjust the sliders on the Gravscale panel.

White balance for Grayscale conversions

Regardless of the initial method you use to convert your color original to Grayscale, try adjusting white balance too (and maybe even change camera profiles)! As mentioned previously, white balance has a major effect on the rendering of the raw capture, resulting in wide variation in the resulting tones.

REMOVING ARTIFACTS

The majority of all digital photographs contain artifacts of one kind or another, introduced either during capture or processing. You should constantly strive to identify and reduce or eliminate artifacts whenever possible. An otherwise beautiful photograph can be killed (technically) by artifacts. Always remember that in the pursuit of high quality imaging, it's the little things that count!

Some artifacts require retouching to remove; however, others are global and can be treated quickly and uniformly with simple adjustments.

The Detail panel contains Lightroom's controls for adjusting for artifacts (see Figure 7-45).

> 3 +5 or Ctrl+5

To open/close the Detail panel.

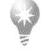

Zoom in and out when processing for small details

To correctly apply many of Develop's adjustments requires you to get in closer to really see what's happening, sometimes at

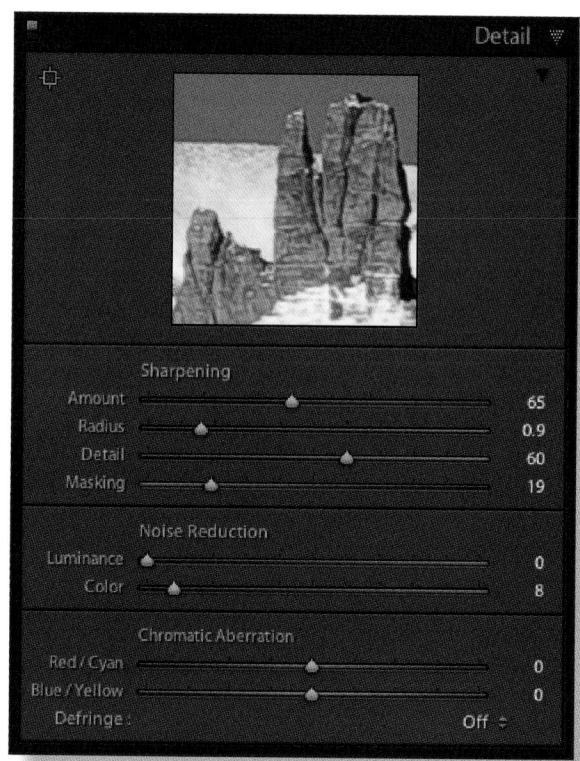

Figure 7-45: Detail panel adjustments for removing artifacts

the pixel level. Use the zoom functions to look closely at key areas of the photo.

1:1 previews

The effects of some Develop adjustments (such as chromatic aberration, noise reduction and sharpening) are not visible in the image preview unless you're viewing the photo at a ratio of 1:1 or greater.

The Detail panel includes a preview window where you can see the effects of adjustments independently from the Develop loupe preview (see Figure 7–46). If it's not showing, click the black triangle button to expand the preview section of the panel.

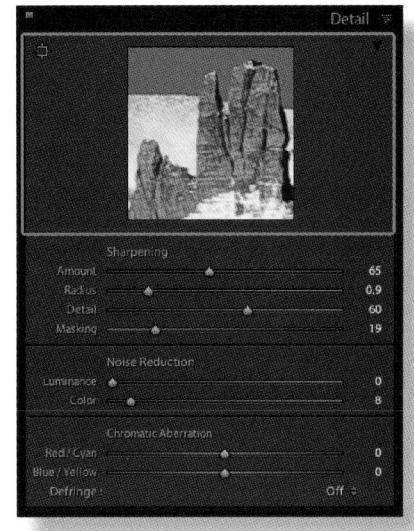

Figure 7-46: Preview window in Detail panel

To set what part of the photo shows in the preview window, click the target button at the upper left of the panel, then click in the photo. The Detail preview window will show the area clicked.

Zoom and pan in the Detail preview

Click and drag to pan in the preview or single-click to zoom in and out, just like in the main image preview area.

Zoom warning triangle button

If the preview window is not expanded, and you're not at 1:1 preview or greater, a warning triangle appears in the panel (see Figure 7–47). Click the warning triangle to zoom the main preview to 1:1.

Figure 7–47: Zoom warning indicator when Detail preview is hidden

Fixing chromatic aberration

Chromatic aberration (CA) is an image artifact caused by the camera lens. When the light comes through the lens under certain lighting conditions, the light rays are scattered at the point where they hit the sensor, causing colored edges to appear in the image. CA is easiest to find near the corners of the image, along edges of high contrast.

7

Use the Chromatic Aberration adjustments in the Detail panel to remove CA (see Figure 7–48). Zoom in very close (up to 11:1 may be helpful). Drag the sliders to realign the color channels until the edges line up. You may often need to adjust both sets of sliders.

Figure 7–48: Finding and fixing chromatic aberration

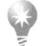

Option or Alt while dragging the CA sliders

Temporarily press the Option or Alt key to hide the other colors not affected by the current CA slider adjustment.

Removing fringing

Fringing (also called blooming) is different from chromatic aberration; it's an artifact that occurs on the sensor itself. Fringing happens when a high amount of energy hits a photosite and some of its charge spills over onto adjacent photosites. Fringing usually shows as purple outlines around very hot specular highlights, such as sunlight glinting on water.

Use the options on the Defringe popup menu to remove fringing. Choose from All Edges or Highlight Edges and see which produces better results. You may need to look closely at different areas of the image to be sure. If Defringe does not produce an improvement in the image, turn it off (see Figure 7–49).

Figure 7–49: Effects of Defringe

Noise reduction

Because other adjustments can affect the appearance of noise, you should check for it at several points during processing. To reduce or remove noise from photos in Lightroom, use the Noise Reduction controls on the Detail panel (see Figure 7–50).

- Luminance: reduces the appearance of gray/black speckles in the image. Be conservative applying Luminance noise reduction; fine detail can suffer. (I try to never go above a value of 10 for the Luminance noise reduction setting.)
- Color: reduces the appearance of color noise, which shows itself as
 multicolored, soft blobs in the image, especially in shadows and solid-color
 midtones.

Figure 7-50: Noise reduction

Smoothing

Though smoothing is technically related to sharpening (it's the inverse) it also makes sense explained in the context of noise reduction. If there are areas of the image that show a "speckled" look or reveal more detail from the original capture than is desired, you can smooth these areas using negative Clarity. For example, smoothing is effective for reducing the appearance of wrinkles in human skin.

Negative clarity

Use negative values on the Clarity slider (Basic panel) to introduce smoothing. You can also paint with negative Clarity using the local adjustment brushes (discussed later in this chapter).

DODGING AND BURNING

Selectively lightening or darkening localized areas in the photo has traditionally been referred to as dodging (lightening) and burning (darkening). Some suggested uses for dodging and burning include:

- Remove distractions
- Enhance depth and dimension
- Increase contrast and "pop"
- · Control eye movement within the frame

Lightroom offers several adjustment tools that can be used for dodging and burning:

- Graduated filters: linear gradients that can be applied anywhere in the image;
- Local adjustment brushes: painted-on adjustments; and
- Vignettes: applied equally to the four corners of the photo.

Graduated filters

On a camera lens, a split neutral density (ND) filter (or *graduated* ND) reduces the amount of light entering a portion of the lens in order to balance the exposure between bright highlights and dark shadows. The most common use for a split ND is to balance a bright sky and a darker foreground within a single exposure.

Lightroom's graduated filter tool is accessed from the tool strip (see Figure 7–51). It simulates the effect of a split ND filter and allows you to apply various adjustments in a smooth, gradual fade. The graduated filter creates linear gradients that are applied in a straight line between two points (start and end). (Unlike in Photoshop, you can't add additional control points between the start and end of the gradient.) The adjustment effect gradually transitions from full strength to no effect. Put another way, the strength of the adjustment at the start of the gradient is 100% and at the end is 0%. From each end, the strength level of the adjustment continues to the edges of the photo. You can't restrict the effect of the gradient to a specific area (use a local adjustment brush for that; see next section).

Apply a graduated filter

- 1. Click the graduated filter tool to activate it (or use the shortcut).
- 2. Place your cursor at the spot where you want the gradient to start.

- 3. Click and drag to the point where you want the gradient to end.
- 4. Set the desired adjustments to be applied by the graduated filter.

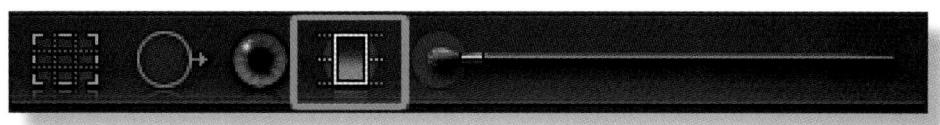

Figure 7–51: Graduated filter tool

To activate/deactivate the graduated filter tool (and show/hide its tool overlay).

Shift (while dragging)

To constrain the gradient to a straight line.

To invert the direction of the gradient.

Option or Alt while dragging

To scale the graduated filter from its center.

Modify a graduated filter after it's been created

You can change an existing graduated filter in the following ways (see Figure 7–52):

- Click and drag the start or end points to reposition them;
- Click and drag the center node point to move the entire graduated filter;
- Click and drag the line extending from the node to rotate the graduated filter; and
- Change the adjustments being applied by the graduated filter.

Figure 7–52: Modifying the graduated filter: dragging an endpoint, dragging the node to reposition the filter, dragging the center line to rotate

Graduated filter and local adjustment brush controls

The graduated filter and local adjustment brush tools provide the same set of adjustments: a subset of controls similar to the global adjustments found on the Develop panels. They all default at 0 and can be adjusted up or down.

- Exposure: use to dodge or burn parts of the image, with an emphasis on lighter tones.
- **Brightness:** use to dodge or burn parts of the image, with an emphasis on midtones.
- Contrast: use to increase or decrease contrast in local areas of the image.
- Saturation: use to increase or decrease saturation in local areas of the image.
- Clarity: use to increase or reduce clarity in local areas of the image (has an effect on the appearance of sharpness and contrast).
- Sharpness: use to increase or reduce sharpness in local areas of the image.
- Color: use to apply a subtle color tint to the local adjustment (see below).

The adjustment controls can be displayed and modified in two ways: buttons or sliders. Click the switch at the upper right of the controls to switch between modes (see Figure 7–53).

- **Effect buttons:** in button mode, each graduated filter or brush mask applies a single type of adjustment.
- Effect sliders: in slider mode, a single graduated filter or brush mask can apply multiple types of adjustments. I almost always work in slider mode.

Figure 7–53: Adjustment control modes—buttons and sliders

Left and Right Arrows (with adjustment slider active)

To decrease/increase the amount of the adjustment.

Color

You can apply a subtle color tint to the graduated filter or local adjustment brush. This is useful for blending adjustments into the image to make them appear more natural and realistic. (Note that it is not possible to use the Color control to paint with a solid, fully opaque color.)

By default, when you apply any of the local adjustments, the color is fully desaturated (neutral gray). To apply a color tint to the adjustment, click the color swatch. Then select a color from the palette, or click and hold your cursor while dragging outside the box to sample a color from the photo, or anywhere on your screen (see Figure 7–54).

Use the S (saturation) slider to increase or decrease the saturation of the color, without affecting hue. (If you have a color selected and want to go back to neutral gray, set the S slider to 0.)

Click and drag over the number in the H (hue) value to adjust hue without affecting saturation.

To close the palette, click the X in the upper left corner, or press Esc.

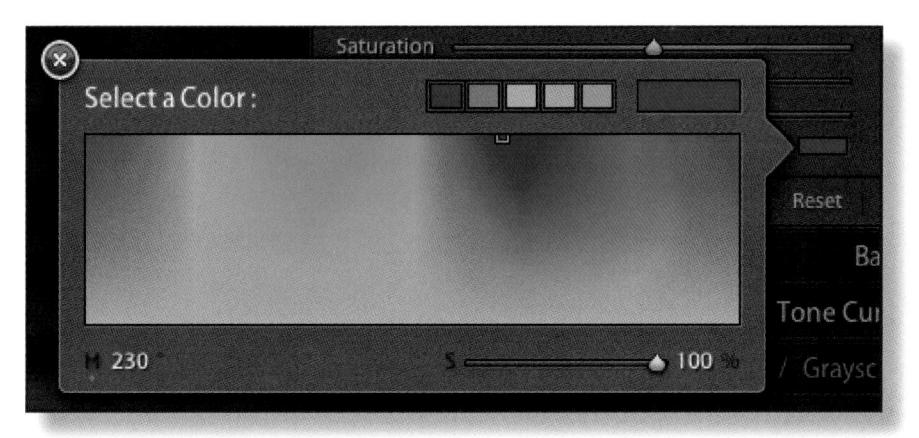

Figure 7-54: Color picker dialog box

Tool Overlays

All the tools in the tool strip—Crop, Remove Spots, Red-Eye, Graduated Filter and Local Adjustment Brushes—provide a *tool overlay* when activated. The tool overlays provide controls for manipulating each instance of the tool application or 7

deleting it entirely. The overlays can also be hidden or shown while the tool is active (see Figure 7–55).

Some of the tool overlays, such as graduated filters and brushes, include a *node pin*, used for selecting each individual instance of the tool within the overlay.

Figure 7–55: Example tool overlay (Remove Spots)

To hide/show node pins.

To always show/always hide node pins.

Show selected/never show the overlay for selected tool.

Local adjustment brushes

Using Lightroom's local adjustment brushes, you can perform precise dodging and burning, localized sharpening, color tinting and much more. The brushes allow you to "paint" on adjustments with varying opacity, feathering and edge control. In addition to dodging and burning, there are virtually unlimited applications for the local adjustment brushes using the range of controls provided.

Activate the local adjustment brush tool by clicking it in the tool strip, or use the shortcut. When the brush is active its controls are displayed in the tool drawer (see Figure 7–56).

Figure 7-56: Activating the adjustment brush

To toggle the adjustment brush on/off.

With the brush active, the first thing you will likely want to do is change its size. Click the black triangle button to adjust its settings at the bottom of the drawer (see Figure 7–57). As with other settings, you can drag the sliders, enter numeric values or use shortcuts to change the brush settings.

- **Size:** the size of the current brush;
- **Feather:** how soft or hard the edge of the brush stroke is;
- Flow: how fast the "paint" is applied to the mask while painting;
- Auto Mask: when this box is checked, Lightroom will try to conform the edge of the painted mask to edges in the image. This can be useful if you need the adjustment to be applied within a specific area, such as whitening teeth in a smile; and

Figure 7-57: Adjustment brush settings

• Density: opacity/transparency of the brush stroke.

To decrease brush size.

To increase brush size.

Shift+[
To decrease feather.

To increase feather.

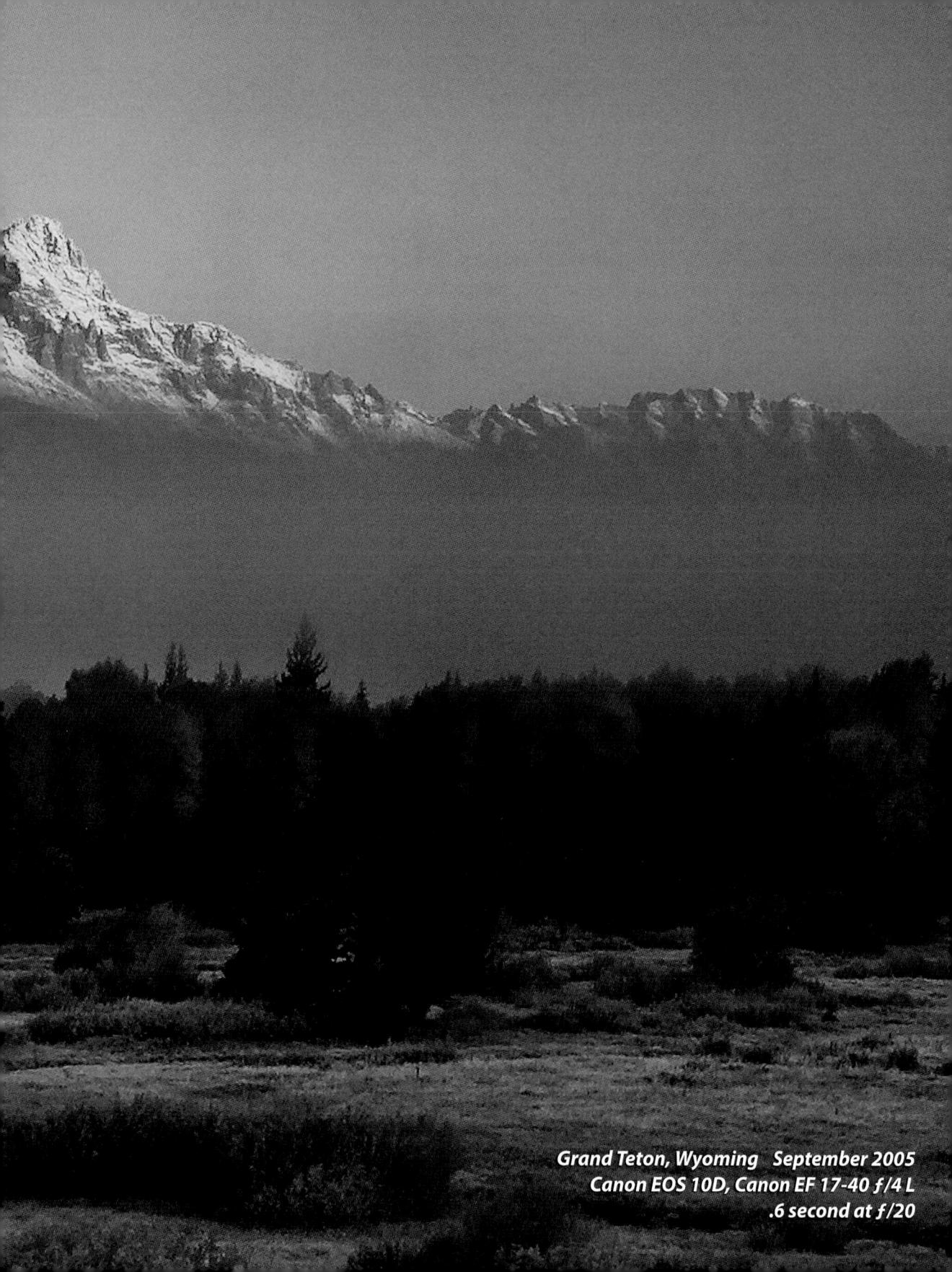

Number Keys

To set flow amount. 1 is 10%, 4 is 40%, etc. Press two numbers quickly for more precise amounts. For example, pressing 7 then 5 consecutively sets the flow to 75%.

To toggle Auto Mask on/off.

Usually leave Auto Mask off

For general dodging and burning, leave Auto Mask off. For one thing, these effects typically look more natural if they are soft and feathered, rather than hardedged. Also, leaving Auto Mask on, especially when painting over large areas, can significantly degrade performance.

A and B brush settings

You can store two brush sets, each with different settings. Each brush set retains the most recently used settings until you change them. I usually use A for the soft, feathered brush and B for a harder edged brush. You could also use one for a large brush and the other for a small brush, etc.

To switch between A and B brushes.

Applying the local adjustment brushes

Click and drag your cursor to paint over areas of the image you want to adjust. As you paint, a *mask* is applied to the image that constrains the adjustment to the painted area. A node pin is placed at the point of the mask where you started painting. Within a single mask, the adjustment can be applied in multiple spots, anywhere in the photo.

Shift (while painting)

To constrain the brush stroke to a straight line.

You can also create additional masks and modify or delete existing masks. Each mask can have its own settings; apply separate masks in different areas of the photo to apply different adjustments in those areas.

Enter or Return

To make a new adjustment brush mask.

A single mask can have multiple brush applications made using different brush settings.

As with graduated filters, you can set the adjustments that are applied with the brush masks before and after you create them.

To select a mask, click its node pin. A solid black center indicates which brush mask node is active.

To temporarily show the mask overlay.

Click and drag left/right over the node pin

To change the values of the adjustments. All adjustments for that mask will be modified simultaneously.

To show/hide the mask overlay.

Shift+O To cycle through the available mask overlay colors.

Just as with global adjustments, you should be economical with your application of localized adjustments. For example, if you want to dodge multiple areas of the photo using the same adjustment, use just one mask for all the areas, rather than separate masks for each of them.

Erasing from masks

You can refine brush masks by erasing. Like the A and B brushes, the eraser has its own settings.

To erase from a mask, first click its node point to activate it. Make sure the eraser is active and set the eraser brush settings as necessary. Paint to erase from the selected mask (see Figure 7–58).

Option or Alt (while painting)

To temporarily switch to Erase mode.

You can't erase from graduated filters
Use a brush to apply opposite adjustment(s) as those of the gradient.

Figure 7–58: Erasing a brush mask

Hiding and showing local adjustments

Use the switch at the bottom left of the panel to temporarily hide or show all of the graduated filters or local adjustment brushes (see Figure 7–59).

Deleting a local adjustment

If you want to completely remove a local brush adjustment or graduated filter, select its node pin and press Delete.

Click the Reset button near the bottom right of the panel (see Figure 7–60) to remove all the graduated filters or brushes at once. (There are also separate Reset buttons for graduated filters and brushes.)

Local adjustment presets

You can save presets for graduated filters and local adjustment brushes (the presets are shared by both tools). Click the Effect: menu in the tool drawer (see Figure 7–61) and select Save Settings as New Preset.

Vignettes

Vignetting is darkening (or lightening) around the corners of an image. A dark vignette can be caused by the camera lens, especially wide angle lenses, particularly with a filter attached.

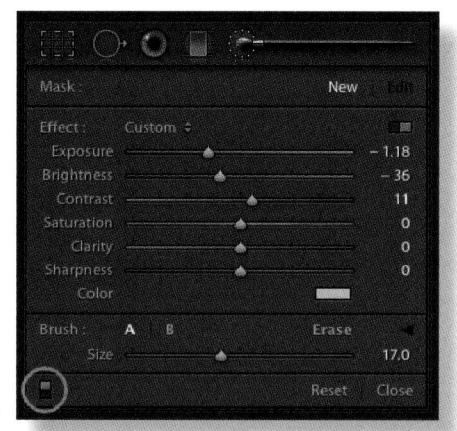

Figure 7–59: Switch for hiding and showing local adjustments

Figure 7–60: Resetting the adjustment brush or graduated filter

Figure 7–61: Saving a local adjustment preset

Depending on the photo and your preferences, vignettes can either be pleasing or altogether undesirable; vignetting has typically been considered an unwanted photographic artifact. These days, it's en vogue. Lightroom provides adjustments for removing or adding lens vignetting, applied to the full frame and/or the crop. There are controls provided for each kind of vignetting.

Lens Correction: this is designed to reduce or remove the effect of vignetting caused by the lens (or simulate it). It's applied at the corners of the full-frame

image, regardless of crop. The Amount slider controls the strength of the adjustment; the Midpoint slider determines how far from the corners the adjustment is applied (see Figure 7–62).

Post-Crop: these adjustments use a different algorithm than Lens Correction and thus produce a vignette effect that looks a bit different. Also, as its name implies, this vignetting control is applied to the inside of the crop, not the outer edges of the original image. Along with Amount and Midpoint, controls are provided for Roundness and Feather (see Figure 7–63).

For both types of vignetting adjustment, you can apply positive amounts to lighten the corners of the image or negative amounts to darken. I encourage you to experiment; you'll get the hang of it quickly and may find many interesting applications for the vignetting adjustments.

Figure 7–62: Lens correction vignette adjustment

Figure 7–63: Post-crop vignette adjustment

> #+6 or Ctrl+6

To open/close the Vignettes panel.

SHARPENING

Sharpening is a complex and esoteric part of the digital imaging workflow. The appearance of sharpness in a photo is determined by edge contrast—the amount of contrast between the pixels defining edges and details in the photo. Every digital image can benefit from some kind of sharpening. The ideal sharpening for any image is completely dependent on the resolution of the file and the medium in which it is viewed. Use the controls on Lightroom's Detail panel (see Figure 7–64) to fine-tune the *capture sharpening* for the photo.

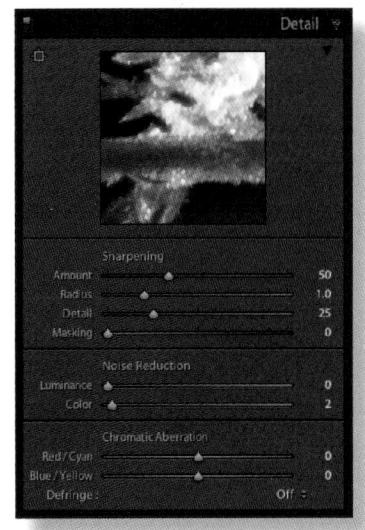

Figure 7-64: Detail panel

7

The sharpening workflow

In today's digital image processing, it's better to sharpen an image in several steps rather than all at once. The late Bruce Fraser is credited with greatly advancing the art of digital image sharpening in recent years, and many of the principles he developed have been implemented in Lightroom's sharpening routines. The modern sharpening workflow is comprised of the following stages:

- Capture sharpening: When the continuous-tone real world is mapped onto a grid of pixels in a digital image, some softening is introduced. The first pass of "gentle" sharpening is intended simply to overcome the loss of sharpness resulting from digital capture. The sharpening controls on Lightroom's Detail panel are for capture sharpening only.
- Creative sharpening: Intermediate rounds of sharpening can be applied, as needed, to enhance all or part of an image, based on its characteristics. For example, areas of *high-frequency* information—those with lots of small, fine detail—require different sharpening treatments than do *low-frequency* areas with relatively little detail. Creative sharpening is also dependent on subjective considerations, such as the desire to emphasize or de-emphasize parts of the photo. Creative sharpening can be applied using Lightroom's local adjustment brushes (see next section).
- Output sharpening: the final application of sharpening is dependent on the size and resolution of the file and the medium for which it is intended. For example, a low resolution image destined for display on a Web site requires different sharpening than does a high resolution file that's going to be printed. Lightroom's output sharpening is applied either when exporting (see Chapter 8) or printing (see Chapter 9).

Lightroom capture sharpening

Use the sharpening controls on the Detail panel to apply capture sharpening to your photos:

- 1. **Amount:** the strength of sharpening to be applied. Typical recommended range: 25-60.
- 2. **Radius:** the width of the edges on which to apply sharpening. Decimals are provided due to the feathered "falloff" of the sharpening. For images with fine, detailed edges, use lower amounts. Recommended range: .8 up to 1.2. As a general rule, to avoid visible halos from sharpening with higher Amounts, use lower radii.

- 3. **Detail:** set this based on the amount of fine detail in the image. Use higher Detail values for images containing lots of high-frequency detail. Recommended range: 25-70.
- 4. **Masking:** keeps the sharpening from being applied to smooth, solid areas of the photo, such as skin and sky. With Masking at 0, sharpening will be applied to the entire image uniformly. At higher values, sharpening will only be applied to defined edges. The ideal masking varies by image. To determine this, preview an area of interest at 1:1 or greater and hold the Option or Alt key as you adjust the slider. This previews the areas where masking will be applied. On the mask, the areas in black will not be sharpened, and the white areas will, with gray levels in between, producing sharpening of varying amounts.

Zoom in close to see the effects of sharpening

... and/or use the Detail preview.

To turn off sharpening altogether

If you're planning to do all of your sharpening in other software, set the Amount to 0 to turn off sharpening in Lightroom. (And make sure you don't apply any sharpening on Export, either; see Chapter 8.)

Set your own sharpening defaults

Sharpening is one of the key settings to consider overriding the defaults with your own preferred values. More information about saving presets can be found at the end of this chapter.

Option or Alt while dragging sliders

To see the sharpening adjustments in the preview window of the Detail panel.

Figures 7–65: Before sharpening (left) and after (right)

RETOUCHING

Here, we're talking about removing what we don't like from the image—if something doesn't work with everything else, we want to get rid of it. Assessing the need for retouching is highly subjective, but most photos can follow some common criteria. Typical retouching tasks include removing dust spots, smoothing or removing wrinkles and blemishes from skin and generally eliminating distracting elements from the composition.

Lightroom's Spot Removal tool is used for getting rid of small- to medium-sized imperfections in the photo. There are two modes available: Heal and Clone. Each has its own strengths and best uses. Note that as a *Spot Removal* tool, it's best used for just that—if you have heavy-duty retouching to do, consider using Photoshop instead.

To activate the Spot Removal tool, click its icon in the tool strip under the Histogram (see Figure 7–66) or use the shortcut. This enables the tool overlay and reveals the controls in the tool drawer, which shows any previous applications of the Spot Removal tool on the photo and the most recently used settings.

Next, set the brush size using the slider or shortcuts (same as local adjustment brushes). As with the other sliders in Lightroom, there are several ways to adjust the value.

You can also adjust the opacity of each instance of the Spot Removal tool, though I usually work with opacity set to 100.

To activate/deactivate the Spot Removal tool.

Setting the ideal spot removal brush size

The Spot Removal tool works best when the size of the brush is just larger than the spot to be removed (see Figure 7–67).

To make the brush size smaller.

To make the brush size larger.

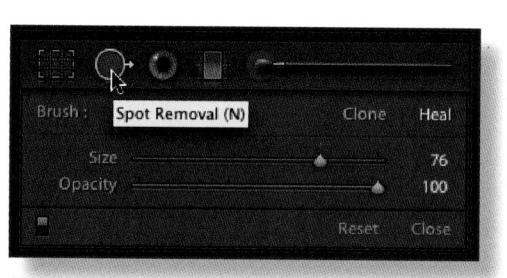

Figure 7-66: Activating the Spot Removal tool

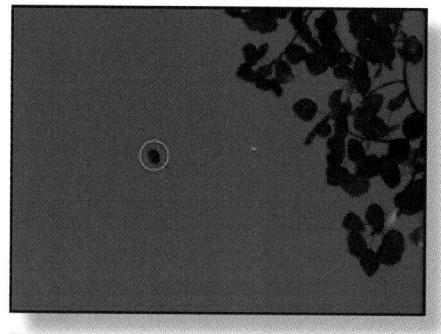

Figure 7–67: The ideal brush size for Spot Removal

If you have a mouse with a wheel, you can use it to change brush size.

To remove spots, click once on each element to be retouched. Lightroom automatically finds a nearby point to sample for the new pixels necessary for the retouching. Each time you click, two circles are added to the tool overlay, connected by a line with an arrow at one end. The arrow shows the direction from the sample to the spot being retouched.

Unlike the Healing Brush and Clone Stamp in Photoshop, you can't really "paint" with Lightroom's Spot Removal tool; each click applies a single, circular spot removal instance.

You can come back later to change all these settings after applying the Spot Removal tool; see below.

Do your retouching late in the workflow

You may often be inclined to perform retouching at the beginning of your processing, such as blotting out annoying sensor dust spots evident in the blue sky or getting rid of the twig poking out of someone's head. But as troublesome as these elements may appear at first glance, most of the time it's best to wait until the end of the workflow to do your retouching—you might save lots of time.

For example, you wouldn't want to spend time retouching the edge of the image and then crop it. More importantly, you will often find that other processing reduces the need for retouching.

Bearing in mind the principle of working from large to small, global to local, it stands to reason that retouching is best done after the other stages of the Develop workflow.

Zoom in first

It's difficult to accurately retouch a photo viewing the full image; zoom in to various magnification levels while doing your retouching.

Heal spots and blemishes

After activating the tool, select Heal mode. Heal works best for retouching areas of solid color or smooth gradients, like sky and skin (see Figure 7–68). Heal mode smoothly blends the sample into the spot.

Figure 7–68: Using the Spot Removal tool in Heal mode

Page Up and Page Down

To scroll the image uniformly, in vertical columns. As you reach the end of each column, the preview resets at the top of the next column. This ensures you cover the entire image.

Space bar

To temporarily enable the hand tool; click and drag to pan the image in any direction.

Clone textures and patterns

Clone is best used for replicating textures, patterns and hard lines in the photo. It makes exact copies of the sampled pixels and pastes them at the destination. Whereas the Heal brush evaluates the surrounding areas when applying the new pixels to the destination, the Clone tool

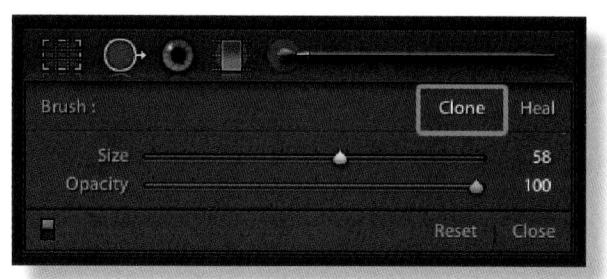

Figure 7-69: Using the Spot Removal tool in Clone mode

does not—it just copies pixels. If you need to retouch over the slats of a picket fence, replicate leaves and grass, or place a third eye on your mother-in-law, the Clone tool is the right tool for the job (see Figure 7–69).

As you might expect, because it exactly copies pixels without blending, Cloning requires you to work with more precision than Healing. After clicking to place your retouch spot, you may need to relocate the source (see below).

H

Like all the other tools, you can hide the spot removal overlay. This often makes retouching easier.

Modifying an instance of the spot removal tool

After applying the Spot Removal tool, you can adjust each instance of it in the tool overlay. Start by clicking a circle to select it. The active circle has a heavier outline than the other. You can modify any existing Spot Removal instance in several ways:

- Click and drag the edge of the circle to change its size;
- Click and drag the center of the circle to move it. (This can be used to move the source circle to a different point for better results.);
- Switch between Clone and Heal; or
- Delete it.

When to use Photoshop for retouching

You can use Lightroom's retouching tools to remove many unwanted elements, but Photoshop's retouching capabilities far surpass those in Lightroom. One example is the replacement of any large section of a photo; Lightroom can't do this—it might better be considered compositing. Heavy-duty retouching is best saved for after export; see Chapter 8.

Remove red eye

As you probably know, red-eye in photography is a phenomenon caused by light from a flash bouncing off the inside of a person's (or animal's) eyeball. Usually, it's an undesirable effect. Lightroom's red-eye removal tool looks for red-colored pixels and changes them to neutral gray or black. Its application is similar to that of the Spot Removal tool.

To remove red-eye from a photo, zoom in close to see the affected eye; work on one at a time. Click to activate the red-eye tool (there is no shortcut). Click and drag to set the tool to just slightly larger than the pupil you're working on (or use the current size). Release the mouse button to apply, and you're done (see Figure 7–70).

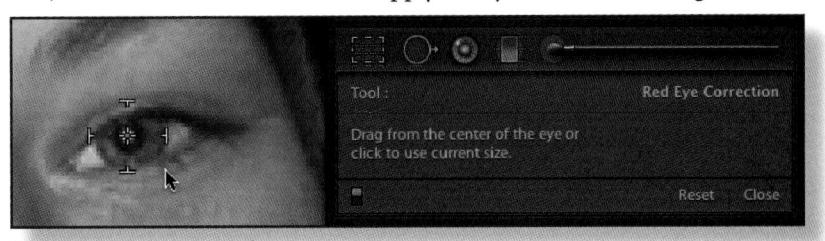

Figure 7-70: Removing red-eye

SPECIAL EFFECTS

Lightroom offers many options for processing your photos in unique ways. With such a wide range of controls, there are unlimited possible outcomes for the way an image will end up.

Trends and styles in photography have been heavily influenced by specific ways of processing the image, and until very recently, these effects were all done in the wet darkroom. But Lightroom provides far more control and flexibility than any photographers working in the traditional darkroom could have ever hoped for.

That said, there are certain photographic processing styles that have endured for decades; some since the earliest days of photography. These can be reproduced in Lightroom; instructions for simulating some of them are provided below.

I encourage you to experiment as you work—maybe you will invent the next popular photographic style!

Split toning

The term *split toning* describes the application of different color tints to highlights and shadows. For example, you can warm the highlights and cool the shadows, or vice versa. Split toning was traditionally done to black and white photos, but you can also achieve some nice effects in Lightroom by split toning color photos (see Figure 7–71).

To apply split toning to a photo, open the Split Toning panel and expand the controls with the black triangle buttons. Adjust the hue and saturation for Highlights and Shadows. You can set the hues with the sliders, or click the color swatches to open the color picker. The Balance slider adjusts the balance between the highlight and shadow tints.

Figure 7–71: Split toning: warming highlights, cooling shadows

₩+4 or Ctrl+4

To open/close the Split Toning panel.

Color tinting

To give a photo a uniform color tint (see Figure 7–72), first convert it to Grayscale using one of the methods described earlier in this chapter. Then use the Split Tone panel to apply the color. For a uniform color tint, set the Highlights and Shadows sliders at the same values, and set the Balance at 0.

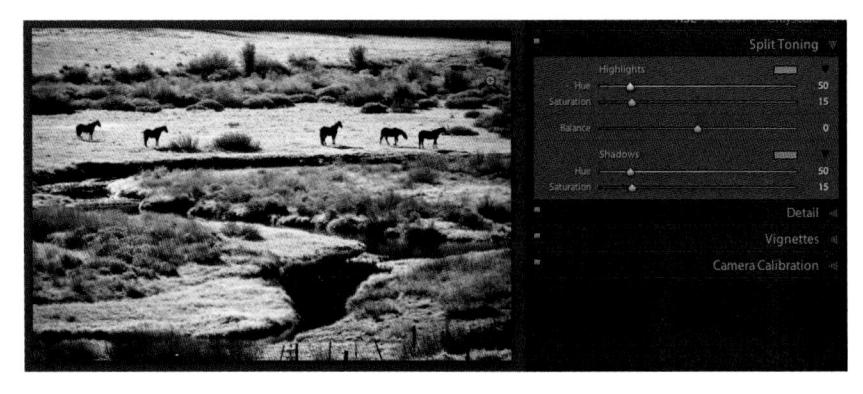

Figure 7–72: Applying a color tint
COMPARING BEFORE AND AFTER

In Develop you can see left/right or top/bottom comparisons of the before and after states of the photo. You can also toggle the Develop loupe preview to show before/after.

To see Before/After previews, click the button on the toolbar (see Figure 7–73) or use the shortcut. The triangle button next to the Before/After button opens a popup menu with options for arranging the before and after views.

The Before state shows:

- The image as it came into the catalog during import, including any Develop presets that were applied on import; or
- A Before state that you have applied yourself at some point during Developing.

The After state shows the image with all current settings applied.

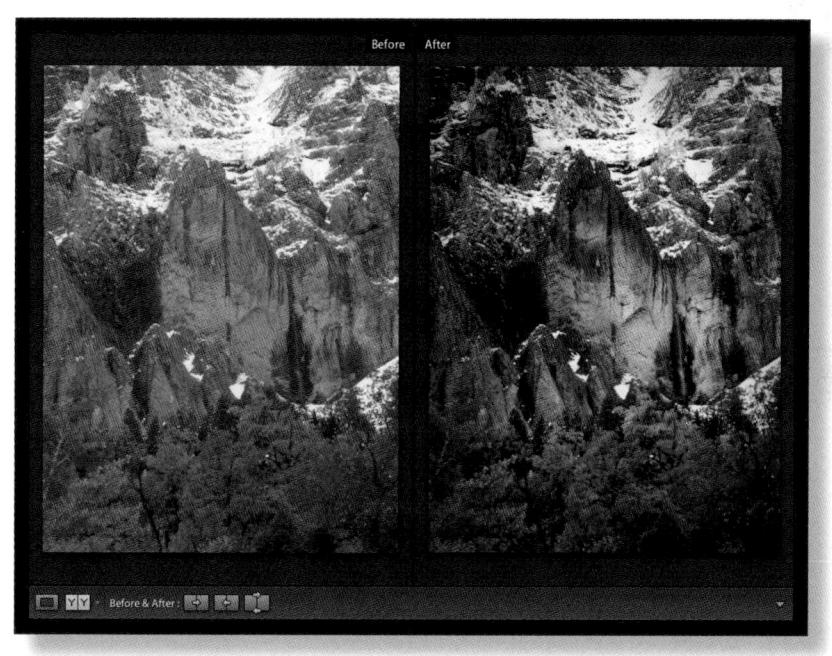

Figure 7–73: Before/After

To show Before/After.

To activate before and after previews and toggle between side by side and split image views.

To activate before and after previews and toggle between top and bottom and split image views.

To toggle before/after on the main preview.

When the Before/After preview is active, you can use the buttons on the toolbar (see Figure 7–74) to copy settings between the Before and After states:

- Copy Before's Settings to After;
- · Copy After's Settings to Before; or
- Swap Before and After Settings.

Figure 7-74: Copying and swapping states

- ₩+Option+Shift+Right Arrow or Ctrl+Alt+Shift+Right Arrow
 To copy the Before settings to After.
- ₩+Option+Shift+Up Arrow or Ctrl+Alt+Shift+Up Arrow
 To swap the Before and After settings.
- To progressively Develop a photo using Before/After

 If you get to a point in processing where you want to take all the current settings and make that the Before state, use the button on the toolbar to do that (see above). You can then continue processing, using the newly-created Before state as your reference.

Come back later

Sometimes it's helpful to work an image up to the point where you can't seem to make it any better, then stop. Come back later, with "fresh eyes", to confirm your previous processing decisions and make additional changes if needed.

CREATING MULTIPLE VERSIONS OF A PHOTO

While processing your photos in Lightroom, you can generate multiple versions from a single original file on disk. This is best done using *virtual copies* ("vcs").

When you make a virtual copy, the current settings on the photo being copied (whether an original or another vc) are used as the base settings for the copy. But this is where the direct connection between settings ends; further modifying the original will *not* affect the copy/copies, or vice versa. (However, you can sync the settings from the original to its copies using the Sync Copies... command.)

In terms of adjustments, vcs are treated exactly like originals.

VCs can be useful in a number of ways. For example, you could try different crops and compare them side-by-side. Or Develop an image in both color and black and white. There are also some interesting and practical uses for vcs when working in the presentation modules (see Chapter 9). The possibilities are virtually endless!

You can also make a copy of a copy, which—unlike in the real world—does not degrade quality due to generation loss. With this method, virtual copies can be used to progressively process an image in a variety of ways, resulting in multiple versions that can then be compared to determine the best one, or used for different kinds of output.

If you're not sure where you want to go in processing a photo, you might want to work on a vc first, then later apply the settings from the vc to back to the original.

A virtual copy is indicated by a turned-corner icon on the thumbnail (see Figure 7–75).

> \#+' or Ctrl+'

To make a virtual copy of the file. The copy automatically becomes the active photo.

Deleting originals also deletes vcs

Virtual copies exist only in the Lightroom database. If the original file on disk is removed from Lightroom its vcs will also be removed.

Stacking vcs

By default, a virtual copy is stacked with its original.

Figure 7–75: Virtual copy badge on thumbnail

RESETTING ADJUSTMENTS

There will be times when you want to remove Lightroom adjustments from one or more photos. Resetting removes the settings you've applied since the photo was imported (excluding any Develop presets applied during import). Resetting a vc will revert its settings back to those in effect at the time it was created.

There are several options for resetting some or all adjustments applied to a photo:

- Reset a single slider by double-clicking its name;
- Reset a group of sliders in a panel by double-clicking the name of the group; or
- Reset all adjustments on a photo with the Reset button on the bottom right of the right panel group (see Figure 7–76). Click the button to reset the photo to the state at which it came into the catalog. If you applied a Develop preset during import, this is the state to which it will be returned. Otherwise, the

photo will be reset to the Lightroom defaults.

Figure 7–76: Reset button; clicking resets all adjustments to the photo

To reset all the adjustments on the photo. (Produces the same result as clicking the Reset button.)

Resetting is undoable

Like most everything else in Lightroom, if you Reset a photo and then change your mind, simply Undo it $(\Re + Z \text{ or } Ctrl + Z)$.

🕽 Hold Shift while clicking Reset

To reset the photo to Adobe defaults (even if you've overridden them with Set Default Settings menu command; see next section).

History

Everything you do to a photo in Lightroom is tracked in the History panel (see Figure 7–77). This is one of the great benefits of using a database-based image editor. You can go back to any point in time unless you clear the history (which I don't recommend; the data being used for each adjustment is so small as to be negligible in terms of performance and storage space requirements).

Clicking any step in the History panel will return the image to that state. History is linear, however: if you make further adjustments after going back to that state, all the steps that were after it will be lost. History is most useful for recovering from mistakes or changing your mind. If you want to go back and forth, that's where Snapshots come in.

Note: History is not saved in a photo's metadata.

> #+Shift+3 or Ctrl+Shift+3

To open/close the History panel.

Snapshots

Unlike presets, Snapshots *always* include all the settings in effect when the Snapshot is made; you don't have the option to choose what settings are saved into the Snapshot. Snapshots are useful for saving various states of processing for a single photo. Use Snapshots when you want to store all the photo's current settings to retrieve later; they are stored in the Snapshots panel (see Figure 7–78).

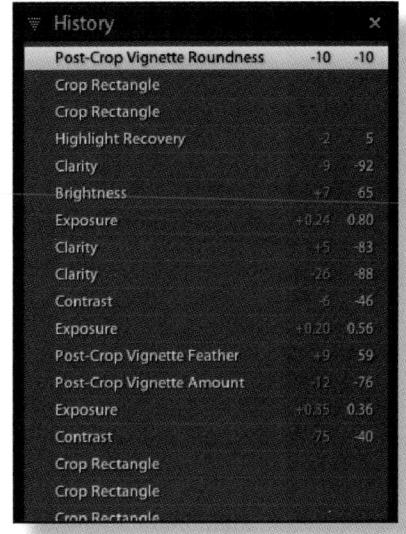

Figure 7-77: History panel

Figure 7–78: Snapshots panel

Note: Snapshots are not stored in a photo's metadata.

> #+Shift+2 or Ctrl+Shift+2

To open/close the Snapshots panel.

The on/off state of panels is included in Snapshots

If you have panels turned on or off using the switch in the panel header, that condition is also stored in the Snapshot.

For versions, use virtual copies instead of history snapshots

If you want to see different versions of a photo all at one time, use virtual copies instead of Snapshots.

Snapshots versus virtual copies

Given all the other functionality provided for managing Develop settings, I don't find Snapshots very useful, and don't often use them. There's no real reason not to use them; it's just a matter of personal preference. If I want to produce variations on a photo I nearly always use virtual copies. I like that I can view multiple virtual copies at once, unlike Snapshots. However, in cases where you need to keep a running record of the work done to a photo in one place, such as when you're progressively working up an image for a client, Snapshots can be useful. And many of my students seem to like them a lot.

Develop menu→Sync Snapshots

Use this command to synchronize settings between the snapshots of one or multiple photos. The selected snapshot of the active photo will be applied to all snapshots.

Applying Settings to Multiple Photos

Lightroom—a batch processing application at heart—allows you to very easily apply Develop adjustment settings to many photos at one time, using a variety of methods. Any Develop setting on one photo can also be applied to other photos; for example, you could replicate your application of Spot Removal or dodging and burning to multiple images using several methods.

Select photos from the Filmstrip or collections

While working in Develop, you don't need to go back to Library to load different images.

Go back to Library in Grid View

If you want to go back to Library to review other photos or change sources, I recommend using the G key to return to Grid, rather than E for Loupe. This eliminates any confusion about where you actually are, as a photo in Develop Loupe and Library Loupe may appear very similar.

COPY/PASTE

You can copy and paste Develop adjustments from one photo to another (see Figure 7-79).

Figure 7-79: Copy and Paste buttons

🕪 ∺+Shift+C or Ctrl+Shift+C

To copy the settings from the active photo. Choose the settings to be copied and click the Copy button.

#+Shift+V or Ctrl+Shift+V

To paste the copied settings to other photos.

SYNC SETTINGS

You can synchronize Develop settings between multiple files in Lightroom. This produces the same results as Copy/Paste—the settings from the active photo will be applied to the other selected photos. It's just another way of doing the same thing.

With multiple photos selected (pay attention to which is the active photo), click the Sync... button on the right panel group, or use the shortcut. A window appears allowing you to choose what settings to sync (see Figure 7–80).

To sync settings from the active photo to other selected photos.

Figure 7–80: Sync and Auto Sync

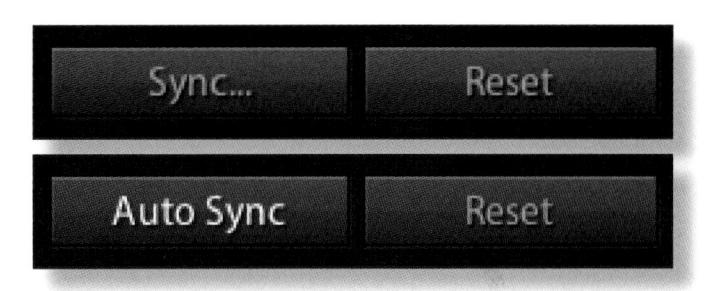

3

Sync white balance

One very useful application of Sync Settings is adjusting white balance. To accurately set white balance for a batch of photos, begin a photo shoot by making an initial capture containing a target reference, such as the X-Rite ColorChecker or a gray card. In Lightroom, use the reference shot to set the white balance with the eyedropper. Then simply use Sync Settings on the rest of the files to match the white balance from the reference image.

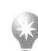

x or Ctrl when clicking Sync

With multiple images selected in the Develop module, press **%** or Ctrl and the Sync... button becomes Auto Sync. When active, Auto Sync will continually apply any adjustments you make to the active image to all the selected images. Click the Auto Sync button to turn it back to the standard Sync.

DEVELOP PRESETS

Using Develop presets can save you lots of time processing files; you can quickly apply previously saved settings to large numbers of images. You can make your own presets and load presets made by other people—there is a growing number of Web sites where photographers share presets (see Resources in Appendix). Lightroom also offers many built-in Develop presets (see Figure 7–81).

After you've worked with Lightroom a while you will begin to identify settings that you frequently apply as a basis for your "starting point" in processing. When you find that you are repeatedly applying the same settings to many photos, you should consider saving a Develop preset with those settings. For example, you can save a preset for

7

your preferred sharpening settings, or one for Blacks, Brightness and Contrast adjustments. Or, one that just applies a linear point curve. Or all of them at once.

I don't like to have the Tone
Curve→Point Curve set to Medium
Contrast as the default. When I begin
to evaluate the tonality in an image,
I prefer to see it in an unprocessed
condition. So I use a Develop preset
with Tone Curve→Point Curve set to
Linear. Blacks is another adjustment
for which many photographers like to
set their own default.

Preview presets in Navigator

With an image loaded in Develop loupe view, move your cursor over the presets in the left panel of the Develop module. The Navigator preview automatically updates to show the effect of the adjustments in that preset.

Figure 7-81: Develop Presets panel

See the contents of presets

You can open Lightroom presets in a text editor. This will show you how they are structured. (I recommend you make a copy of any presets or other metadata XML files before you open them.)

Making your own presets

With the settings you want to make into a preset applied to the active photo, click the + button on the Presets panel header. A dialog box opens asking you to select the settings that you want to save into the preset. The Develop settings shown are very similar to those in Copy/Paste and Sync dialogs.

This choice is important. Remember that Develop settings are absolute. Thus, a preset that contains a value for a given adjustment will override the current setting when the preset is applied. Any adjustment that *isn't* included in the preset will not be changed when the preset is applied.

For example, if you have a photo with a Contrast setting of +25 and you apply a preset that contains a Contrast setting of +35, the resulting value will be +35

(not +60). But if you apply a preset that doesn't contain a setting for Contrast, it will remain +25, regardless of the other adjustments that are changed.

As each adjustment checked in the dialog box will be saved into the preset using the current value, you should carefully consider which settings to include. Eventually, you'll likely make some presets with lots of settings included and others that include only a single adjustment. It all depends on the purpose of the preset.

Give your presets meaningful names

Name your presets according to their settings or purpose.

Create a Develop Preset to be applied on import

When you've established the baseline settings that can reasonably apply to the majority of your photos, save them as a Develop preset. Then, during future imports, apply the preset to photos in the Import dialog box. Your images will come into the catalog looking much closer to the way you like them.

Using presets made by someone else

To use presets from an outside source, you need to copy them into the presets folder and restart Lightroom. Any preset with a valid format will then appear in the list; you can organize them as you see fit; use the + button on the panel header for options or right-click/Ctrl+Click to open the presets popup menu. You can also drag and drop to rearrange presets and presets folders.

Preferences→Presets→Show Lightroom Presets Folder

To show the Lightroom presets folder in Finder or Explorer.

Save an alias or shortcut to the Lightroom folder on your desktop

If you frequently add, remove or otherwise maintain presets, you may want to save some shortcuts in your file system to make finding the Lightroom folders easier. This way, you can update Lightroom folder contents without needing to launch the program first. (This tip applies for all types of Lightroom presets and templates; not just Develop.)

Modifying and Removing Presets

You can update the settings contained in a preset or remove it from the list entirely.

Right-click or Ctrl+Click on a preset or folder To open the presets contextual menu (see Figure 7–82).

Select an option from the menu:

• Update with Current Settings: replaces all the settings in the selected preset with all the current develop settings.

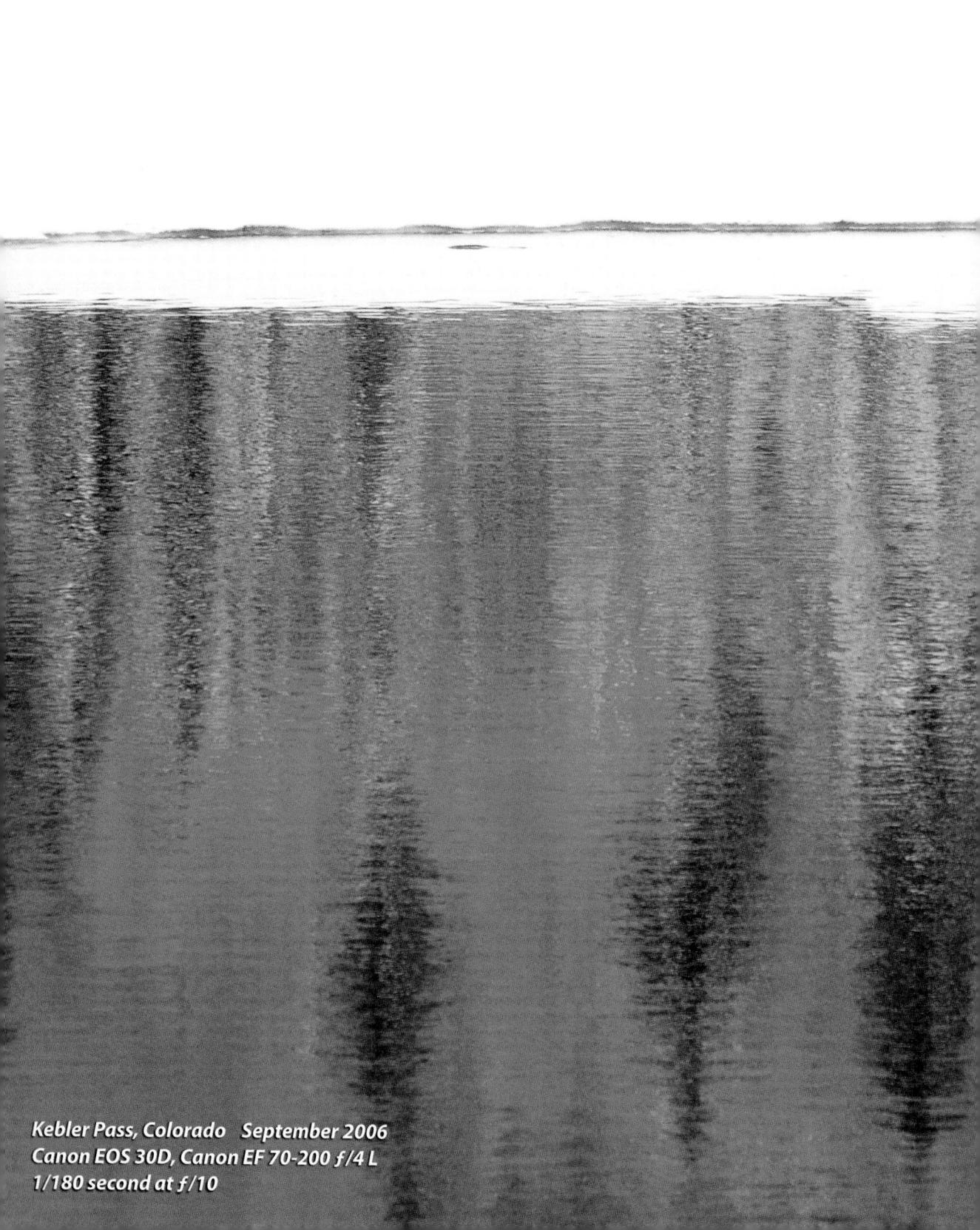

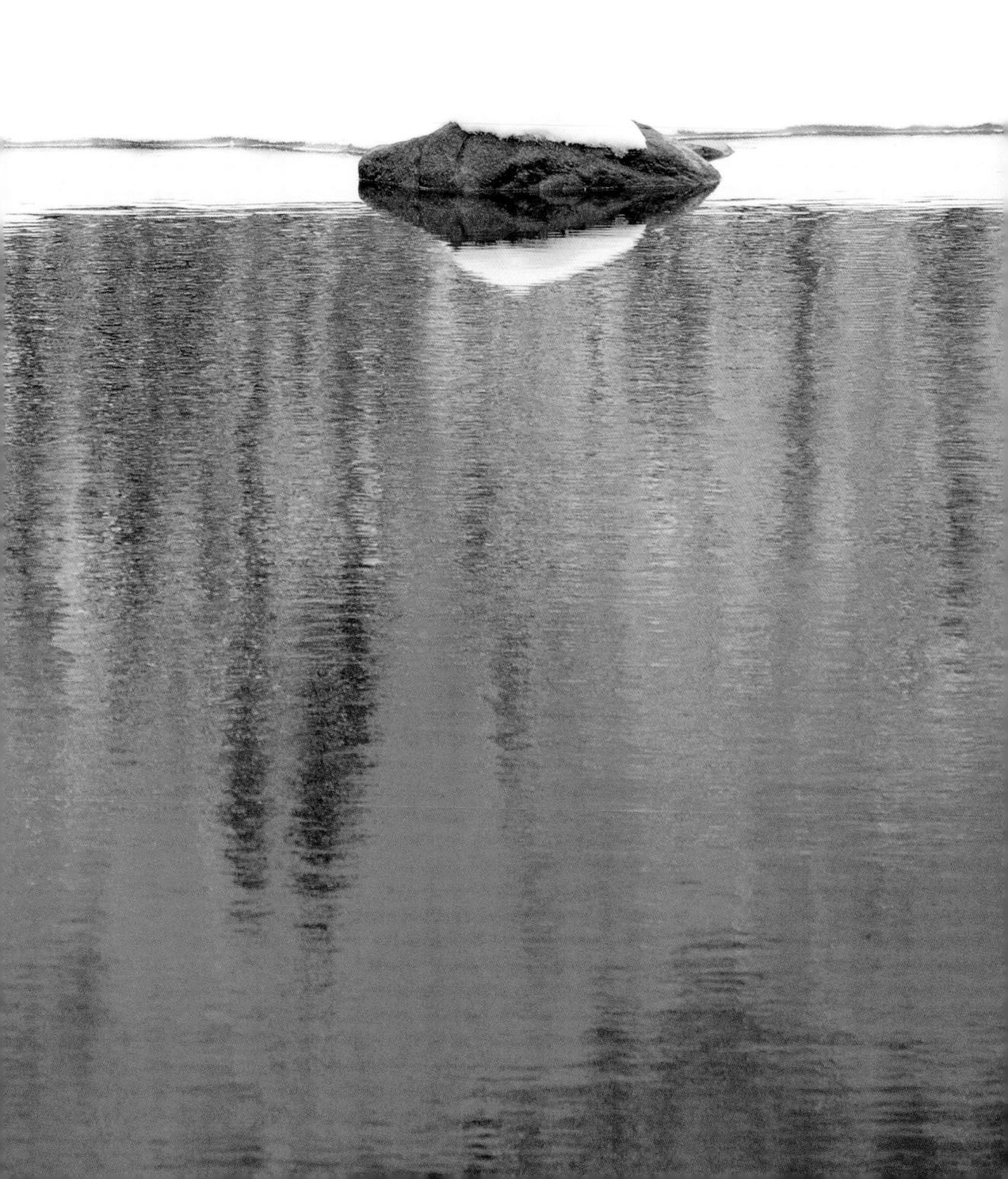

 Delete or Delete Folder: immediately removes the preset from the list and deletes it from the Lightroom presets folder.

! No confirmation when deleting presets and preset folders Be forewarned that when you select Delete or Delete Folder from the presets contextual menu you will not get a confirmation dialog—the preset files will be deleted from disk immediately. They do not go to the trash or recycle bin! (However, deleting presets or preset folders is undoable within the current program session.)

Figure 7–82: Presets contextual menu

Auto and Default Settings

You will find Auto adjustment buttons in several places throughout Lightroom's Develop (and Quick Develop) panels and menus. As you might imagine, I generally don't recommend using Auto-anything! Establish your own default processing parameters.

As previously mentioned, if you apply your own Develop preset during import, you will see initial previews closer to what you expect. But what about photos you've already imported, those without a preset applied?

Setting your own default

Beyond applying presets on import, you can also override the main Lightroom default, which is applied to all raw images that haven't otherwise had settings applied.

To change the Lightroom default, first make sure all the Develop settings are the way you want them. (You will need to have a sample image loaded in Develop for this.)

Then select Develop menu→Set Default Settings. A dialog box will appear asking you to confirm your choice (see Figure 7–83). Note that by running this command again later you can restore the original Lightroom defaults.

Now, if you don't use a Develop preset during import, these default settings will be applied to all newly imported images as they come into the catalog.

Figure 7–83: Set Default Settings

Default settings by camera or by camera and ISO

In Lightroom preferences (see Figure 7–84) you can specify to have defaults applied based on camera serial number or a specific camera and ISO setting. This way you can use a wide range of defaults without needing to apply different presets to each and every image from different cameras or at various ISO settings.

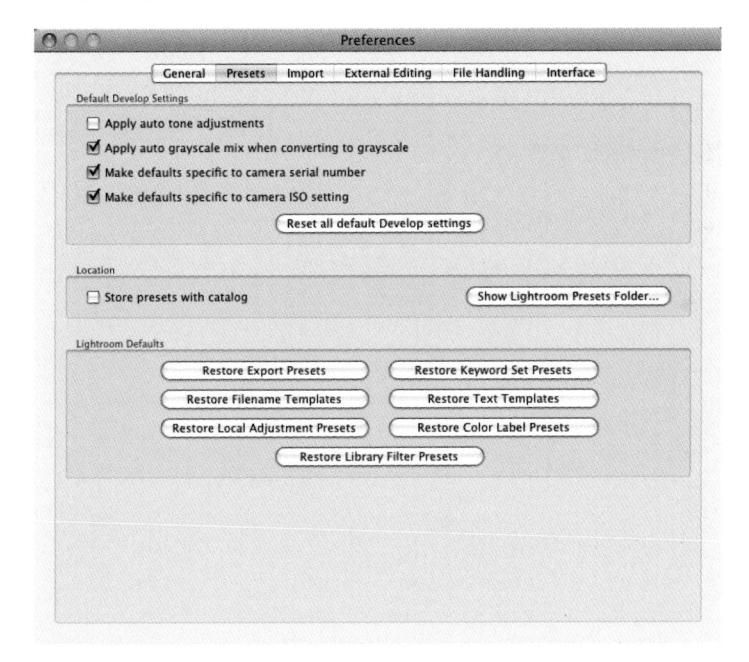

Figure 7–84: Preference for defaults by camera and Iso

Preferences→Presets→Apply Auto-Tone Adjustments

Lightroom has a preference setting to either apply Auto-tone adjustments or not. The default is off. For the most control over Developing your photos, check your preferences to verify this. Otherwise, Lightroom will auto-process your photos.

Workflow: Develop a Photo

- 1. Apply defaults and/or camera profile
- 2. Crop and straighten
- 3. Adjust tone
 - 3.1 Exposure (white point)
 - 3.2 Blacks (black point)
 - 3.3 Brightness (midtones)
 - 3.4 Contrast
 - 3.5 Clarity
 - 3.6 Tone Curve
- 4. Adjust color
 - 4.1 White balance
 - 4.2 Saturation
 - 4.3 Vibrance
 - 4.4 Selective colors
- 5. Remove artifacts
 - 5.1 Chromatic Aberration
 - 5.2 Noise
 - 5.3 Smoothing (optional)
- 6. Dodge and burn
- 7. Sharpen
- 8. Retouch

Keep checking for clipping and noise throughout processing

While processing your photos in Develop, periodically check for clipping and other artifacts, and as necessary, apply appropriate adjustments to remove them.

Workflow: Roundtrip Editing with Photoshop

As much as Lightroom is capable of, there will be times when you've got to move a file into Photoshop to finish your work.

One common example is when you need to combine multiple captures. This is called *compositing*—you're making a *composite* image from multiple original photos. Compositing can be done manually, such as stacking multiple layers with masks in Photoshop, or automatically, such as with HDR tone mapping or stitching panoramas. The outcome of all of these processes is a final, composite image.

Another example is heavy retouching, which also could reasonably be considered compositing. If you need to replace a large or complex section of a photo, you'll likely need more retouching power than Lightroom can provide.

Many photographers like to apply fancy special effects, like a watercolor painting, charcoal effect, etc., or create ornate borders for their photos. Photoshop reigns supreme here—it has long been the platform for the development of an astounding range of plug-in filters, used for a seemingly endless variety of special effects. When it comes to special effects plug-ins, current versions of Lightroom can't touch Photoshop.

Also, there are advanced sharpening and noise reduction packages available that go far beyond what Lightroom can do in these areas and are also often done through the use of Photoshop plug-ins.

Finally, there are the issues related to preparing files for print, and printing itself. While the files you generate from Lightroom's Export capabilities cover many of the most common scenarios, reproducing a photo in print still requires some fine-tuning in Photoshop. One key example of this is soft-proofing. Photoshop can simulate, on-screen, the appearance of an image printed on a certain printer and paper combination. You can then make Photoshop adjustments to get the image to look as much like your reference image as possible. Lightroom currently doesn't provide softproofing.

Prepping files for printing at an outside vendor, such as an offset print shop, can also require Photoshop, especially if it's a смүк process. (Lightroom does not support files in CMYK color mode.)

Situations where you will want to take photos out of Lightroom and into Photoshop (or other software):

- HDR (High Dynamic Range) imaging: you can use Photoshop or other software to blend exposures for HDR. To do it in Photoshop, use the menu command in Lightroom: Photo→Edit In...→Merge to HDR in Photoshop;
- Panoramas: out of Lightroom, you can use Photoshop or other software
 to stitch exposures for panoramas. To do it in Photoshop, use the menu
 command in Lightroom: Photo→Edit In...→Merge to Panorama in
 Photoshop; and
- Placing multiple images in a Photoshop (TIF) file as layers.

External editors

In Preferences, you can specify up to two other programs to use as *external editors* for Lightroom. If you have one or more versions of Photoshop installed on your computer, the most recent version will be selected by default.

Edit in Photoshop

With one or more photos selected in Library Grid or the Filmstrip in any module choose the Photo menu→Edit In... command, or use the shortcut or contextual menu.

Depending on the type of original, one of two things will happen:

For DNG and camera raw files and virtual copies: Lightroom will render the file and open it into Photoshop memory. No file has yet been created; the image data has simply been opened as a new file in Photoshop. (For Lightroom versions earlier than 2.0, a file is rendered to disk first.)

For all other file types: Lightroom opens a dialog box offering the following options (see Figure 7–85):

- Edit a copy with Lightroom adjustments: instructs Lightroom to render a copy file to disk, including all the currently active Lightroom adjustments, and open that image into Photoshop;
- Edit a copy: same as above (creates a new file on disk), but Lightroom adjustments will be ignored. The resulting copy is then opened in Photoshop; and
- Edit original: opens the original file; again, ignoring Lightroom adjustments.

To edit a photo in the primary external editor.

> #+Option+E or Ctrl+Alt+E To edit the photo in the secondary external editor.

Whereas an export operation generates new

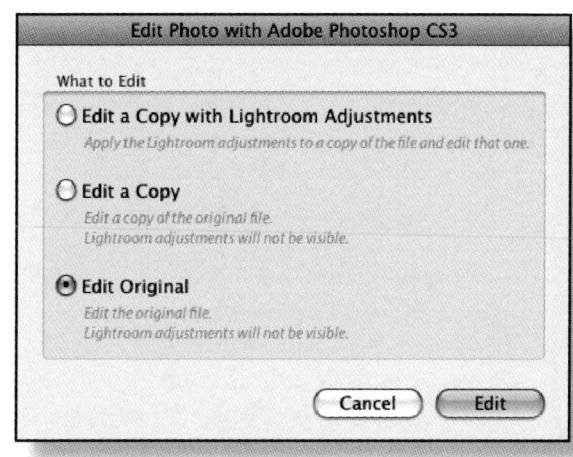

Figure 7–85: Edit in... dialog box

files and saves them to disk (or burns to CD/DVD), the Edit in... commands rely more on computer memory (RAM) to maintain an active, "dynamic" link between image files from the Lightroom catalog being edited in Photoshop. For more about exporting, see Chapter 8.

Don't use PSD

From this point forward, I recommend that you don't use PSD files for any of your layered Photoshop work. Use TIF instead. It provides all the same capabilities as PSD (layers, type, alpha channels, etc.), with a distinct advantage: TIF offers much more long-term viability than PSD. The TIF format is an open source, industry standard. It's much more likely that software many years in the future will be able to read TIF files than PSD. PSD is proprietary, and in my opinion, outdated, with a number of programmatic disadvantages to TIF.

You need the latest version of Photoshop for full functionality with Lightroom

If you have photos selected in Lightroom and the above described options are grayed out, it's because you don't have a recent enough version of Photoshop. You'd need to upgrade for full interoperability between Lightroom and Photoshop.

Photoshop Layers

With multiple photos selected in Lightroom, use Photo menu→Edit In... →Open as Layers in Photoshop. Each photo will be opened as a new layer, all in the same file.

Photoshop Smart Objects

Though outside the scope of this book, using Smart Objects is a very clever way to keep your Lightroom edits to originals in-sync with copies edited in Photoshop. If you have Photoshop CS2 or higher, I recommend you spend some time investigating the use of Photoshop Smart Objects with Lightroom in the roundtrip editing workflow.

To open a photo/photos in Photoshop as a smart object, go to Photo menu→Edit In...→Open as Smart Object in Photoshop.

Save... and Save As... from Photoshop

When you're done working on the file in Photoshop (or other external editor), be sure to do a regular Save in that application. Lightroom will automatically update its version of the file in the catalog.

Example Before/After Photos

Following are before and after examples of photos processed entirely in Lightroom (Figures 7–86a-86e).

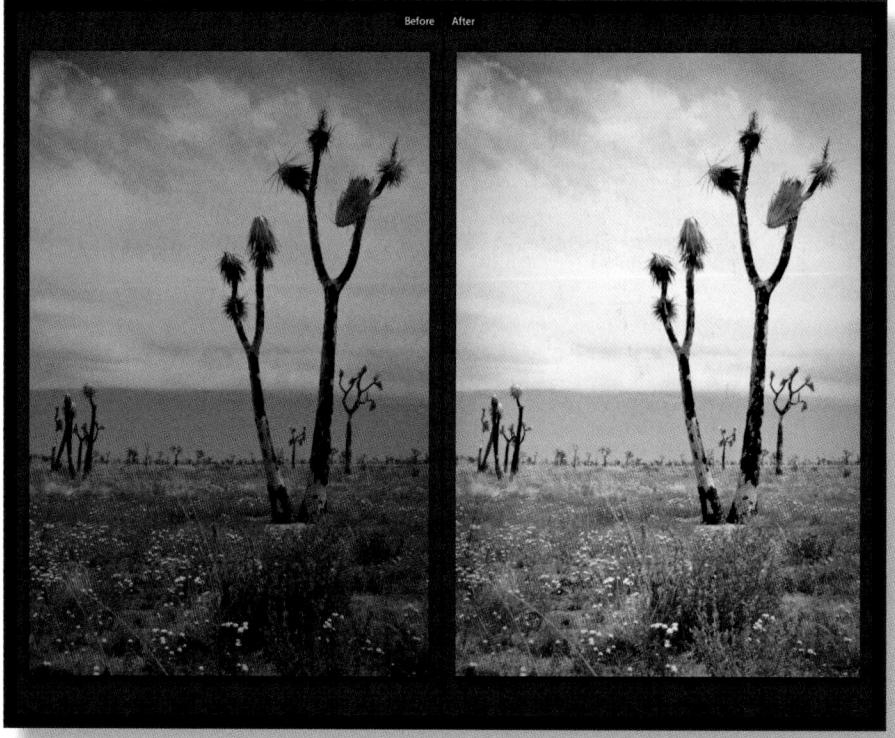

Figure 7-86a: Before/After

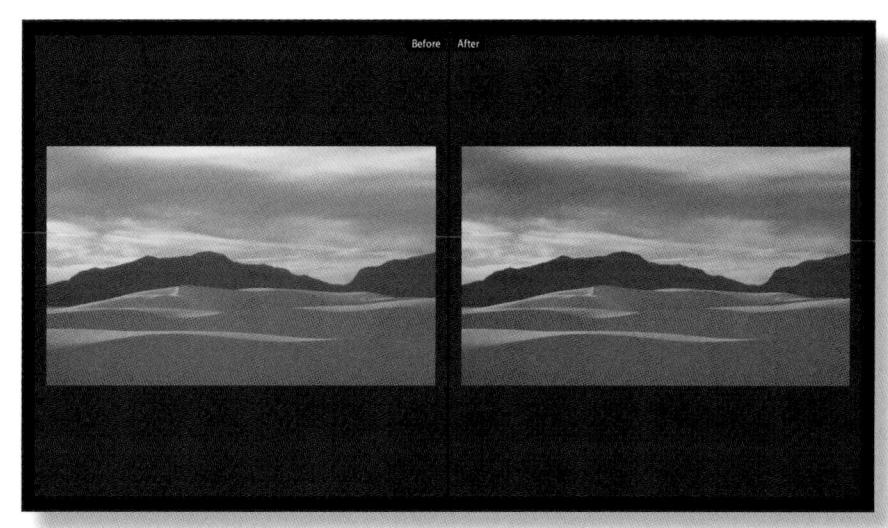

Figure 7–86b: Before/After

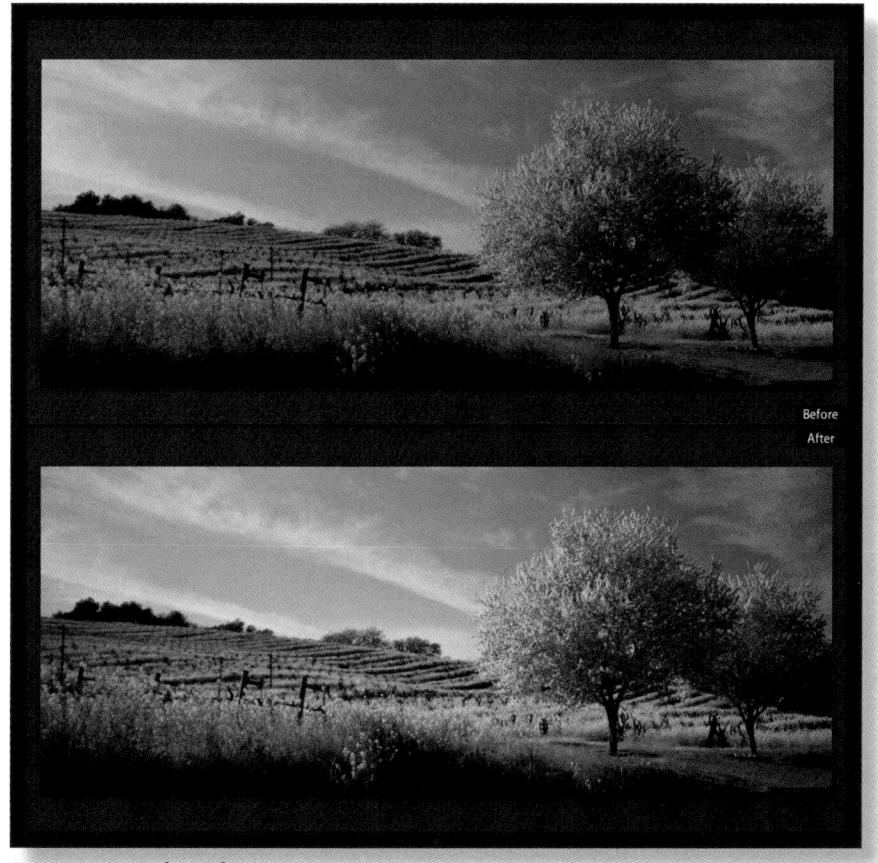

Figure 7–86c: Before/After

7

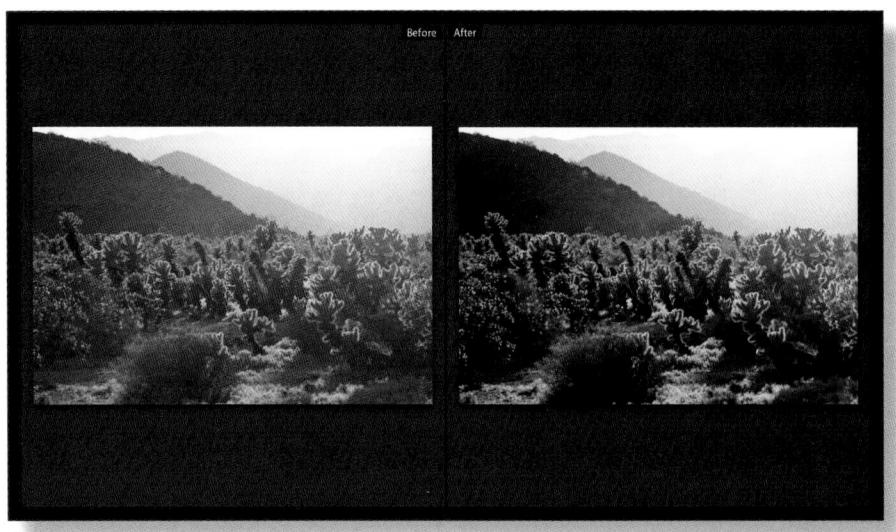

Figure 7–86d: Before/After

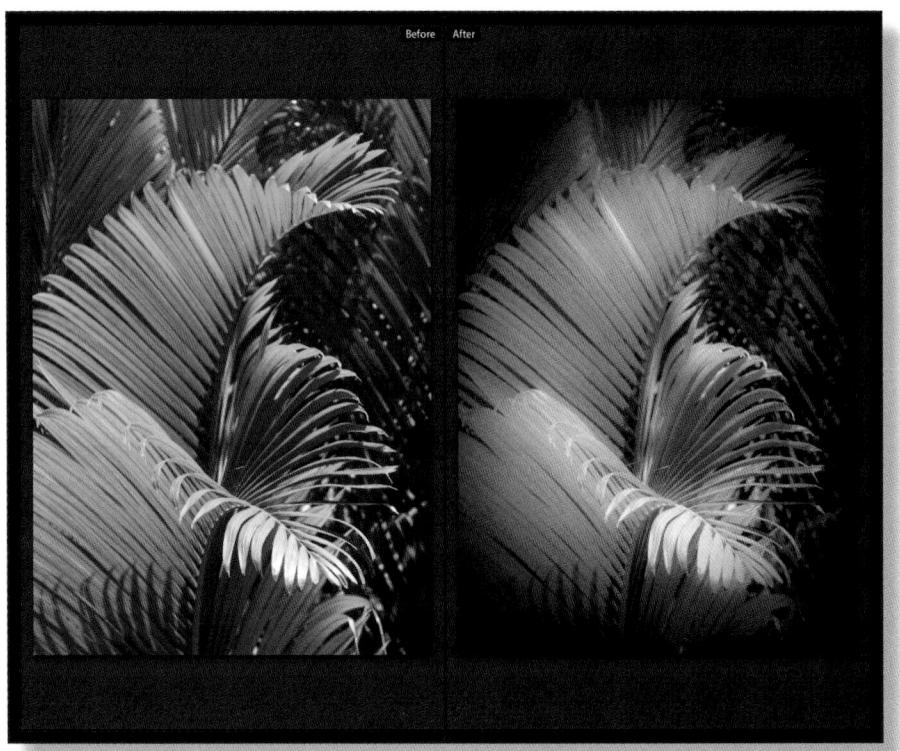

Figure 7–86e: Before/After

Chapter Summary

Lightroom provides most of the tools you will need to make your photos look their best. Take your time working in the Develop module, use a consistent sequence of steps and use the provided controls to make the image look as good as it can.

Experiment! There's no harm you can do to your image files processing them in Develop. You can always go back to any previous point.

Continually examine the photo at different zoom levels to ensure your processing is as clean as it can be. Keep checking for clipping and confirm the quality of your work before deciding you're finished.

CHAPTER 8

EXPORT IMAGES FROM LIGHTROOM

When you've gone as far as you can with your photos in Lightroom you can export images to work with them in other programs.

So when should you export? It all depends on the job at hand.

Often, exporting represents the end of the processing workflow: your photo is finished and you simply want to transmit a final copy of the image somewhere else.

Other times, exporting is just the next step in a more complex workflow in which you will use the exported files to do further processing.

This chapter explains the export process and suggests some practical applications for getting your files out of Lightroom and into other software.

You're Done in Develop...Now What?

After processing in Lightroom, it's common to want to do more with your photos outside Lightroom. Maybe you want to send someone a photo in an email message, post a set of images on a photo sharing Web site, or burn a set of files to DVD for a client.

Often you will want to process the photo further in other imaging software; Lightroom can help you send the resulting image files into extended, automated workflows. Using plug-ins and post-processing scripts, Lightroom can trigger all kinds of automated processes on the exported photos.

In all these situations, when you've gone as far as you can working in Lightroom, you need to *export* your photos to get them to the next point in the workflow.

Exporting from Lightroom always generates new image files, but depending on the purpose of the export, the new files aren't always saved to disk following the completion of the export operations. If you do save the newly exported files to disk, you will likely also want to add those images into the current Lightroom catalog.

Export versus Edit in...

If you need to get photos out of Lightroom to process them in Photoshop you likely don't need to (and probably shouldn't) export them. Instead, use the Edit in... command, discussed in Chapter 7.

Export versus the presentation modules

Before exporting files for a particular use, also consider whether using Lightroom's presentation modules (Slideshow, Print, Web) would better generate the files you need. The functions of those modules provide some capabilities that make certain tasks easier than through an export. Examples are the "Export JPG" command in Slideshow and "Print to JPG File" in the Print module. See Chapter 9.

Library→Convert Photo(s) to DNG

If you have camera raw files in your catalog that you want to convert to dng, you can do this without doing an export. In Library, run the command from the Library menu (see Chapter 6).

Making real files from virtual copies

Remember that a virtual copy (vc) does not exist anywhere on your hard disk. It's just another instance of the file generated within the Lightroom catalog. If you lose your catalog, and don't have a backup (shame, shame), those vcs will be gone, and also the work you put into them. However, if you export a vc as an actual file on disk you can also backup and archive those files to another hard drive or removable media.

ORIGINAL AND DERIVATIVE FILES

When you export photos from Lightroom, the *original* is the photo from which the new files are being made. An original can be any file or virtual copy in your catalog (see Figure 8–1). *Derivatives* are copies of the original, made for a specific purpose, whose settings have been uniquely modified for the task at hand.

For example, let's say you have several DNGs that you want to blend together using a specialized HDR program. You can export TIF files from Lightroom to bring into the other software. In this example, the DNGs are the originals and the TIFS are the derivatives.

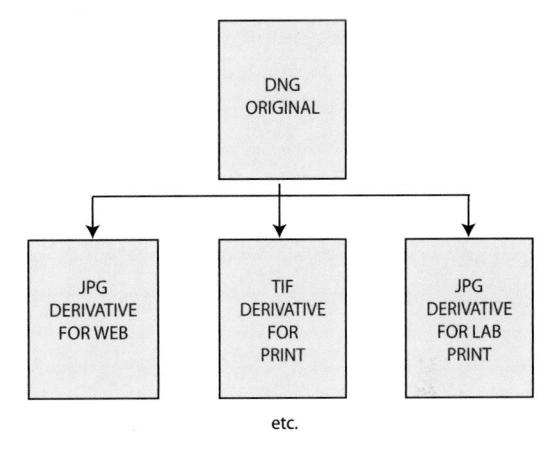

Or, you might have a layered PSD file in your

Figure 8–1: Originals and derivatives

catalog from which you export a JPG file to send to a lab for printing. The PSD is the original; the JPG is the derivative.

You might also have more than one original version of a photo in your catalog, made from a single capture. Each variation could be considered an original. For example, if you use virtual copies to produce multiple versions of a photo in color, black and white and split-tone, each VC would be an original from which derivatives could be exported.

What to do with original JPGS

Remember that in Lightroom, with metadata editing, JPG files are processed non-destructively, just as with all other file types. But in other programs (such as Photoshop) you should never work on a JPG and then save it as a JPG again—you will lose significant amounts of quality. If you have photos in your catalog that were originally captured as JPG, and you want to edit them in other software, you should export them as TIFS first, then use those TIFS as your working masters.

Don't keep anything you don't need

Some derivatives don't need to be kept around after you're done using them for their immediate purpose. For example, I usually don't keep derivative JPGs, since they're always made for a specific purpose and making/remaking them if necessary doesn't take much effort. I delete these temporary files when I'm done with them.

PLANNING THE EXPORT

Like other parts of the workflow, exporting from Lightroom requires thinking ahead. Before exporting, determine the specifications for the files that will be generated. Try to be as specific about the settings as you can be. Write it out if it helps. Ask yourself:

- How are the files to be used?
- Do you have a set of specifications to follow?
- How will you name the exported files?
- Where will you store them in your file system?
- Following the export, what additional tasks need to be performed on the files?
- Do you want these new files to be added to the current Lightroom catalog?

₩+Shift+E or Ctrl+Shift+E

When you're ready to export, make sure the correct file or files is/are selected in Grid or Filmstrip. In Library, you can click the Export button (see Figure 8–2), or from anywhere in Lightroom, use the above shortcut to open the Export dialog box.

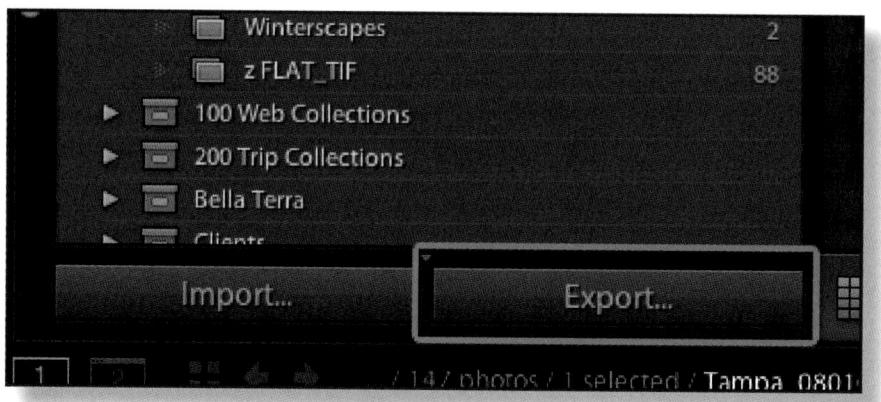

Figure 8-2: Opening the Export dialog box

Export options on the contextual popup menu

Once again, the right-click delivers. The contextual menu that appears when you right-click or Ctrl+Click on an image provides an export command, complete with presets. This bypasses the Export dialog box entirely (see Figure 8–3).

Batch exports

Like import and Develop work, Lightroom exports provide powerful batchprocessing capabilities. Simply select any number of multiple photos, from any catalog image source, and the export will process all the selected files.

The Export Dialog Box

As with other dialog boxes and panels in Lightroom, you need to carefully enter the settings in the Export dialog box (see Figure 8–4). If you botch the settings and have to redo the

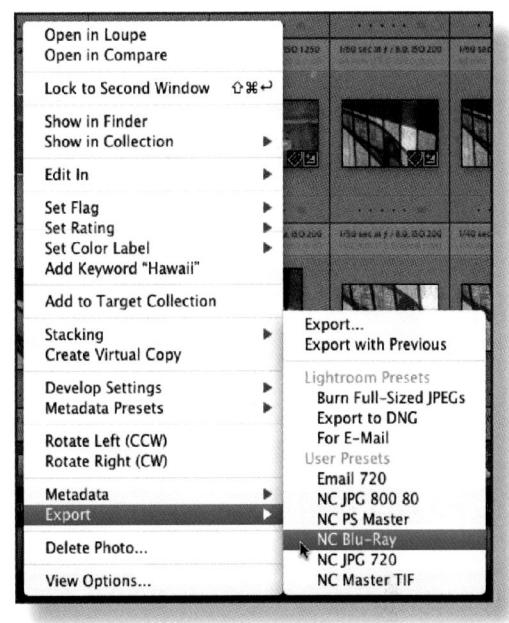

Figure 8–3: Initiating the export from the contextual menu

export you may have a mess of files to clean up first. Start at the top and work your way down methodically, making sure everything is correct before you start the export.

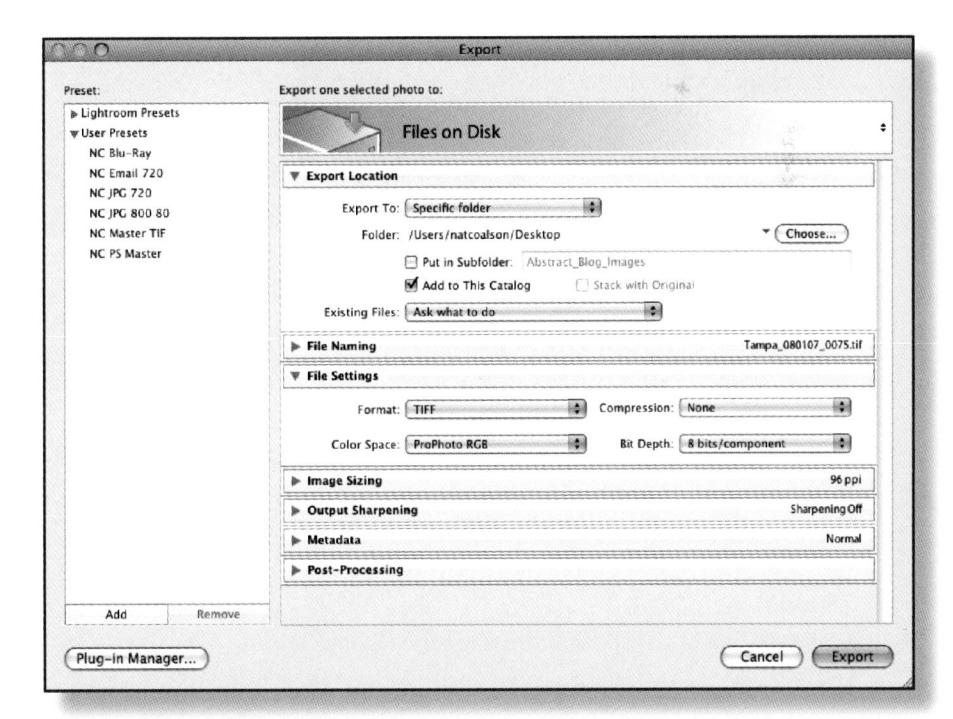

Figure 8–4: Export dialog box

Work in the Export dialog box without exporting

With any image selected, executing the Export command will open the Export dialog box. However, you don't necessarily have to complete an export at this point. You can view and change settings, create and modify presets, etc. and when you're done just click Cancel to close the box without performing an export.

Canceling an export in progress

If you start the export and realize you made a mistake, it is possible to cancel the export by clicking the "X" to the right of the status indicator (in the identity plate area of the top panel).

EXPORT LOCATION

You have a simple choice for the destination of the exported derivatives: Files on Disk or Files on CD/DVD. The top part of the Export dialog box shows which option has been selected (see Figure 8–4).

The first critical decisions to make are:

- 1. Where to save the exported file(s); and
- Whether or not to add the new file(s) into the current Lightroom catalog.

Export To

Use the popup menu to specify one of the following:

• Same folder as original photo

I usually save derivatives in the same folder as the originals unless the files are only temporary, in which case I save them to a folder on my desktop that is routinely emptied.

Specific folder

If you want to save the exported files in a location other than the original folder, specify it here.

• Temporary folder (will be discarded upon completion)

If you are using Lightroom export to burn the exported files to a CD/DVD, you can choose to not retain the exported file(s) on the hard disk at all.

Folder

If exporting to a specific folder, click the Choose button and navigate to the target folder on your hard drive. During this step, you can create a new folder

for the exported files. When you make new folders during an export and you add the exported files to the catalog (see below) the new folders are added, too.

Recent folders menu

Click the small black triangle to the left of the Choose button to select a recently used folder from the popup menu.

Put in Subfolder

With this field you can create a new subfolder under the one selected above. Setting the Folder (above) to an upper-level directory and then specifying a new subfolder to be created here is faster and provides more control than making a new folder in the Folder dialog box.

Add to This Catalog

Enable this option to automatically import the newly exported file(s) into the Lightroom catalog. I always do this for derivatives I intend to keep, and usually don't for temporary ones.

Stack with Original

If you enable Add to This Catalog, you can stack the exported derivatives with the original masters. I frequently enable this option.

Use stacks to group originals and derivatives

If you generate derivatives that you want to add to the catalog, stacking them with the original can help keep your image sources neat and tidy.

Existing Files

This setting determines what Lightroom should do if files with identical names are found in the destination folder. I usually keep this on "Ask what to do" unless I'm doing a large batch and/or just want to overwrite everything in the target folder, in which case the other options come in handy.

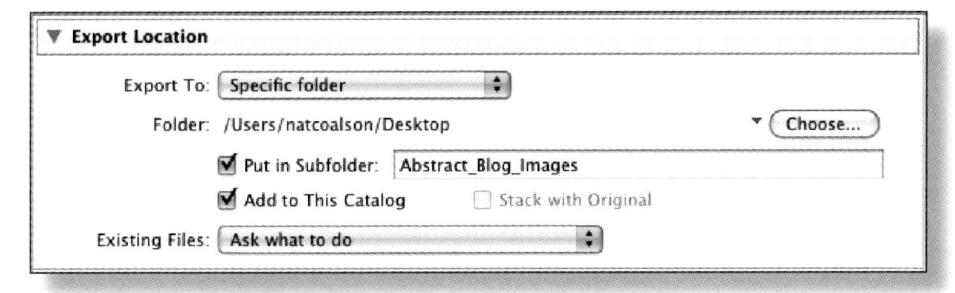

Figure 8–5: Export Location

Open and close the export box panels

Each of the sections of the export dialog box (see Figure 8–4) can be closed if not needed; click on them to open and close them. When closed, a section's header shows its current settings.

FILE NAMING

Exported derivatives can use the same or different filenames as their originals (see Figure 8–6). Carefully consider the names for your exported files. Think of this like a "Save As…" operation in other programs: you're starting with a set of image data and creating a new file from it. Just as with Save As… you should be deliberate about how you name the copy file. As with other stages in the workflow, practical naming of exported derivatives makes your work much easier.

You have two options:

- Keep the same base file name as the original; or
- Use a different name.

For example, exporting

Death_Valley_080412_044.dng

could create a derivative file named

Death_Valley_080412_044.jpg

or, it could become

NCoalson_DeathValley2008_420px_srgb.jpg

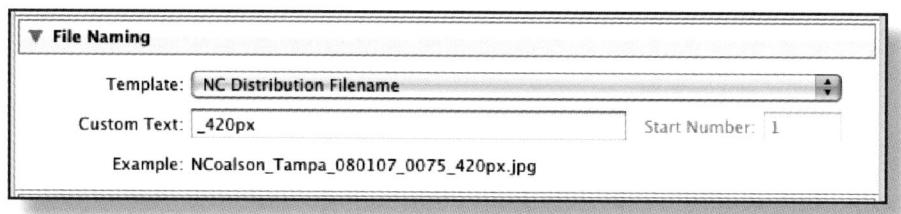

Figure 8-6: File Naming

Use special names for derivative exports

I almost always apply new names to derivative files to indicate their settings and/or what they are to be used for. But there are times when keeping the original base filename would be more appropriate, such as when exporting derivatives to be further processed in other software.

Use file naming templates

Just as during import or when renaming in Library, using templates for your exported file names greatly speeds the process.

File name shown in red

An option in Lightroom Preferences→File Handling→File Name Generation controls Lightroom's file naming behavior. When the name being given to an exported file is not Internet-friendly, the Export box will show your file name in red, indicating that it will be modified to conform to Internet naming conventions.

FILE SETTINGS

In this section of the export dialog box (see Figure 8–7), you enter the specifications for the derivative files. If you're doing a batch export, all the files will be exported using the same settings unless the output file format is set to Original.

First, select the file format. Then, depending on which format is chosen, apply the other settings specific to that format.

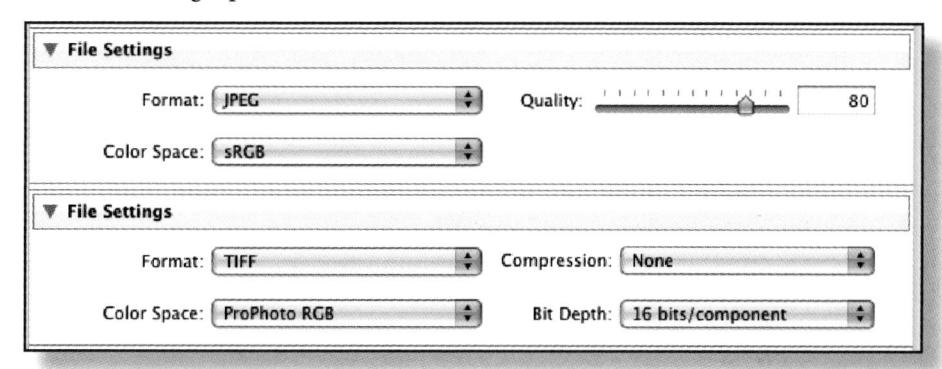

Figure 8–7: File Settings

Format

File formats are discussed in detail in Chapters 1 and 5; here's a list and descriptions of the formats available in the popup menu:

• **JPG: Joint Photographic Experts Group.** Use for Web and email purposes. Exporting as JPG allows you to specify a quality level in numeric values from 0 to 100. The quality setting determines the amount of compression to be applied to the files. With lower quality settings, more compression is applied, resulting in degraded image quality. Higher quality numbers will apply less compression and thus produce better looking files. The higher the quality, the larger the size of the resulting file will be, but keep in mind that JPG compression is always lossy—data is discarded during compression, even at the highest quality setting. I usually keep JPG quality between 70 and 80 unless I need to adhere to provided specifications.

File Formats, continued

- PSD: Photoshop Document. Can be used to create layered master files to work with in Photoshop or Elements (but I don't recommend this; see reminder below). Exporting as PSD allows you to set the bit depth.
- TIFF (.TIF): Tagged Image File format. TIF is the most versatile of the supported formats; it can be used for virtually any purpose except posting to the Web. When exporting TIFS you can also specify bit depth and apply compression. In all cases, compression on TIF files is lossless—no data is discarded during compression. Still, I usually prefer to not apply compression to exported TIFS because uncompressed TIFS are more portable between applications/platforms and are faster to open and save.
- DNG: Digital Negative. Use to re-encode raw captures. I always work with my raw captures in DNG format and I don't save the original raw files from the camera after they've been converted. However, I do the DNG conversion on import, or at least, using the menu command in Library. (I would never use a Lightroom export to convert raw captures to DNG files; I just don't think it's practical). In any case, I recommend using the default settings for DNG conversions in Lightroom.
- **Original:** you can export derivative files in the same format as the original. In a batch with multiple file types selected, each derivative will be saved in the same format as its own original. If virtual copies are being exported, the resulting files will be in the same format as the original from which they were made; this can be a good way to generate "real" files from vcs. You can't change file settings when exporting to Original format.

Don't use .PSD

From this point forward, I recommend that you don't use PSD files for any of your layered Photoshop work. Use TIF instead. It provides all the same saving capabilities as PSD (layers, type, alpha channels, etc.), with a distinct advantage: TIF offers much more longterm, archival viability than PSD. The TIF format is an open source, industry standard. PSD is proprietary, and in my opinion, outdated, with a number of programmatic disadvantages to TIF. It's highly likely that more software, many years in the future, will be able to read TIF files than will read PSD. You might currently have many files in your image archives in the PSD format. Consider the benefits of re-saving all of them as TIF.

Exporting layered originals produces flattened derivatives

Though Lightroom will respect and preserve layers in TIF and PSD files when they are imported, if you export them (to any format), the resulting derivative will be a flattened file. (Unfortunately, the same goes for Photoshop's Image Processor... however, you can make an action/droplet to batch re-save PSDs as TIFS from Photoshop.

Use 16-bit for the highest quality

When exporting TIF files I recommend you usually use 16-bit depth, especially if you're going to continue processing the image(s) in other software. One exception might be if you're sending exported TIFS to a service bureau for printing, in which case 8-bit is usually adequate. (Ask your vendor for details on how they want files prepared.) As explained in Chapter 1, 16-bit is most useful when applying adjustments to high quality captures. Depending on your circumstances, 16-bit might not be worth the additional file size.

Color space

To recap the fundamentals of color management from Chapter 1: the color space of an image determines colors possible and allows those colors to be accurately translated to different devices through the color management system. The image's color space is indicated to the CMS by an embedded ICC profile.

When you're working on a photo in Lightroom you don't need to worry about color spaces. Lightroom respects and preserves color profiles embedded in image files. (For images that don't have one, a space similar to srgb is automatically assigned.)

However, when you export a photo from Lightroom you *must* choose a color space for the new file (even for an original with a profile already embedded). There is no option to use the same profile as the original or to export a file without embedding a profile.

Example: if you work on a TIF file in Lightroom that has the ProPhoto profile embedded, you would still need to choose ProPhoto again when exporting if you want to keep the derivative file in that space.

When you choose a color space for exporting from Lightroom (see Figure 8–8), you need to do so based on how the file will be used. Lightroom will convert the colors in the photo to the selected color space and embed the ICC profile for it.

The default (and most common) color spaces/profiles are:

• srgb: "Standard rgb"; developed by Microsoft and often referred to as "small rgb" due to its relatively small gamut. Of the three main working spaces, srgb most closely resembles the output spaces of computer monitors and laser imaging devices (LightJet, Frontier, Chromira, etc.) srgb excels in producing vivid greens and blues. For our purposes, think of it as the "small" color space. If you're preparing files for viewing on screen (e.g. a Web site) or having prints made by a lab, use srgb.

- Adobe RGB (1998): "argb" or "rgb98" is the most flexible of the color spaces supported by Lightroom. It's capable of producing rich reds and oranges while maintaining dense blacks. Some examples: argb translates well to CMYK for offset printing and can also work great in wider-gamut inkjet printing. And converting argb files to srgb produces only minor shifts in color. Think of argb as the "medium" color space. Use argb if you're preparing the file for offset or inkjet printing, or if you don't yet know the ultimate destination of the file.
- **ProPhoto:** while not the largest color space ever developed (try Googling EktaSpace and Bruce RGB), ProPhoto is the largest of the three standard color spaces included in Lightroom Export (though you can use your own color space; see Figure 8–8). ProPhoto maintains the most vivid saturation of the three popular spaces and contains some colors that can't (yet) be reproduced in print, particularly super-saturated yellows, oranges and reds. When exporting files from Lightroom to be processed in other software, I always use ProPhoto and 16-bit.

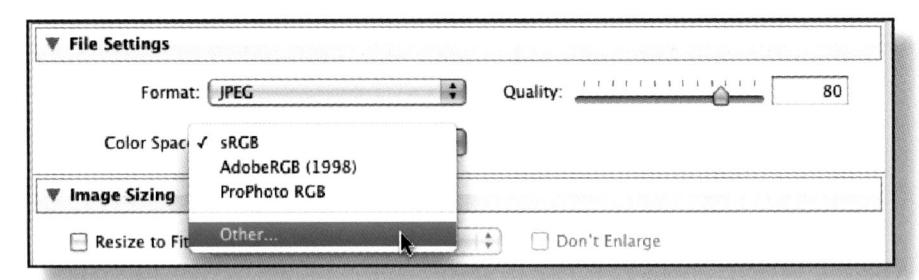

Figure 8-8: Color space selection

Embed your own profile

You can also select your own color space by selecting "Other..." from the popup menu. This allows you to export files in any color space available on your computer and is especially useful when preparing files for printing by an outside vendor.

Ask vendors about profiles

When sending an image to a lab or service bureau, you need to know how your file will be reproduced. Ask them if there is a specific color space that they want the file saved in.

! Rendering intents

In Lightroom you don't have the option to choose the rendering intent for color space conversions. If this is important to you, use Photoshop to perform the conversions instead.
IMAGE SIZING

As mentioned previously, when you're working on photos in Lightroom you're always working at the files' native resolution. When exporting, however, you have the option to resize the exported derivatives. The Export dialog box provides several controls for this (see Figure 8–9). You can only resize the exported images if they are to be TIF, PSD or JPG.

Remember that resizing a bitmap (raster) image always requires resampling: pixels must either be created or discarded. Both cases result in a loss of image data (insignificant as it may be for the circumstances). Lightroom uses resampling algorithms similar to Photoshop's with equivalent quality in the results. When enlarging (upsampling) an image, new pixels are synthesized from the existing ones. When reducing (downsampling), pixels are discarded, and the values of the remaining pixels are averaged to produce the final image.

Resize at the end of the workflow

Always resize your photos after all other post-processing has been completed, and only resize as necessary for the intended purpose. If you're planning to do more processing on the files after the export, leave the derivatives at the native resolution of the original. But if the exported derivatives are to be used for a final implementation of the photo, you can resize them during export. For example, if you're going to work on an exported file in Photoshop, don't resample it during export. But if you're exporting a JPG to email to someone, go ahead and resize it during export.

Resize to Fit

In this section of the export dialog box you specify the size for the new files. All of the numeric entries represent maximum constraints: the numbers entered here are always the largest possible size that would be output.

Regardless of how you specify the output size, no distortion of the exported images will result; all the resizing controls in Lightroom export produce images that retain the proportions of the original.

The choices for resizing are:

- Width and Height: enter the maximum size(s) for width and/or height. (You can leave one or the other blank.) The photo(s) will be scaled so that both dimensions fit within the specified measurements.
- **Dimensions:** the images will be scaled to fit within the specified dimensions without regard to which is width and which is height. The smaller of the two numbers will determine how much the image is scaled.

- **Long edge:** set the size for the long side of the photo; the short edge will be scaled proportionately.
- **Short edge:** set the size for the short side of the photo; the long edge will be scaled proportionately.

Don't Enlarge

Check this box to prevent Lightroom from enlarging any images whose originals are already equal to or smaller than the specified output size.

Resolution

You'll recall that the term "resolution" has two meanings, either referring to the actual pixel dimensions of the file (x pixels by y pixels) or the "resolution" setting in Photoshop, Lightroom etc. (ppi—pixels per inch). In the second instance, resolution is simply a metadata value embedded in the file; the pixel dimensions have no relationship to this so-called "resolution". The resolution setting in Lightroom Export—and its equivalent in Photoshop—is only relevant for printing.

Remember that a pixel does not have a fixed size. On a monitor, projector etc., the actual pixel dimensions are all that matters and, typically, one image pixel will be displayed as one screen pixel. This applies for Web browsers, email clients, television, handheld devices, etc. If you're exporting files for any kind of screen output, don't worry at all about the Resolution setting. It will have absolutely no effect on the final output of screen-based media.

Making a print is another matter entirely. With printed output, besides the actual pixel counts, you have another issue to consider—real world, physical measurements such as inches or centimeters. On a printed photo, the pixels in the image need to be discreetly mapped to the real world measurements. Which raises the question, "how many pixels in an inch?" That's where the Resolution setting comes in: it determines how the pixels in the image will translate to the printed output. If the export is intended to produce print-ready files, set the sizes for the derivatives to the final dimensions and resolution for the type of printing being done.

For example, let's say you have specs from a printer that includes sizes in inches and resolution in pixels per inch: 5x7 inches at 300 ppi. Enter those measurements in the export dialog box. (This would make a file that is 1500x2100 pixels.)

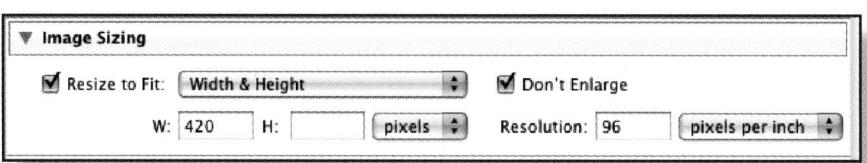

Figure 8–9: Image Sizing

OUTPUT SHARPENING

Remember that we use three types of sharpening in our workflow: capture sharpening, creative sharpening and output sharpening. Lightroom provides the capability to automatically apply output sharpening during the export (see Figure 8–10). With this method the new files are sharpened at the ideal point in the processing workflow and at the proper amount for the type of media for which the file is intended.

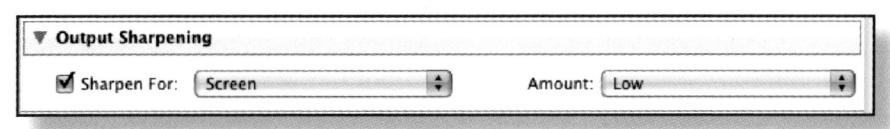

Figure 8-10: Output Sharpening

To enable output sharpening, tick the "Sharpen For:" box, choose the type of sharpening and the amount to apply.

- **Screen:** use this if you're exporting files for display on a monitor, TV, etc.
- Matte Paper: use for printing on matte paper, such as cotton rag art papers like Hahnemühle Photo Rag and Epson Exhibition Fiber.
- Glossy Paper: use for printing on glossy, luster and "pearl" photo papers like Harman Glossy FB AL, Epson Premium Luster and Ilford Galerie Gold Fibre Silk.

After choosing the type of sharpening, set the amount.

- · Low
- Standard
- High

What's the right amount of sharpening?

Because sharpening routines are image-specific and dependent on resolution, finding the ideal amount may require you to do some testing. Try the standard amount first, evaluate the results and adjust as needed.

When not to sharpen

If you're going to resize, apply noise reduction and/or sharpen in another program (i.e., Photoshop), think carefully about whether or not you really want to apply sharpening during the Lightroom export.

METADATA

This section of the export box provides controls for how each file's metadata is handled during the export (see Figure 8–11).

Minimize Embedded Metadata

Ticking this checkbox will prevent the full metadata from the original file from being copied into the newly exported files; all except for the copyright. The purpose for this is to allow you to create smaller files; depending on how much other metadata you've applied, this can result in relatively significant savings in file size. If you need to export files at the smallest possible size, enable this option. Just be aware that all metadata except copyright—including keywords—will not carry over to the new files.

Write Keywords as Lightroom Heirarchy

If you use parent/child keyword hierarchies in Lightroom, checking this box will preserve these relationships when the keywords are written into the exported files. Note that this keyword structure may not be respected by other software reading the keywords from the files. The only real benefit here is that if you're going to bring the files into another Lightroom catalog you can retain the hierarchies you've previously created.

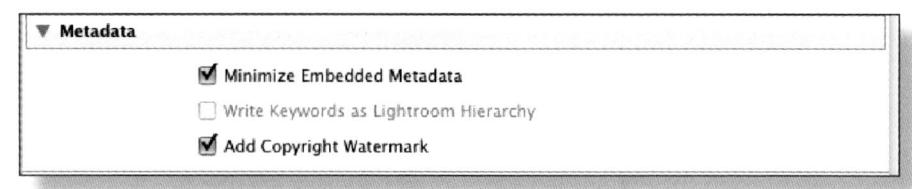

Figure 8-11: Export metadata options

Add Copyright Watermark

This adds a semi-transparent line of text in the lower left corner of the exported image (see Figure 8–12). The text comes from the copyright metadata field; if it's blank, no watermark will be output. There are currently no built-in controls provided for the styling of the watermark text. (However, there are other options for applying watermarks with more control, discussed toward the end of this chapter.)

Figure 8–12: Lightroom's Export Copyright watermark

POST-PROCESSING

Use the controls in this section of the Export screen to process the files further after Lightroom is done exporting them. Lightroom can integrate its export routines with those of other software applications: when Lightroom is done with its part, the files are handed off to the other program(s) for further processing (see Figure 8–13).

Final derivatives are handed off to the other application or plug-in

The post-processing options are just that—all of Lightroom's processing is fully completed before anything will be applied from this section of the dialog box. For example, if you run a Photoshop action on the exported files, all the steps in that action—and any resulting changes to the files—will be performed *after* Lightroom's color space conversion, resizing, sharpening, watermarking, etc. Keep this in mind when you're planning the export workflow; it has a significant effect on how your steps should be arranged when post-processing is involved.

After Export

Select an item from this menu to either run the actions contained in a Photoshop droplet or a script, or open the selected application, upon completion of Lightroom's export. Some example uses of After Export menu items:

- Running Photoshop actions contained in droplets, such as applying noise reduction, advanced sharpening routines, etc.;
- Sending photos in email or transferring by FTP;
- Uploading to photo sharing Web sites; or
- Opening the files in another program.

If the derivative files are added to the catalog during the export, any post-processing operations applied will also be automatically reflected on the files in the catalog.

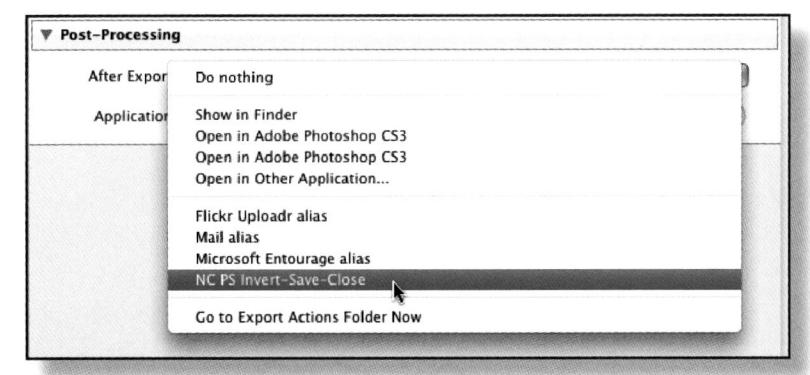

Figure 8–13: Post-processing

"Seasonal Cycles" 2007 Canon EOS 30D, Tamron 18-200 XR II Di 1 second at f/32

Add your own Export Actions

You can add Photoshop droplets, scripts and shortcuts to other software programs to the After Export menu. Any item that can be executed by opening a photo (or set of photos) can be added as an Export Action.

From the popup menu, select "Go to Export Actions Folder Now". This will take you to the Export Actions folder within the Lightroom presets folder on your computer. (The Lightroom presets folder contains subfolders for all the methods for extending Lightroom.)

Place your droplets or shortcuts in the Export Actions folder and they will be added to the After Export menu.

Export Plug-ins

Lightroom Export Plug-ins are standalone scripts that private developers have created for specialized post-processing outside of Lightroom. You can find and download Lightroom plug-ins from the Web; however, as a relatively young program, Lightroom's capabilities in this regard have yet to be fully developed and exploited. Examples of popular plug-ins currently available are:

- LR/Mogrify by Timothy Armes: performs a wide range of very useful image modification functions, including highly customizable watermarking and graphical overlays, borders, resizing and sharpening.
- LR/Enfuse by Timothy Armes: a very capable HDR processor of Lightroom.
- Lightroom Export Plug-in to Photomatix Pro: for owners of Photomatix HDR software (highly recommended), this plug-in streamlines the interaction between Lightroom and Photomatix.
- DxO Optix Pro: lens distortion correction and much more.
- Web photo sharing plug-ins: for SmugMug, Picasa, Flickr, Zenfolio and more.
- Export to Facebook and other social networking sites.

There are more online resources for plug-ins in the Appendix.

After downloading plug-ins, put them in the Modules folder (in the main Lightroom presets folder). Next, click the button at the bottom left of the Export dialog to open the Plug-in Manager (see Figure 8–14) and install each plug-in. This will add more Post-Process Actions to the Export dialog box (see Figure 8–15).

Add plug-in controls to the main settings list

With plug-ins installed and showing in the secondary Post-Process Actions list, select a setting and click the Add or Insert button to add them to the export dialog box settings. To remove a plug-in setting from the list, select it and click the Remove button.

Figure 8–14: Plug-in Manager

reset:	Export one selected photo to:	
▶ Lightroom Presets ▼ User Presets NC Blu-Ray	Files on Disk	
NC Email 720 NC JPC 720 NC JPC 800 80 NC Master TiF NC PS Master	► Export Location	/Users/natcoalson/Desktop/Abstract_Blog_Images
	▶ File Naming	NCoalson_Tampa_080107_0075_420px.jpg
	▶ File Settings JPEG: 80 quality / sRGB	
	▶ Image Sizing 96 ppi / Resize to W: 420 H: pixels	
	▶ Output Sharpening	Sharpening Low, for Screen
	▶ Metadata	Minimize / Add Copyright Watermark
	▼ Mogrify Configuration	
	Configuration W Use LR2/Mogrify's built-in version of Imag	eMagick (recommended)
Add Remove	Extra command line parameters (advanced users)	
ost-Process Actions:	Extra command line parameters (advanced users) Parameters for start of command line:	
ost-Process Actions: VLR2/Mogrify Mogrify Configuration		
ost-Process Actions: # LR2/Mogrify	Parameters for start of command line:	
ost-Process Actions: VEZ/Mogrify Mogrify Configuration Borders Graphical Watermark Text Annotation 1 Text Annotation 2	Parameters for start of command line: Parameters for end of command line:	
ost-Process Actions: • LR2/Mogrify Mogrify Configuration Borders Graphical Watermark Text Annotation 1 Text Annotation 2 Text Annotation 3 Resize Photo Sharpening	Parameters for start of command line: Parameters for end of command line: Metadota handling Strip all metadata from exported image LR2/Mogrify version 1.51 (Limited ve	rrsion, please donate), by Timothy Armes
ost-Process Actions: V LR2/Mogrify Mogrify Configuration Borders Graphical Watermark Text Annotation 1 Text Annotation 2 Text Annotation 3 Resize Photo	Parameters for start of command line: Parameters for end of command line: Metadota handling Strip all metadata from exported image LR2/Mogrify version 1.51 (Limited ve	
Process Actions: ▼ LR2/Mogrify Mogrify Configuration Borders: Graphical Watermark Text Annotation 1 Text Annotation 2 Text Annotation 3 Resize Photo Sharpening Colour Space	Parameters for start of command line: Parameters for end of command line: Metaduta handling Strip all metadata from exported image LR2/Mogrify version 1.51 (Limited ve	ome page

Figure 8–15: Post-Process pane for plug-ins

Export Presets

As with the other areas in Lightroom's interface, you can save export presets for later use (see Figure 8–16).

First, you need to have the desired settings applied in the Export screen—saving a new preset will store all current settings.

Next, click the Add button at the bottom of the presets list on the left pane in the Export dialog box. Choose where to store the new preset (I prefer to put them in the default location: User Presets) and give it a name. Click Return or Enter to finish.

You can update presets (see below) or delete them from the list by clicking the Remove button.

Figure 8-16: Export presets

Add an identifier at the beginning of the preset name

I always use my initials at the beginning of presets I make. This way I can easily identify my own presets from those made by others and they all show in the same place in preset lists.

Update existing presets

To update any preset with the current settings in the Export dialog box, rightclick or Ctrl+Click the preset and select Update with Current Settings from the popup menu.

Exporting using the most recent settings

Select File→Export with Previous to initiate an export using the most recent export settings.

Initiating multiple exports

You can start a new export while a previous one is still in progress.

Export Workflows

Bearing in mind the unlimited possibilities for handling your photos outside of Lightroom, I've put together the following few workflows based on some of the most common uses for exporting.

If at this point you're still unsure of how this whole exporting business fits into your particular workflow, I strongly suggest that you perform lots and lots of exports, even just for practice, so you get a handle on the settings. You can export files to your heart's content into a special folder from which you simply delete the derivative files every so often.

There is no inherent risk in exporting a given original file an infinite number of times. Sometimes the best way to master a process is to play with it for a while. Just be careful that your exported files are stored and handled with the most possible efficiency.

Junk files clog the system

Since exporting generates new files, it introduces the likelihood that you will produce files that, in the end, serve no purpose and only waste space on your hard drive. It's easy to wind up with a host of renegade image files strewn all over your hard drives. Try to avoid this by being careful and conservative with your exports, unless you're just practicing, in which case it's best to do your exports into a folder that is routinely emptied.

BURNING A DVD

You can burn your exported photos to a CD or DVD straight out of Lightroom. During the export operation you can also apply any of the file conversion options but postprocessing options are not available.

After Lightroom generates the derivatives they will be burned to the disc using your operating system's built-in functions. With a few exceptions (based on operating system and disc burner), Lightroom works with your os to complete the entire process automatically.

Step 1. Select a disc burning preset from the left pane of the window, or, with any preset or previous settings selected, choose "Files on CD/DVD" from the popup menu at the top of the Export window (see Figure 8-17).

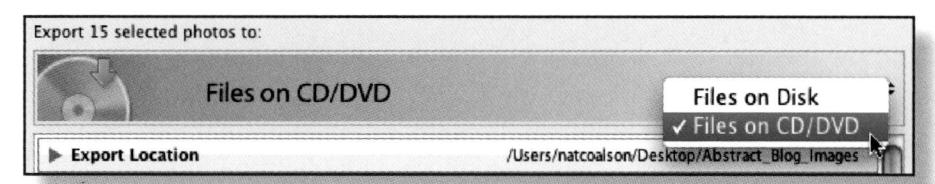

Figure 8–17: Selecting Files on CD/DVD

8

Step 2. When a CD or DVD is selected as the destination for the exported files, the Export To: menu on the Export Location section provides an additional option: "Temporary folder (will be discarded upon completion)" (see Figure 8–18). If you enable this, the rest of the options in the section become disabled. When the export has completed and the disc is burned, no files will be saved to your hard disk.

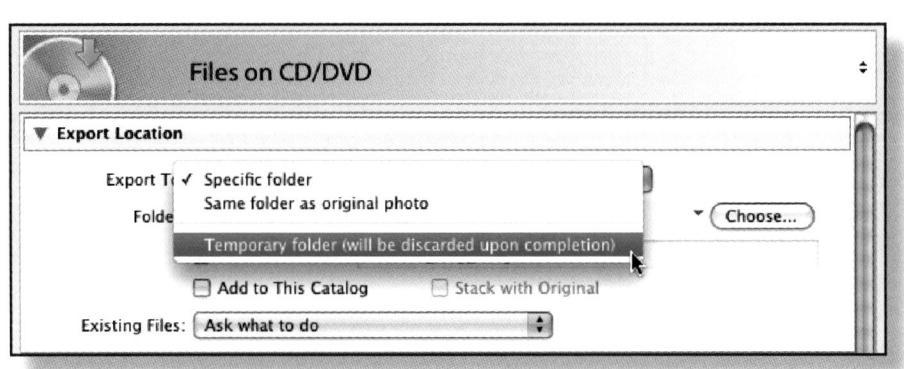

Figure 8–18: Option for Temporary folder (will be discarded upon completion)

To save or not?

It's up to you to decide whether or not you need to save (to your hard disk) copies of the files that have been burned to CD/DVD during the export. If the disc you're making is for a specific, one-time use and the file settings are not such that you would be likely to use the files again, it's probably more efficient to *not* save them. For example, if you're submitting a set of portfolio images to a gallery or competition, and specific or unusual requirements such as dimensions, color space etc. have been provided for you to follow, you might enable the option to use the temporary folder and discard the files after burning the disc. This will help keep your hard disk (and Lightroom catalog) free of unnecessary clutter.

Step 3. Configure the remaining options for the files to be exported and burned—taking even more care than usual, because a disc will be burned—even if your file settings are incorrect.

Step 4. Click the Export button, or press Return/Enter.

If you don't already have a blank, writable CD/DVD in the writer, Lightroom will alert you when it's necessary to insert one.

EMAILING PHOTOS

When you want to send photos to someone by email, you have a couple of options (see Figure 8–19):

- 1. Do a regular export of the files, saving them somewhere on your hard disk, then attach them to the message in your email program; or
- 2. Use Lightroom to help streamline the process through post-processing actions.

In both cases you will need to be sure that the exported files are saved somewhere on your hard disk where they are accessible to your email program.

Lightroom 2 provides a built-in export preset for emailing files (see Figure 8–19). However, in my opinion, this preset is not very useful as-is; it serves best as an example starting point for how you might configure your own settings for this purpose. (For example, the built-in email preset doesn't include an email program as a post-processing function; you need to add your email program yourself.)

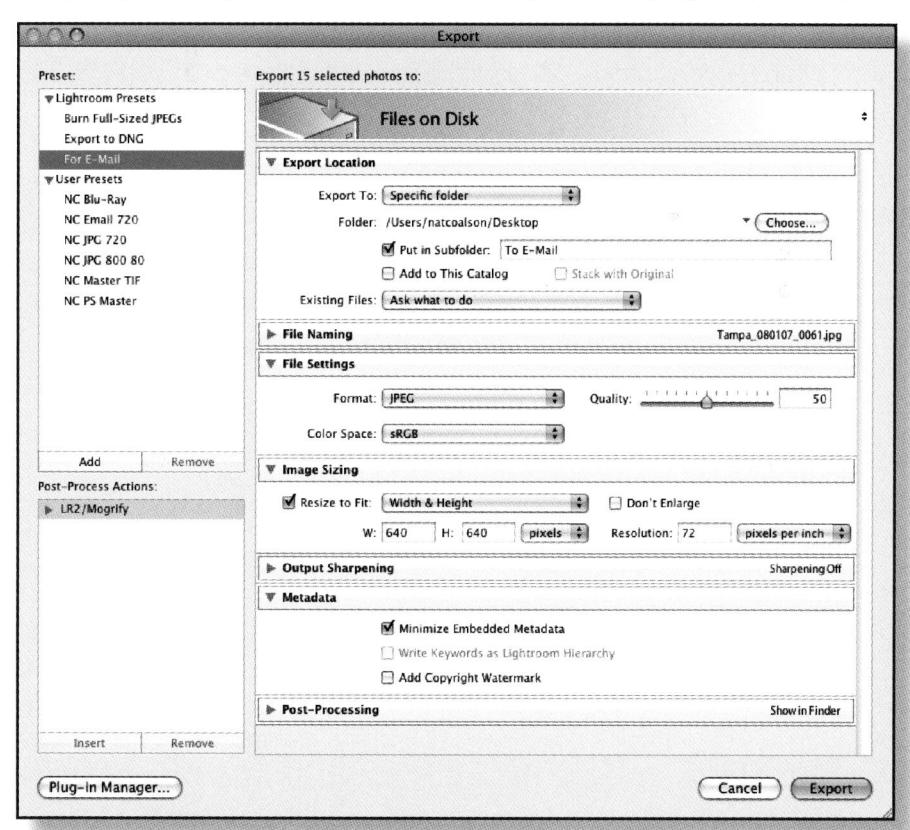

Figure 8–19: Lightroom's built-in email export preset

Export images for copyright submission

For serious photographers, registering photographs with the U.S. Library of Congress is an essential part of running your business. I recommend that at least once per year you export finished photos from Lightroom to submit to the copyright office. Probably the easiest way to approach this is to export small JPGs and burn them to disc—you can submit many files to the copyright office using just one form. You can also use their new online registration system. See the Resources section in the Appendix for a link.

WATERMARKING IMAGES

Historically, *watermarks* were added to fine paper documents—actually using water in the process—as a mark of authenticity and identification of the originator of the document.

In our digital age, watermarks are text or graphics superimposed over digital images. Photographers commonly use watermarks to inform viewers of the copyright holder (creator of the image) and, maybe more importantly, to make it difficult to produce a high quality reproduction of the image. See Figure 8–20.

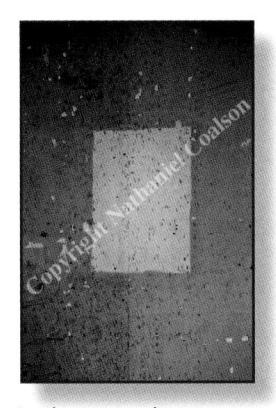

Figure 8-20: Examples of customized watermarks

While opinions vary widely on the appropriate use of copyright notices and watermarks on digital images, most photographers who are sharing photos over the Web or in email want to include some form of identification on the photo.

In the export dialog box, Lightroom provides a single, simple option for adding a copyright watermark. In this case, the watermark is a single line of text, overlaid on the lower left corner of the image in a semi-transparent fashion. The text comes from the Copyright field in the file's metadata. If the file does not contain this text, no watermark is displayed. You have no control over the size, position or style of the text.

If you want to watermark your images in any way besides Lightroom's simple, default watermark, you have a few options:

- 3. Use the LR/Mogrify plug-in;
- 4. Use Photoshop actions to add your watermark in post-processing; or
- 5. Use the Slideshow or Print module with Identity Plates (see Chapter 9).

At the time of this writing, honestly, none of these options are ideal. It's my hope that in the coming months (maybe even by the time you read this) Adobe's developers will add full-featured watermarking functions within Lightroom.

Extended batch processing with Photoshop Droplets

You can use Photoshop's Actions, either triggered from the Export box or from Droplets, to perform an infinite range of image processing, including elaborate, customized watermarking.

Exporting Catalogs

You can export a batch of images as a new catalog. Individual images to be exported must be selected, or you can export entire collections and folders as catalogs.

When exporting a catalog, you have the option to either generate new copies of the files for the new catalog, or have the new catalog reference the same files in the current catalog.

Right-click or Ctrl+Click a file, folder or collection Select Export as catalog from the contextual menu.

Export catalogs to share them

Exporting catalogs is a great way to share work between different people, multiple computers, etc.

Chapter Summary

The more you use Lightroom, the more exporting you will do. Whether you're finished processing photos or you need to do more work with them outside Lightroom, the export functions provide numerous ways to batch process your images and get them on their way to their next destination.

It's critical that you carefully work through the settings in the Export dialog box before initiating the export. Think about how the new files will be used and stored and make the settings accordingly.

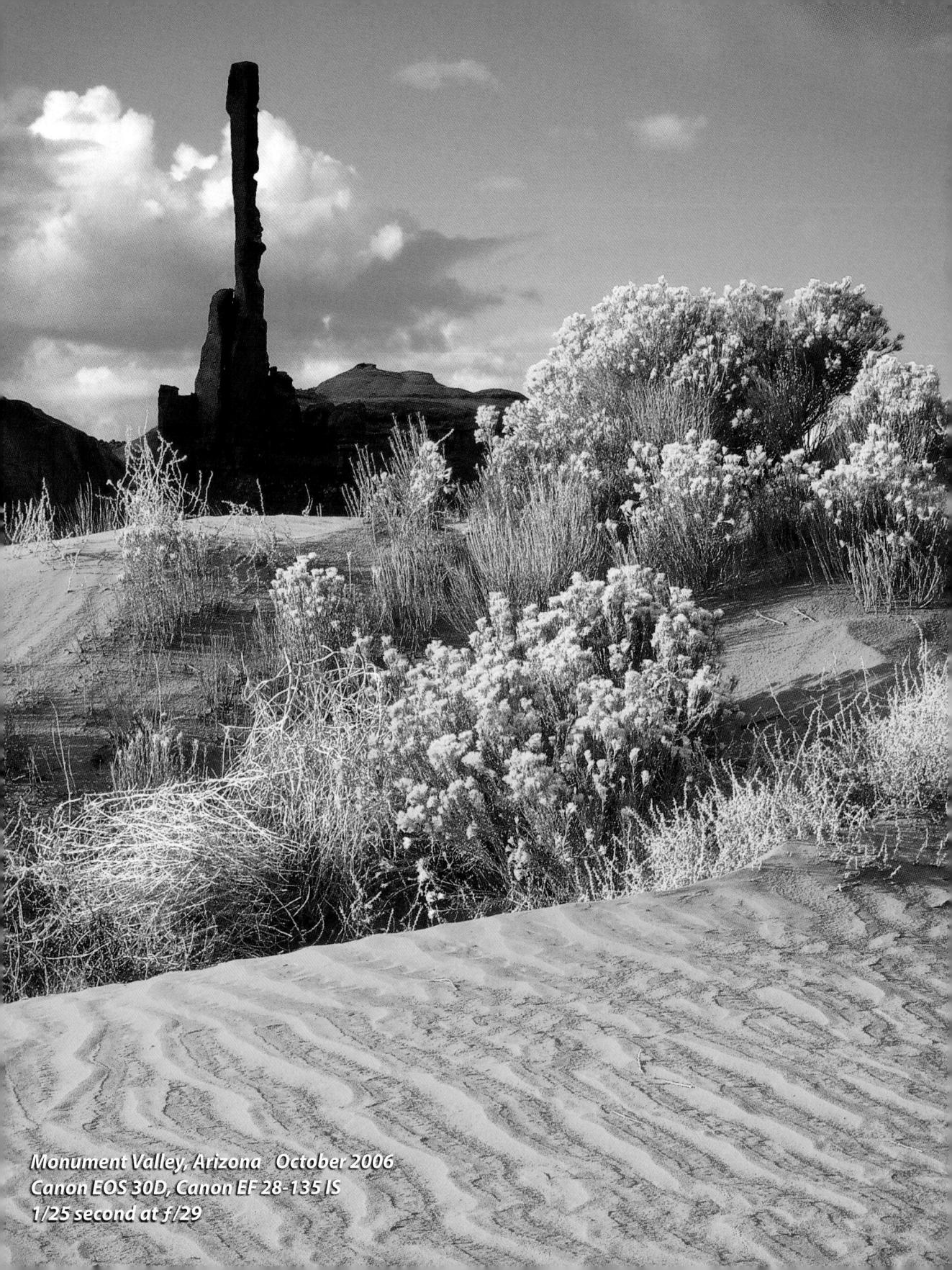

CHAPTER 9 PRESENTING YOUR WORK

When your photos are processed to perfection, it's time to share them with the world.

Lightroom's presentation modules—Slideshow, Print and Web—provide a host of capabilities for these tasks.

Making and Presenting Slideshows

Lightroom's Slideshow module allows you to create and present slideshows complete with customized designs, soundtracks and effects.

However, be aware that currently, Lightroom's slideshow capabilities are limited compared with dedicated slideshow software. For example, if your intention is to burn the finished slideshow to a CD/DVD to give to the client, I suggest you consider using other slideshow software that will allow you to compile a self-playing executable file. (Search the Web to find good solutions for your os.) To make a slideshow outside Lightroom, you will need to export the files from Lightroom first, as described in Chapter 8. (JPG is probably the most common format for this, but some slideshow programs will let you import TIF files.)

With this in mind, if you choose to create and play your slideshow from within Lightroom, there are plenty of options available.

You can also export complete slideshows from Lightroom as PDF or JPG files.

\Rightarrow % + Option + 3 or Ctrl + Alt + 3

To switch to the Slideshow module.

SETTING UP THE SLIDESHOW

Start with photos from a collection. You can select photos for your slideshow in Library first, or simply choose the source photos directly in the Slideshow module. To make this easy, the presentation modules' left panel group includes the same Collections panel as the other modules (see Figure 9–1). Optionally, from the

Toolbar, click the Use: popup menu to refine the source of photos to include in the slideshow (see Figure 9–2).

Figure 9–1: Collections panel in Slideshow

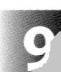

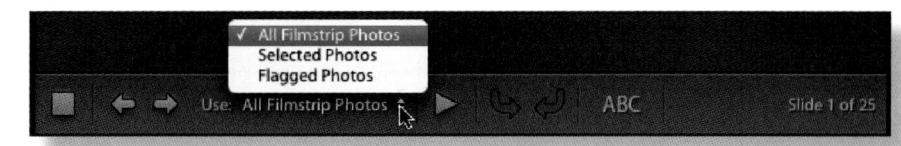

Figure 9–2: The Use: popup menu

Next, from the Template Browser panel, choose a template you can use as a starting point for the slideshow (see Figure 9–3). Lightroom comes with several basic templates. Move your cursor over the templates to see them in the Preview panel. Click a template to load it.

Customize the slideshow design with the controls in the right panel group. I usually work through the panels from top to bottom. If you're not sure how a specific control works, try it! Remember that you can't possibly screw anything up here; just keep tweaking the controls until you like the way the slideshow looks.

Options panel

Starting in the Options panel (see Figure 9–4), set how the photo fills the slide frame (zoom to fit will enlarge and crop the images), add a stroke border, and/or a shadow behind the photo.

To open/close the Options panel.

Layout panel

The Layout panel (see Figure 9–5) is where you set the slide margins. To use the same value for all margins, tick the Link All box.

Figure 9-3: Template Browser panel

Figure 9-4: Options panel

Figure 9-5: Layout panel

₩+2 or Ctrl+2
To open/close the Layout panel.

₩+Shift+H or Ctrl+Shift+H
To hide/show the layout guides.

Click and drag the guides

To adjust the margins (guides must be visible).

Overlays panel

In the Overlays panel, you can configure text and graphical elements that appear on the slides (see Figure 9–6):

• Identity Plate: check the box to show or hide the Identity Plate (see Figure 9–7). In the Identity Plate preview box, click the small triangle button to choose an Identity Plate from the list, or click Edit... to make a new one. You can set up multiple Identity Plates for different purposes, but a slide layout can only include one Identity Plate at a time. (However, you can apply additional text overlays, see next bullet). Below the preview, set the various options for the display of the Identity Plate.

Figure 9–7: Enabling the Identity Plate; selecting with popup menu

Figure 9-6: Overlays panel

(i.e., don't flatten the file); the photo will show through the transparent areas. You can use this method for elaborate photo borders and for totally customizable watermarking. The potential design flexibility of placing layered Photoshop PNG files containing transparency over your photos in Lightroom is significant.

I mocked up the cover for this book in several ways using PNG designs with transparency, brought into Lightroom as Identity Plates. I applied the Identity Plates to several photos in my catalog (see Figure 9-8).

Figure 9–8: Identity Plates designed in Photoshop, applied to photos in Lightroom

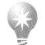

Click and drag the Identity Plate

To reposition it in the slide layout. To scale the Identity Plate, drag its control handles.

- **Rating Stars:** check the box to show stars if photos have them applied. Click the color swatch to change the color of the stars.
- Text Overlays: check the box to display text overlays on the slides. This option enables/disables all text overlays. However, with an individual text overlay selected in the layout, the controls affect only the selected overlay.

To make a new text overlay, make sure the Toolbar is showing (press the T key to hide/show the Toolbar). Click the ABC button or use the shortcut, and from the popup menu (see Figure 9–9) choose what kind of text to display. For Custom Text, type into the text field. The new Text Overlay is inserted at the bottom left of the slide. Click and drag to move and/or resize it. Use the Text Overlay controls on the panel to change Color, Opacity, Font and Face for each overlay. Note that Custom Text Overlays are applied to all slides; if you want to show titles and captions for individual images you must do so using metadata (see below).

To delete an existing text overlay, select it with your mouse, then press Delete.

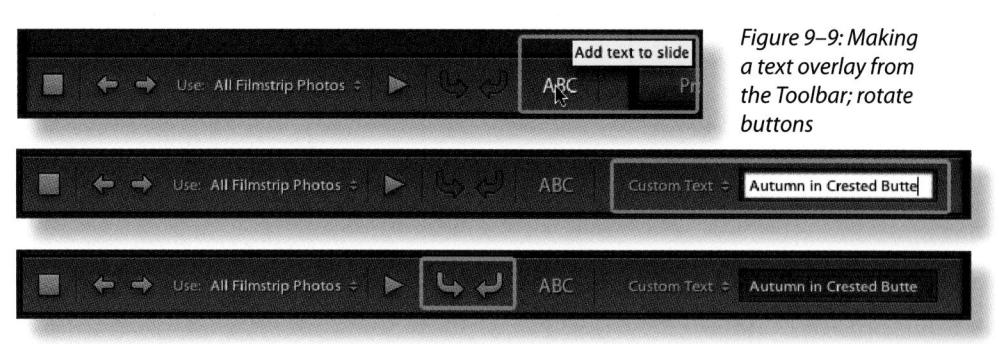

To open/close the Overlays panel.

To add a new text overlay.

Titles and Captions

For titles and captions to be displayed in the slideshow, they first need to be entered for each photo using the Metadata panel in Library.

Rotate adornments

You can rotate adornments (Identity Plates and text overlays) by selecting them and clicking the rotate buttons on the Toolbar (see Figure 9–9).

≥ 3 or Ctrl+3

To open/close the Overlays panel.

Backdrop panel

On the Backdrop panel you can design the background for the slides. Uncheck all the options for a solid black background. Otherwise, use the provided controls (see Figure 9–10) to set the following:

- Color Wash: this setting applies a gradient across the background. Click the swatch to open the color palette; click and drag the eyedropper to choose a color from anywhere on the screen. Use the Opacity and Angle controls to fine tune the application of the gradient.
- Background Image: here you can set an image for the background, which interacts with the other Backdrop design controls. Click and drag from the Filmstrip to place an image as the background.
- **Background Color:** this sets a solid color for the background. Click the swatch to open the color palette; click and drag the eyedropper to choose a color from anywhere on the screen.

₩+4 or Ctrl+4

To open/close the Backdrop panel.

Keep backgrounds simple

Remember that the goal of the presentation is to feature the photos. To that end, keep your backgrounds and other adornments simple and clean so they don't distract from the images.

For the most control over the look of the backgrounds, set them up in Photoshop and import them to the catalog. You can then drag and drop to apply them as the slideshow background.

Titles panel

The Titles panel (see Figure 9–11) provides options for creating intro and ending screens for the slideshow. The title screens can be made simply of a solid color background, or you can use Identity Plates to apply text or graphics. Different title screens can be used for intro and ending screens.

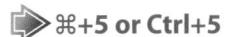

To open/close the Titles panel.

Playback panel

On the Playback panel (see Figure 9–12), set the parameters for the playback of the slideshow. You can load a folder of mp3 audio files for the soundtrack. Under Slide Duration, set

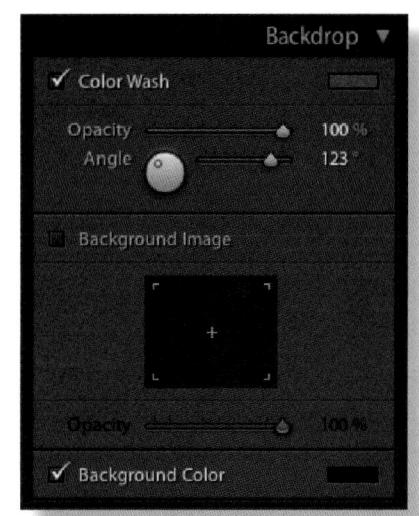

Figure 9–10: Backdrop panel

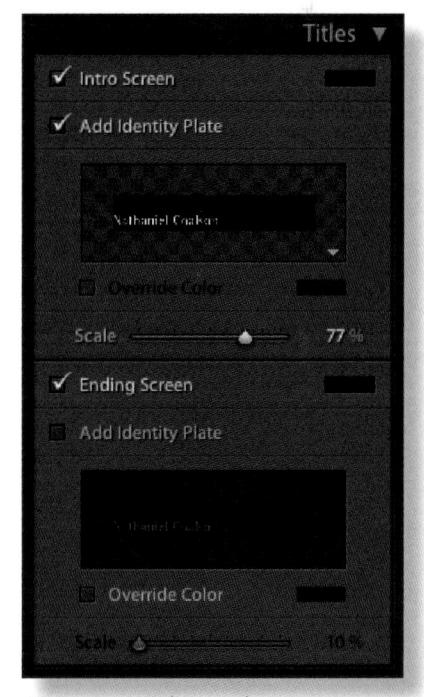

Figure 9-11: Titles panel

the amount of time to display each slide and the length of transitions between slides. The background color for the fade can also be set here. Finally, select whether the slides should be shown randomly and whether or not the slideshow should repeat until stopped manually.

To open/close the Playback panel.

PREVIEW THE SLIDESHOW

You can see how the slideshow will look by previewing in the central preview area. Click the Preview button on the toolbar or on the right panel. See Figure 9–13.

To exit the preview, press the Stop button in the toolbar or press Esc.

Option+Return or Alt+Enter

To preview the slideshow.

Save a new template

After you've designed a slideshow you like, be sure to save it as a template. Click the + button on the Template Browser panel header (see Figure 9–14).

Update a template

If you want to save changes you've made to an existing template, right-click or Ctrl+Click on the template, and from the popup menu, choose Update with Current Settings.

PRESENTING THE SLIDESHOW

When you've finished designing your slideshow, you have three presentation options (see Figure 9-15):

 Play the slideshow in Lightroom. This blacks out the display and shows the slides full screen. Press Esc to stop playing.

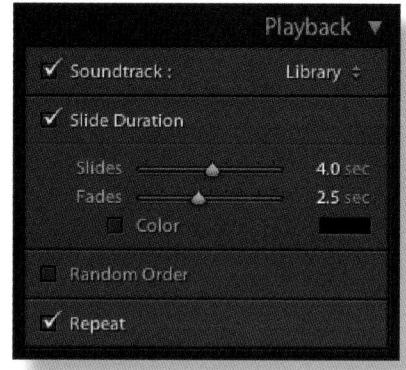

Figure 9-12: Playback panel

Figure 9-13: Preview button

Figure 9–14: Saving a new template

• Export the slideshow as a single PDF file. Slide transition settings won't be honored; Acrobat plays PDF slideshows with fixed transition times. The PDF slideshow will include intro and ending screens if you have them selected. The soundtrack will not be included in the PDF.

• Export the slides as JPG files. A single JPG file will be created for each slide as it appears in the preview. The Save dialog box provides controls for the size and compression level of the files.

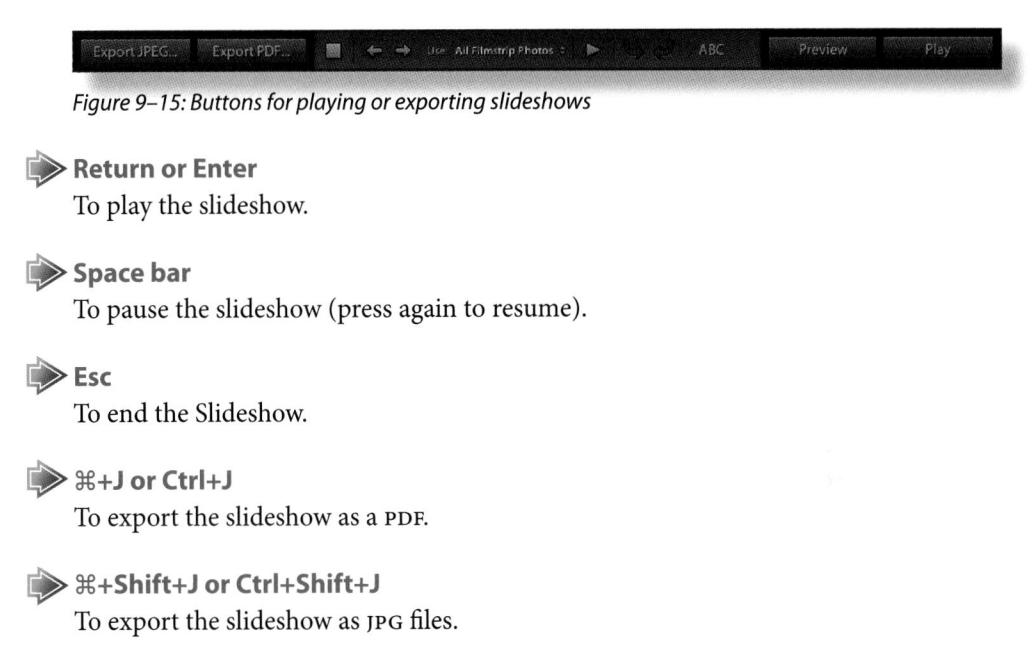

Printing photos from Lightroom

For many years before Lightroom came along, I did all my fine art printmaking from Photoshop. Its combination of highly sophisticated sharpening and color controls enabled me to produce the best prints possible.

However, Photoshop has some shortcomings when it comes to printing, especially when you need to output many photos at once. In the past, if I needed to arrange multiple images on the paper, expensive and cumbersome RIP (*raster image processor*) software was often required.

Now, I'm printing the majority of my work from Lightroom—and really enjoying it! With the right procedures in place, the printed image quality is outstanding. Lightroom provides far more control over multi-image layouts than does Photoshop, and templates make printing a breeze.

With the recent advances in inkjet technology, many photographers are now making their own high quality prints. Still, some prefer to send their image files to a lab for output, and Lightroom can assist with this as well.

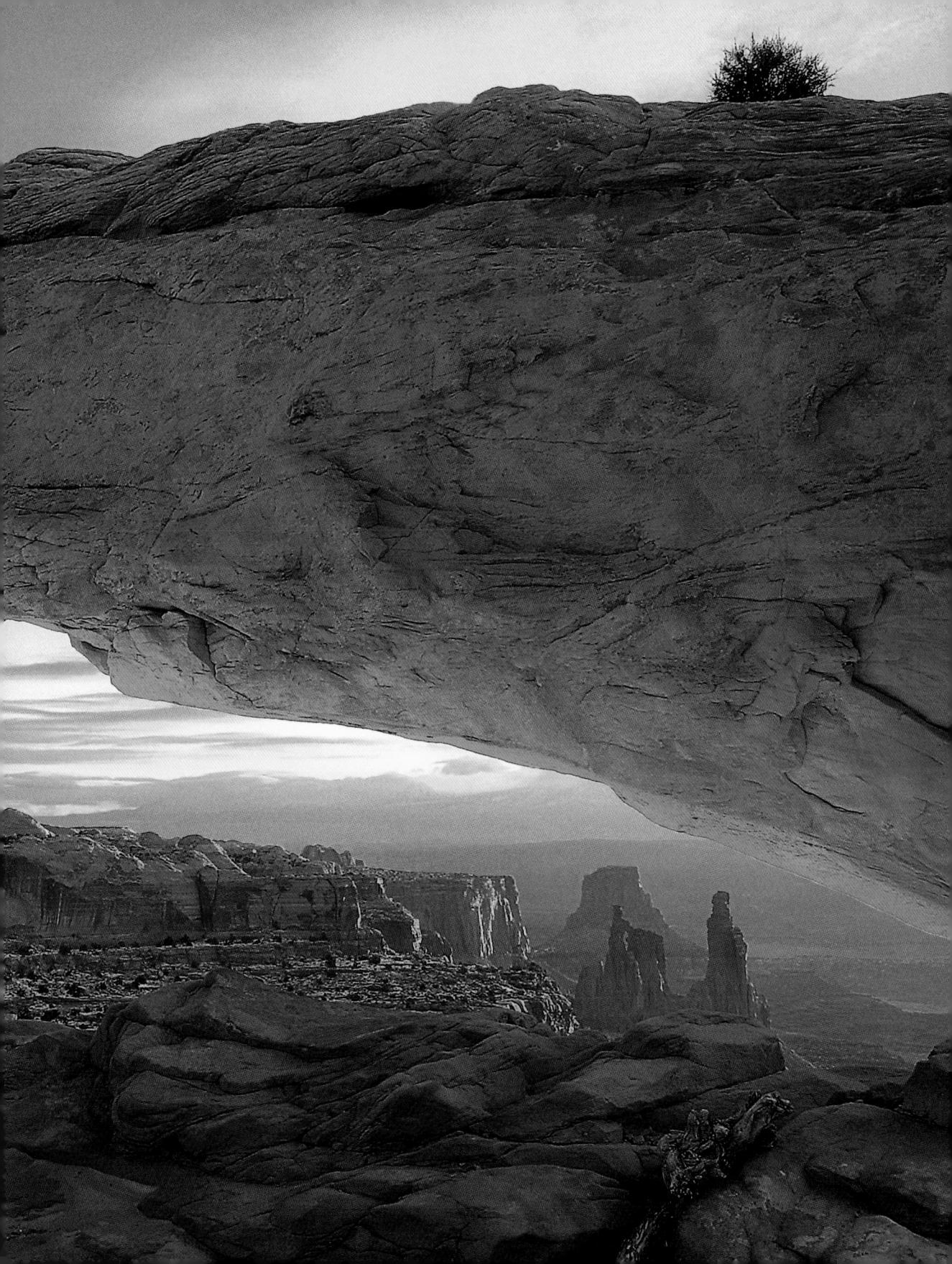

9

Though the printing options and workflow may be different than what you are used to, I think you'll agree printing from Lightroom is a joy once you get the hang of it. Lightroom's Print module provides ample freedom in laying out print jobs: you can use Lightroom to print contact sheets and proofs, picture packages containing prints of various sizes, and fine art enlargements. And of course, you can save templates for repeated use. Lightroom also provides resizing, sharpening and color management controls.

₩+Option+4 or Ctrl+Alt+4

To switch to the Print module, (see Figure 9–16).

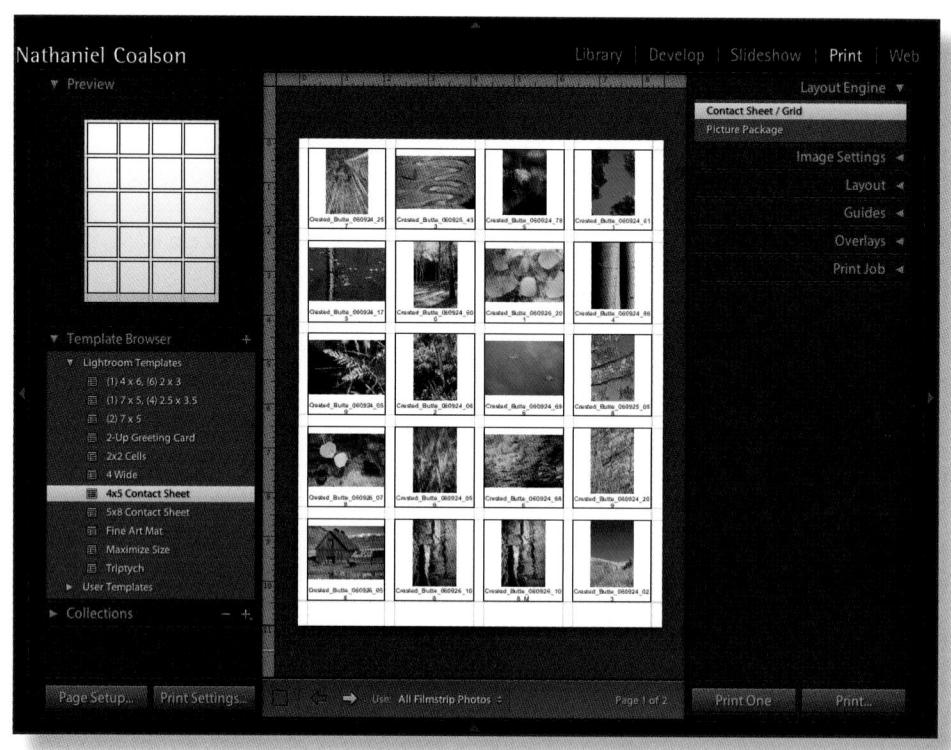

Figure 9–16: The Print module in its default state

SETTING UP THE PRINT JOB

Before setting up your print job, give some thought to the optimal process and the settings you will use. Are you printing just one photo, or multiple photos? What kind of paper will you use? Will all the photos be printed at the same size, or different sizes? Do you need to print textual information or graphics, along with the images themselves?

You first need to choose a Collection (or folder, in Library) of the images you want to print. The Print module includes the Collections panel on the left panel

group. You can then print all the images in the chosen source, or just selected ones, by choosing an option from the popup menu in the Toolbar (see Figure 9–17). You can also use the Filmstrip to assist with selecting images for printing.

Figure 9–17: Choosing the photos to print

Use virtual copies for printing

When you've processed a photo, the finished version becomes the *Master*. No matter if it's a raw/DNG file, a layered TIF or a virtual copy, in essence, it's a new Original, from which derivatives are made for specific purposes. When you want to print one or many photos, using vcs can provide a lot of flexibility for variation.

When you need to adjust a photo to meet the criteria of a given print job, using a vc is more efficient than History or Snapshots. From your finished Masters, make virtual copies for different print jobs. You can adjust the size or cropping of the photos differently, apply adjustments specifically for the printing conditions and add unique Identity Plate overlays.

Using virtual copies, your work can be economically retained for future use, or deleted when you're done. Through it all, your Master file is never altered. You can return to it to make new derivative vcs later, as needed.

Page Setup

The most important control for specifying the size of the printed pages, and thus the size of the photos that can fit on it, is Page Setup. You need to apply a Page Setup as one of the first steps in the printing workflow; all the other measurements will be determined based on the Page Setup. Click the Page Setup button at the bottom of the left panel group (see Figure 9–18).

Figure 9–18: Page Setup button

In the Page Setup dialog box,

choose the correct paper size and orientation for the current print job. Depending on your operating system, the controls for this may vary, but the common goal is to precisely specify the size of the page and the direction the images will be placed on the page. After selecting your printer, you can then choose from preset paper sizes

9

provided by the printer driver software, or set up a custom page size. You also need to specify whether the paper source is sheet or roll (see Figure 9–19).

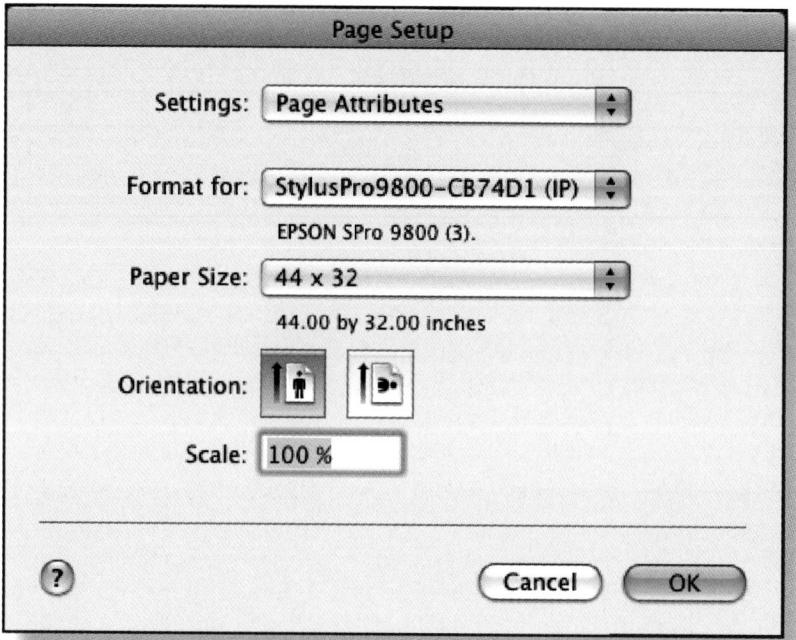

Figure 9–19: Page Setup dialog box

Once you've completed the Page Setup, proceed to setting the options for the placement of photos on the paper.

To hide and show the information overlay in the preview area.

Layout Engine panel

Like the other presentation modules, preparing a job in the Print module requires the selection and customization of a template. However, before you choose a template, you might first need to select a different Layout Engine from the panel (see Figure 9–20). The selection of a Layout Engine determines the options available in the right panel group.

Figure 9–20: Layout Engine panel

As of this writing, Lightroom offers two built-in Layout Engines, each providing different controls for a particular purpose:

Contact Sheet/Grid

Use the Contact Sheet/Grid engine when you want to print a single image or multiple images in layout cells of the same size. This engine creates a grid of cells—a table—made of rows and columns. You can rotate photos and/or scale them to fill the grid cells differently, but all the grid cells remain the same size (see Figure 9–21).

Picture Package

Use the Picture Package engine when you want to print one or more photos at multiple sizes. You will have more control over the size and positioning of the printed photos on the paper than with Contact Sheet/Grid, but with Picture Package, each page only prints one photo. In other words, you can't print one each of multiple photos, at different sizes, on the same piece of paper (see Figure 9–22).

Contact Sheet/Grid and Picture Package are discussed in more detail in the next sections.

To open and close the Layout Engine panel.

Figure 9–21: Example Contact Sheet/Grid layout

Figure 9–22: Example Picture Package layout

Template Browser panel

Lightroom comes pre-loaded with quite a few print layout templates; some of which are more useful than others, depending on the kind of photography you do and the anticipated printing needs you might have. Choose templates from the Template Browser panel. As with the templates in Slideshow and Web, you'll likely need to make significant changes to the selected template in order for it to meet your needs. Note that templates include the paper size and orientation specified in Page Setup (see below); this is one of the settings you will frequently need to change (see Figure 9–23).

Preview the templates

With the Preview panel open, move your cursor over the templates to see a preview of the layout settings each provides. Choose the template most similar to your desired layout.

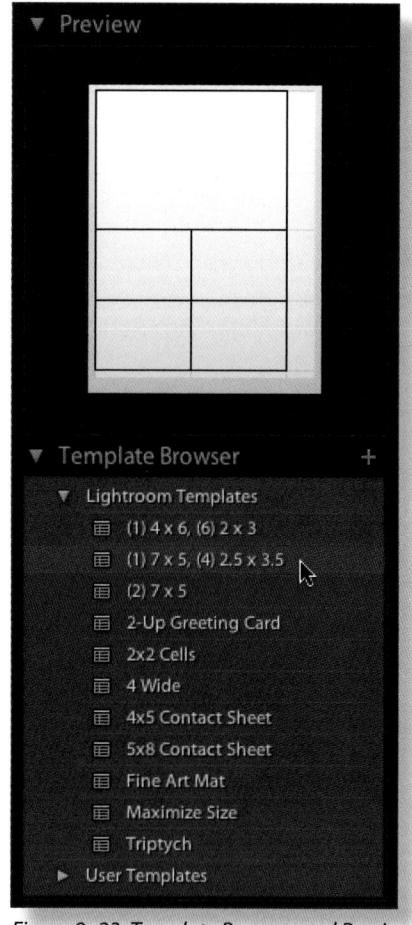

Figure 9-23: Template Browser and Preview

> \H+Shift+1 or Ctrl+Shift+1

To open and close the Template Browser panel.

Save a template

Particularly with Print layouts, if you spend any significant amount of time working on a layout, be sure to save a template when you're done. If you make changes to the layout and want to update the template with the new settings, use the Template Browser menu options to Update with Current Settings.

Note: you can't update or delete the built-in Lightroom templates.

Multi-page jobs

Depending on the number of photos and the layout options used, you may often end up with a print job comprising multiple pages. The Toolbar shows how many pages are in the current job and which page you're previewing, and provides arrow controls for moving forward and back in the multi-page print job. Click the square button to go to the first page (see Figure 9–24).

Figure 9-24: Using the Toolbar controls to navigate within a multi-page job

Setting up a Contact Sheet job

Use a Contact Sheet/Grid when you want all the photos to be printed in the same size cells. This effectively sets the maximum possible size for the longest side of the photo(s).

(The term *contact sheet* comes from the old days of film and photo paper. Strips of processed film were placed in rows on the photo paper, which was then exposed. This produced a sheet of thumbnail images for proofing.)

Image Settings panel

The settings on this panel configure how the photos are placed within the grid cells (see Figure 9–25).

• **Zoom to Fill:** enlarges the photos to fill the entire grid cell. Note that this almost always results in some cropping of the photo.

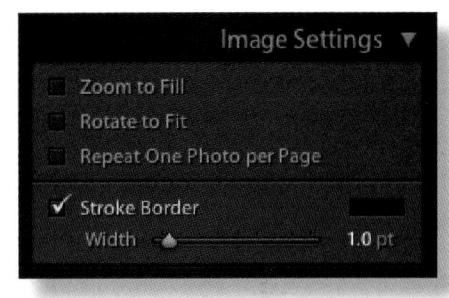

Figure 9-25: Image Settings panel

- **Rotate to Fit:** rotates photos as necessary to use the most available space in the cell.
- Repeat One Photo Per Page: with multiple images selected, enabling this option will force Lightroom to place only one photo on each page of the print job.

 Depending on the rows and columns you specify, this could result in just one photo per page or multiple copies of the same photo, repeated at the same size in all the cells.
- **Stroke Border:** enable this option to add a solid, outline border to the printed photos. You can specify the width and color of the border.

≫ #+2 or Ctrl+2

To open and close the Image Settings panel.

Layout panel

The Layout panel contains settings for adjusting the grid layout (see Figure 9–26). These measurement settings all work in conjunction; changing one setting often also changes others. You'll likely need to work the settings back and forth until you get all the measurements you're looking for:

- **Ruler Units:** use the popup menu to specify inches, centimeters, millimeters, points or picas.
- Margins: sets the outer page margins in the specified units. (Note that the minimum allowable margins will be determined by the Page Setup settings.)

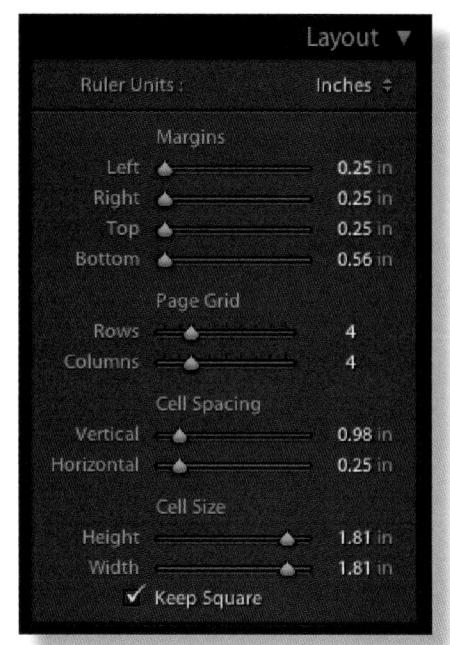

Figure 9-26: Layout panel

- Page Grid: specifies the number of rows and columns for the photos on the page. Along with the other options, the number of rows and columns determines the size of the cells.
- Cell Spacing: adjusts the amount of vertical and horizontal space between cells.
- Cell Size: sets the size of the cells in which the photos are placed. The cell sizes possible are determined by the other measurements. You can tick the checkbox to force the cells to Keep Square; depending on the other measurements, you may also be able to specify square cells with the numeric entries you use.

> #+3 or Ctrl+3

To open and close the Layout panel.

Enable Solo Mode

To automatically hide inactive panels.

If you're framing the print, don't print borderless

Be sure to leave an inch or two of blank paper around all the outside margins.

Guides panel

Check or uncheck the boxes on this panel to show or hide the available guides and measurement indicators (see Figure 9–27):

- **Rulers:** turns rulers on and off in the main preview.
- Page Bleed: bleed refers to the amount that the image(s) go off the edges of the page. Bleeds are used to provide room for error in placing full-page images on the paper, so that the printed image is ensured to go all the way to the edge of the paper. The bleed size is shown on the rulers.

Figure 9-27: Guides panel

- Margins and Gutters: margins are the spaces around the outer edges of the paper; gutters are the margins between page elements.
- Image Cells: show and hide the cell border previews.
- **Dimensions:** enable this option to display the sizes of the photos as they are placed within the cells.

₩+4 or Ctrl+4

To open and close the Guides panel.

Click and drag on the preview guides To modify the layout.

Overlays panel

With the settings on the Overlays panel, you can include other elements on the printed page along with the photos (see Figure 9–28):

- **Identity Plate:** graphical or textual overlays, used for adding logos, border effects, watermarking and other design elements.
- Angle: the default is 0 degrees; click the number for a popup menu with rotation values.
- Override Color: enabling this option will fill your Identity Plate with the specified color.

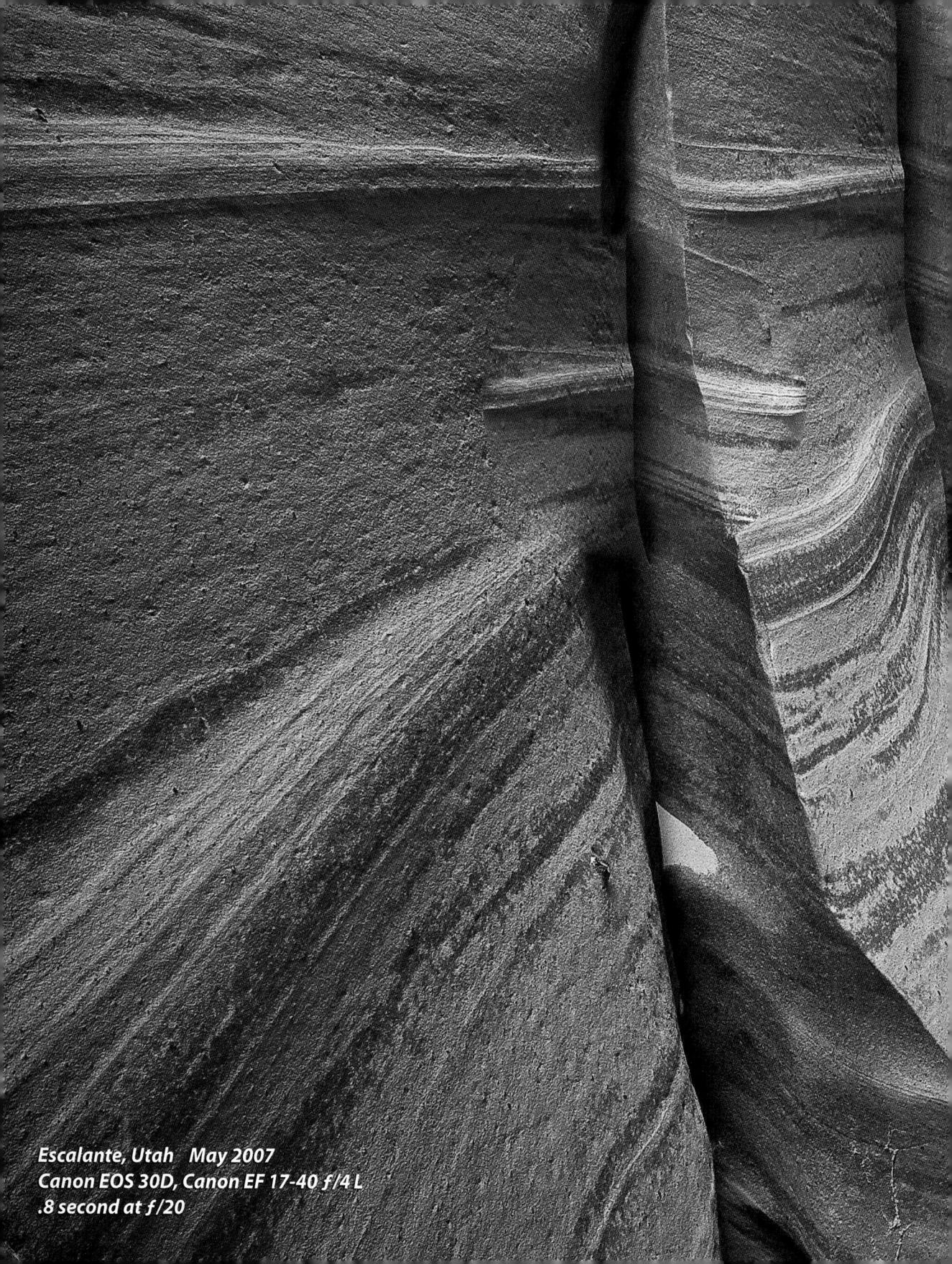
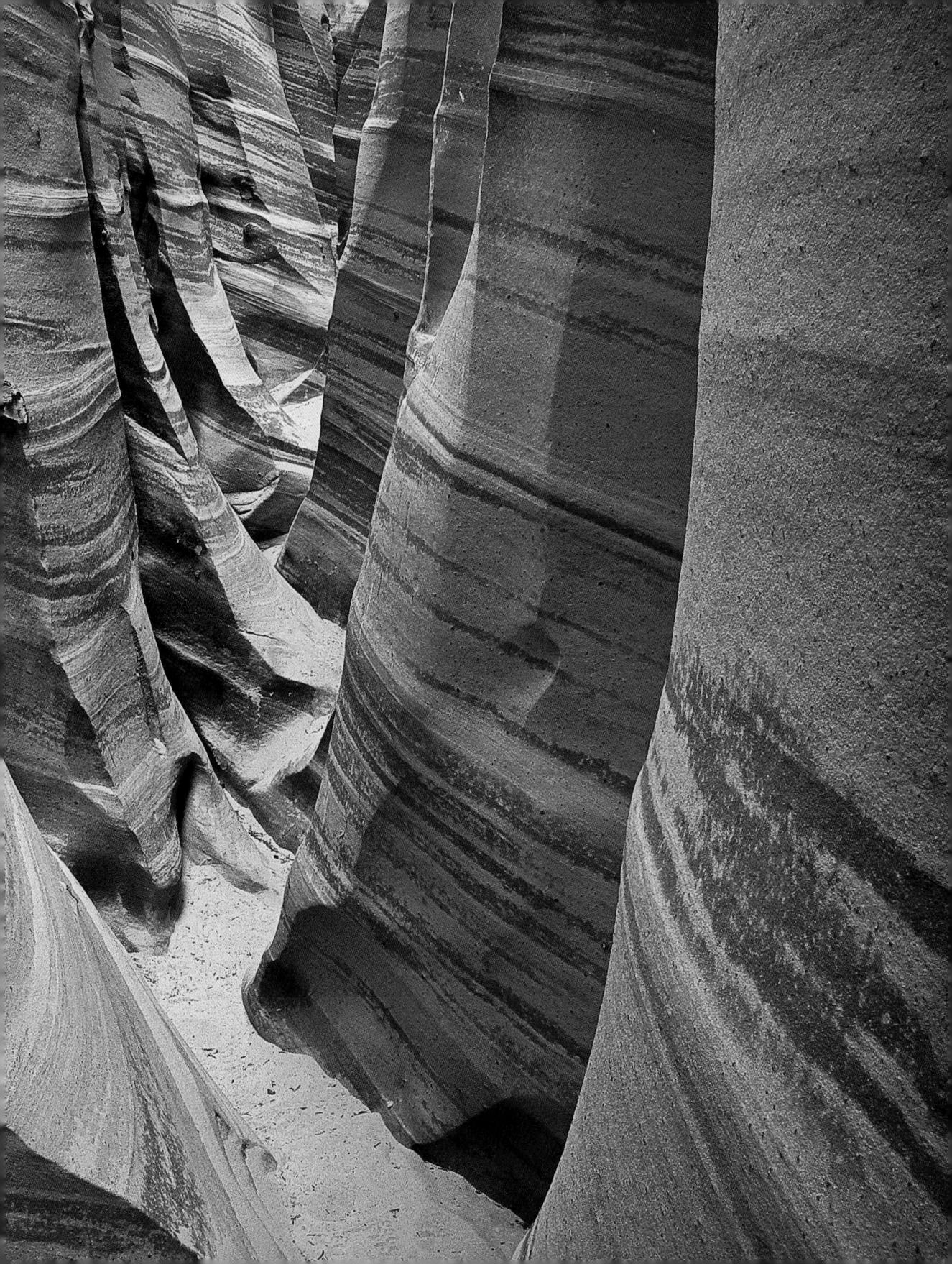

- Opacity: sets the level of transparency for the Identity Plate.
- Scale: enter a value to enlarge or reduce the Identity Plate. You can also click and drag to reposition and/or resize your Identity Plate. (Working with Identity Plates is discussed further in this chapter.)
- **Render Behind Image:** when checked, the Identity Plate will be placed behind the photo(s).
- **Render on Every Image:** applies the selected Identity Plate individually to every photo in the layout. Enable this if you're applying borders or other graphics; see Tip below.
- Page Options
- · Page Numbers
- · Page Info
- Crop Marks
- **Photo Info:** choose from the popup menu or create your own.
- Font Size: in points.

To open and close the Overlays panel.

Printing custom borders or graphics on your photos

You can use Identity Plates to overlay customized borders or other graphical elements on your photos. Design your border or other artwork in Photoshop, making sure to leave the center area

Figure 9–28: Overlays panel

transparent on a layer. Save the file from Photoshop as a PNG and bring it into Lightroom as an Identity Plate. On the Overlays panel, you can specify your border as the active Identity Plate. Be sure to enable the option to Render on Every Image (see Figure 9–29).

Figure 9–29: Using PNG Identity Plates to superimpose custom borders and graphics on printed photos

Setting up a Picture Package job

Use a Picture Package when you want to print a photo at different sizes.

The panels and settings for Picture Package are similar to those of Contact Sheet/Grid, with a few significant differences.

Manual layout in Picture Package

In Picture Package, you can click and drag to rearrange or scale the photos on the page. If any cells are overlapping, a warning triangle is shown at the top right of the page preview.

Right-click or Ctrl+Click on a photo on the page

Select from the contextual menu to rotate or delete the photo.

Image Settings panel

Use these settings to configure how each photo is styled within the cells (see Figure 9–30):

• Zoom to Fill and Rotate to Fit function the same as in Contact Sheet/Grid.

- Photo Border: you can set the width of an outer, white border around each photo (but you can't change the color). Uncheck the box if you don't want an outer border.
- Inner Stroke: set the width and color of the border around the perimeter of the photo.

Rulers, Grid & Guides panel

These settings (Ruler, Grid, Bleed and Dimensions) are used to hide and show the layout assistants (see Figure 9–31).

🖣 Grid Snap

The Grid menu (see Figure 9–32) allows you to snap photos to other cells or to the grid as you drag to reposition them. If you're manually adjusting the layout, and you need precise positioning, make sure to enable this.

Cells panel

This panel provides controls for adding and removing cells and pages to and from the Picture Package (see Figure 9–33).

Use the buttons and their popup menus (see Figure 9–34) to add cells. Click a button multiple times to add more cells to the page.

Click the arrow at the right of a button to change the size for that button. To create a custom cell size, select Edit from the popup menu.

Figure 9–30: Image Settings panel for Picture Package

Figure 9-31: Rulers, Grid & Guides panel

Figure 9-32: Enabling Grid snap

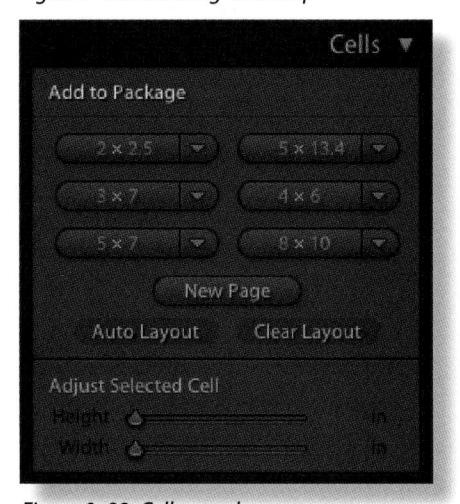

Figure 9-33: Cells panel

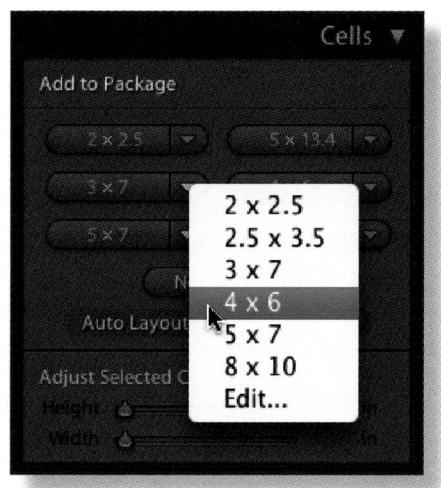

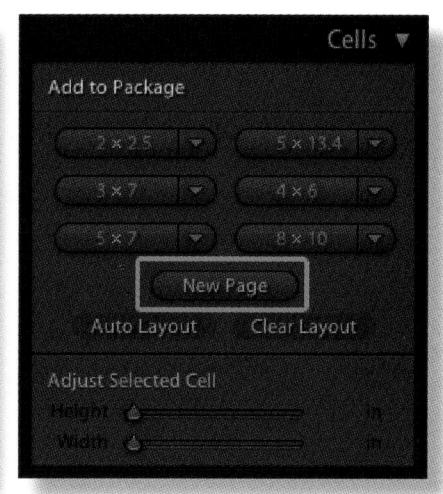

Figure 9-34: Cell buttons and popup menu

Figure 9-35: New Page button

Click the **New Page** button (see Figure 9–35) to create a new, blank page in the current template. All the pages in the current package are shown in the preview area. To delete a page, place your cursor over it, then click the red X at the top left of the page (see Figure 9–36).

If you click a cell button and there is not enough room on an existing page, a new page will be added automatically.

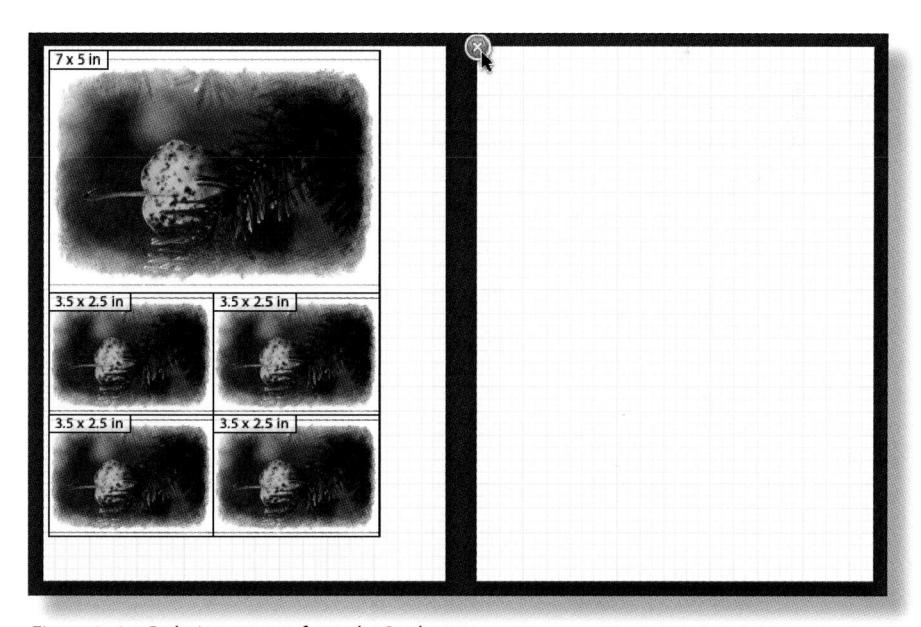

Figure 9–36: Deleting a page from the Package

9

Click the **Auto Layout** button (see Figure 9–37) to have Lightroom arrange the existing cells in the most economical manner.

Click **Clear Layout** (see Figure 9–38) to remove all the cells from all pages and delete all but one page.

The **Adjust Selected Cell** sliders allow you to resize the currently selected cell (see Figure 9–39).

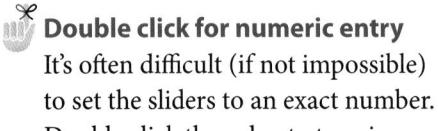

Double click the value to type in a number.

Undo

While there is no History for the Print and other presentation modules, you can undo changes you make to the layout(s).

Overlays panel

This panel offers the same Identity Plate controls as Contact Sheet/Grid (see Figure 9–40).

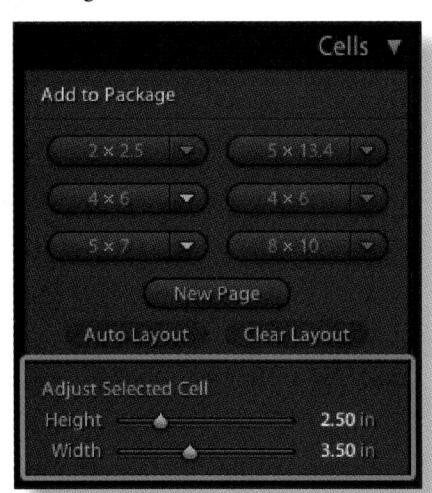

Figure 9-39: Adjust Selected Cell

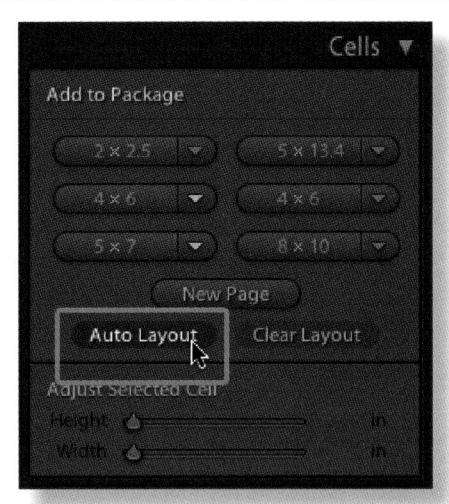

Figure 9-37: Auto Layout

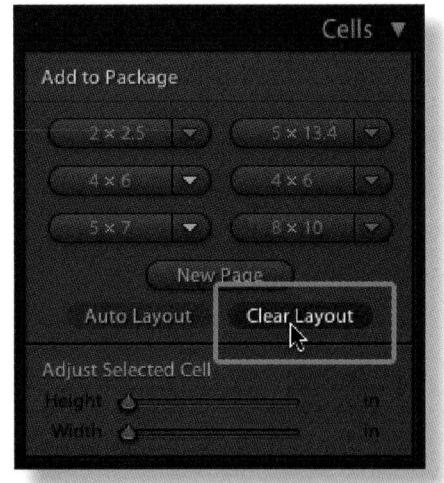

Figure 9-38: Clear Layout button

Figure 9–40: Overlays panel in Picture Package; Cut Lines

You can also tick the box to apply **Cut Lines** and use the popup menu to choose solid lines or corner crop marks.

Print Job panel

After laying out your page(s), configure the options on the Print Job panel (see Figure 9–41). The choices you make here determine the destination and quality of the printed output.

Print To:

This popup menu allows you to

Figure 9-41: Print Job panel

spool the job to your printer or generate a JPG file. The latter is very useful when preparing files to be printed by a lab, explained in detail at the end of this Print section.

Draft Mode Printing

When Draft Mode Printing is enabled, Lightroom outputs the image data from the photo previews, not from the full-resolution, original file on disk. This can dramatically speed print time but produces lower quality output. The rest of the Print Job options are disabled. Use Draft Mode Printing if you only need a very rough print of the photo(s). Otherwise, for the best quality prints, leave Draft Mode Printing unchecked.

Print Resolution

When Print Resolution is checked, you can specify an output resolution (unfortunately, in pixels per inch only). The photos in the print job will be resampled to the specified resolution as they are output from Lightroom. Depending on the size and native resolutions of the photos involved, and the output sizes, this most often results in either upsampling or downsampling. The maximum Print Resolution you can set in Lightroom is 480 ppi; the minimum is 72 ppi.

As mentioned earlier, the importance of higher resolution determines the ability to resolve more detail and make larger prints. The actual resolution of an image can be output to different print sizes based on the requirements of the printing method. The reproduction process and intended viewing distance determines the necessary resolution for high-quality output.

For example, to reproduce high-quality photographs in a book like this one, the image file must be somewhere around 300 pixels per inch (ppi) at final print size. A high quality inkjet print most often requires resolution between 180 and 240 ppi at final print size. A very large print, one that a viewer needs to stand several feet from to view, can be printed at 180 ppi or less with good results. Huge, building-size billboards can be successfully printed using files of 72 ppi and less.

Example: A 10 x 10 inch file at 100 ppi is the same as a 1 x 1 inch file at 1000 ppi.

Example: A photo with a resolution of 1000 x 3000 pixels is:

- 10 x 30 inches at 100 ppi
- 5 x 15 inches at 200 ppi
- 2 x 6 inches at 500 ppi

It's usually OK to print multiple photos that have different native resolutions all at once, as long as they are all within the specified tolerance. However, this can be impractical, and sometimes resampling is necessary to produce the best possible quality. For example, if you're printing a group of photos that, at final print size, have different resolutions, you may want to resample all of them to the same resolution so that the printed results appear similar.

If your photo, when scaled to final print size, falls anywhere between 180 ppi and 360 ppi, it's usually best to leave it at its native resolution. The negative effects of resampling may produce worse results than leaving the file at a lower resolution.

Showing the output resolution in the preview

When you have the Dimensions displayed in the previews, and Print Resolution is not checked, the Dimensions also show the native print resolution at the specified size (see Figure 9–42).

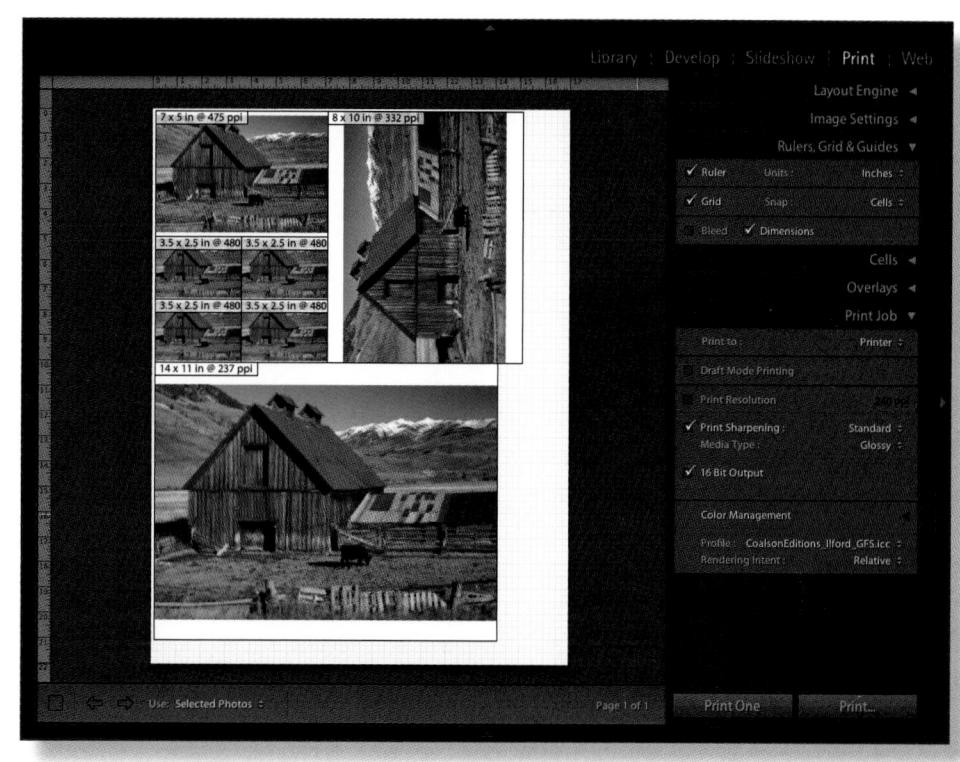

Figure 9-42: Resolution shown in Dimensions preview info

Print Sharpening

Tick the checkbox to have Lightroom apply output sharpening during the print job. Like the capture Sharpening controls in Develop and Export, Lightroom's Print Sharpening is based on algorithms developed by Bruce Fraser and his colleagues at Pixel Genius, LLC.

Choose an amount (Low, Standard or High) and a media type (Matte or Glossy paper; Matte applies stronger sharpening). Using these simple menu selections, Lightroom is often capable of applying the ideal sharpening for print. Make a few test prints using different settings to determine what works best for certain photos. If you have Photoshop, you might also make test prints using different sharpening methods in both Lightroom and Photoshop.

! Don't over-sharpen

If you've used Photoshop to resize or sharpen your files for printing, leave Lightroom's Print Sharpening off.

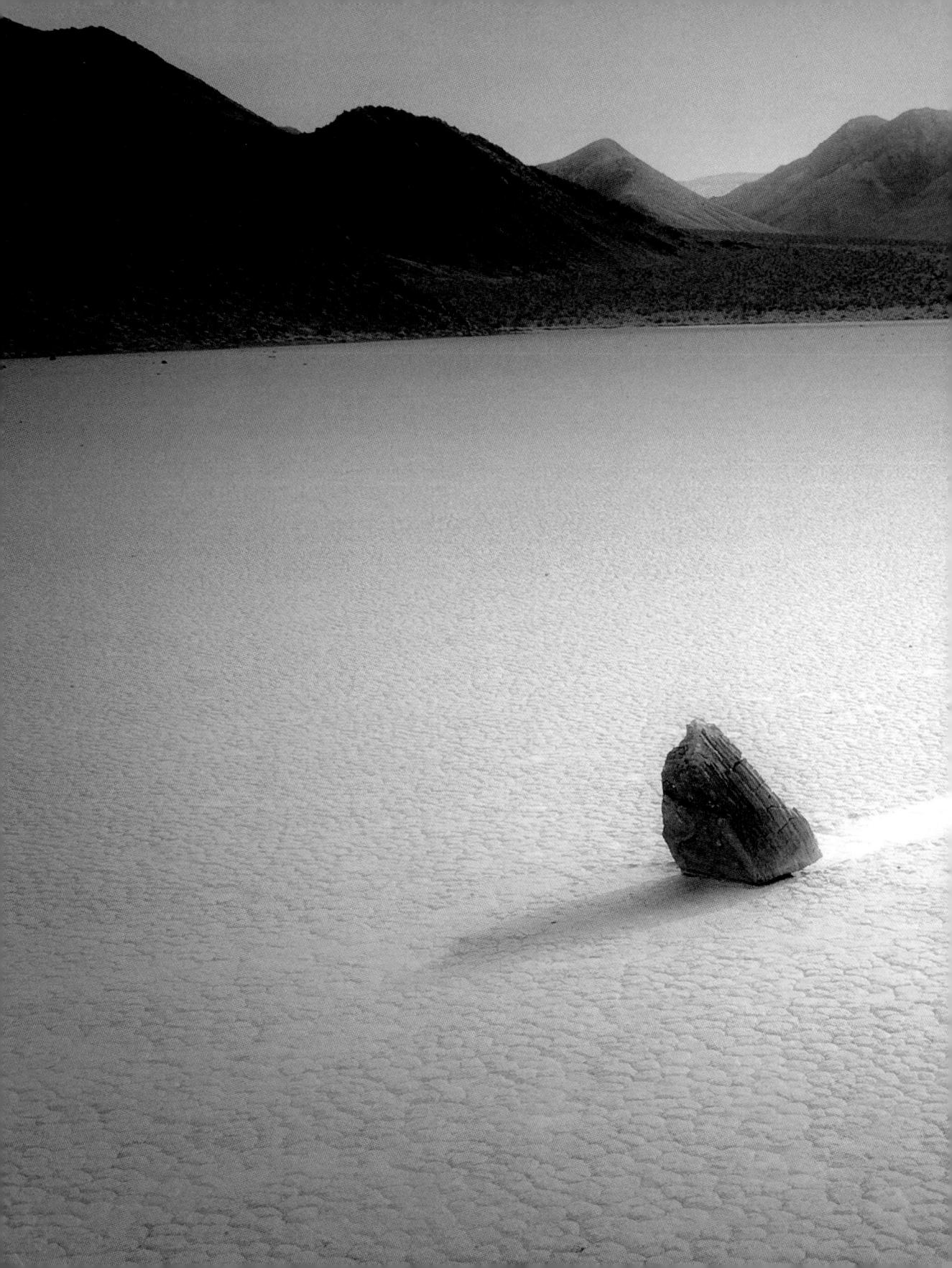

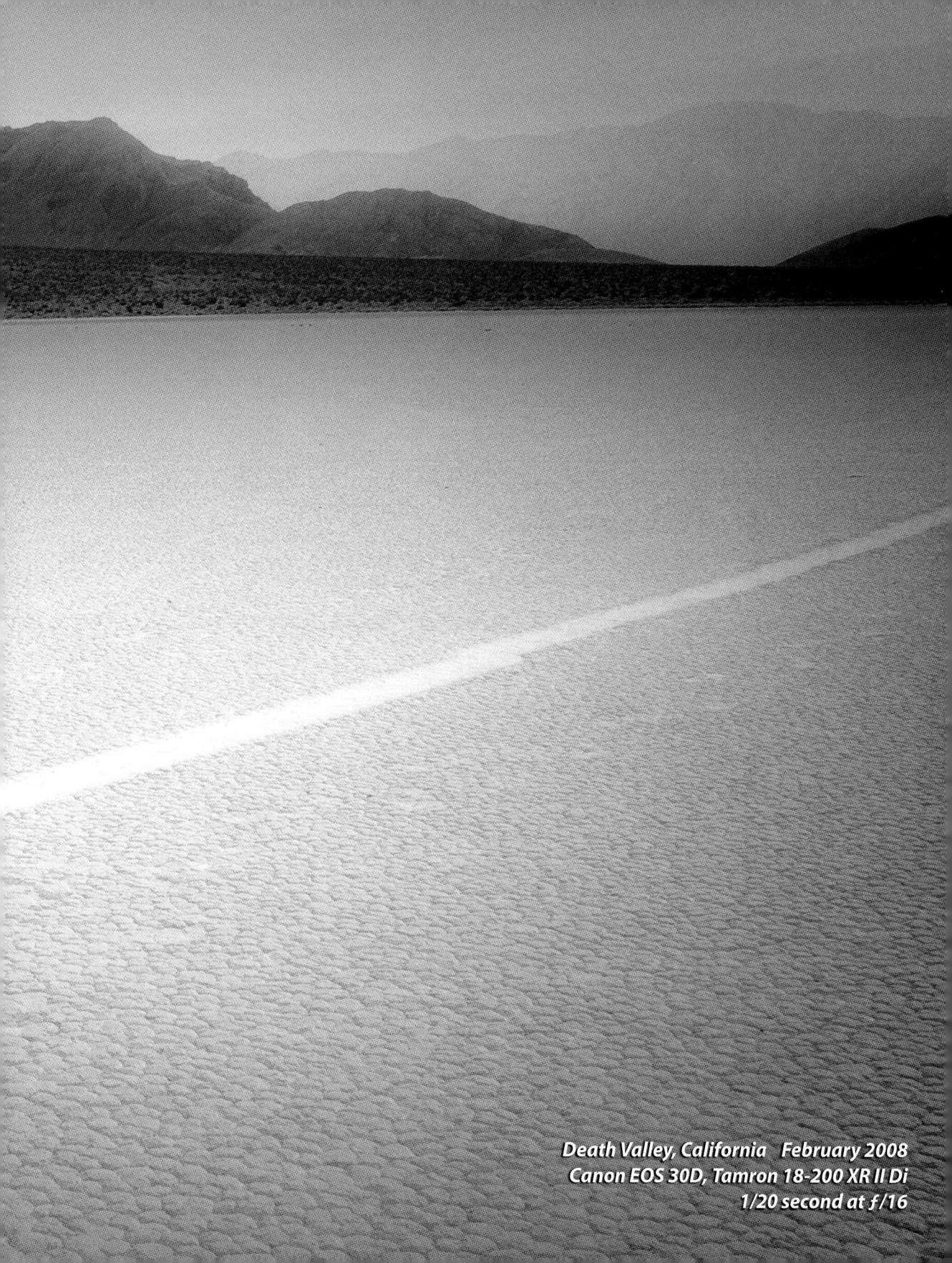

Color management

You have two options for Color Management when printing from Lightroom. Click the black triangle button at the top right of the panel to show additional information about the settings:

- Have Lightroom handle the output color conversions using an ICC profile; or
- Let the printer driver handle color management.

For accurate color, in nearly all cases I recommend using ICC profiles and having Lightroom handle the color management. (I always use this method, unless I'm printing black and white; see next section).

To do this, select a profile from the popup menu. If none are listed, select *Other*... A dialog box appears that allows you to add profiles into Lightroom. All the available profiles on your computer are listed. (If no profiles are listed, you can download them from your printer and/or paper manufacturer's Web site.) Check the boxes for the printer/paper profile(s) you want to add and click οκ (see Figure 9–43). When added, they will remain in the Profile popup for future use.

Figure 9–43: Choosing Icc profiles

Next, **choose the Rendering Intent**. As explained in Chapter 1, the Rendering Intent determines how the colors in the photo are translated to the printer's color space. Depending on the photo and your printer, some images may look better printed using Relative and some look better using Perceptual. It's worth doing a few tests to determine this.

If, for some reason, you don't want to have Lightroom handle color management, set the popup menu to Managed by Printer. Lightroom's color management controls become disabled. I use Epson's Advanced Black and White driver options and have been very pleased with the results. In this case, I turn off Lightroom's color management altogether. You should also set the menu to Managed by Printer if you're sending the files to a RIP (such as ImagePrint or ColorBurst) and want color management handled there.

Adjust files for printing using Quick Develop

Since the Quick Develop controls are relative, you can apply adjustments required for printing on top of the existing settings. Adjustments to Fill Light, Brightness and Saturation (or Vibrance) might all help. (Hold the Option or Alt key in Quick Develop to adjust Saturation.)

Soft proofing in Photoshop

It's important to remember that because a monitor is a *transmissive* device (transmitting light to generate color on the screen) and a print is a *reflective* image (made visible by light reflecting from the surface of the paper and ink) it is physically impossible to have a print look *exactly* like what you see on screen.

However, in Photoshop, *soft proofing* provides a reasonable simulation of the printed output on-screen, and with practice, you can train your eye to accurately predict how your prints will look.

As of this writing, soft proofing is not available in the current version of Lightroom. If you need this capability, you can open the file from Lightroom into Photoshop, do your soft proof and make any necessary adjustments, then return the file to Lightroom to print.

PRINTING THE JOB

Click the Print button at the bottom of the right panel group (see Figure 9–44). The printer driver dialog box appears. (Because printer driver dialog boxes vary in the extreme, I can't go into further detail on this here. Read your printer driver documentation for more about its specific settings.)

9

Apply the appropriate settings for the print job. If you're using Lightroom's color management, you need to take special precautions to make sure that color management is turned off in the printer driver. The vast majority of color problems on prints are due to "double color management". Depending on your printer and driver software, this will be found in different places. Make sure that color management is disabled in the driver.

Finally, you'll need to click Print in the printer driver one more time to spool the job to the printer (or file).

Most printer drivers allow you to save your custom settings for the driver. Also, all the printer driver settings are stored with the print template when it's saved. So be sure to save or update your template when you're done.

The Print One button (see Figure 9–44) allows you to quickly send a print job, bypassing the driver dialog box and using the most recent settings.

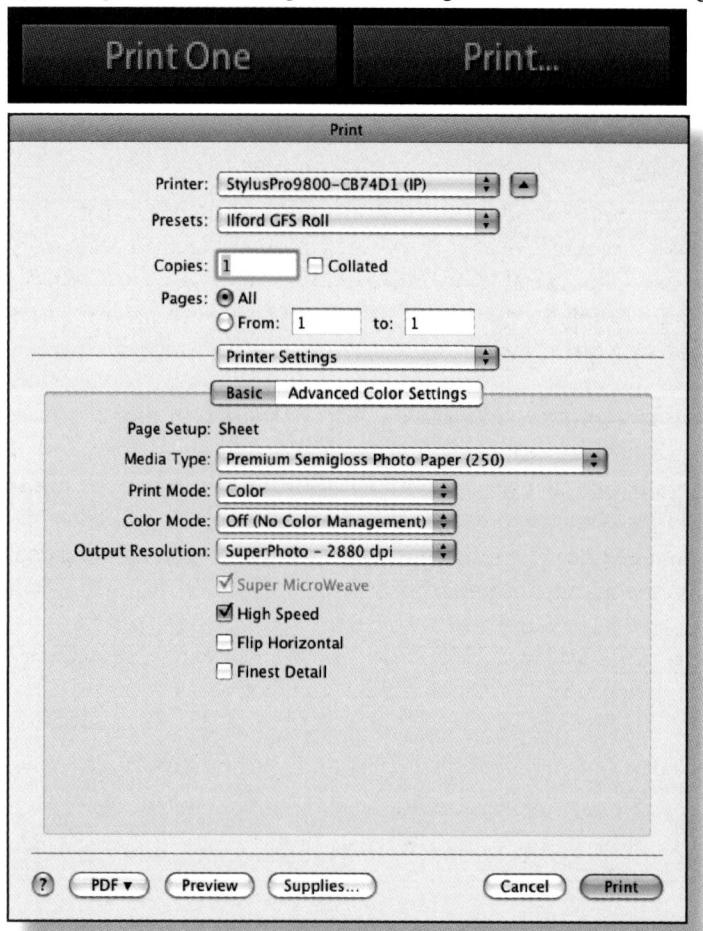

Figure 9–44: Printing the job

Getting the Best Possible Printed Output

The printer and paper you use make a huge difference in the quality of your prints. Most mid- to high-end printers, when using good quality papers, are capable of making very accurate, beautiful prints from Lightroom. Here are a few tips to help you make good prints.

Use good paper

You really do get what you pay for. When you're printing your photos for display, don't skimp. I highly recommend papers from Hahnemühle, Harman, and Ilford. Choose the right paper for the image: photos with large solid areas look better on smoother papers. Photos with lots of texture look great on textured paper or canvas.

Photo papers (gloss, luster, semi-gloss, etc.) provide the widest gamuts and the deepest blacks. This results in prints that look vivid, clear and show the most possible "depth".

Art papers (matte, cotton rag, etc.) provide a more artsy look. Prints on art papers may lack the three-dimensional characteristics of those on photo papers and thus appear more "painterly". Color gamuts available with art papers are significantly smaller than photo papers.

Use good profiles

For the most part, the profiles you download from a printer or paper manufacturer can get close to optimal color, but they weren't made using your printer. Don't expect perfect color from canned profiles. A custom printer profile, made specifically for your printer and paper combination, will produce the best possible results. Search Google for "custom printer profiles".

Adjust derivative photos to maximize the potential of the printer/paper gamut Different papers have widely varying color gamuts. It's highly likely that you won't get equally good results printing the same photo on a variety of substrates by only using different profiles and driver settings. Sometimes it's necessary to adjust the image prior to output to compensate for the destination gamut. It depends on the printer, the paper and the ink.

For example, Ilford Galerie Gold Fibre Silk has an extremely wide gamut on my Epson Stylus Pro 9800. The colors in most photos translate well to the print, with not much shifting of color or tone (using my custom profile). Still, I usually lighten the shadows a bit (Fill Light is good for this), and bump the Saturation by +4 to +7.

9

On art papers (and especially canvas) it's necessary to tweak the file settings more dramatically in order to produce similar appearances in tone and/or color.

Use vcs to make different versions, with different adjustments, for the various printing conditions you encounter.

Test, test, test

If you're planning to do a lot of printing from Lightroom, I recommend you do your own tests to see the results on paper. Lightroom doesn't preview the resolution and sharpening settings in the Print module, and there's no substitute for an actual print. Print the same images using different settings and you will quickly get a feel for how the settings affect the final output. Get the hang of Lightroom's printing workflow and identify key settings before you're up against a deadline or an important print job.

Print anomalies

Some users have reported seeing differences in prints made from Lightroom versus those from Photoshop. Problems have been reported on a few printers from Epson, HP and Canon.

There are several possible reasons for this. First, as Lightroom is still a relatively new program, some printer drivers have trouble with Lightroom's color-managed output. In cases where the problem lies with Lightroom's printing pipeline, Adobe has worked diligently to iron out the bugs. Unfortunately, this hasn't always been the case with problems in printer drivers. Printer manufacturers notoriously blame the operating system (and vice versa), so these kinds of problems are resolved slowly, if ever.

It's important to note that true software bugs related to printing from Lightroom are rare; the vast majority of prosumer and professional printers are capable of producing excellent prints from Lightroom. **Problems with printed output are most often due to incorrect settings in Lightroom, the printer driver, or both.**

Google the name of your printer model along with "Lightroom printing" etc. to see if people are discussing problems with your particular printer.

WORKFLOW: PRINT FROM LIGHTROOM

- 1. Choose a paper, get the printer set up and the paper loaded. Check ink levels, and ideally, print a nozzle test pattern;
- 2. In Lightroom's Print module, select a print engine and template;
- 3. Apply Page Setup options for paper size and orientation;
- 4. Modify the print layout to arrange the image(s) how you want them on the paper;
- Optionally, add overlays for Identity Plates, photo information and/ or cut lines;
- Set the output options in the Print Job panel and printer driver dialog boxes;
- 7. Send the job to the printer (or print to file).

Preparing print files to send to a lab

You can use Lightroom to generate print-ready files for printing by a lab. All photographic print labs accept JPG files for output. Lightroom's Print module allows you to render JPG files using the current print settings, instead of spooling the job to your printer.

Perform the workflow steps as usual, up to the point where you are setting the options in the Print Job. Instead of setting Print To: Printer, use JPEG File (see Figure 9–45).

The Print Job panel options change to let you specify:

- File Resolution;
- · Print Sharpening;
- JPEG Quality;
- Custom File Dimensions; and
- Color Management options: if a custom printer profile has been provided by the print lab, you can specify it here. Otherwise, use sRGB.

Ask your print vendor for a list of specifications to guide your decisions when making these settings.

When the correct settings have been entered, click the Print to File button, choose a location to save the files, and click Save.

Making Web Galleries

As a Web designer/developer since 1995, I have long had a practical, personal interest in the latest methods for efficiently generating high-quality, professional-level Web sites—especially Web photo galleries. Today, there are innumerable ways to approach this very common need.

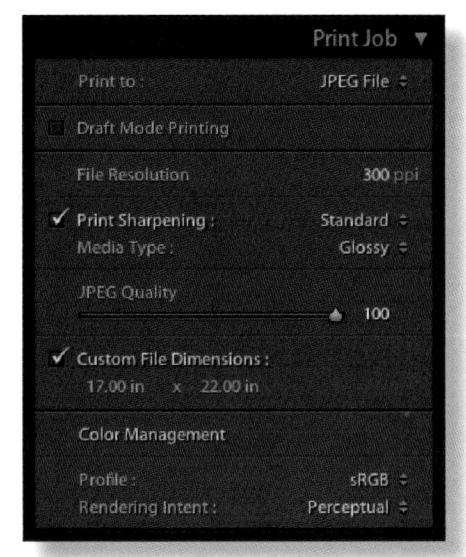

Figure 9–45: Print Job panel for Print to File

I really like the simple approach Lightroom offers, and I now produce almost all my Web gallery pages straight out of Lightroom. Rather than using a complicated, database-driven Web application to generate my Web galleries, I prefer to use Lightroom to create all the files I need—HTML, JPG images, CSS style sheets and all—and upload them directly to my server.

Be sure to have your desired photos selected before proceeding. As with Slideshow and Print, you can use a folder or collection as the source, and choose whether to use all images or only use selected or flagged photos.

SELECTING A TEMPLATE

As with the Slideshow and Print modules, with Web, you must first choose a template from the Template Browser, and again, you can preview them in the Preview panel.

By default, the templates you see in the Template Browser are from Lightroom's HTML and Flash libraries.

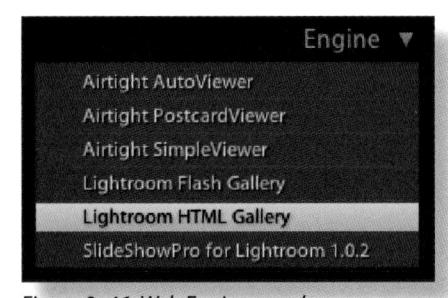

Figure 9-46: Web Engine panel

However, like the Print module, you can greatly expand your range of options by selecting another source of templates from the Engine panel (see Figure 9–46).

There is a growing number of third-party Web gallery engines available; take a look at Slideshow Pro and LightRoomGalleries; see Resources in Appendix.

Templates from the selected engine are listed in the Template Browser panel (left side of the Web module).

CUSTOMIZING THE TEMPLATE

After choosing a template as a starting point, continue through the controls in the right panels to customize the design.

Most Lightroom Web gallery templates make use of thumbnail "index" pages, and pages that show a single, large photo.

Note: the available design controls vary greatly based on the template Engine selected. The following examples are based on Lightroom's default HTML gallery:

Site Info panel

The Site Info panel (see Figure 9–47) provides controls for setting text on the page. In most templates, each line of text is styled differently.

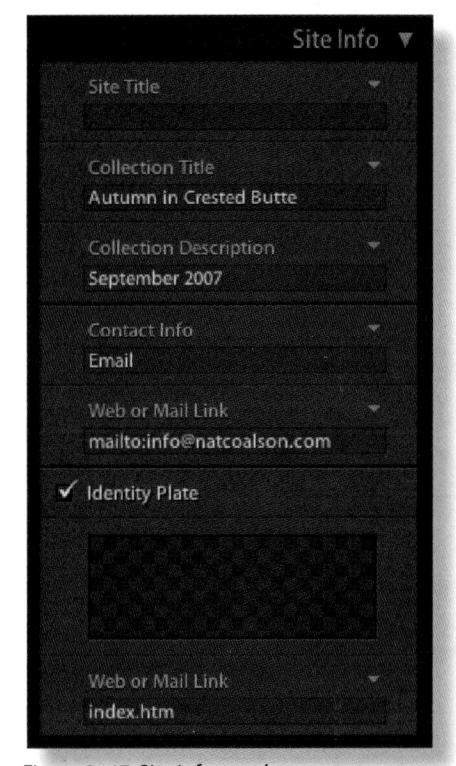

Figure 9-47: Site Info panel

The first section of the Site Info panel includes:

- Site Title;
- · Collection Title; and
- Collection Description.

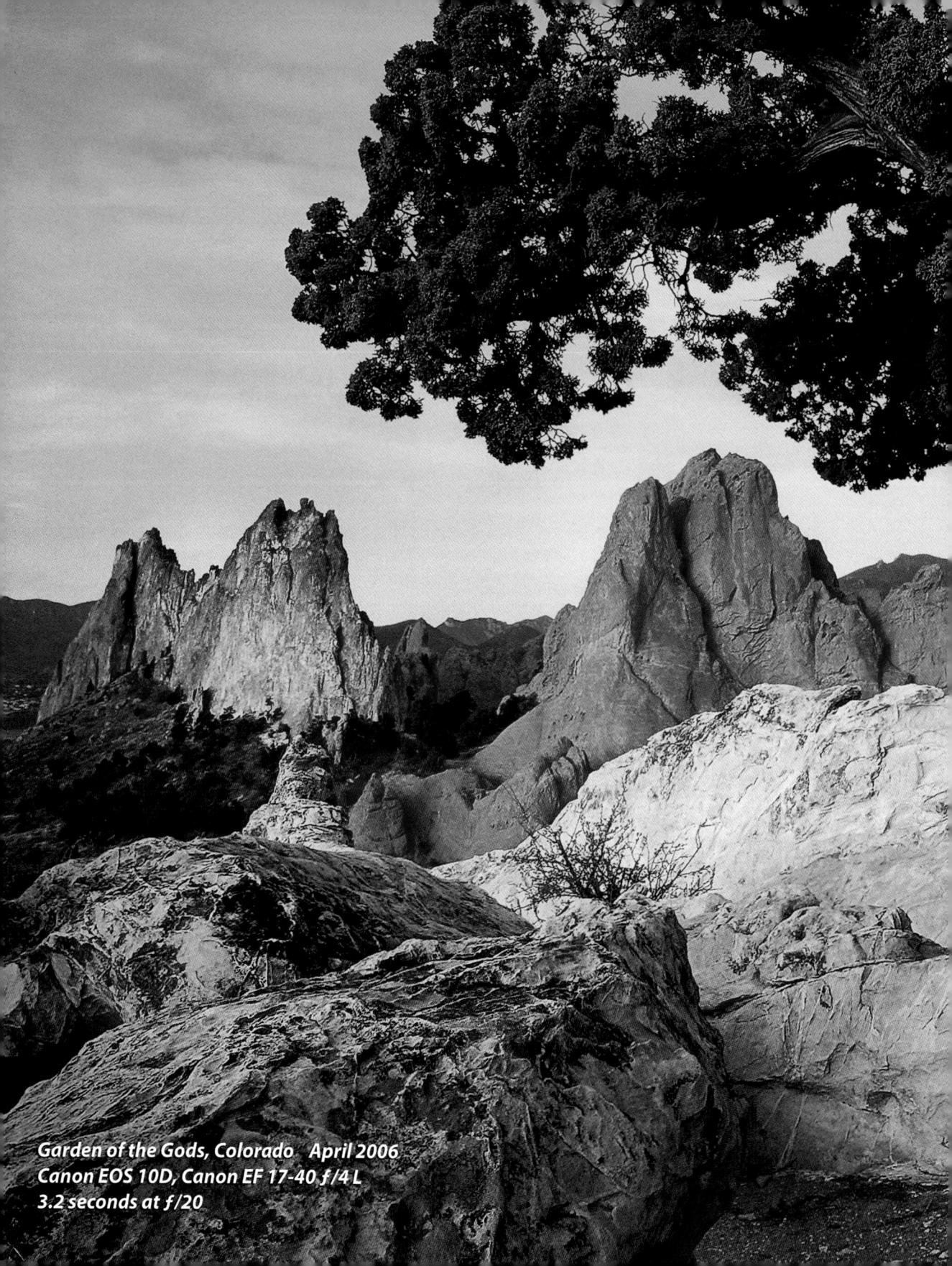

Note that this "Collection" has no relationship to Lightroom's Collections image source.

Below the first section are:

- Contact Information
- · Web or Mail Link

The last section of the Site Info panel is for the Identity Plate. Configuring the Identity Plate here works the same as in the other presentation modules, with one addition: here, you can choose to make the Identity Plate a Web or email link.

To remove any element from the layout, leave the text field blank.

Recent items

The triangle button at the right of the text fields provides quick access to recently used text values (see Figure 9–48).

Figure 9–48: Recent items menu

Linking to other Web pages

The default Lightroom Web templates provide two places to create links to other Web pages (or email). If you are adding Web galleries to an existing site, you may want to include a link to the home page of the site as one of the two provided links.

Color Palette

You can specify colors for the following elements:

- Text
- Detail Text
- Backgrounds
- Detail Matte
- Cells

- Rollover
- Grid Lines
- Numbers

Click the color swatches to open the color palette. It looks and functions like color palettes in other modules, with one minor difference: you can view and select colors using Hex

(Hexadecimal) color values. Hex colors are commonly used for Web graphics, because their values can be specified to conform to operating system color palettes. To switch between Hex and RGB values click each respective text button in the palette (see Figure 9–49).

Sample a color from anywhere on the screen

From within the color

palette, click and drag the eyedropper anywhere on your screen to sample a color. This is very useful for precisely matching colors from any other items visible on your screen, even if they're in other programs.

You can store up to five custom colors in the rectangular swatches (presets) at the top of the palette (see Figure 9–50). Click and hold on a preset to set the current color in that position. Click a preset to load that color.

Figure 9-49: RGB and Hex color values

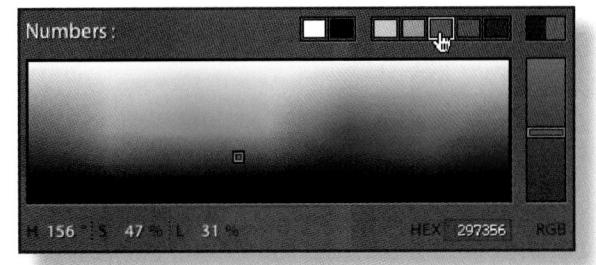

Figure 9-50: Custom color swatches

Previewing the Web gallery

As you make changes to the settings, you can preview the gallery in the main preview area. This preview is "clickable"; click the photos to see how their links function. This allows you to view both thumbnail pages (if applicable) and full size image pages.

In addition to previewing the Web gallery within Lightroom's image display area, you can also test the it in the default Web browser on your computer; click the Preview in Browser... button at the bottom of the left panel group (see Figure 9–51).

Figure 9-51: Preview in Browser...

Note: previewing in a browser requires Lightroom to render temporary files for all the photos and can be very slow. I recommend that you use the built-in preview whenever possible, or use a limited number of photos for your test previews.

() F

Previewing in multiple browsers

To see how the Web gallery looks and functions in various browsers you need to export it. You can then open the index file(s) in each browser.

> \#+R or Ctrl+R

To reload the Web gallery preview.

Appearance panel

The Appearance panel (see Figure 9–52) contains varying options for the presentation of thumbnail and single-image pages.

Figure 9-52: Appearance panel

Common Settings allow you to add drop shadows and section borders.

In the **Grid Pages** section of the panel you can specify the grid layout of the thumbnail pages. Click in the grid preview box to set the number of rows and columns. You can also choose whether or not to show the number of each photo in the sequence, and add colored borders to the thumbnails (but you can't adjust the size of this border).

The **Image Pages** section controls the length of the longest side of the large image displayed on the single-image pages. You can also adjust the width and color of the photo border, if one is applied.

If you're viewing the thumbnails preview while adjusting the Image Pages controls, a warning icon appears indicating that any changes you make in that section of the panel aren't visible in the current preview (see Figure 9–53). Click a photo to see the large image page; click it again to return to the thumbnails.

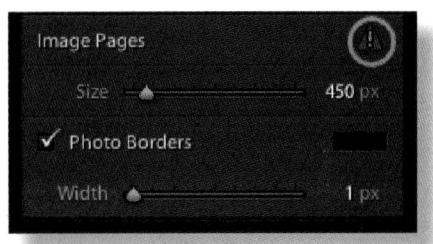

Figure 9-53: Preview warning

Image Info panel

This panel offers the ability to display up to two lines of text information on the large image pages. Tick the checkboxes to enable or disable **Title and Caption text labels.** These Web gallery titles and captions are not the same as the metadata fields by the same name, though by default that's what they display. The title is displayed above the photo; the caption below.

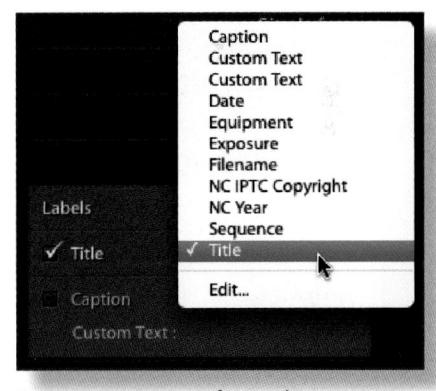

Figure 9-54: Image Info panel; popup menu

Click to open the popup menu to choose what to display for each label. With the Edit... selection on this menu you can configure your own titling presets (see Figure 9–54).

Output settings panel

The Large Images Quality setting on the Output Settings panel (see Figure 9–55) sets the level of JPG compression for the large images.

The **Metadata** popup menu selects whether to include all metadata in the JPG files or Copyright Only. Using Copyright Only can help reduce the size of the resulting files for faster loading.

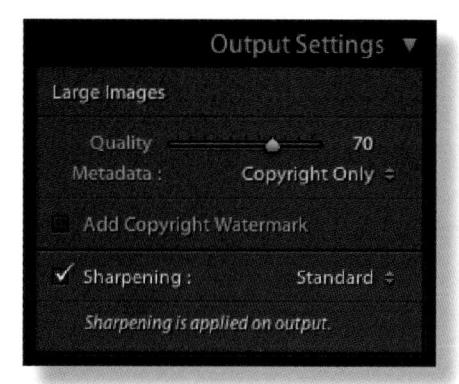

Figure 9-55: Output settings

Tick the checkbox for **Add Copyright Watermark** to add a watermark to the image files. Like Export, there are no controls for adjusting the size, style or placement of the watermark.

Finally, to apply output sharpening to the files, tick the **Sharpening** box and choose a strength from the menu. Lightroom applies the optimal amount of sharpening for the size of the output images when the gallery is created.

DEPLOYING YOUR WEB GALLERY

When you've got the template set up the way you want, you have two choices:

- **Export** the Web galleries to your hard drive (presumably to upload them to a server or burn them to a disc later); or
- **Upload** the files directly to a Web server.

In both cases, Lightroom will create all the files necessary to produce the finished Web gallery. Depending on the Engine and template selected, this will produce varying results in terms of the number and types of files generated.

Do a few test runs before doing it for real

It's highly likely that—even with lots of experience under your belt—you will occasionally (if not frequently) run export or upload operations from Lightroom's Web gallery that, for one reason or many others, is not what you wanted. This is normal and should not be feared!

That said, if you're under the gun, such as when presenting to a client, it's a good idea to do a few trial runs with any template/settings that you haven't used before.

Uploading Web Galleries to a Server

You can upload Web Galleries directly to the server as they are created. To do this, you must have a Web server account already set up and you must have all the necessary information required to log in to the server using the FTP protocol.

Upload Settings panel

To upload files to a server, you need to first enter the server and Subfolder information in the Upload Settings panel (see Figure 9–56).

FTP Server

The first and most important configuration settings to make are for the FTP server. From the popup menu (see Figure 9–57), select Edit... to open the Configure FTP File Transfer window.

In the Configure FTP File Transfer dialog box (see Figure 9–58), enter the server name/address, username and password for the FTP account. If you plan to save a preset for this server, I recommend you enable the option to store the password in the preset (unless you have a reason not to). This will simplify the uploading process.

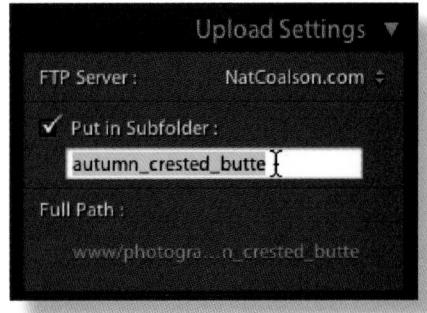

Figure 9-56: Upload Settings panel

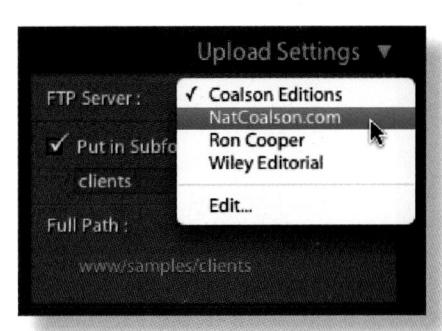

Figure 9-57: FTP server popup menu

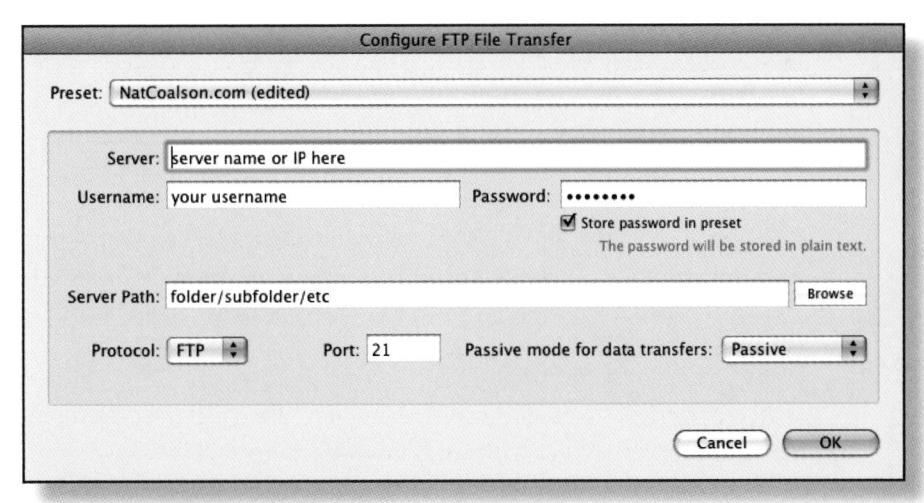

Figure 9–58: Configure FTP File Transfer

If you need to put the files in a folder other than the site root, enter the directory path in the Server Path field. Most often this would be something like /www/, / public_html/ etc. The use of leading and training slashes is important; check your account documentation as necessary.

In most cases you can leave the Protocol, Port, Passive Mode for Data Transfers fields at their default values.

If you're not sure what to enter for any of these settings check your Web hosting account information or ask your Web server administrator.

Click OK to apply the settings or Cancel to leave the dialog box without saving changes.

Next, in the Upload Settings panel, you can choose to put the uploaded files into a subfolder (the default is a folder called "photos"). If you entered a value in the Server Path field the subfolder(s) will be created under that directory (see Figure 9–59).

At the bottom of the Upload Settings panel, the Full Path: info shows the full

directory path where the Web gallery will be uploaded (not including the domain name). If you're publishing a link to the gallery or sending it by email, provide the full URL (Web address) including the domain name and the Full Path.

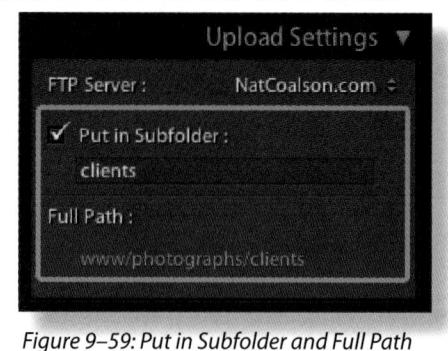

Create multiple subfolders

You can create multiple subfolders here by entering their names into the text field, separated by slashes, for example: photos/trips/new_mexico_2009/.

Always use Web-friendly names

When you're creating any folders (and files) for Web use, don't use spaces, punctuation (except hyphens and underscores) or any special characters.

Upload the Gallery

When you're done configuring your Web gallery, click the Upload button. Lightroom will generate all the files required for the gallery, including JPG images and HTML pages (and Flash files, if necessary) and will upload them to your Web server in the location specified.

Uploading does not save a local copy

When you use the Web module to upload Web files directly to your server, no local copy is stored on your hard drive. If this matters to you, you have two options: 1) use Export instead, and manually upload the files using an FTP client, etc., or 2) after using Lightroom to upload, download them to your local disk.

Save a preset

When you've correctly configured the server settings be sure to save a preset. It will appear in the FTP server popup menu for easy selection. This is especially important if you are generating Lightroom Web galleries for multiple Web sites.

Save a template

After you've set up the design the way you like, remember to save a template for later use. All the panel settings—including Upload Settings—will be stored in the template.

EXPORTING WEB GALLERIES

You can export Web galleries from Lightroom even if you don't have a Web hosting account set up. An Export is the opposite of Upload: the files are saved to your hard drive but not to a Web server.

Click the Export button at the bottom of the right panel group (see Figure 9–60) to begin the process.

Figure 9-60: Export button

A dialog box appears, asking you to choose the location and name for the root folder that will be created. Enter a name and click Save. Lightroom will save out all the necessary files for the Web gallery you've created. Lightroom creates all the files and subfolders necessary to run the Web gallery in the folder specified, using relative links (see below). You can then upload them using FTP software or burn them to a CD/DVD.

About relative links

By default, the links that Lightroom generates for files are always relative to that file. In other words, all the files in the Web gallery are linked relative to one another. This means that if you change the folders or move files after the gallery has been generated, the links will be broken. To make changes to links requires you to either generate a new gallery or use dedicated Web development software (such as Adobe Dreamweaver) to modify the files.

9

Use Web galleries as disc-based presentations

Because a Lightroom-exported Web gallery is fully contained, with all links, images etc. in place, they also make good off-line presentations. I often generate Web galleries and burn them to disc for delivery to clients, galleries and prospective vendors. This allows viewing the gallery without an Internet connection, and the presentation looks and works just the same as if it was being accessed from a Web server. (Just be careful about the links you build into these. You can include a link to a Web site from a disc-based gallery as long as you use a full URL, including http://.)

> X+J or Ctrl+J

To export the Web gallery.

Chapter Summary

Lightroom's Slideshow, Print and Web modules give you a wide range of professional quality presentation options. All the presentation modules share similar panel controls which are easy to learn and use. Work through the settings until the previews look the way you like, then present, export, upload or print.

Like the presets in the Library and Develop modules, using templates is key to speeding up your work. When you're done making the settings be sure to save templates for future use.

Congratulations, you've made it through the complete Lightroom workflow. Best of luck with your photography!

In loving memory of Bethany Miller-Amrich

APPENDIX A: MOST USEFUL SHORTCUTS

From anywhere in Lightroo	m:	₩+R	Show selected file(s) in Finder
]	Grid	or Ctrl+R	or Explorer
	Loupe	雅+Shift+S or Ctrl+Shift+S	Synchronize selected photos
	Develop	V	Convert to Grayscale
	Crop	' ₩+,	Open Lightroom Preferences
āb	Hide/show side panels	or Ctrl+,	open Lightroom references
hift+Tab	Hide/show all panels		
Right-click or Ctrl+Click	Open contextual menu	In Library: Arrows	Move between photos
	Hide/show Toolbar	Shift+Arrows	Select contiguous photos
	Cycle Lights Out	#+A	Select All
lumbers 1-5	Apply star rating	or Ctrl+A	Select All
	Apply Reject flag	ж +D	Select None
3	Add to/remove from Target Collection	or Ctrl+D	
Delete	Remove photo or virtual copy	₩+G	Stack selected photos
Return or Enter	Finish typing into a text field	or Ctrl+G	Comment
SC	Escape a text field, color palette, etc.	(Compare two images
#+Z	Undo	N	Compare multiple images
or Ctrl+Z			Hide/show Filter Bar
	Go back	発+L or Ctrl+L	Enable/disable filters
₩+Option+Right Arrow or Ctrl+Alt+Right Arrow	Go forward	光+N or Ctrl+N	New collection
₩+Shift+I or Ctrl+Shift+I	Import	In Develop:	
=====================================	Export	W	White balance selector
or Ctrl+Shift+E	· ,	Α	Constrain aspect ratio
₩+′	Create virtual copy	N	Spot Removal
or Ctrl+'		M	Graduated filter
% +=	Zoom in	K	Local adjustment brush
or Ctrl+=	7	[Smaller brush
₩+- or Ctrl+-	Zoom out]	Larger brush
₩+[or Ctrl+[Rotate left	Option or Alt	Erase from brush mask
#+]	Rotate right	Н	Hide/show tool overlay
or Ctrl+]		Υ	Before/After
₩+E or Ctrl+E	Edit selected photo in Photoshop		Toggle Before/After in main pre

APPENDIX B: LIGHTROOM WEB RESOURCES AND OTHER USEFUL LINKS

Online help for Lightroom, with a fairly recent list of all shortcuts—http://help.adobe.com/en_US/Lightroom/2.0/

Adobe Lightroom Community: tutorials, help—http://www.adobe.com/support/photoshoplightroom/

Lightroom Resource Center—http://www.photoshopsupport.com/lightroom/index.html

Julieanne Kost Lightroom tips and tutorials—http://jkost.com/lightroom.html

Richard Earney - Presets, blog—http://inside-lightroom.com/

Web gallery templates—http://www.lightroomgalleries.com/

Lightroom Journal: development team blog—http://blogs.adobe.com/lightroomjournal/

Sean McCormack Lightroom blog—http://www.seanmcfoto.com/lightroom/

Ian Lyons Web site; Lightroom tips and tutorials—http://www.computer-darkroom.com/

Lightroom blog—http://lightroom-news.com/

Jeffrey Friedl's Lightroom plugins and tools—http://regex.info/blog/lightroom-goodies

Weekly Lightroom video tutorials—http://www.thedigitalphotographyconnection.com/LFDP.php

Lightroom plug-ins (LR/Mogrify, LR/Enfuse, etc.)—http://www.timothyarmes.com/blog/category/my-plug-ins/

Lightroom tips and tutorials—http://www.image-space.com/

Presets, tutorials, blog—http://www.lightroomkillertips.com/

Lightroom support forum—http://www.lightroomforums.net/

Web gallery templates—http://theturninggate.net/lightroom/

 $Web\ gallery\ engine-http://slideshowpro.net/products/slideshowpro/slideshowpro_for_lightroom$

Adobe DNG editor—http://labs.adobe.com/wiki/index.php/DNG_Profiles:Editor

Carbon copy cloner backup software for Mac—http://www.bombich.com/ccc

Chronosync backup software for Mac—http://www.econtechnologies.com/

RPG Keys workflow plug-in and specialized keyboard—http://www.rpgkeys.com/

Digital asset management for photographers—http://www.thedambook.com/

Keywording and metadata—http://www.controlledvocabulary.com/

Adobe Exchange—http://www.adobe.com/cfusion/exchange/

PTlens, external editor for Lightroom—http://epaperpress.com/ptlens/

Photomatix by HDRsoft (HDR software)—http://hdrsoft.com/

DxO Optics Pro and Lightroom plug-in—http://www.dxo.com/

Lightroom presets—http://wonderlandpresets.tumblr.com/

Lightroom presets—http://www.presetsheaven.com/

Lightroom shortcuts and F.A.Q's—http://lightroomqueen.com/

Nat Coalson's main Web site—http://www.natcoalson.com/

Nat Coalson's workflow blog—http://www.prophotoworkflow.com/

The online landscape for Lightroom-related products, services and information is rapidly evolving. I recommend that you periodically perform searches for phrases like "Lightroom plug-ins", "Lightroom presets", "Lightroom help", etc. There are some very talented people out there, producing very cool solutions for real-world needs.

I'd especially like to point out the work of Victoria Bampton, aka The Lightroom Queen. Victoria has done a great job of continually providing up-to-date lists of shortcuts and frequently asked questions about Lightroom—no easy feat. If you're inclined to learn every shortcut possible, check out her site to download very complete PDFs of Lightroom shortcuts at the address above.

Lightroom is a fast, lightweight application that can usually run quickly, even on not-so-fast computers. But if you find Lightroom to be running slowly, there are several ways you can improve its performance:

- 1. Keep ample free space on your system hard drive and the drive that holds the Lightroom database and preview files. This is true for all photo-editing and imaging applications—you don't want to be working from a drive with limited free space as data corruption may occur.
- 2. Load your machine with as much RAM as it will hold (or that you can afford). Lightroom likes to have lots of memory available.
- 3. If you have 4 GB of RAM or more, and your operating system supports 64-bit processing, make sure you're running Lightroom in 64-bit mode. If you're not sure what this means, you can find more information about it online.
- 4. Take control of your previews. Each time you make an adjustment to a photo, Lightroom has to render new previews. The speed it can do this depends on your computer hardware and the size of the original files you're working with. Remember that Lightroom maintains three separate previews for each image: thumbnail, standard size and 1:1. Lightroom will generate any previews it needs on-the-fly, sometimes this means you'll see a delay as Lightroom builds a preview. If Lightroom already has all the necessary previews rendered, moving between images should be quick. Using the commands on the Library→Previews menu or the contextual menu, you can instruct Lightroom to discard and re-render the previews whenever you choose.

For faster performance, you might try lowering the File Handling settings.

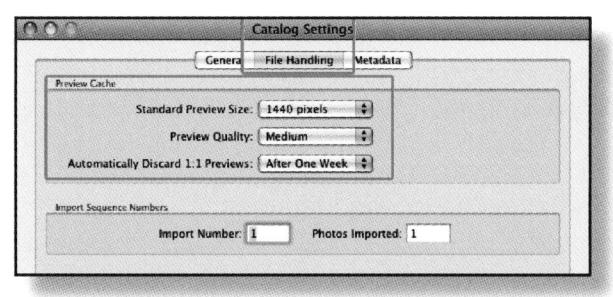

Preview options in Catalog Settings-->File Handling

- In File→Catalog Settings→File Handling, you can set the size of your standard preview, based on your screen size and how fast you want the preview redrawing to be. No need to use larger standard previews than what your display system is capable of handling.
- Don't select folders/subfolders with large numbers of images when you don't need to, because Lightroom will re-read all the files in the chosen source, attempting to get information about all previews and metadata. For example, if you click the All Photographs source from the Catalog panel, and you have many thousands of photos in the catalog, reading all those files can take a while. Click on the folder that contains only the images you want to work with. (Using Collections; see Chapter 6; is a more efficient way to organize your edited photos.)
- Optimize your database periodically—maybe every eight to ten days worth of intensive work—using the button in the Catalog Settings dialog box.

Avoid force-quitting Lightroom whenever possible

If you experience what appears to be a crash in Lightroom, especially if you can still move the cursor, give it a few minutes to see if the application and/or operating system recover from the condition. Force-quitting Lightroom at any time and for any reason dramatically increases the likelihood of data corruption. Of course, sometimes it can't be helped... keep good backups! (Backup strategies are discussed in Chapter 5.)

Change modules

If Lightroom appears to hang, especially in the Develop module (see Chapter 7), wait a few moments, then try switching back to Library. Changing modules often resets a troublesome memory condition within Lightroom.

Customizing Lightroom Preferences

In most scenarios the default Preference settings in place when Lightroom is installed are ideal. However, when you've worked with Lightroom for some time, there may be settings you want to change to suit your computer configuration or work habits. Spend some time getting to know the options available in the Preferences dialog boxes; they are fairly straightforward, and with an understanding of Lightroom's interface and functionality the settings you want to change will become more evident.

Symbols		bit depth 4, 51
	1:1 previews 245	Blacks 216, 222, 223, 224, 225, 276, 282
	16-bit 4, 5, 303	Brightness 224
	10 010 1, 3, 303	c
	A	
	A and B brushes 256	Camera Calibration 210, 212
		camera profiles 210, 211, 212, 244
	active photo 135, 145, 148, 157, 185	camera raw 8, 10, 11, 99
	Activity Viewer 29	camera settings 58
	Add Keywords 165	Candidate 147
	adjusting tone and contrast 216	capture 50
	Adobe Bridge 118	catalog 69, 70, 71, 72, 73, 74, 75, 78, 82, 84,
	Adobe Camera Raw 118	85, 88, 89, 96, 97, 102, 104, 105, 106,
	Adobe RGB (1998) 7, 9, 58	107, 108, 109, 112, 113, 115, 117,
	All Photographs 113	118, 119, 123, 125, 129, 143, 162,
	alpha channel 2	163, 166, 167, 173, 175, 179, 182,
	alternative import workflows	185, 189, 190, 192
	import workflow for road trips 105	Catalog panel 112
	Appearance panel 364	changing thumbnail size 128
	applying settings to multiple photos 274	channels 5
	arrow buttons 38	chromatic aberration 202, 245, 246
	artifacts 197, 201, 204, 244, 282, 283	Clarity 227
	aspect ratios 214	clipping 57, 222
	attributes 168	Clone 264
	Attributes filters 175	CMS 7, 8
	audio files 155	смук 5, 11
	Auto Advance 169	Collections 177
	Auto Import 102	Collection Sets 183
	Auto Mask 253, 256	Collections Panel 112
	Auto Stack by Capture Time 142	color 196, 198, 201, 205, 209, 216, 217, 220,
	В	223, 234, 235, 236, 237, 238, 239,
		240, 241, 244, 246, 247, 250, 251,
	backing up image files 109	252, 263, 268, 271, 282, 283
	backing up Lightroom catalogs 108	Color Labels 169
	backups 73, 75, 92, 95, 99, 105, 106, 107,	Color Label Sets 169
	108, 109	color management 7, 8, 11, 332, 352, 353,
	Backup to: 92	354
	badges 129, 132	Calibrating your display 9
	Basic panel 223	Lightroom Color Management 7
	batch exports 295	color management system. See смs
	batch file conversions 74	color mode 5
	batch processing 69, 83, 86, 104, 109	Color Palette 362
	Before/After 269, 270	color space 7, 8, 58, 303

ColorSync 7	Draft Mode Printing 347	
color temperature 6	DxO Optix Pro 312	
Compare 145	dynamic range 56	
composite images 208	_	
Contact Sheet/Grid. See Print module	E	
contextual menus 40	Edit Capture Time 154	
Contrast 227	Edit in Photoshop 284	
converting a photo to black and white 240	Eject card after importing 89	
converting raw files to DNG 88, 188	emailing photos 317	
Copy/Paste 186, 274	Error Photos 113	
Copyright Watermark 308	EXIF 153, 154, 175	
Copy Status 175	Export Actions 312	
critiquing photography 196	exporting catalogs 319	
crop and rotation 197	exporting from Lightroom 292	
crop frame tool 216	Add to This Catalog 297	
Crop Presets 185	file name shown in red 299	
crop tool 212	exporting Web galleries 369	
Custom Text token 86	export plug-ins 312	
D	export presets 314	
	expose to the right 57	
database corruption 73	Exposure 55, 209, 217, 222, 223, 224, 225,	
Default Settings 280	250, 282	
demosaicing 51	external editors 284	
Density 253	eyedropper/selector 236	
derivatives 3, 18, 293	_	
Detail panel 244, 245, 246, 247, 259, 260,	F	
261	Facebook 312	
Develop 23, 195, 196, 198, 205, 208, 209,	Feather 253	
211, 212, 222, 225, 236, 240, 241,	file backups 108	
244, 245, 250, 263, 269, 270, 271,	file formats 10, 73	
272, 274, 275, 276, 277, 280, 282,	File Handling 89, 97, 104, 107	
283, 289	Filename Template Editor 86	
Developing photos 209	file naming templates 86	
Develop presets 87, 269, 272, 275	File Settings 299	
digital photo storage 74	Fill Light 226	
disk drives 75	Filmstrip 29	
DNG 8, 10, 11, 18, 19, 73, 74, 77, 79, 82,	Filter Bar 112, 174	
88, 89, 92, 94, 95, 98, 99, 104, 105,	Filters 173	
159, 188, 204, 210, 211, 284, 292,	filter switch 176	
298, 302, 333	finding a folder on your hard disk 122	
dodging and burning 248	finding a photo on your hard disk 122	
Don't Enlarge 306	finding missing photos 125	
Don't re-import suspected duplicates 89, 97	flags 168, 169, 172, 173, 175, 189	

Flickr 312	IPTC 154
Flow 253	ISO 62, 63, 66, 201, 281
folder and file naming 78	
Folders 114, 116	J
folder structures 76	JPG 53
fringing 246)FG 33
FTP Server 367	K
G	Kelvin 6
	Keywording Panel 164
gamut 8, 9	Add Keywords 165
Google Maps 155	Keyword Sets 165
GPS and Altitude 155	Keyword Suggestions 165
graduated filter 248, 249, 250, 251, 258	Modify Keywords 165
Grayscale 4, 233, 234, 239, 240, 241, 244,	Set Keyword 166
268	keywording strategies 163
Grid 127	Keyword List Panel 166
Grid Snap 344	Keywords 88, 112, 126, 152, 163, 164, 165,
н	166, 167
п	Keywords panel 126
Heal 263	Keyword Suggestions 165
High Dynamic Range 4, 57	
histogram 57, 58, 66, 135, 212, 217, 220, 222,	L
223, 262	lens filters 63
History 272	Library 22, 112, 116, 122, 124, 127, 128, 129,
HSL panel 239	133, 134, 136, 152, 169, 173, 176,
Hue 6, 234, 239, 241	184, 185, 188, 190, 192, 193
	Lightroom application window 44
1	Lightroom data architecture 70
ICC profiles 8, 352	Lightroom defaults 204
ICM 7	Lights Out 44, 213
Identity Plate 28, 324, 325, 333, 339, 342,	Link Focus 146
346, 362	Live Loupe 152
Image Info panel 365	Local adjustment brush 248, 250, 251, 252
image size 198	Local adjustment presets 258
Image Sizing 305	Locked 152
image sources 112	lossy compression. See JPG
import and export keywords 167	Loupe View 143, 144
importing 83	LR/Enfuse 312
Import screen 84	LR/Mogrify 312
import workflows 104	Luminance 6, 234, 239, 240, 241, 247
Include Subfolders 117	
Initial Previews 97	М
interpolation	master file 18
downsampling 3	
	metadata editing 16
upsampling 3	metadata editing 16

pixel limit 3

metadata filters 175 Plug-in Manager 313 Metadata panel 152 Point Curve 229, 232, 233 metadata presets 86, 87, 156 posterization 4 Metadata Status 157 Post-Processing 309 Minimize Embedded Metadata 308 Preferences 44, 46, 284 missing folders/photos 124 preparing print files to send to a lab 357 modifying and removing presets 277 presets 85 Modify Keywords 165 previewing in multiple browsers 364 Module Picker 28 previews 71, 72, 74, 88, 92, 93, 95, 97, 98, modules 22 109, 116, 117, 118, 142, 148, 159, multiple filters 176 184, 190, 204, 210, 245, 261, 269, 270, 280, 339, 347, 348, 364, 370 N Previous Import 113, 118, 190 printing photos from Lightroom 329 native resolution 3 multi-page jobs 336 Navigator 30 Print module 24, 334 noise 196, 201, 202, 240, 245, 247, 283 Cells panel 344 noise reduction 247 Color management 352 non-destructive image processing 16 Contact Sheet/Grid 335 None filter option 176 Image Settings panel 337 0 Layout Engine panel 334 Layout panel 338 offline volumes 116 Overlays panel 339 orientation 215 Page Bleed: 339 Original 18, 293, 297, 299, 302 Picture Package 335 Output Sharpening 307 Print Job panel 347 Template Browser panel 336 Print Resolution 347 Page Options 342 Print Sharpening 349 Page Setup 333, 334, 336, 338, 357 progress indicators 28 Painter 187 ProPhoto 7, 9, 303 Paint Target Collection 188 0 panel end marks 36 panel groups 34 Quick Collection 113, 179 panels 27 Quick Develop 184 panel switches 39 Perceptual 353. See rendering intents R Photomatix 312 raster images 3 Photoshop 4, 7, 10, 118, 162 ratings 168, 173, 175, 190 Picasa 312 raw capture 50 pick 172 reading metadata from files 162 Picture Package. See Print module Recent Sources 113 pixel 2

Recovery 225

Refine Photos 173 Reject flag 173	Slideshow 24, 322, 323
	Background Color 326
Remove Red Eye 265	Background Image 326
removing artifacts 244	Color Wash 326
removing folders 119	delete an existing text overlay 325
removing photos 123	Layout panel 323
rename a batch of images 122	Options panel 323
renaming folders 119	Overlays panel 324
renaming photos 122	Playback panel 327
rendering intents 9, 353	presenting the slideshow 328
Perceptual 9, 353	Rating Stars 325
Relative Colorimetric 9, 353	rotate adornments 326
resampling 3	Text Overlays 325
Reset 186	Titles panel 327
resetting adjustments 272	Smart Collections 182
resetting the crop 216	SmugMug 312
resize panels 34	Snapshots 273
Resize to Fit 305	Solo Mode 36
resolution 2, 197, 198, 259, 260, 305, 306,	Sort Order 128
307	split controls 232
retouching 204, 209, 244, 262, 263, 264, 265, 283	Split Toning 268
rotating and flipping images 142	Spot Removal 262, 263, 264, 265, 274
roundtrip editing with Photoshop 283	srgb 7, 8, 9
1	Stacks 138
S	stars 168
0	stopping an import 96
Saturation 6, 234, 237, 238, 239, 241, 250, 282	straighten 212
Save Metadata to File 159, 190	subfolders 116, 117, 118
saving your work 17	Survey view 148
screen modes 44	
Secondary Display Window 47, 149	Sync 113, 157, 185, 186, 271, 275, 276
Select All 135	Synchronize Folder 118
selecting and deselecting images 134	synchronizing 118, 129
selection commands 136	Sync Metadata 157
Select None 136	Sync Settings 185, 275
Set Keyword 166	т
sharpening 196, 203, 245, 247, 252, 259, 260,	•
261, 276, 283	Target Collection 178, 179, 188
sharpness 197, 198, 203, 227, 250, 259, 260	targeted adjustment 223, 233, 234, 240
shooting tethered 63, 102	Template Browser 323, 328, 336, 358, 359
shortcuts 41, Appendix A	templates 85
show unsaved metadata 158	Text filter 174
sidecar files 11, 18	Text Overlays 325
sliders 38	Thumbnail Badges 129

U

Undo/Redo 209 upload 366, 367, 368, 369 using multiple catalogs 71 using multiple computers 85

V

Vibrance 237 View Options 132, 133, 145, 158 Vignettes 248, 258, 259 virtual copies 271, 292, 293, 302 voice notes. *See* audio files Volume Browser 115

W

X

хмр 99

Z

Zenfolio 312 zoom clicked point to center 144 zoom ratio 30, 31